Radio Production
Art and Science

Michael C. Keith

Focal Press
Boston London

Focal Press is an imprint of Butterworth–Heinemann.

Copyright © 1990 by Michael C. Keith.
All rights reserved.

No part of this publication may be reproduced, stored in a retrieval system, or transmitted, in any form or by any means, electronic, mechanical, photocopying, recording, or otherwise, without the prior written permission of the publisher.

Recognizing the importance of preserving what has been written, it is the policy of Butterworth–Heinemann to have the books it publishes printed on acid-free paper, and we exert our best efforts to that end.

Library of Congress Cataloging-in-Publication Data

Keith, Michael C.
 Radio production : art and science / by Michael C. Keith.
 p. cm.
 Includes bibliographical references.
 ISBN 0-240-80017-6
 1. Radio—Production and direction. 2. Radio broadcasting.
I. Title.
PN1991.75.K45 1991
791.44′0232—dc20 89-78286
 CIP

British Library Cataloguing in Publication Data

Keith, Michael C.
 Radio production : art and science.
 1. Radio programmes. Production
 I. Title
 791.440232

 ISBN 0-240-80017-6

Butterworth–Heinemann
80 Montvale Avenue
Stoneham, MA 02180

10 9 8 7 6 5 4 3 2 1

Printed in the United States of America

To Dottie, Curt, Mac, Joe, and Jim

Space is the world created by sound.

—Marshall McLuhan

Radio is a noble and powerful medium—a little art form.

—Garrison Keillor

CONTENTS

Preface	xi

I THE RADIO PRODUCER

1 A Retrospective — 3
- An Electronic Medium Is Launched — 3
- A Year of Change — 5
- The Role of Ad Agencies — 6
- Radio Is Not Depressed — 6
- Catchy Commercials — 7
- Creating the Sounds — 7
- Recording the Message — 9
- Summary — 9
- Chapter Highlights — 10

2 The Role of the Production Staff — 11
- The Big and Small of It — 11
- Production Staff — 11
- Out-of-Station Production — 12
- The Production Director in the Flow — 12
- A Day in the Life of a Production Director — 13
- Chapter Highlights — 21

3 Skills, Qualities, Responsibilities, and the Art of Production — 22
- Skills — 22
- Qualities — 27
- Responsibilities — 29
- The Art of Production — 32
- Chapter Highlights — 33

II STUDIOS AND EQUIPMENT

4 The Studios and the Use of Equipment — 37
- Studio Size — 37
- Acoustics — 37
- Layout — 38
- Storage — 40
- Points on Equipment Use — 41
- Studio Maintenance — 42
- Taking Charge—Mastering the Possibilities — 43
- Chapter Highlights — 45

5 The Audio Console — 47
- Console Components — 47
- Console Designs — 55
- Labeling — 57
- Practical Points on Use — 59
- Patching — 59
- Remoting — 60
- Chapter Highlights — 60
- Spot Assignments — 62

6 Tape Recorders — 63
- Reel-to-Reel Machines — 63
- Cartridge Machines — 65
- Cassette Machines — 69
- Tape Heads — 70
- Tape Machine Speeds — 71
- Magnetic Tape — 72
- Bulk Erasers — 75
- Digital Audio Tape (DAT) — 75
- Chapter Highlights — 79
- Spot Assignments — 79

7 Turntables and Compact Discs — 81
- Turntable Components — 81
- Cueing on the Turntable — 83
- Compact Discs — 84
- Disc Maintenance — 85
- Chapter Highlights — 87
- Spot Assignments — 88

8 Microphones, Speakers, and Headphones — 89
- Sound — 89
- Microphone Designs — 89

		The Microphone in Use	93			Record Cart Machine	149
		Speakers	97			Post Mixdown	149
		Headphones	99			Timing Elements	149
		Chapter Highlights	102			Chapter Highlights	150
		Spot Assignments	103			Spot Assignments	151
	9	**Audio Processing, Computers, and the New Tools**	**104**		**13**	**Editing**	**152**
		Digitalization	104			Purpose of Editing	152
		Multitracking	106			Editing/Splicing	152
		Compression	107			Tools of the Edit	153
		Equalization	108			The Edit	154
		Audio Processors	109			Razorless Editing	158
		Samplers and Synthesizers	112			Chapter Highlights	159
		MIDIs and Computers	115			Spot Assignments	160
		Workstations	115				
		Industry Notes by Ty Ford	116	**IV**	**PRODUCTION IN FORMAT RADIO**		
		Chapter Highlights	123				
	10	**Ingredients of the Mix**	**125**		**14**	**Production in a New Era**	**163**
		Music	125			Specialization	163
		Bed Time	125			Pop Chart Radio	164
		Bed Sources	126			Rock Spots	165
		Strictures	128			Adult Stations	166
		Indexing Beds	129			The FM Sound	166
		Sound Effects	131			FM Progresses	167
		Indexing Sound Effects	131			Sounds of the 70s	168
		Storage	133			Formatics in the 1980s and 1990s	169
		Chapter Highlights	133			Overview: Programming and Production	170
		Spot Assignments	134			Industry Notes by Jay Williams	171
III	**PLANNING, MIXING, AND EDITING**					Chapter Highlights	171
	11	**Preproduction Planning**	**137**		**15**	**Rock Radio Production**	**173**
		Writing Copy	137			Copy Formatics	173
		Delivery Preparation	141			Contemporary Hit Radio (CHR)	174
		Assembling Mixdown Ingredients	143			Album Oriented Rock (AOR)	178
		Sequencing and Setup	143			Urban Contemporary	182
		Chapter Highlights	144			Vintage Rock	185
		Spot Assignments	145			Chapter Highlights	188
	12	**Mixing Time**	**146**			Spot Assignments	188
		Audio Console	146		**16**	**Adult Radio Production**	**189**
		Reel-to-Reel Machine	146			Adult Contemporary	189
		Turntable	147			Country	193
		Playback Cart Machine	148			Middle-of-the-Road	198
						Chapter Highlights	201
						Spot Assignments	201

17	**"Good Music" Radio Production**	**202**	V	**PRODUCTION IN NONCOMMERCIAL RADIO**	
	Easy Listening	202			
	Classical	206	19	**Mixing Between 88 and 92 MHz**	**227**
	Nostalgia	210			
	Chapter Highlights	212		College Radio	228
	Spot Assignments	212		Public Radio	232
				Community Radio	233
18	**Nonmusic Radio Production**	**213**		Noncommercial Radio Production	234
	News	213		Industry Notes by Alan Frank	237
	Talk	214		Chapter Highlights	239
	News and Talk Hybrids	215		Spot Assignments	240
	News and/or Talk Copy	216		**Glossary**	**241**
	News and/or Talk Delivery	217			
	News and/or Talk Mixdown	217		**Suggested Further Reading**	**246**
	News Production	218			
	Public Affairs Production	219		**Index**	**247**
	Interview Production	220			
	Religious Programming	222			
	Chapter Highlights	223			
	Spot Assignments (Chapters 15 through 18)	224			

Preface

This book had its genesis (at least in part) in an earlier work, which I titled *Production in Format Radio Handbook*. While this text was the first full-length study devoted to an examination of the effects of station programming formats on the production process, it did not attempt an assessment of studios and equipment. *Radio Production: Art and Science* does both—and more.

This is the first book to take a fully integrated approach to the subject of radio production. In my opinion, radio production cannot be adequately taught without imparting to the student an understanding and appreciation of how programming influences the entire mixdown process. Production and programming are not mutually exclusive areas. In fact, they are one and the same. Radio production *is* programming—and vice versa.

In Part I the reader is provided with a brief history of radio production and then taken into a modern production studio for a realistic depiction of a production director's workday. This is followed by an examination of the skills and qualities that a production person must possess in order to meet the responsibilities of this unique position.

Part II begins with an analysis of studio design characteristics (size, acoustics, layout) and then discusses the standard equipment contained in a production room—in terms of its operation and application. The newest cutting-edge audio gear (digital processors, MIDIs, synthesizers, computers) is also evaluated in the context of its role in today's production studio environment.

Part III discusses the basics of copy preparation and the fundamentals of good announcer delivery. In addition, this section of the text provides a comprehensive look at the techniques of tape editing.

How radio formats affect the way commercials, public service announcements, promos, and features are produced is the focus of Part IV. A dozen of the medium's most popular formats are analyzed in respect to their impact on production mixdown.

The final section of the text—Part V—explores several aspects of the production experience in noncommercial (Public, College, Community) radio formats.

It is my hope that the reader will derive from these pages a genuine feeling of what it means to work in radio production, as well as an understanding of equipment basics and an appreciation of how programming influences mixdown. Few occupations offer as many challenges and rewards.

Many people deserve to be acknowledged for their generous contributions to the making of this book. Over one hundred broadcast professionals added their insights to these pages, and the book is far better because of this. The use of industry quotes has always been an integral part of my texts. In the following statement, study skills expert Professor Lou Emond explains why. "Besides demonstrating to the students that the text deals with the realities of the profession, not just theories, the quotations lend credence to the instructor's presentation—much like the use of multiple guest speakers. These excerpts from industry professionals can become springboards for discussion or can lead to research of local market outlets as sources of comparison. Because the experts don't always agree, the students will realize that not every station operates the same and that, as employees, they will have to adjust to the operating philosophy of their immediate superiors. The bottom line for anyone intending a career in communications is flexibility. The medium is continually changing, never static, and those wishing to advance their careers must be ready for changes in operating principles and technology. The input of so many industry professionals underscores the variety and vitality of the medium."

For many years my colleagues and friends—Lindy Bonczek, Roger Turner, and Lou Emond—have served as readers on my

writing projects, and their suggestions and advice have always proven valuable. To no small measure, I am in their debt. Finally, a mention of appreciation is owed Phil Sutherland and Karen Speerstra of Focal Press for their excellent support, vision, and good humor.

Radio Production

I THE RADIO PRODUCER

1 A Retrospective

The term *radio producer* belongs more to the medium's golden age than it does to the present day. The role of the radio producer during the medium's heyday, which spanned three decades (1920–1950), is more akin to today's television producer. The radio producer of yesteryear generally oversaw the entire production of a broadcast, including its advertising, casting of talent, scripting, and so forth. The modern radio station producer—or production director, as he or she is generally called—primarily concentrates on the mixing (recording) of sounds as related to the preparation of commercials (spots) and promotional pieces (promos).

Individuals involved in the production of long-form features (mixes of a quarter hour or more) are commonly referred to as radio producers (or independent radio producers) because their duties more closely resemble those of their forebears.

Early radio production was accomplished in an environment that was at once similar to and very different from that of today's radio production experience. The heyday producer plied his or her craft in a studio setting—usually in an acoustically enhanced area, replete with a variety of audio paraphernalia—and this is also true of today's producer. But what really distinguishes the experience of the producer of the past from that of the present-day producer is that the former nearly always performed "live" for the listening audience, whereas the modern radio production person is aided greatly by the tape recorder.

Few live productions are presented over the air today. Most commercials, promos, and features that require a mix of sound elements are pretaped or "canned" (more on this later). For the moment, the focus of this text will be on production during radio's much-heralded golden era.

AN ELECTRONIC MEDIUM IS LAUNCHED

In 1920, radio as a mass medium made its debut, most notably with a dependable schedule of daily broadcasts by KDKA in Pittsburgh, Pennsylvania. Prior to this, radio broadcasts had been offered sporadically and often infrequently. The public would watch the newspapers for notices announcing a broadcast by a particular station. Days would often pass before another program was fed to waiting receivers. However, KDKA's dependable schedule gave the medium credibility. The absence of regularly scheduled broadcasts had hampered the establishment of the new medium. Predictability inspired listenership, as well as the purchase of receivers, something KDKA's parent company, Westinghouse Electric, certainly desired. A regular daily schedule of programming provided many consumers with the rationale they needed to invest in the "new-fangled" device called radio.

At first, radio sought no advertiser support. Thus listeners heard no sales pitches over the air. American broadcasting, which in a few short years would establish itself as the greatest advertising vehicle ever known, began as a noncommercial medium.

Prior to the commercialization of the medium—which did not take long—programming consisted primarily of agricultural, sports, and news reports, and what can be called fine arts features. Performances by theater artists—singers and dramatic orators—were common. The broadcast of phonograph (Victrola) records served as bridge and fill material between live features.

The idea of selling airtime occurred at AT&T-owned station WEAF in New York. On August 28, 1922, barely two years after the medium's official launch, an advertisement was transmitted into the electromagnetic spectrum. By today's standards the message was anything but a commercial. Convinced by WEAF to promote their Queens-based housing development, the owners of Hawthorne Court leased ten minutes of airtime for one hundred dollars. The announcement, which was delivered by a representative of the firm, sounded more like a classroom lecture.

The concept of providing advertisers with a portion of broadcast space for a fee was

4 THE RADIO PRODUCER

FIGURE 1.1
Early control studio.
(Courtesy WTIC.)

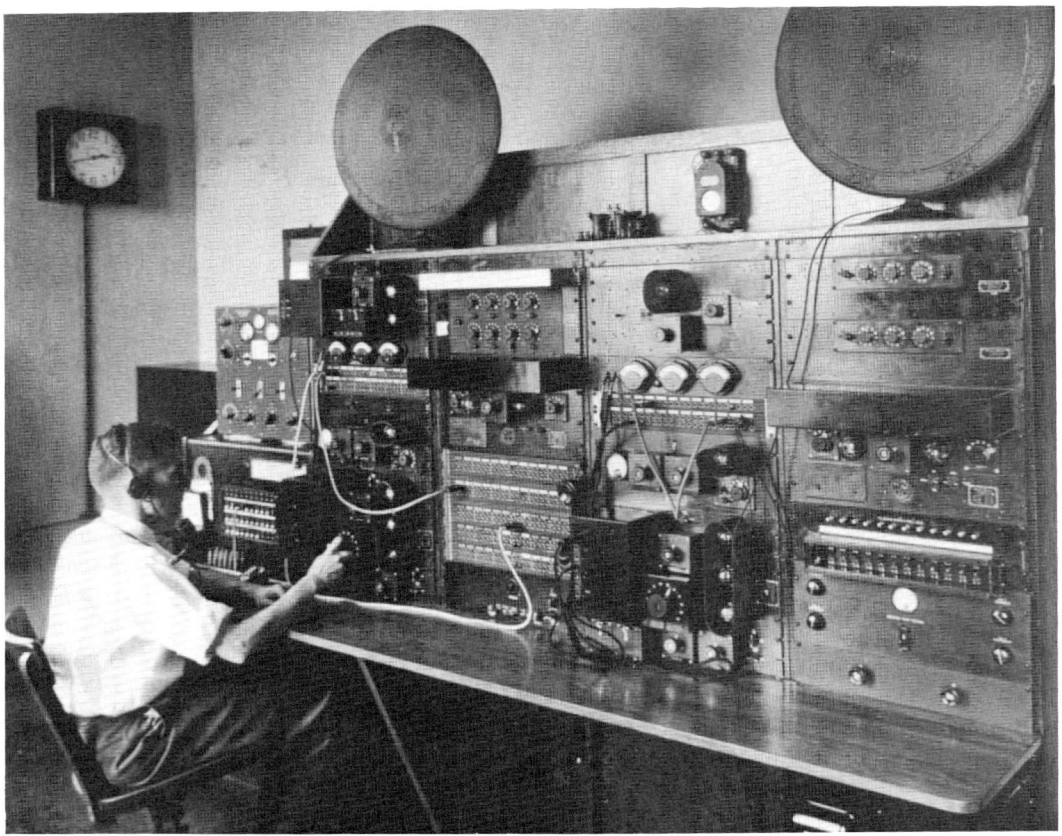

FIGURE 1.2
Carbon microphone
from the 1920s.
(Courtesy Jim Steele.)

FIGURE 1.3
Theater performer
on the air. The
microphone is con-
cealed by a lamp-
shade so as not to
intimidate the per-
former. (Courtesy
WTIC.)

called "toll-casting" by WEAF. The company that owned the station perceived an analogy between a long distance telephone toll call and the use of the station's microphone to reach an audience; thus the term *toll-casting* originated.

Soon after WEAF's enterprising experiment, other stations began offering airtime to businesses. The idea of turning the public airwaves into an advertising tool appalled Secretary of Commerce Herbert Hoover, who was vested with the responsibility of overseeing the fledgling medium. Stations argued that advertising revenues were necessary to sustain their operations. A tense relationship existed between the government and broadcasters during the conversion of the industry from a noncommercial to a commercial medium.

So as not to incur the full wrath of the secretary of commerce, the majority of radio stations went the route of indirect advertising in the 1920s. Programs were sold to sponsors, and their names were attached to them, such as "The Palmolive Hour,"

"Voice of Firestone," and "The Coty Playgirl." The actual commercial content in these programs was small, since the client was mentioned only during introductions and conclusions, as in "Welcome, ladies and gentlemen, to 'The Eveready Hour.'"

This subtle approach to generating revenue was inevitably abandoned, and by the late 1920s the government had all but resigned itself to the reality of commercial radio.

Despite the emergence of direct, if not blatant, sales pitches on the air, commercials remained fairly simple productions. Whereas programming had become more sophisticated by the mid and late 1920s with variety shows and dramatizations capturing listeners, commercials retained their rudimentary and austere quality. The unembellished, straight-ahead statement, usually delivered in an overly pedantic manner, was the norm. These mostly unengaging messages were occasionally accompanied by an instrument, such as a piano or organ, but this was more the exception than the rule.

A YEAR OF CHANGE

For a number of reasons, the year 1926 was a watershed for the infant medium. The first network, NBC, began operating; broadcasters and the government began to address the interference problem that threatened to strangle radio; and the jingle (singing) commercial was introduced. All three of these events, although not exactly equal in significance, would have an important role in the future of broadcasting.

The advent of network radio marked the beginning of a more sophisticated and elaborate schedule of programs available to the listening public. By the end of the decade both NBC and CBS were offering an impressive list of daily features. In the 1930s, network radio would reach its apex as yet another broadcast organization, Mutual Broadcasting System (MBS), entered the airwaves with a web of affiliates. Soon the majority of the nation's stations relied on the networks for the rich schedule of programming they broadcast.

As the networks were about to be launched, American broadcasting reached a crisis point. Reception of signals was poor in almost every area of the country. Due to the lack of foresight on the part of both the government and broadcasters, station interference was rampant. By 1926 hundreds of radio stations were beaming signals to home receivers. However, no legislation had been adopted to provide broadcasters with

Vischer Randall

This afternoon the radio audience is to be addressed by Mr. Blackwell of the Queensboro Corporation, who through arrangements made by the Griffin Radio Service, Incorporated, will say a few words concerning Nathaniel Hawthorne and the desirability of fostering the helpful community spirit and the healthful, unconfined homelife that were Hawthorne's ideals. Ladies and gentlemen, Mr. Blackwell.

Mr. Blackwell

It is fifty-eight years since Nathaniel Hawthorne, the greatest of American fictionists, passed away. To honor his memory, the Queensboro Corporation, creator and operator of the tenant-owned system of apartment homes at Jackson Heights, New York City, has named the latest group of high-grade dwellings "Hawthorne Court."

I wish to thank those within the sound of my voice for the broadcasting opportunity afforded me to urge the vast radio audience to seek the recreation and daily comfort of the home removed from the congested part of the city, right at the boundaries of God's great outdoors, and within a few minutes by subway from the business section of Manhattan. This sort of residential environment strongly influenced Hawthorne, America's great writer of fiction. He analyzed with charming keenness the social spirit of those who had thus happily selected homes, and he painted the people inhabiting those homes with good-natured relish.

There should be more Hawthorne sermons preached about the utter inadequacy and the general hopelessness of the congested city home. The cry of the heart is for more living room, more chance to unfold, more opportunity to get near the Mother Earth, to play, to romp, to plant and dig.

Let me rejoin upon you as you value your health and your hopes and your home happiness, get away from the solid masses of brick, where the meagre opening admitting a slant of sunlight is mockingly called a light shaft, and where children grow up starved for a run over a patch of grass and the sight of a tree.

Apartments in congested parts of the city have proven failures. The word *neighbor* is an expression of peculiar irony—a daily joke

FIGURE 1.4
Text of first radio advertisement, aired over WEAF in 1922.

1936	
Top Radio Advertisers	Spent on Network Advertising
Procter and Gamble	$3,299,000
Standard Brands	2,275,000
Ford-Lincoln	2,251,000
Sterling Products	1,621,000
Colgate-Palmolive	1,556,000
American Tobacco Company	1,508,000
General Foods	1,472,000
American Home Products	1,447,000
Pepsodent	1,352,000
Campbell Soup	1,314,000

FIGURE 1.5
List of top radio advertisers during early days. (Reprinted, with permission, from the author's book, *Production in Format Radio Handbook* [Washington, D.C.: University Press of America, 1984].)

sufficient channel space. In fact, only two frequencies existed for the use of broadcast transmissions. Metropolitan areas, such as New York, suffered from the greatest congestion, as several stations fought to be heard simultaneously. This had a chilling effect on listeners, who became disillusioned with the hodgepodge of sounds emanating from their radio speakers.

The last attempt at regulating the medium had occurred in 1912, when the idea of radio as a mass medium had yet to be conceived. It was not until half a decade later that a remarkable young visionary and entrepreneur named David Sarnoff would propose that the wireless communication device be manufactured and marketed for home use.

In a short span of time radio was transformed into the world's first electronic mass medium. By the middle 1920s, millions of American homes possessed Sarnoff's "radio music box." Yet, sufficient regulation to ensure the proper use of radio had not been written, and disaster loomed.

However, the Radio Act of 1927 was designed to address the upheaval, and the office created by the new legislation, the Federal Radio Commission (FRC), was charged with the task of devising a solution.

This it did with great wisdom and energy. Not long after the commission was formed, it plunged into the quagmire headfirst. The number of stations was reduced by nearly a third, the Standard Broadcast Band (AM) was established with nearly one hundred channels, and stations were assigned frequencies as well as operating parameters. A myriad other changes were implemented as part of the FRC's mission. Within eighteen months, the interference problem was conquered.

In 1934, the FRC was supplanted by the Federal Communications Commission (FCC), a permanent and autonomous branch of the government established to regulate all forms of electronic communication, both wired and wireless.

As the wheels of change were rolling, the first-ever musical commercial was broadcast over a New York station. On Christmas Eve in 1926, a group of singers assembled to harmonize about Wheaties cereal, thus setting a new course in the presentation of over-the-air advertisements.

THE ROLE OF AD AGENCIES

During this period advertising agencies were becoming involved in the medium, and not simply as client reps. As the 1930s approached, ad agencies were taking an active part in the formulation of broadcast programs at the networks. Not only would an agency develop promotional material for a client, but it would also participate in the actual production and scheduling of programs in which their client's messages were placed. In fact, at one point during their omnipotent reign, advertising agencies all but dictated network programming. In many instances the networks were forced to play ball. They could take a packaged program from an agency or miss out on the buy. In the latter case, this meant forsaking income, something the networks generally were disinclined to do.

Advertising agency dominance existed into the 1940s, at which time the government viewed the role of the agencies as monopolistic. Thus agencies were left to perform their original function—to prepare client campaigns and place them where they would do the most good. Fortunately for radio broadcasters, this usually meant radio.

RADIO IS NOT DEPRESSED

The 1920s witnessed radio's evolution from something of a hobbyist's toy to an established industry, yet the 1930s would observe its elevation to institutional status. When broadcast historians talk about the golden age of radio they are referring to the years between 1920 and 1950, but specifically the 1930s. Although this decade may represent one of the bleakest periods in U.S. history, with the collapse of the economy and the Depression, radio's fortunes advanced. The public needed an inexpensive way to escape the somber realities that threatened to overtake the world, and radio was eager to provide one.

No one could dispute the popularity of the medium in 1930, when the country would virtually cease what it was doing to tune in the antics of "Amos 'n' Andy" and

other comedy and adventure shows. Retailers and theater owners saw traffic decline on the evenings when the networks' hit programs were aired.

CATCHY COMMERCIALS

During this period the dramatized commercial (inspired by the radio drama) gained popularity with sponsors. Advertisers like Chase and Sanborn coffee and Lucky Strike cigarettes believed audiences to be particularly receptive to their messages when presented in something other than a straight announcement format, so humor and melodrama were employed to convey the virtues of a product. Actors as well as staff announcers were called upon to perform in these miniproductions, which occasionally ran for several minutes.

At the same time that the dramatized commercial approach was being adopted, the singing commercial was winning a greater following among major advertisers. Barbasol had one of the most memorable and popular jingles of the day. It was performed by Harry Frankel, who gained national notice as Singing Sam, the Barbasol Man.

Clever and catchy lyrics, such as these devised for the Tastyeast Candy Company, made a strong impression on listeners:

Tastyeast is tempting to your appetite;
Creamy wholesome candy, try a luscious bite.
Vitamins are hiding in this candy bar;
Pep, vim, and vigor linger where they are.
Children like this lovely creamy food delight;
Let them eat it daily, every morning, noon,
 and night.
You will see them growing strong every day;
Take yeast this dandy, handy, candy way.

Grocers reported hearing children sing the jingle in their stores, and the candy company noticed a marked increase in sales. Thus, for many sponsors, the singing commercial became the prevailing means of pitching the listening audience. Few who listened to radio during the 1930s and 1940s have forgotten lyrics such as "You'll wonder where the yellow went, when you brush your teeth with Pepsodent" or "Halo everybody, Halo. Halo is the shampoo that glorifies your hair" or "Get Wildroot Cream Oil, Charlie." Nor would those who recall the lyrics to these and other popular jingles have forgotten the melodies that so effectively accompanied the words.

Another type of radio commercial emerged during this period as well. It presented verbal testimony by the consumer pertaining to the product advertised. Frequently the individual providing the endorsement was merely an actor and not an actual user of the advertised merchandise. Nonetheless, testimonial commercials proved effective and joined the ranks of the jingle and dramatization to become one of the most frequently employed approaches to selling a client's goods.

The production of these and other types of commercials posed some unique challenges to the person in charge of their broadcast. Remember, this is the period prior to the invention of recording tape or 33⅓ LPs. Commercials were rarely prerecorded in the 1930s, since this involved a rather complex process—the results of which were often subpar anyway. Thus, in a medium such as radio, which renowned writer and producer Arch Oboler referred to as "an insatiable sausage grinder," innovativeness and expediency were of utmost importance.

Live programs and live commercials were the natural order of things around the clock at the networks. Production personnel were kept extremely busy planning and devising the sounds required by the broadcasts. A great deal of imagination and creativity went into the preparation of commercials alone. The production demands of some advertisements equaled and even exceeded those of the programs they punctuated. Musicians, actors, and extravagantly constructed sound effects were routinely required to sell dog food or laxatives. By the late 1930s, certain commercials had become as famous as the most popular programs of the day. Commercials had achieved the status of pop art.

CREATING THE SOUNDS

Still, the early radio station production studio was primitive by today's standards.

FIGURE 1.6
Sound effects person at work. (Courtesy WTIC.)

Sound effects were mostly improvised from show-to-show, commercial-to-commercial, in some cases using the actual objects that sounds were identified with. Glass shattered, car horns beeped, guns fired, and furniture overturned as the studio's on-air light flashed. A production person might recruit the services of a plump, ripe melon and a stepladder to create the sound illusion of someone falling to the ground from a great height, or crumble cellophane to produce the sound of fire. One enterprising technician placed a microphone in a noisy air conditioning duct to create the impression of a rocket ship in flight. The "whooshing" noise was just right. Sound effects people collected objects that would produce specific sounds when tapped, rubbed, shaken, squeezed, or even dropped within a given distance of a microphone.

Large objects employed to generate sounds, such as doors, were placed on wheels so that they could be easily moved about from one studio to the next and to and from the storage area. Phonograph recordings (78 rpms) containing sounds were also incorporated into productions, but the selection of prerecorded effects was often incomplete.

Programs as diverse as the "Columbia Workshop" and "Amos 'n' Andy" manufactured their own audio effects, and one of the medium's outstanding innovators, Arch Oboler, devised some of the most memorable and unusual effects for his program "Lights Out."

From the beginning, performers relied on their own wit and ingenuity to meet the demands of the scripts. In his book, *A Tower in Babel* (Oxford University Press, 1966), Erik Barnouw recalls a time when actors created their own effects during live broadcasts: "One became good at thumping his chest for horses hoofs and began doing it for everyone. Various principles emerged. The microphone distorted what was very close, favoring low tones. A key chain close to the microphone could therefore serve as a prison chain."

By the late 1930s and early 1940s sound effect technology had been significantly refined, and the world evoked by radio was ever the more poignant, especially to the young and impressionable listener, as this excerpt from Jeff Kisseloff's memoir, *You Must Remember This* (Harcourt, Brace, and Jovanovich, 1989), testifies: "Back in those days, you listen to the radio in the living room, and on the 'Inner Sanctum,' the door would open up (high squeaking), 'eeeeeek.' The funny thing about it, you really imagined it happenin'. It scared the shit outta' you. When you listened to 'The Shadow,' you really thought those people were real."

FIGURE 1.7
Sound effects storage area. Note 78 rpm turntable at far right. (Courtesy WTIC.)

Today sound effects are rarely, if ever, manufactured by the station staff, but during the medium's heyday the sound effects person played a vital role in creating the sounds necessary for a convincing broadcast. The sound effects person was an indispensable ingredient in what poet Stephen Vincent Benet called the "theater of the mind."

RECORDING THE MESSAGE

The live spot enjoyed a solitary reign throughout most of the medium's golden age, until the flexible long-playing vinyl disc arrived on the scene in the late 1940s. The innovation allowed agencies to record their commercials. This approach proved efficient from a number of perspectives and provided sponsors with a guarantee of performance. Once the tracks were set, they were set. That is, the recorded message eliminated the chance of production errors and inaccurate interpretations by broadcasters. The client knew exactly what would be aired.

Around the same time that vinyl discs were making their presence known to the advertising and broadcasting communities, another recording methodology emerged in the form of magnetic tape. Oddly enough, this innovation was a by-product of World War II. Nazi scientists had come up with magnetic tape for espionage purposes. Fortunately, the war ended before any significant application of the invention benefited the Third Reich. However, broadcasters were quick to seize upon magnetic tape for production purposes, and by the 1950s tape recorders were being installed in stations throughout the country.

Magnetic tape provided broadcasters with a host of useful features that literally revolutionized the production and mixing process. To begin with, tape could be reused simply by erasing it with a demagnetizing device. Furthermore, tape could be spliced for editing purposes. To alter the recorded surface all that was necessary was a razor and splicing tape. Of course, editing skill was essential for success, but tape editing could be learned fairly easily. Mastery was another thing, however. (See Chapter 13.)

Before long, advertising agencies were taping commercials for distribution, as well as pressing them onto vinyl. Radio stations took to recording programs as well as announcements onto tape. In the late 1950s, a product called a tape cartridge (cart) was marketed to broadcasters. A cart consists of a continuous loop of time-measured magnetic recording tape housed in a plastic container. The benefits this provided broadcasters were manifold: accessibility, ease of handling, and flexibility (carts will be discussed in detail in a later chapter). Suffice it to say that since the 1950s, the tape cartridge has been the primary purveyor, the modus operandi, of recorded material—commercials and public service announcements (psa's)—broadcast by radio stations.

SUMMARY

Things have changed dramatically since the first program and commercial were broadcast. As previously stated, the bulk of what is aired today is prerecorded. When commercials and features involve production (the mixing of sound ingredients such as music and effects), they invariably are recorded.

Despite the universal adoption of tape recording technology, the live message never went away. Its length was shortened after the 1930s. Rather than a several-minute-long exposition on the values of a product or service, today the live spot is delivered in a variety of different styles depending on station format. It is always a cappella—no piano or organ accompaniment—and it is framed within a thirty- or sixty-second time period. Remember, modern radio sponsors use "spots" of airtime.

Gone, too, are the days when networks hired personnel merely to create sounds during live broadcasts, although the networks do employ sound people (audio technicians). However, these individuals do not drop plump melons from atop ladders to create an effect. Sound mixing has become a much more sophisticated undertaking.

On the local radio station level the production staff operates a room full of state-of-the-art equipment to devise the effect desired by the advertiser or programming department.

In the chapters that follow, readers will be introduced to the world of modern radio

production and learn about the science and art of this unique profession.

CHAPTER HIGHLIGHTS

The Chapter Highlights in this text were prepared by study skills specialist Lou Emond.

1. Early radio producers (1920–1930) oversaw the entire broadcast production. At that time, production was live, whereas today's production elements are prerecorded.

2. The expansion of programming to a dependable schedule produced a predictable listenership, which made commercialization of the medium practical. Tollcasting, the earliest form of radio advertising, originated at New York's WEAF in 1922.

3. Early commercials were somewhat lengthy, unembellished, direct pitches.

4. The first watershed year for radio was 1926. The first network (NBC) began operating; the government addressed the interference problem between stations; and the singing commercial (jingle) was introduced.

5. Network radio provided a more sophisticated and elaborate program schedule than local programming.

6. The Radio Act of 1927 established the Federal Radio Commission (FRC). The commission reduced the number of stations by nearly a third, established the Standard Broadcast Band (AM), and assigned frequencies to each station. The FRC was supplanted by the Federal Communications Commission (FCC) in 1934.

7. On Christmas Eve in 1926 Wheaties aired the first singing commercial.

8. The golden age of radio (1920–1950) peaked during the 1930s. Dramatizations, testimonials, and singing commercials became popular. By the late 1930s, commercials were often more extravagantly produced than the programs, achieving the status of pop art.

9. Early radio's "theater of the mind" relied on live sound effects created by ingenious sound effects technicians and even by performers.

10. The live commercial spot prevailed until the late 1940s, when the vinyl LP and magnetic tape made prerecorded spots feasible.

11. Since the 1950s, the tape cartridge has been the primary medium for prerecorded commercials and psa's.

2 The Role of the Production Staff

Approximately twelve thousand radio stations in the United States provide listeners with an inestimable variety of programs, and all but a very few produce some form of material for broadcast. What this means is that hundreds of thousands of items—commercials, psa's, IDs, promos, and features—are mixed annually. Perhaps it would be more accurate to say that millions of sound "bites" are produced yearly, since some stations record tens of thousands of spots on their own.

THE BIG AND SMALL OF IT

Without debate it can be asserted that the radio station production studio is one of the planet's more active locations. Before detailing the events that make the production facility such a hot spot, let us examine how this sanctum differs from place to place.

First of all, when broadcasters talk geography it is usually by differentiating the size or population of a station's "market." This is usually expressed in terms of small, medium, and large, or metro, market size. For instance, a radio station situated in a city with a population under one hundred thousand inhabitants would be operating in a small market, whereas a station transmitting in an area with a population around a quarter million would be regarded as a medium market outlet. Usually stations broadcasting in cities with populations exceeding a half million residents are termed large or major market facilities. Keep in mind that these figures are not hard and fast. There are always exceptions when it comes to estimating a station's size and market position.

The point to be made here is that the bigger the market the larger the station (in most cases), and the bigger the station the bigger or more elaborate the production facilities. This statement may be conveyed another way by saying the larger the station the greater the income, and the greater the income the better the facilities. Of course, this is not always true. There are exceptions—many, in fact. But, generally speaking, large market stations tend to have fairly elaborate production studios compared to their smaller market siblings. The bottom line is: equipment and studios cost money.

It follows, too, that the bigger the station the bigger the staff, and vice versa. Whereas a major market station may employ fifty people (three assigned in various capacities to the production department), a small market station, or simply a small station (there are small stations in big markets) may employ a half dozen people, with no one individual assigned exclusively to the production room.

PRODUCTION STAFF

With few exceptions, a radio station holds one individual responsible for the assembly of commercials, promos, psa's, and so forth. In some instances (mostly in small markets) the program director or chief (senior) announcer assumes the responsibility for getting material "carted up." This usually means that this person does the majority of the station's mixing and recording. Typically with this type of arrangement, other announcers or deejays are allocated production chores.

The person assigned the primary production responsibilities may or may not be referred to as the production director, but more often than not the person who does the bulk of the station mixing is awarded this title. Some stations are reluctant to append a formal designation to the position,

12 THE RADIO PRODUCER

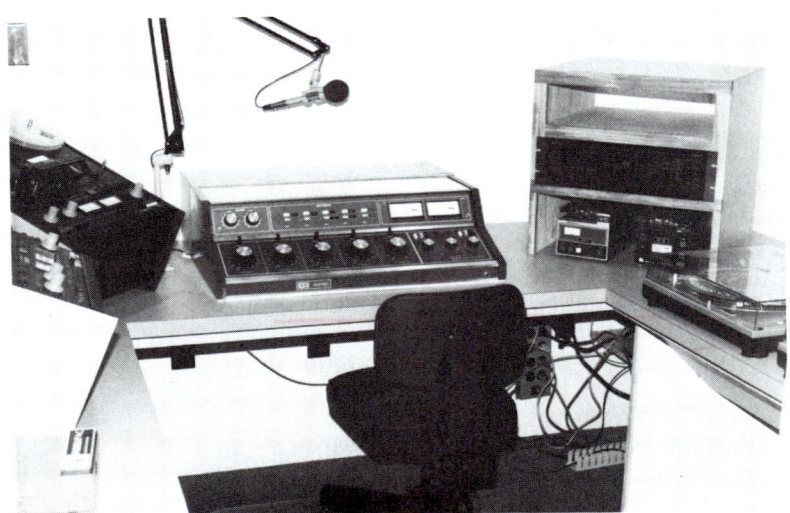

FIGURE 2.1a
A small market production studio. Due to simple economics, small market stations have more modest facilities.

FIGURE 2.1b
A large market production studio.

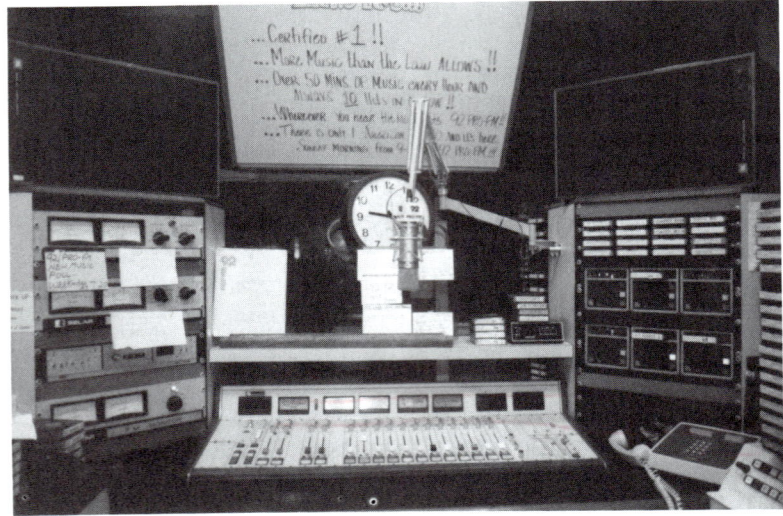

especially those stations that do not employ one individual to work in production on an exclusive, full-time basis.

Stations that do employ a full-time production person are more likely to use a term such as director, manager, or supervisor to lend credence to the position. Not all production directors spend their whole day within the confines of the production studio. Many stations require their production employee to take on an airshift as well. Metro market outlets are much less apt to have their production director performing in a "combo" capacity. "Here at WTIC in Hartford you have enough to do without being committed to a daily airshift," contends the station's production director, Peter Drew.

The production director usually constitutes a department of one. That is, very few stations employ more than one full-time production person. Of course, huge stations are the exception. At the so-called mega-outlets (the ones with the "killer signals," as a colleague describes them) three or even four people may be assigned exclusively to production.

In the far more common instance where the production director is the only individual working the mixing studio turf full-time, additional help may be hired on a part-time basis or drawn from the on-air staff.

OUT-OF-STATION PRODUCTION

Many advertising agencies and audio production houses also employ the services of a studio production person. As in radio, this individual's primary responsibility is the mixing of audio (spots, features, psa's) for broadcast.

However, the majority of radio production is accomplished on the station level, and it is because of this that the focus of this text is on the radio studio mixdown experience.

Of course, the basic tenets of good production are universal and as applicable to the agency or production house studio as they are to the radio station mixdown room.

THE PRODUCTION DIRECTOR IN THE FLOW

The production department is at the core of station operations. Therefore, the production director must interact with numerous people. As the organizational flow charts of Figure 2.2 illustrate, the production department is a component of the programming department, which is headed by the program director.

However, the production director often has as much contact with members of the sales, traffic, copy, news and engineering departments as he or she does with the station's programmer. In the next section the reader will see how these relationships are formed.

THE ROLE OF THE PRODUCTION STAFF

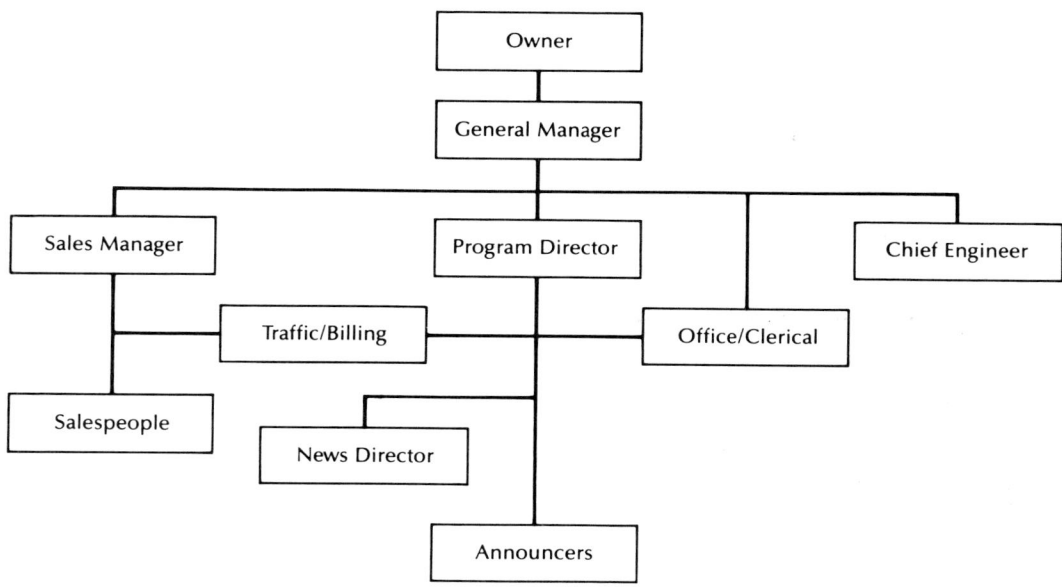

FIGURE 2.2a
A small market radio station flow chart.

A DAY IN THE LIFE OF A PRODUCTION DIRECTOR

This section illustrates the duties of a radio station production director during the course of a representative day. It is a profile of the experiences of a professional radio production person. Therefore, do not feel exasperated by a lack of understanding of what is taking place. However, after a thorough study of the chapters that follow, re-read this section—it will possess added meaning. For the time being, simply read these pages to obtain an appreciation of the production person's role as a key member of the radio station's staff.

Our fictitious model will be a medium market FM station broadcasting an Adult Contemporary (AC) format. The station will

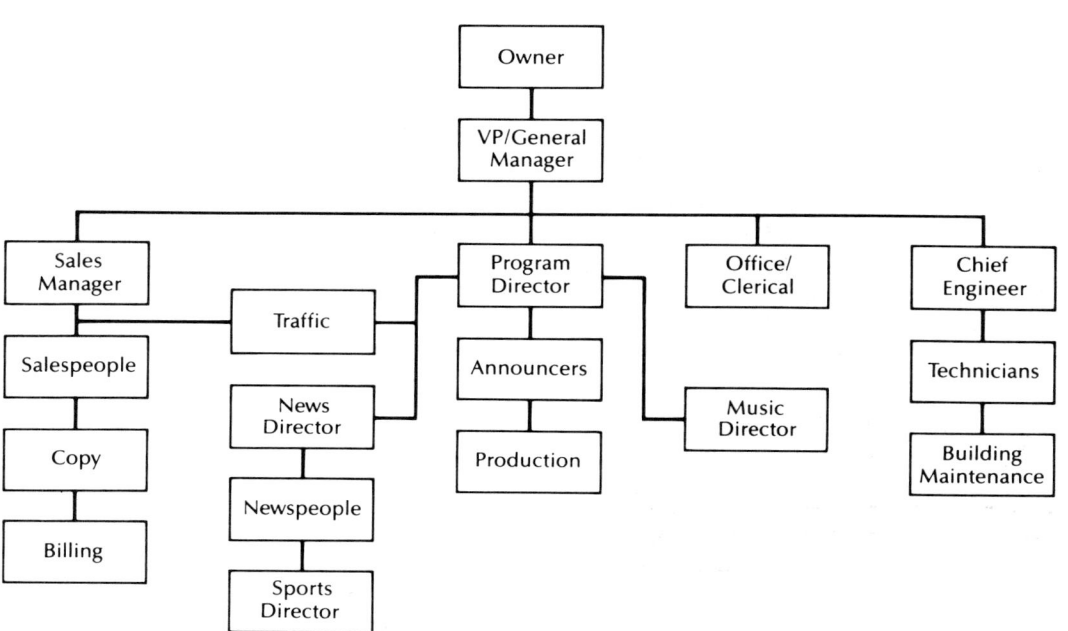

FIGURE 2.2b
A medium market radio station flow chart.

FIGURE 2.2c
A large market radio station flow chart.

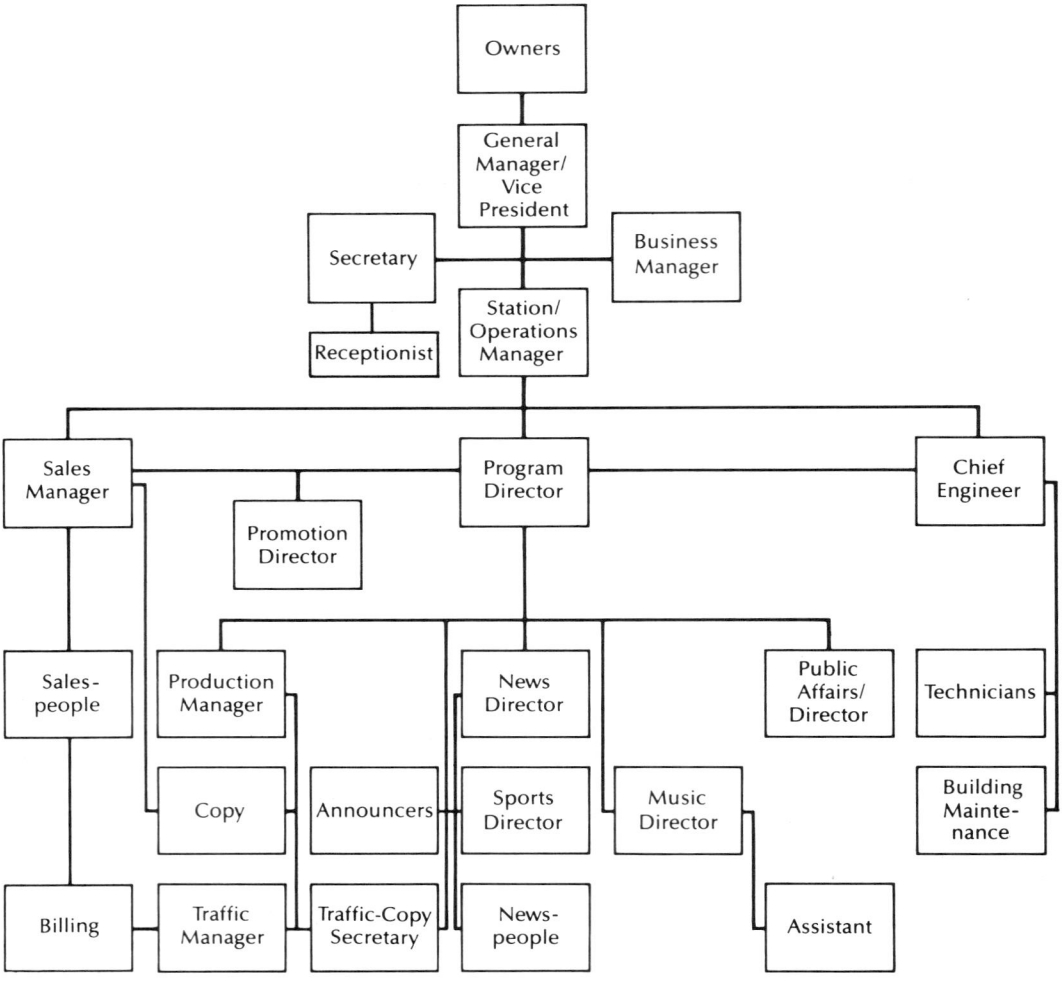

be known as Y95-FM, and the production director, an eight-year veteran of the medium, will be called John D. Arlin, or "J.D." for short.

The workday for off-air personnel begins at 8:00 A.M. and ends at 5:00 P.M. J.D.'s shift in the production studio coincides with these hours.

J.D.'s first chore is the removal of dated production material (tape cartridges—carts) from the control room. (The word *room* is used interchangeably with the word *studio*, as in control room and production room. The term *on-air studio* is also a synonym for control room. See the Glossary for clarification of terms used throughout this text.) At Y95 this also means clearing dated material from the copybook (usually a three-ring binder containing the written copy for commercials currently being aired). J.D.

scans the cart racks to make certain that no dated material is left behind. The overnight deejay is responsible for putting new carts into their designated slots in the rack and stacking the old carts in a designated area.

J.D. exits the control room for the production studio with several carts and pages of commercial copy, all of which have reached their expiration (end) date.

Once in the production room, J.D. strips the carts of labels and demagnetizes them so that they may be reused. He also runs them through the splice detector to make sure that future recordings will not be impressed across splice points (places where sections of tape have been joined together). Recording over a splice may result in an undesirable noise (clicking) on playback, which detracts from on-air presentation. Not

FIGURE 2.3a
Copybook in control room.

FIGURE 2.3b
Cart rack in control room.

FIGURE 2.4
Production director looking for splice.

all stations possess a machine designed to locate splices; when there is no machine, the search must be accomplished with the human eye and an open-top cartridge machine. A splice detector can save the production director valuable time.

Dated live copy removed from the control room's copybook is routed to the copywriter for filing. At stations that do not employ a full-time copywriter, the production person will see that this is done. Y95 has a copywriter, so J.D. has one less chore to perform.

Another point about copywriting responsibilities: at those stations not employing a full-time copywriter, the preparation of commercial copy usually falls to the salesperson handling the account or to the station's production person. Very often writing responsibilities are shared by both parties. Even at Y95, which has a copywriter, J.D. is occasionally asked to assist in copy composition. Since he has been producing commercials for a number of years and has developed a keen sense of broadcast copy style and structure, he is the natural person to pinch-hit when the copywriter is inundated, vacationing, or out sick.

Prior to launching into the day's production assignments, J.D. cleans all of the studio's tape recorders' recording heads. This helps prevent problems with fidelity, not the least of which are muddy or muffled recordings. J.D. will repeat this procedure several times during a regular production day. Keeping the recording heads clean is vital.

Heads cleaned, J.D. begins to prioritize the orders awaiting him in the "to be produced" box. He arranges them according to start date (when the recording will first be aired) and complexity. For instance, if it is Monday the seventh, a production order with a start date of the eighth would be given priority over one dated the ninth, and so on.

FIGURE 2.5
Production order form.

```
                        PRODUCTION ORDER
                     (Fill in all information below.)

    ┌─────────────────────────────────┐   ┌─────────────────────────────────┐
    │         ACCOUNT EXECUTIVE       │   │            ANNOUNCER            │
    │  CLIENT _____ │   │  DATE COMPLETED _____ │
    │  A/E _____ │   │  TIME COMPLETED _____ │
    │  DATE TO BE COMPLETED _____ │   │  COMPLETED BY _____ │
    │  CASSETTE   YES ____  NO ____   │   │                                 │
    │  OUTGOING DUBS (LIST STATION) __│   │                                 │
    └─────────────────────────────────┘   └─────────────────────────────────┘

    ┌─────────────────────────────────┐   ┌─────────────────────────────────┐
    │             TRAFFIC             │   │       PRODUCTION DIRECTOR       │
    │  CART #  AM _____ │   │  ASSIGNED TO _____ │
    │          FM _____ │   │  DATE _____ │
    └─────────────────────────────────┘   └─────────────────────────────────┘

- - - - - - - - - - - - - - - - - - - - - - - - - - - - - - - - - - - - - - -
                              DUB ORDER

        AM _____ # OF SPOTS _____ LENGTH _____ START _____ END _____
        FM _____ # OF SPOTS _____ LENGTH _____ START _____ END _____
        CUTS _____
        TAGS:  LIVE _____  PRE-RECORDED _____
        TAG COPY _____
        _____
        _____

        SPECIAL INSTRUCTIONS/SPOT CHANGES _____
        _____
        _____
        _____

              (RETURN THIS FORM TO PRODUCTION DIRECTOR)
```

J.D. finds four production orders with next day starts. Three require simple dubbing (copying) of prerecorded spots onto cart, and the fourth involves mixing two voices—one a female—and several production elements. J.D. must line up the talent needed for the verbal elements, called *voice tracks*.

Once the voice talent has been nailed down and taping time arranged, J.D. proceeds to transfer onto cartridge the prerecorded spots slated for broadcast the next day. Within fifteen minutes he has completed the dubbing and labeled the carts with all the pertinent information (see Figure 2.6.)

At this point in the morning a station AE (account executive/salesperson) arrives in the production room to hear a *spec tape*, or *demo* (a commercial prepared for a sponsor in the hopes that the sponsor will purchase airtime). J.D. runs the tape for the AE, who is not completely satisfied with the second bed (musical component, usually background music) used on the spot. J.D. plays a couple of different beds for the AE's consideration, and a replacement bed is chosen. The salesperson requests that J.D. telephone the spot to the client while he is there. This J.D. does, after which the salesperson departs production to continue his conversation with the client in his own office. A thumbs up gesture by the salesperson indicates the sponsor's satisfaction with the demo.

Following this encounter, J.D. telephones another sponsor for approval on a copy change that resulted when additional sound effects were added to its spot. Two lines of copy were "chopped" (edited) when a laser gun and explosion were incorporated into the spot. With the client's approval, J.D. places the revised commercial in the control room for subsequent airing.

Next, J.D. begins to dub onto cart a tape

containing several commercials produced by an ad agency and given to the station to air. However, he discovers that a cartridge machine is malfunctioning. He immediately calls the station's engineer, who arrives within seconds to inspect the machine. After a few moments the engineer concludes that the machine must be taken to the shop. He removes the defunct recorder, and in less than five minutes he has installed a backup.

J.D. is back on track with only a minimum loss of time. Now he is able to proceed with the dubbing of the agency spots. Because of the special *rotation* (scheduling of commercials for the same client) requested by the agency, this will be a time-consuming job. There are ten sixty-second commercials on the tape, which is to cover a ten-day period (known in radio advertising parlance as a *flight*). Here is how the agency wants the spots to be aired:

August 10	cuts 1, 4, and 5
August 11	cuts 3 and 7
August 12	cuts 2, 6, and 9
August 13	cuts 8 and 10
August 14	cuts 2, 4, 6, and 8
August 17	cuts 5 and 7
August 18	cuts 4, 8, and 9
August 19	cuts 1 and 10
August 20	cuts 3 and 7
August 21	cuts 7, 9, and 10

After examining the rotation schedule, J.D. concludes that the most efficient way to cart-up the spots is simply to allocate one per cart, starting with cut number one through cut number ten. On the label of each carted spot he will write its corresponding number. He must then inform the station's traffic director, who coordinates the station's scheduling, that the agency's commercials must be logged with the numbers as reflected in the rotation schedule. This will guarantee that the cuts will be aired according to the agency's request.

Why did J.D. decide to use ten separate carts for the ten taped commercials? The reason is simple. If he were to dub each day's spots based on the rotation schedule, he would need ten carts of varying lengths—two-and-a-half to four-and-a-half minutes. In all, he would be dubbing ten spots twenty-six times and creating almost three times the work for himself.

The traffic director must do a little more work to ensure that the spots are properly

FIGURE 2.6
Cart labels for most commercial production contain the name of the sponsor, length of the spot, start and end dates, and outro information, such as the last few words of copy or final production ingredient. The outro information serves as a cue to the on-air person, so that he or she may avoid dead air.

rotated, but ultimately this will require less total effort and a smaller expenditure of resources and time for Y95.

Shortly after 10:00 A.M. J.D. informs the station's morning personality, Marlowe Curtis, that he is needed to voice track three pieces of copy, which must be carted for next day airing. By 10:30 Curtis has cut the spots and returned the tape to J.D. for *mixdown* (blending production elements to create the final recording).

While the spots were being voiced, J.D. consulted with the station's copywriter concerning the use of bed music in a thirty-second piece of copy. The instructions on the production order called for three different beds, which J.D. felt would be excessive given the nature of the account and the tenor of the copy. While the use of multiple beds can be very effective, it can also prove disruptive, drawing the listener's attention away from the intended message. In this particular case, Y95's production director was able to convince the copywriter that a single bed would actually work better. He then proceeds to the studio for mixdown.

Now in possession of the Curtis voice track tape, J.D. transfers the voice cuts (selected segments) onto a single cart without adding any production ingredients. The client has specified that no bed music be used. The aim is to create the impression in the listener's mind that the spots are being read live each time they are aired, even though Curtis is off the air when they are scheduled.

The next production order J.D. fetches from the "to be produced" box calls for two voices, one a female. The only female an-

nouncer employed by the station has an evening airshift, so she does not arrive until 6:00 P.M. Normally this would not create a problem, since J.D. would leave a notice in her mailbox telling her to voice a piece of copy that evening. In this instance, however, the sponsor has requested that Marlowe Curtis, who leaves by early afternoon, share the voice responsibilities with a female. Fortunately, Y95's receptionist has become quite adept at reading commercial copy and actually enjoys being called upon for this purpose. J.D. brings the two together, and within a matter of minutes he is in possession of the voice track.

The sponsor is new, so J.D. wants a distinctive bed that may be used on future spots. As it happens, a recently released movie sound track album has made its way into the production room, so J.D. begins probing it for the right background accompaniment. The cuts on side one are not right for this particular account, but J.D. notes that cuts three and four may be used on other production work. He will later place this information in a computer file for future reference.

Midway through the album's second side, he finds what he is looking for, a piece of music that will complement and enhance the copy and voices in a way that will create a positive statement in the listener's mind. With all the production ingredients in hand, J.D. mixes the spot.

Next, Y95's production director makes two dubs of a spot that a client wishes distributed to other stations. The client has purchased airtime at an Easy Listening station and an All-News station in an effort to reach as many adult listeners as possible. Y95 provides the dubs free of charge as a gesture of goodwill. The fact that the client is advertising on other radio stations does not disturb Y95, since the stations are not directly competing for the same audience demographic.

Furthermore, the client is spending more money advertising on radio than ever before because of the very strong response received. In the future Y95 may decide to charge the client for production services unrelated to the station, especially since J.D. had to use the station's graphic equalizer to eliminate tinniness from the tape it received from the client.

Incidentally, whenever J.D. makes dubs for outside distribution he does so at tape recording speeds of 7½ IPS (inches per second). Why? Because most, if not all, radio stations possess reel-to-reel machines capable of playing at this speed, whereas not all stations have equipment with slower (3¾ IPS) or faster (15 IPS) speeds. Thus, 7½ is the industry reel-tape-speed standard.

Dubbing three promotional pieces to cart is the next item on J.D.'s agenda. The first to be carted is a twenty-second promo for a syndicated music special being aired by the station Tuesday evening. This involves two reels of tape: one containing the syndicator-produced promo and the other Y95's ten-second tag (closing line). While J.D. is carting the promo he receives a phone call from a salesperson about a minor copy change. Normally the salesperson would convey this information to the station's copywriter, who happens to be unavailable at the moment. Since the change is effective immediately, the salesperson has decided to go directly to the production department.

J.D. notes the copy change and assures the concerned salesperson that it will be taken care of. He then proceeds to label the promo cart, after which he goes to the control room to get the cart containing the spot that is to be revised. Luckily the voice on the cart is his own, so the change will not require that he coordinate voice tracking with another announcer. Within fifteen minutes, J.D. has located the copy, made the small but important change, and revoiced and remixed the announcement.

It is 11:35 A.M., and J.D. can take a breather, which amounts to an abbreviated lunch break, because he is expected on the air at noon to fill a two-hour shift made vacant by a sick announcer. Since J.D.'s appointment as production director, he has volunteered to substitute for air people when the need arises. He enjoys the occasional on-air stints and regards them as an excellent way to keep in touch with the station's overall programming sound, which enhances his perspective as production director.

By 2:15 P.M., J.D. is back in the production room. During his absence several more production orders have found their way into the "to be produced" box. J.D. also brings work with him from the control room. During his shift a cartridge malfunctioned, re-

sulting in the destruction of the tape and the spots recorded on it. J.D. is not exactly certain why this happened, but he speculates that the problem exists in the cartridge itself, rather than in the cart machine, since no other carts malfunctioned while being run in the machine during his time on the air.

As a consequence of this mishap, J.D. must redo the production on the damaged cart. This means revoicing three pieces of copy and remixing each with two separate beds. A problem exists, however. The morning personality, Marlowe Curtis, is the announcer on the spots, and he has departed for the day. J.D. must check with the copywriter to see if someone else can recut the spots, which are scheduled for airing throughout the day. He must act quickly, since a spot is due to be aired shortly after the 3:00 P.M. newscast.

The copywriter indicates that the client wants Curtis on the spots, but that it is all right for the spots to be read live until they can be recut. The copywriter tells J.D. that he will place the copy in the control room until this is accomplished. J.D. attaches a note to the broken cart indicating a remix is in order for the next day, and he places it in the "to be produced" bin.

While mixing another voice track by Curtis, J.D. discovers that he has a length problem. The voice track runs fifty-nine-and-a-half seconds. When the requested production elements (two beds and a sound effect) are added, the spot runs two-and-a-half seconds too long. In other words, the spot is timed at just a hair under sixty-three seconds. Y95 abides by a strict policy concerning the length of spots, which stipulates that none may run more than one second over its allocated time.

Once again, J.D. is in contact with the copywriter, who advises him to retain the production elements but to cut the following line of copy: "REMEMBER, THAT'S THIS FRIDAY FOR THE MOST FANTASTIC SALE EVENT EVER." By doing this the spot should fall within the acceptable limit. J.D. performs an edit on the voice tape, and on playback the mixdown is timed at just under sixty seconds.

The next thing J.D. decides to do is add the new beds found earlier on the sound track album to his file, which is maintained on computer. J.D. calls up the bed "enter" file to input the appropriate information. The data on the VDT (video display terminal—screen) appears:

Y95 Production Bed Music
ACCOUNT SOURCE TYPE
ARRANGEMENT LENGTH

When J.D. has made his entries, they appear as follows:

ACCOUNT: Morrow Clothing
SOURCE: PR310, CUT3/SIDEB
TYPE: Medium tempo
ARRANGEMENT: Acoustic LENGTH: 60
ACCOUNT: unassigned
SOURCE: PR310, CUT3/SIDEA
TYPE: upbeat
ARRANGEMENT: full-orchestral
LENGTH: 60
ACCOUNT: unassigned
SOURCE: PR310, CUT4/SIDEA
TYPE: ethereal/high tech
ARRANGEMENT: synthesizers/electronic

When J.D. presses the "store" command, the computer alphabetizes the new entries by account. Those beds not yet assigned to an account are listed under "U" for unassigned. Incidentally, the "PR" in PR310 (SOURCE) stands for "production." This distinguishes production music from that retained in the station's regular (on-air) music library.

Shortly after J.D. has added the new beds to the computer file, the station program director (PD), Joanna Kirk, drops by the production room. She brings J.D. an assortment of CDs and LPs, which she will not be adding to the station's playlist. She hands them over to J.D. for possible mixdown use.

The production director at Y95 has free reign to choose background material as long as it falls within the guidelines established by the station's programmer. In other words, since the station is an Adult Contemporary, J.D. would not be backing a spot with a heavy rock 'n' roll sound (see Part IV). However, rather than reject out of hand a CD or album whose cover makes it obvious that it is not in format, J.D. takes the time to audition almost everything in the hope of finding useful bits of sound that he can incorporate in a mix somewhere down the line.

Even at a fairly conservative adult music station, production can be quite diverse, and a bizarre or unusual sound may be exactly what is needed. J.D. has learned to listen with an ear to the future. His experience has taught him that you never know what the next piece of copy may require to make it come together.

Very often a CD or album will contain sound effects not found elsewhere, not even in a prepackaged sound effects library of the type owned by Y95. Over the past few years of his tenure as production director at the station, J.D. has built an impressive sound effects library by lifting bits and pieces from demo albums, which arrive at the station on almost a daily basis. As with new bed music, he also stores sound effects information in a computer file for easy access. For example, as he is auditioning a CD he comes across an unusual ringing sound somewhat reminiscent of that made by a telephone. It strikes him as having a potential use, so he calls up the SFX (abbreviation for sound effect) file and makes the following entry:

SFX
Telephone ring (electronic/reverb/eerie)
SOURCE: PR/CD62, TRACK8
LENGTH 10 sec.

Since J.D. lifts this sound effect from a CD, the SOURCE is noted as PR/CD62. The number signifies that this is the sixty-second CD to be added to the production room library. As with the bed music file, the computer alphabetizes each new entry. Therefore, the "telephone ring" would be accessed by calling up "SFX-T."

Keep in mind that this is an example devised for illustrative purposes. Each computer software package is different, often a station will write its own to meet its specific needs.

Returning to the "to be produced" box, J.D. removes a reel of tape containing two promos—one voice tracked by the morning man for his show and another tracked by the program director for use as a general station promo. Each requires bed music. The morning show promo voice track runs twenty seconds and is to be logged as such, according to the production order. J.D. beds the track, allowing for no musical "open" or "close," which means the bed will coincide with the duration of the voice track—not preceding or succeeding it.

On the other hand, the general station promo is to be logged as a thirty, but the voice track is only twenty-two seconds long. This gives J.D. the opportunity to work in some production values (audio) that he hopes will optimize the impact of the promo. After a period of deliberation, J.D. decides on two beds and two sound effects. The result of J.D.'s mix meets with considerable approval from the program director.

As the day winds down, Y95's production director mixes a news intro onto cart using a bed from Century 21 Programming's production library (which the station has recently acquired based on his recommendation). (A number of companies sell or lease libraries of sound effects and music to stations for production purposes.) To J.D.'s great satisfaction, the bed music library has proven a rich source of fresh and innovative sounds.

At 4:15 P.M., J.D. and the station's copywriter meet with a client to discuss the client's new piece of copy and work over the points of its delivery. The client will be voicing the spot herself, and J.D. will sit in on the taping to provide coaching and assistance. Usually the individual cutting a track will "ride his or her own board" (operate equipment), but nonprofessionals are accompanied by J.D., who handles the recording equipment. It takes the client five takes to achieve the delivery she and J.D. are after.

With the approach of five o'clock, J.D. begins to wrap things up. This involves shutting down equipment and tidying up the studio. J.D. checks through the "to be produced" box one last time to make sure nothing has escaped his attention. He leaves the recently recorded client voice track and three other production assignments in his assistant's "in" box. His assistant will arrive at the station later in the evening, about an hour-and-a-half before his nightly 10:00 P.M. to 2:00 A.M. airshift. During this time he will produce what J.D. has assigned him.

J.D.'s last chore is to place the next day's carted material and live copy in the control room. (You will recall that he began his day by removing dated cartridges and copy from the on-air studio.)

The preceding is a general overview of the type of day a station production director may experience. Take heart, there are days when J.D. is able to take several coffee breaks and a full lunch hour. To be sure, no two days are the same in the production room, and for many people that is what makes working there so appealing. Indeed, each day poses its own unique challenges and rewards. There are very few occupations as exhilarating and at the same time as demanding. Obviously, every radio production person must possess many special skills and virtues, and it is the goal of this text to convey what these are and how to develop them.

CHAPTER HIGHLIGHTS

1. Radio stations are differentiated by market size (population in the signal area): small (under one hundred thousand), medium (about two hundred fifty thousand), large or metro (five hundred thousand plus).
2. The production director may be a full-time person in a larger station or one of the announcers/deejays in a smaller station.
3. Production is a component of the programming department but also interacts with sales, traffic, copy, and engineering.
4. A typical production director's day might involve:
 a. removing dated production material from the control room
 b. stripping expired carts of labels, demagnetizing them for reuse, and checking them for splice points
 c. routing dated live copy to the copywriter for filing
 d. cleaning production studio recording heads
 e. dubbing prerecorded spots onto carts and scheduling voice talent for tracking live spots
 f. allowing account execs to screen and, if necessary, change spec tapes (demos)
 g. checking copy changes with sponsors
 h. coordinating special rotation schedules for agency spots with the traffic director
 i. combining voice tracks, beds, and production elements for multitracked spots
 j. making client tape dubs (7½ IPS) for use at other stations
 k. dubbing promotional pieces onto cart
 l. doing an airshift, filling in for an absent deejay (keeps production director in touch with the station's overall sound)
 m. working with copywriter to make copy changes that reflect customer requests or affect the spot timing
 n. updating the bed music computer file
 o. auditioning LPs and CDs to find potential bed music appropriate for the station's sound; other unusual sounds may be selected for use as sound effects with atypical spot requirements
 p. handling the board and voice coaching an advertiser who is voicing his or her own spot
 q. at end of day, shutting down equipment and tidying up the studio
 r. placing the next day's carted material and live copy in the control room.

3 Skills, Qualities, Responsibilities, and the Art of Production

The job of production director (or any position entailing production duties) requires a unique combination of skills and qualities. In order to fulfill the responsibilities of the position, a person must possess a multitude of attributes. In this chapter many broadcast professionals outline their criteria for hiring people who must face the daily challenges of the radio production studio. This chapter provides an overview of the nature of production work; subsequent chapters discuss these skills and qualities—and how to develop them—in greater detail.

SKILLS

Obvious to anyone entering a radio studio is the need for an understanding of how equipment operates. Audio studios can be very intimidating to the uninitiated. The station production person must possess a complete knowledge of how each and every piece of equipment functions. This does not necessarily mean a knowledge of the inner workings of an audio machine, but rather how it is used—its role—in the production or mixdown process. Certainly a technical appreciation of audio equipment is a plus. The more anyone knows about something the better off he or she is, but a degree in electrical engineering is not necessary to effectively perform the duties of a station production director.

Operating Equipment

Many employers place equipment operating skills at the top of their lists when hiring production personnel. "Technical ability—by this I mean the ability to master the operation of studio equipment—is an absolute essential," says Vance Dillard, operations manager, WPCH-FM in Atlanta, Georgia. John F. Nixon, production/creative director at KKYY-FM in San Diego, California, concurs with Dillard. "Know-how when it comes to operating the equipment is a given. A station seldom, if ever, hires a production person who lacks this. It isn't enough to know what a piece of equipment does; the production person must develop a kind of synergistic relationship with it. It is important that the production person be at one—in sync—with the studio elements."

A producer with a command of production studio equipment will have the most success. "Obviously, knowing everything possible about the operation of the studio machinery will allow the production person to use the studio to its fullest potential. A lot of production people only know the ABCs or 1-2-3 basics and never explore a piece of equipment's full capabilities. This keeps them from turning out more exciting and effective spots," believes Ken Dixon of WBJW-AM/FM.

Knowing some fundamentals of electronics gives the production person a broader appreciation of broadcast equipment, contends Ford Michaels, director of programming at K-PALM-FM in Palm Springs, California. "How many times have I heard statements like this from production people: 'Whaddya mean oudda phase? It sounded great on these here stereo monitors.' Get some electronics basics under your belt. Take an introductory course in elec-

SKILLS, QUALITIES, RESPONSIBILITIES 23

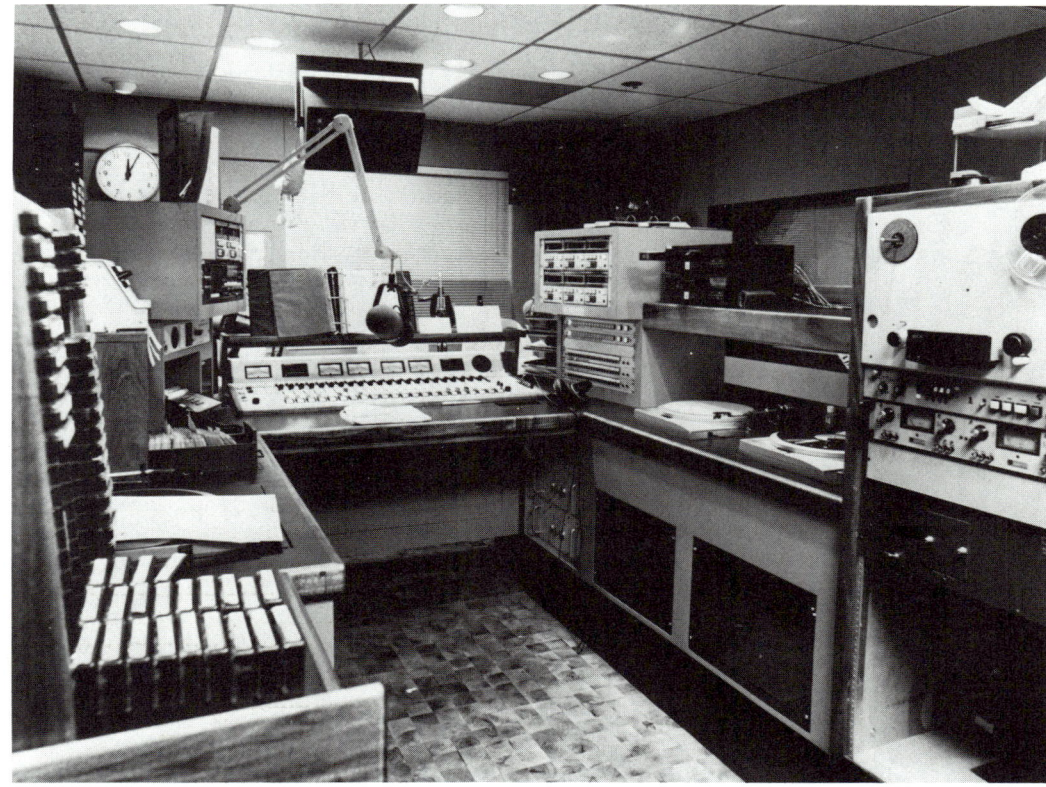

FIGURE 3.1
A metro market production studio containing a variety of sophisticated equipment. (Courtesy WHJJ/WHJY.)

tronics at a local trade school or community college. You'll see things clearer when you do."

Michael W. Dorwart, operations director at KSTP-AM in St. Paul, Minnesota, believes that technical competence in the studio must exist in order for a station to sound its best. "You can't afford to have someone with only a pedestrian knowledge of the studio environment on staff. That constitutes a weak link. Technical competence can be learned, provided there is a willingness. All too often I hear mistakes that stem from a person's lack of knowledge as to the operation of equipment."

In order to master the tools of his or her trade, the production person must know how a particular piece of equipment operates and its function or role in the production mixdown process. Parts II and III of this text deal specifically with these essentials.

Voicing

Nearly every production director is expected to share in voice tracking responsibilities. At some stations the production person is the individual most heard on recorded material. For this reason voice quality and delivery skills are highly valued by station management and play an important role in the hiring process. "A great voice, one that is deep and resonant, is what managers look for and hope to hire. You want your production chief to possess a good sound, because [this person] usually tracks more spots than anyone else," notes WPCH's

FIGURE 3.2
Want-ad in trade journal for production position. (Courtesy *Radio and Records*.)

FIGURE 3.3
The author in the 1960s rehearsing copy before taping at WRCH AM/FM. The equipment in the studio—as well as the clothing worn—was regarded as cutting-edge at the time. Note the absence of a microphone. The voice track suite was separate from—but adjacent to—the production room.

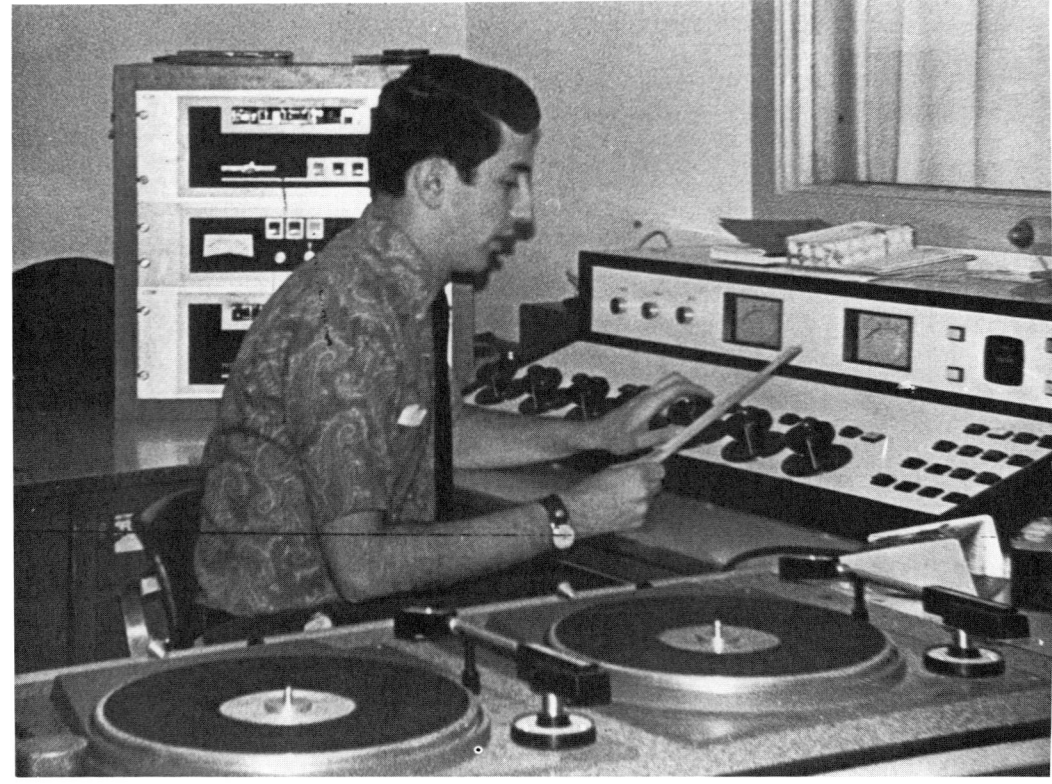

Dillard. However, a memorable, effective voice can be either deep or higher pitched (but probably not squeaky!). Training can enable most people to develop an effective voice.

K-PALM's Michaels wants a person in the production studio who is capable of doing many things with his or her voice. "A flexible set of pipes is valuable. In production you have to be able to shift from one persona to another—meaning from sell to sell, style to style, and character to character."

Dave Morris of KFRU, Columbia, Missouri, picks up on a point made by K-PALM's Michaels. "There are a host of different ways to get a client's message across, but at the center of all the bells and whistles is the voice. The ability to sell the product is of utmost importance. If a production person can't get the sell across in his voice track, then no amount of special effects is going to help."

Besides good voice quality, reading and interpretive skills are important in conveying copy intent, comments Michael Cook of KYCK. "You may have a fine radio voice but not be able to relate the message of a piece of copy. An announcer must be capable of deriving a feel from the typed page and communicating it with his or her voice."

Peter Drew of Hartford's WTIC-AM concurs with Cook's observation. "Don't just read for the sake of reading. Read interpretively. Reading skills are as important as any other skill in production. Actually, the ability to discern the full meaning of the written word in a piece of copy is essential in this job."

Good voice characteristics and an ability to relate to the audience the meaning of the printed page are not only essential to the production director but to anyone going on mic.

Multimachine Mixing

Radio production recording involves the mixing of several elements. While some production assignments involve as few as two or three pieces of studio equipment, others may require the whole flotilla—a half dozen or more—and the production person must

possess the hand and eye coordination, knowledge, and confidence to bring it all together to form an effective commercial, promo, psa, or other aired production. "This is one job that requires dexterity. To handle some of the mixing challenges it would help if you had another set of arms and hands, or a multitrack facility," says Paul Artman, Jr, operations manager of Greenville, Mississippi's WBAQ-FM.

Within the confines of a very short amount of time, usually thirty or sixty seconds, a production person in a multimachine studio may have to take action twenty or more times. "Mixing skills are the production director's stock in trade. To be an effective mixer you must know your equipment and be intimately familiar with the way it is arranged in the studio," observes Robert Conrad, vice president and program manager at WCLV-FM, Cleveland.

The degree of mixing skills that a production director possesses will be reflected on the air. Obviously, sophisticated production gives a station a smooth, professional sound, whereas sloppy or amateurish production makes a station sound second-class.

Editing

The print industry "cuts and pastes" to achieve a desired effect or arrangement. To the same end, the radio production person edits tape and splices it together. To work in production, an individual must be able to perform editing tasks. "Tape editing is a primary skill in this position. You don't belong in the production studio if you don't know how to make an edit—be it electronically via multitracker or workstation—or with the ol' razor and tape," says Boston's WBCN-FM's Tom Sandman.

An Ear

The station production person must be able to hear in a very special way. "The ability to hear a commercial even before laying tracks is essential and time-saving," comments Lincoln, Nebraska, station KFRX-FM's Dean Lambert.

A heightened aural sensibility takes time to develop, notes WBAQ's Artman. "You don't get an ear overnight. The more you produce, the more sensitive you become to

FIGURE 3.4
"To handle some of the mixing challenges it would help if you had another set of arms and hands," says Paul Artman, Jr.

what comes out of the speakers. Hopefully you do, that is. In this position a person must have an ear for mixing voices, effects, and beds, not to mention audio effects such as equalization, compression, delay, and the like."

Pacing and tempo require an astute ear, says Richard Clear, talk show host and production talent at Spokane's KXLY AM/FM. "In the production room you definitely need an ear for tempo—when to break tempo and when to sharpen tempo. Everything needs to line up in terms of pacing, not just voice but the whole enchilada. The ear tells you when something is out of step."

Writing

Since at many stations the production director writes copy, solid writing skills are necessary. WBCN's Sandman states this more emphatically. "Writing is the key! If a person can conceptualize a commercial properly and write with authority, then half the battle is won. Writing is the first, second, and third item on the list of things a production director must possess."

Writing skills are often lacking in production people, claims Chuck Hill of Flint, Michigan's WWCK-FM. "A lot of guys can get an idea onto tape but have an impossible time getting one down on paper in a clear and succinct manner. Copywriting skills are awfully important but often in short supply."

26 THE RADIO PRODUCER

Joe Lawrence, creative services director at KISS-FM in San Antonio, Texas, agrees, "It all starts with the word and the sentence. I feel the ability to work with the language is most important of all. It may sound a bit bizarre, but a production guy must, and I repeat *must*, know how to put thirty-eight million words in a sentence that is only ten words long. Mastery of the word is what makes a production person masterful."

Organization

On a typical day dozens of production orders cross the production director's desk. Each contains its own particulars: start and end dates, talent to be used, and mixdown specifications. A production person must be able to prioritize tasks and organize material, or he or she cannot hope to be effective, offers WBJW's Dixon. "Organizational skills are a necessity. A lot of work flows across your desk. If you don't have the ability to keep things moving orderly and smoothly, the job will overwhelm you."

Managing time is the key to getting the work done, WAZY-FM's Fred Stuart says. "Good time management is essential. On busy days you feel like a contestant on the old TV show 'Beat the Clock.' The trick is organizing the day's work load. Determine what work needs your attention right away and what work can be done later in the day. Prioritize, but don't procrastinate. You should know where you are at all times. Things pop up all day long in the production room, and you can't let them throw you. Follow-up is very important. Finish what you start, and do a complete job on each order."

Your author is reminded of his own days in the production room; were it not for his penchant for order and a desire to control a situation rather than be controlled by it, he would have been buried under the work, especially before holidays and elections, when advertising is heaviest. Organization—you bet! Without it there is only chaos and defeat in the radio production studio.

Timing

Everything that is broadcast is timed. The production director deals in increments of time—a thirty-second psa, a ten-second promo, a sixty-second spot, and so on. The ingredients within these mixed pieces are timed as well—a thirty-second music bed in the psa, two seconds of digital delay in the promo, and a three-second sound effect mixed over a sixty-second music bed in the spot.

Since the production person works with factors of time, he or she is well served to possess split-second timing to accomplish the effects desired in certain mixdowns. For example, during the mixdown of a thirty-second commercial, WXXX's production director must introduce three separate sound effects within the first eight seconds, followed by two music beds and a *stinger* (musical kicker at the end of a spot). The production director can relate to the saying "timing is everything," because with one misbeat another take is necessary.

"Timing is the name of the game, the whole game. It can be learned to a certain degree, but mostly it is intuitive," says KXLY's Clear. Chris Todd, production director of WKKD in Aurora, Illinois, adds, "Timing must become second nature, especially in two-voice spots. Good timing requires less thinking than it does feeling."

Lee Kent of KZOU in Little Rock, Arkansas, sums it all up when he says, "Anyone can put together a decent spot. A great spot takes timing."

Typing/Keyboarding

Up to this point the broadcasters in this chapter have listed the following as necessary to the job of production director:

FIGURE 3.5
Time is the clay and bronze of the production studio sculptor.

equipment operation, announcing, mixing, editing, having a good ear, writing, organization, and timing. Now typing is added to the list of skills. "You have to be an okay typist or keyboardist in the production room. It's a basic and necessary skill," K-PALM's Michaels says.

The production director who does not prepare copy must still type labels for carts containing spots, IDs, and the like, as well as a variety of other recorded material. It is not unusual for a production room to generate two or three dozen carted and reeled items in a day, and that constitutes a lot of typing, observes Dave Morris of KFRU-AM. "Typing may be considered a clerical function or a secondary skill, but it is one that gets you through the production day. You spend considerable time tapping the keys in this job."

Some production studios, especially in larger markets, are equipped with computers; thus, in some instances, keyboard skills are needed, along with a basic familiarity of computers.

It should be apparent by now that station managers expect their production personnel to have many skills. The production director wears many hats and has a significant impact on the station's sound. Indeed, the production position is very demanding, and it requires a unique type of person.

QUALITIES

Not only are certain skills necessary to the job of production director, but station managers cite a number of personal qualities they believe must exist in the person filling the position.

Creativity

It goes without saying that to be an effective production person one must be capable of innovating. This requires an active and fertile imagination—the ability to see beyond the mundane and ordinary. "In this job you always have to be thinking of new and unique angles or ways to do things. A vivid imagination is a definite asset," says KKYY's Nixon.

Finding a production person who possesses genuine creativity presents a challenge to station management. "Not everybody is endowed with a great creative mind. To be really effective, a producer must be able to imagine what the final production will or can be. It's hard to work with someone who doesn't have the capacity to envision or imagine something," comments Kimberly Skinner, creative director, KDVV-FM.

To WAZY's Stuart, a production director must have a creative mind in addition to studio skills in order to bring ideas to full fruition. "A good production director—and the emphasis is on the word *good*—is creative and technically adept. If either of these is missing your production room is only operating at fifty percent effectiveness."

Interpersonal Relations

A production director must interact with many people during the course of an average workday. Thus the ability to get along with people is very important. "Communication is essential. You have to be able to deal with sales, programming, and engineering—empathize with their problems and make them happy," says WBJW's Nixon.

A "people person" is what managers want in the production room, believes KISS-FM's Lawrence. "The job requires interaction, so stations avoid noncommunicators, that is, individuals who don't connect with those around them. In this position you have to be able to work with all sorts of people. Sure all production guys have their favorite reps, those they like to work with more than others, but in production you have to know how to work with different kinds of people from all walks of life."

Good interpersonal relations involve listening, too, says Al Jennings, vice president, WJCL-FM in Savannah, Georgia. "The ability to listen to the salesman or client has to be there. Good listeners are rare. Tact is necessary, too. Don't make the salesrep or sponsor feel like they're stupid."

Treat people the way you would like them to treat you, suggests KFRX's Lambert. "A production person must possess the ability to deal with people on a pleasant and thoughtful level no matter what the situation or number of the take."

Patience/Composure

Because of the hectic and sometimes frantic pace in the production room, patience is a valued quality. "A calm demeanor is required in this job. Production is at the hub of activity in the station. It is in the crossfire between programming and sales. There are always deadlines to meet, late hours to work because of other people's mistakes and lack of consideration, and there are always temperaments to deal with. A short fuse in this job just compounds the headache," observes KKYY's Nixon.

This is not a job for a person with a low boiling point, stresses WGER's Bill Harnsberger: "An even temper gets you through those tough situations. Clients will often demand the tiniest changes or the copywriter will have the telephone or address wrong, forcing the production person to redo his work. This happens, and not just occasionally. There's nothing that can be done about it, either. Last week we had to recut about seven commercials for various reasons. It would be easy to fly off the handle and yell at the salesperson in charge of the account, but production redos are simply a fact of life. Grin and bear them. Patience is, indeed, a virtue in production. Just like anything else, what you put in is what you get out. So don't blast out a spot in five minutes, because it'll sound like you blasted it out in five minutes."

Your author can attest to the importance of developing "cool" in the role of production director. After popping his lid a few times because things did not go as planned, he realized that he had to adopt a plan or method to keep from developing hypertension. Therefore, he typed the word *restraint* on a label and stuck it on the wall directly in front of where he sat, as a constant reminder that composure was the path to survival. The word *restraint* became his mantra.

Energy/Enthusiasm

Both energy and enthusiasm are qualities that must exist in the production person. "If you don't get excited about what you're doing, it will show in what you do. I really feel the juices flowing when I'm in the middle of a piece of production. The old adrenaline kicks in and you're in overdrive. Enthusiasm begets energy. Get psyched, and watch the energy level rise," states Vic Michaels of WPRO-FM, in Providence, Rhode Island.

WKKD's Todd says the job involves long hours and consequently is not for those who take only a casual interest in radio production. "This is a demanding profession. A willingness to work long and sometimes odd hours to get the spots out is necessary. If you enjoy it, and you should enjoy what you're doing, then it's not grueling or unpleasant."

Dedication

A wholehearted commitment is a most desirable quality, says KSTP's Dorwart. "Dedication to creating the best possible production is awfully important. Not willing to accept second best is the kind of attitude that results in the best."

Taking pride in everything that originates in the production studio gives WTIC's Drew a sense of professional fulfillment. "I take what I do very seriously. This is a unique profession, and I like making a contribution. Settling for mediocre is not acceptable from my perspective. To feel good about what you do, to take pride in what you do, requires that you do the best you know how at all times."

Knowledge

An appreciation and understanding of the station's format is required of production personnel. "You can't produce material for a station if you don't have a thorough grasp of its programming approach and philosophy. Production is an ingredient of the format. It must meld—cohere—with that which surrounds it, or the format is compromised," asserts WCLV's Conrad.

In the ever-changing world of broadcast technology a production person who knows what is happening can help guide the station in its plans concerning future equipment acquisitions, contends KFRX's Lambert. "It is important today to be up on cutting-edge studio technology. There's so much out there with digital, computers, multitrack, and all, that you have to be aware of what can boost the effect of your air product."

WAZY's Stuart agrees with Lambert. "It is wise to set aside time to scan the trades. Today we must keep up with the changing technological scene. I try to read engineering and technical data for at least an hour or so each week. Attending broadcast trade shows is a good idea, too. This gives you a firsthand look at what is being manufactured that could give you a leg up."

Humility

The least desirable quality in the production room is an inflated ego. "A professional is in control of his ego. You don't need someone who feels he must always be right," says K-PALM's Michaels.

In other words, no big star should be affixed to the production studio door. A production director should feel good about what he or she does and take pride in production work, but a big head invariably gets in the way of positive relationships.

By now it should be obvious that stations have high, but certainly not unreasonable, standards. Managers seek a production person who is creative, communicative, energetic, sensitive, knowledgeable, conscientious, and modest. Certainly this list is far from conclusive. However, the bottomline is that the quality and substance of a person's character—personality—plays a key role in his or her success in the production studio.

RESPONSIBILITIES

From the depiction of a production person's day in Chapter 2 it should be apparent that the duties of the position are numerous indeed.

In this section radio professionals comment on many of the production director's responsibilities.

Copywriting

As stated earlier, many stations require that the production person write commercial copy. The commercial copy comes before the voice tracking and mixdown, and is the foundation of a good piece of production, claims WBCN's Sandman: "It all comes out of the typewriter first. Good copy makes good production. I'm sure you've heard that before. The greatest mix in the world can't save a bad piece of copy—a script that doesn't motivate or interest the listener. Many commercials talk about the mere qualities of a product or service, kind of a catalog of features. Forget it. Commercials should sell the benefits of a product or service. That's what motivates listeners, and that's what your job is about in production."

Writing is one of the production person's primary challenges, says K-PALM's Michaels. "The production person must devote a lot of time prepping copy. The idea is to be creative without being cutesy. It's not that easy to write something that really grabs the listener." WJCL's Jennings concurs, adding that a production person must maintain perspective. "When you're copywriting keep in mind that you are not commissioned to create art for art's sake. Sure you should be creative, but remember that you are to present the client's business or product in the best, that is, the most salable, light. You are to make the cash register ring. That's what commercial copywriting is all about."

Keep in mind, says KFRU's Morris, that copy is a selling tool, a pitch, designed to get people to buy. "Copy has to *sell*. The production person must sell the product as if he or she were a member of the advertiser's own staff."

FIGURE 3.6
Production person reading a trade publication.

The goal of any piece of copy is to get the listener to act, says KFRX's Lambert. "When you sit down to write an advertiser's spot your responsibility is to create something that induces or inspires action. I always find the things that set the client apart from his competition. I create a unique selling point or positioning statement and accentuate the positive differences."

A production person should approach every copywriting job as an opportunity to reach and motivate an audience, and this involves avoiding stale and overused concepts, says KSTP's Dorwart. "I want copy that sounds fresh coming out of the production room. I think a willingness to try new things, and not be afraid to take a few chances is very important. Don't get lazy or complacent. Be wary of the mundane. Another piece of advice: what you think is a funny, inspired spot may not impress the client as such. You must keep in mind that clients typically are not very daring and do not have the experience to judge an unusual commercial."

By becoming acquainted with the process that leads to the sale, a production person is better able to satisfy the needs of both the client and the audience, observes KKYY's Nixon. "Learn as much as you can about what leads to the sale of the advertiser. Find out all you can about the sponsor. This will certainly help you translate the buyer's thoughts and perspectives into an effective radio advertisement. You can't work in a vacuum."

Voice Tracking

As previously stated, cutting spots is one of the production director's primary responsibilities. "Getting the voice down and getting it right is crucial, whether you're taping copy or someone else. When another announcer is cutting the voice track, it is your job to make sure he or she has all the tools needed to do it to spec," WBJW's Dixon says.

Although the production director assumes primary responsibility for selecting and assigning voice tracking tasks, clients, account executives, and copywriters often request a certain announcer. Possessing good judgment in assigning voicing duties to announcers is essential, believes K-PALM's Michaels: "All too often the production director assumes the responsibility for *doing* spots, versus *assigning* spots. A good production director will get tracks done by a variety of talent and then do the building of beds, MFXs, SFXs, pickups, whatever it takes, and leave the talent free for what the talent does best—talking. A station promo voice is imperative, regardless of format. When the production person is not burdened by an airshift, or only works a weekend shift, the station should use him sparingly, as, say, the "different" voice, to sell the station. Great pipes aren't mandatory. A great understanding of delivery technique is."

In addition, WAZY's Stuart says that objectivity is important when looking for a voice for a specific spot. "As a production director you must know the announcers—their strengths and weaknesses. I try to tailor copy and production for an announcer. Some people are better at certain things than others. It is your responsibility to know this. I make a special effort to delegate the spot load evenly among the station announcers, as I keep in mind what announcer is best for the particular kind of spot that needs to be done."

Mixing

When the copy has been written and the voice track has been cut, the mixdown takes place. At this point the production person must gather all her forces together to create something that pleases the client, audience, and herself. As previously stated, this part of the job requires special dexterity (both mental and physical), a good ear, and a command of the equipment.

"To mix a spot in a way that will enhance the message, not detract from it, is the producer's goal. This is accomplished through the successful integration of many elements. A well-mixed spot catches the listener's ear from the moment it begins, keeps it through the entire message, and then causes the person attached to the ear to go and buy the product. The key to this all happening is in the hands of the producer," comments D'anne Inman, production director at KTXR in Springfield, Missouri.

Keeping the message clear is the aim of good production, contends KXLY's Clear. "It is also the production manager's responsibility to make certain the message is

not buried under layers of unnecessary production elements. The purpose is to maintain the texture and tone of the copy. Production is there to enhance the written message, not obscure it."

Like copy, the mix must reflect the station's format. "The producer must have the good taste and sense to produce commercials that are within format. That is what the production director is hired to do," says WCLV's Conrad.

Organization

In the section on skills, broadcasters cited organizational skills as crucial to the production position. It is the production person's responsibility to keep his or her department from slipping into disarray. Keep in mind that every commercial, public service announcement, ID, and promo aired by a station is processed through the production room. The volume of work is prodigious. "The production director walks a tightrope between sales and programming, ensuring that spots are produced on time and in a manner consistent with the needs of the client and the standards of the station. It can and does get chaotic in the production studio, but if you know your job and you're well organized, you can be successful no matter how intense the pressure," says WBJW's Dixon.

Delegating work is part of the job's management aspect, notes WWCK's Hill. "To be an effective production director you have to manage, and to be an effective manager you have to possess strong organizational skills, which means not being afraid to delegate responsibilities. For example, don't try to do all the promos. Set up a schedule for others to follow, including when work is due. Know when to take yourself or others off spots, as voices can become overexposed on the air."

In addition to delegating responsibilities, the scheduling of studios is also the job of the production person, offers WBJW's Dixon. "After you've assigned copy, you have to schedule the use of studios and make certain that the announcer has all the specs of delivery down pat."

Making sure that all work is accomplished on time and placed in the control room is a fundamental production responsibility. "When a spot is missed the station loses money, and make-goods are killers. Having spots in the air studio on time is what the job is about," says K-PALM's Michaels.

One-third of the job is follow-up, contends WAZY's Stuart. "It is the responsibility of the production person to make sure all bases are covered. There are steps to this job. You don't stop at the next to last step. What good is producing and carting a spot if you fail to get it into the control room or don't get the client's final approval. Follow up! Make certain that everything is done that must be done. Check things. Then check them again."

Quality Control

The production director must be ever vigilant about mixes that are not up to standard. "From my perspective the single most important aspect of the position is to guarantee that the final product is air quality. The best copy in the world is of little use if it is mixed with poor levels, unbalanced stereo, badly erased carts, or if the finished product is simply placed somewhere other than where it is supposed to be," says Kalamazoo, Michigan, station WQLR's Kenneth Lamphear.

Keeping a critical ear on everything that comes out of the production studio is a defense against mediocrity, observes KFRU's Morris. "You can't let poor quality production reach the control room. As a production director, I consider this the most important aspect of my job. I am constantly monitoring our production—listening for problems and analyzing the workmanship."

WGER's Harnsberger has put together a quality control checklist to help ensure that work is done right. "If I find that one of my production people is doing sloppy work, they hear about it pronto. By 'sloppy' I mean things like this: (1) Not cueing up carts past the splice—otherwise you get a warble effect when the splicing tape rolls over the playback head. (2) Bad levels—for example, one element of production is hotter or softer than another, or the left channel is much stronger than the right. (3) Muddy or tinny spots—perhaps the consequence of too many dub downs or the absence of proper EQ. (4) Spots that are either too long or too short—at WGER a sixty-second spot

must fall between fifty-eight and sixty-two seconds. (5) Poor voice quality or delivery—if an announcer slurs his or her way through a spot or sounds too intense or stiff, then he or she will have to recut the spot (in our format—Easy Listening—unless the copy calls for a character voice, the read should be relaxed and conversational). (6) Out of sync—if a producer fails to create the appropriate environment in a spot, that is, if the music is inappropriate (heavy metal under a spot for a retirement community, for example), or the sound effects are out of step with the personality of the format, then a remix is in order."

The responsibilities of the production director are many and diverse. It was stated earlier, and it deserves to be stated once again, that the job of production director requires a very special kind of person.

THE ART OF PRODUCTION

As mentioned earlier, renowned American poet Stephen Vincent Benet, who wrote for radio in the 1930s and 1940s, called the medium the "theater of the mind," and producer, writer, and all-around innovator Stan Freberg demonstrated this brilliantly for the benefit of later generations. In the 1960s, Freberg produced a series of unforgettable promotional spots for radio. In one spot he converted Lake Michigan into a million-ton tub of hot chocolate crowned by a seven-hundred-foot-high mountain of whipped cream and a two-ton maraschino cherry. Stimulated by the artful use of words and sounds, the listener formed his or her own images—a mental theater—and suddenly the world's largest cup of hot chocolate is very real.

"Some people paint on a canvas, some on television with new paint programs. Some people create sculptures out of clay or bronze, and some produce art with vinyl or plastic. The production person rearranges magnetic particles on recording tape as a means of conveying his message, and all art is a message of some sort. The radio producer creates something that did not exist before. Like most artists he creates a world, and his art is further embellished by the listener's thought processes," offers KZOU's Lee Kent.

Radio production is an involving and demanding art form. "Television destroys man's most precious possession—his imagination," believes WJCL's Al Jennings. "Radio, with its word pictures, encourages people to think, to imagine. It massages the grey matter, as they say. If the message is good, if it is truly artful, it will move the listener. Radio can create warmth, intimacy, laughter, and sadness. It can arouse the curious side of our nature. Good radio production can liberate and educate. It can launch the imagination into limitless flight. Good production—good art—motivates and inspires."

To Paul Hemma, operations director at Dubuque, Iowa's WDBQ-AM, radio's artistic potential exceeds that of video. "Well-done radio production is an art form just as television production is. We have the ability to create vivid word pictures, which can last longer than the high-tech fleeting images of television. When I teach my radio production class at a local college I always play great commercials of the past by the masters, like Dick Orkin and Stan Freberg, to acquaint my students with radio's legendary creative forces. They are amazed at how long radio production has been an art form."

FIGURE 3.7
The production person can create worlds.

Not all production people become accomplished audio artists. There are people who write and then there are "writers," says WQLN's Thomas McLaren. "The ability to create something that truly reaches and moves an audience requires artful communication—a unique vision and sensibility. Not all production people have this."

KFRU's Morris agrees. "Not every production person can reach the level of art, nor can every person who writes create something artful. When you read a book you know it's art if it has moved you or touched you in a special way. In this business when you hear a piece of production and you think to yourself 'I wish I had thought of that' or 'What an original spot,' then I believe you are hearing a piece of art."

Siding with McLaren and Morris, WAZY's Fred Stuart adds, "Lots of guys can do production, but not everyone can take an idea and mold it into an audio message that people can see with tremendous vividness in their minds; to be able to deliver a message about a restaurant that makes people's mouths water or to create a promo for a Bahamas cruise giveaway that causes office workers to get in trouble for daydreaming about the tropics is a special talent. Anyone can put something on tape, but not anyone can make something evocative and memorable."

Artful production is the result of hard work, reminds WBAQ's Artman. "You must master the tools of the profession before you can produce something exceptional and uncommon. Mastery of the tools is the first and essential step toward making something that exceeds the commonplace. Only with unremitting desire to make something special can something special be made."

The true art of production is in the bringing of pleasure and joy to the listener, says WKKD's Todd. "I guess it's the entertainment aspect of radio commercials that qualifies them as a kind of art form. Your spots are successful if they hold the listener's interest throughout the spot set. We all know how hard that can be in this push-button age. I finally settled on a production career because you're actually creating something with the potential to bring pleasure to others while helping sponsors sell their products. Unlike deejay work, where the pressure to perform is intense and you have to be "on" every three minutes, and unlike live news where you only report on what others are doing, the production person can breathe life into a piece of copy and in doing so please the station, sponsor, and listener."

Russ Eckerea of Minnesota's KWWK adds this interesting insight. "I believe most full-time radio producers are frustrated fiction writers, frustrated actors, and frustrated standup comedians living in the same body. When you get all of these things percolating at once something outstanding usually occurs, like great commercials, for example. I think the public, or perhaps more accurately the critics—whoever they are—neglect to see the art that exceptional audio production contains. Maybe someday."

If not presently, no doubt someday, as Eckerea speculates, the best commercials, promos, psa's, and other short-form production pieces will be regarded as an important part of the popular art form known as radio.

CHAPTER HIGHLIGHTS

1. The production person must possess a complete knowledge of how each piece of studio equipment functions in the mixdown process. Effective productions result from exploring each piece of equipment's full potential and then creatively integrating those potentials. An introductory knowledge of electronics is useful.

2. The production person must possess solid voice quality and delivery skills, because this person usually tracks more spots than anyone else at the station. The flexibility to shift voice from one persona to another for varied presentations is desirable. Reading and interpretive skills are equally important for conveying copy intent.

3. A production person must possess the dexterity—hand and eye coordination, equipment mastery, confidence—to simultaneously mix several elements to effectively complete complex production assignments.

4. Electronic and manual editing skills are a staple of the successful production person.

5. Having a great production ear means

possessing heightened aural sensibility for mixing voices, effects, and beds; for controlling the pacing (tempo); and for achieving excellent sound quality (for example, equalization, compression, delay, and so forth). Successful productions result from being able to hear (imaginatively) the desired product before the production process begins.

6. Because production directors often also write the copy, they must be able to conceptualize a commercial properly and write with authority. Strong writing skills are essential.

7. A production person must be able to prioritize tasks and organize material, as well as adapt to last-minute rush assignments.

8. A production professional should have a good sense of timing to integrate smoothly all of the production elements. Basic typing/keyboarding skills are also needed.

9. An effective production director possesses a fertile imagination, excellent interpersonal communication skills, a patient and balanced temperament, a high level of energy and enthusiasm, and dedication to producing a quality product. It is also essential to understand the philosophy, goals, format, and audience of the station and its competition.

10. Production copy must motivate the listener to act (that is, to purchase the advertiser's product or service, to become involved in a psa's cause, to participate in a station's contest, and so forth). Motivation results from a thorough knowledge of both the client and the audience.

11. Selecting the proper voice for a spot from the announcing talent available is a critical ingredient of spot production. Stations must avoid using the same voice too frequently.

12. The mixdown elements added to the voice track should not distract the listener from the client's message. The production person must make the spot attention-getting and memorable, but also clear.

13. The production director is a coordinator among sales, traffic, and programming. This requires exceptional organizational skills; the ability to delegate intelligently, as well as to establish work priority and studio use schedules; and the persistence to follow up on all assignments.

14. Continual monitoring of everything produced for on-air is the only means by which the production director can ensure proper quality control.

II STUDIOS AND EQUIPMENT

4 The Studios and the Use of Equipment

Every radio station has an on-air studio/control room. In some cases this studio also doubles as the station's production room. When this is the case, equipment designed for the dual purposes of broadcasting and production mixing are installed. Without going into detail at this point it is necessary to point out that the primary production mixer, the audio console ("the board"), features two modes—one for the purpose of off-air production called *audition* and the other for broadcast feeds called *programming*. But more on this in Chapter 5, which deals with audio consoles.

The majority of radio stations have at least one production studio. Remember, the size of the station, which is often tied to the size of the market, usually determines the extent of production facilities.

Small stations or small market stations are likely to have one studio set aside for production. Larger stations, those in medium and large markets, may have two or more production facilities. Network radio headquarters contain several production studios.

At those stations with more than one production area, the additional studios may be similar or may serve more limited functions. For example, a station may have a main production studio and a voice tracking room (sometimes referred to as a *booth* or *suite*), where announcers record copy. These voicing rooms are not equipped for mixdown because they only contain tape recorders, primarily reel-to-reel machines.

Stations with extensive production facilities are likely to have one studio that contains advanced audio equipment, including multitrack recorders, effects processors, and even synthesizers, and another with a less elaborate setup for simple or less complicated mixdowns. Of course, many stations invest equally in each production studio. This is especially true at large metro market stations that are very production oriented.

STUDIO SIZE

Studios come in all sizes and shapes. Undersized studios are undesirable because they are conducive to clutter and confusion, not to mention a feeling of claustrophobia. According to engineers, a small area into which equipment is jammed also lends itself to technical failures and fidelity problems. A closet-sized studio can also become a catch-basin for dirt and trash.

A spacious studio, one that is well planned and pleasing to the senses, will eliminate many potential problems. Starting with ample space when designing a studio is central to creating a more positive and healthier studio environment.

ACOUSTICS

During the actual construction of an audio studio several things must be considered. Since a production studio is essentially a sound room, its acoustic design is a crucial factor. When a broadcast production studio is built, noise reflection is calculated. A studio that does not deaden outside noise and reduce the reflection of inside sound is going to affect the quality of live (on-mic) recording negatively.

To reduce the incidence of unwanted noise and vibration several measures are taken:

1. During the construction phase special sound-absorbing and room-isolation materials are used.

FIGURE 4.1
Voice tracking room.

2. Studios are built on solid foundations.
3. Rooms are designed to be structurally autonomous; walls are built on different angles from one another. ("A studio should be designed to break up the paths of sound waves to prevent their building momentum," states Stanley Alten in *Audio in Media*.)
4. Ventilation systems and duct work are soundproofed and air vents strategically located.
5. Windows are placed on angles (45 degrees) and are double-paned using various thicknesses of glass, such as ¼- or ⅜-inch.
6. Acoustical tiles, foam, or carpeting (sometimes a combination of all three) are affixed to studio walls and ceilings.
7. Weather stripping is attached to doors, which may also be covered with sound-absorbing materials.

These are just a few ways (among many) studio designers and builders cut down on unwanted external noise and internal sound wave reflection—*echo* and *reverberation*.

LAYOUT

The foremost criterion in the layout design of a production studio is accessibility. For example, it would be very impractical and inefficient to have a cart machine on one side of the room and a turntable on the other (unless, of course, the production person is the comic book character Rubber Man). Ease of handling is crucial to any mixdown situation.

For this reason the most popular layout design of radio studios is the horseshoe or "U" shape. With this arrangement everything is within arm's reach of the production person. Equipment literally envelops or surrounds the producer, who is located within the bay or pocket of the U itself. The space within the U is generally no wider than four feet. This permits the producer quick access to equipment. The general rule of thumb is that the production person should be able to make contact with the equipment placed on either side when he or she has both arms extended. Easy access to equipment is very important during multimachine, real-time mixdown, even when remote buttons are available.

FIGURE 4.2
A cramped studio can cause many problems.

THE STUDIOS AND THE USE OF EQUIPMENT 39

FIGURE 4.3a
Sound deadening material is attached to doors, walls, and ceilings to keep noise from entering a studio.

FIGURE 4.3b
Sound deadening material also reduces in-studio sound wave reflection.

For instance, a producer may need to slip-cue (see Chapter 7) a record as part of the mixdown. This requires physical contact with the record. There are numerous other instances when contact with equipment is necessary, so the proximity of studio components to the production person is a key factor.

Equipment is distributed proportionately or symmetrically around the U. At the center is the audio console—the heart of the production studio. Fanning out from both sides of this piece of equipment are cartridge machines, turntables, reel-to-reel machines, cassette recorders, and so on. (Some production directors like to think of this setup as analogous to that of the left and right brains.) Equipment is evenly and neatly divided for easy reference. The producer can relate to what is located where and eventually function in a rote fashion, rather like the touch typist who has developed a sense of where the keys are and therefore can type with greater speed and efficiency.

For the sake of accessibility studio counters are built at stomach (desk) level (when the production person is seated), and equipment is not located above shoulder level.

Reel-to-reel machines, which serve as the primary editing points in a studio, are often installed on an angle so that heads may be accessed. Speakers are typically mounted on a wall of a studio and angled slightly downward in the direction of the seated production person so that sound may be more effectively assessed.

FIGURE 4.4
U-shaped studio creates greater accessibility.

40 STUDIOS AND EQUIPMENT

FIGURE 4.5
Production room storage area.

FIGURE 4.6
Cart drawer.

In summation, the more sensible—that is, the more practical—the layout of the production studio, the more fluid the mixdown experience. Studios in which equipment is randomly and thoughtlessly installed impair the production director's ability to perform with maximum effectiveness.

STORAGE

Considerable materials are used in the production of commercials, psa's, promos, features, and so forth. A single spot may require several pieces of bed music and a number of sound effects. These production ingredients are stored in the studio for easy availability. A production studio is built to accommodate an abundance of items used in mixdown.

Record and CD compartments are commonly built into or adjacent to the counters on which equipment rests. Often a small cartridge rack is installed near the audio console for carts containing sound bites and drop-ins frequently included in IDs and promos.

Shelves designed to hold record albums, CDs, reel tape, and cassettes containing bed music and effects are constructed against or into walls. These may cover an entire wall. It is not unusual for a production studio to contain hundreds of pieces of music, plus an extensive album or CD sound effects library. (However, computer technology promises to eliminate the need for such extensive physical space.)

In addition to the storage space needed for the materials used in the mixdown of spots, tapes for current advertisers (usually provided by agencies) must be retained for reference and possible future use. Stations sometimes hold tapes for years, often needlessly. This area of the production facility is sometimes referred to as the morgue—for obvious reasons.

Space for unused or blank cartridges and tapes also must be factored into the storage equation. Since producers place hundreds of spots of varying lengths (ten, twenty, thirty, sixty seconds) onto carts during the course of a typical week, an area must be allocated as a tape vault and kept well stocked.

Many production room designs include drawers or cabinets for storing editing supplies (razors, leader tape, grease pencils, splicing tape) and head cleaner and cotton swabs. An equipment cabinet for headphones, stopwatches, microphones, and such, used by announcers assigned voice tracking chores, is included in most production facilities as well.

POINTS ON EQUIPMENT USE

It does not take a master logician to conclude that a production person must know how to handle equipment. In fact, several broadcasters quoted in this text have already pointed this out. Obviously, there is much to know about audio equipment.

Kurt Stoecker of Tampa's WUSA-FM regards hands-on practice as a method for learning what equipment can do. "Learning to work with production equipment is a lot like learning a sport. It is important to work hard and practice often until working with the equipment becomes second nature. Only then can a production person really concentrate on the creative process at hand."

Become an audio equipment use expert, says William Cochran of Chicago's WXRT-FM: "It may seem obvious, but nothing can replace a thorough knowledge of how the equipment you work with functions. I don't mean in terms of theory, but rather what all the buttons, pots, and other controls can do. My role as production director is to make every production piece sound great when logged with everything else at this station. By knowing what the gear can do and exploiting its features and limitations to create interesting production effects, I can make each piece of production something more than just another object off the assembly line. This was true when I only had a couple tape decks, cart machines, and turntables to work with, and it is even more so now that WXRT is about to complete a new eight-track production facility, featuring an array of audio processing gadgets. Whatever you have on hand, whether it is a simple stereo deck or a digital delay unit, play with it and become expert in its use. Explore what it is capable of doing. You can make it do a lot more than the manufacturer sometimes intends."

Being aware of a piece of equipment's limitations is important, contends K105's Gary Newlon. "Know how to get the maximum from your machines. If you can use a piece of equipment all out, full-throttle, you will perform to your creative potential. But know a piece of equipment's limitations as well. Never be afraid to experiment. This is the only way to grow and develop. But don't plan an idea that you cannot possibly accomplish with the gear you have."

Experimenting and testing the limits of equipment are all part of getting the most out of what you have, says Peter Drew of WTIC-AM: "Hey, look, equipment is simply a means to an end. Conquer the means, and the end will be a success. Some of the best radio production ever done has been produced at some of the most poorly equipped stations in the country. With a fulltrack reel-to-reel, two cart decks, a couple turntables, some tape, and a razor you can create a piece of production that rivals a first-class studio with all the cutting-edge stuff. It all comes down to a simple question—what do you hear in your head? If you don't hear anything special when you're conceiving a piece of production, then all the high-tech equipment in the world isn't going to raise that mundane concept above the level of mediocrity. Look, if you can work your home stereo equipment, you can work the equipment in the typical radio station room. Production equipment simply has more buttons and knobs to remember. Of course, making something with the equipment is another thing."

David Ball of Knoxville, Tennessee station WIMZ-FM has a few more suggestions about using equipment: "The production chief should know all input and output routing (how they are connected) so that complete flexibility can be realized. Otherwise you may want to do something but not know how. In production you also need to know all signal processing capabilities, including today's digital systems and the old tape tricks of the traditional audio studio—tape flanging, precision splicing, and variable speed use. One final observation about equipment use: you have to know the difference between machines that are misaligned and tape that is bad. It is surprising

to me how many professionals do not know the difference."

Dealing with sophisticated equipment requires a full awareness of the techniques that bring out the best performance, states Ed Kellerman of Colorado's KKFM. "There are two production modes: multimachine and multitracking. With the first, to produce a spot that has music, effects, and a voice track, a deft hand is necessary to coordinate all the elements. Multitracking requires coordination, sure, but not the way two-tracking does. Of course, multitrack equipment brings with it its own set of specs, and the production person must be on top of these. A multitrack tape machine won't necessarily make a good broadcaster better, just a heck of a lot more efficient."

WTIC's Drew says listening to how other stations use their equipment can be revealing and instructive. "The first thing a production person, or would-be production person, should do is turn on the radio and monitor other stations, both AM and FM. Listen to every element broadcast on every format. Analyze each commercial, promo, jingle, new sound bite, and so on, for concepts, sound effects, volume levels, edits, special effects, voice-over techniques, instrumentation, and the logical flow of ingredients. Hear what and how sound is being presented on other stations."

Understanding equipment and the way it is operated is the focus of the next several chapters.

FIGURE 4.7
A sign in a production studio makes it clear that food, beverages, and cigarettes are not welcome.

STUDIO MAINTENANCE

Most stations require that food and drinks be kept out of the production studio. They can damage equipment should contact occur. "A spilt cola can wreak havoc on a piece of equipment," observes WPRO's Michaels. Smoking also is verboten in studios at many stations because it, too, represents a threat to equipment.

Keeping equipment clean, especially magnetic tape heads, is a way of avoiding troubles and ensuring a good product, states WBZZ's Brian Oberle. "Keep equipment clean. Many times your production quality will decrease simply because heads are dirty. Regardless of how hard you work on a piece of production, if the final result is muffled and distorted you haven't done your job. Clean the heads, and keep the other equipment dirt-free."

Eric H. Gerstein, production manager at WCAU in Philadelphia observes, "When I was in college there were unlimited funds for repair and upkeep and for buying new things. Outside, in the real, nasty world it seems to me that the last place to receive funds in any radio operation is the production studio. Just enough dollars come our way to keep afloat, so maintenance and care are crucial. Just the simple things like cleaning heads and not slamming buttons can make a huge difference."

Daily maintenance is the key to eliminating problems, contends K105's Newlon. "Ongoing maintenance, not sporadic maintenance, keeps the studio hale and hardy. I can't stress enough the importance of maintaining gear. This goes beyond just cleaning heads. Production is an exacting science as well as art, and it helps to know as much as possible about your equipment. Recognizing when your heads are dirty, when tape tracking is out of sync, when you have bad phase, wrong record set levels, and so forth keeps your product sharp."

Equipment breakdowns are common when a studio is neglected and not maintained. It is incumbent upon the production director to, as they say in the navy, "keep a tidy ship." Ignoring the specified care of equipment leads to countless problems.

TAKING CHARGE—MASTERING THE POSSIBILITIES

Carrying a naval metaphor a step further, an analogy can be made between a ship's captain and a production studio's director. The captain is responsible for getting the ship to port, and the production director has the task of getting professional quality audio onto the airwaves. Both have an awesome amount of hardware to master in order to do an effective job. What follows are suggestions from various broadcasters on assuming control of the production studio vessel. Each of the following topics introduced here—audio levels, multitracking, editing, and selection—are discussed in greater detail in the following chapters.

FIGURE 4.8
A production person must master the possibilities of the production studio.

Audio Levels

The audience's perception of loudness—the level or volume of each ingredient comprising a mix—is something a production person must control. There are countless things to understand about equipment operation, but handling levels is the most basic, says WINK's Rick Peterson. "Nothing can ruin a piece of production faster than poor levels, be they too low, too high, out of balance, or all of the above. All good production begins with appropriate levels. Once this is accomplished then equipment is able to give you its best performance."

WTIC's Drew details a specific, common problem that occurs when working with levels: "Mastering levels is vital, especially voice to music that runs on an FM stereo station. Interestingly, if the voice-over and music sound perfect in the production room, they probably will not sound perfect on the air. A radio station's on-air audio processing very often boosts the midrange of the voice-over. This makes the sound a little too loud for the music background. In my experience, there is a perceived loudness difference between stereo and mono. This psycho-acoustic difference of about 3 dB doesn't show on the meters in the production room, but your ears are fooled into believing there's a difference in levels between stereo and mono. When the music and voice aren't mixed properly, the mono voice will sound too loud over the stereo music. To overcome this loudness differential, mix stereo spots in mono so the voice just swims in the music. Played back in stereo in the production studio, the music will sound a tad too loud compared to the voice, but when the spot is aired on the radio, either in stereo or mono, the music to voice levels will be just right. Be careful when playing an ad mixed this way to a salesperson or client. The music may sound too loud to them. It may be wise to mix it with softer music for demonstration purposes, then remix it hotter for on the air."

Producer Ty Ford notes, "If all elements of the stereo source are in phase [synchronized], the resultant mono signal will increase slightly. The further out of phase the two stereo channels are with each other, the more canceling will occur, and the lower the mono sum."

KKFM's Kellerman outlines his own approach to the problem of controlling levels: "The most difficult thing to master in a production studio is the relationship between how your spot or promo sounds in the studio and how it will sound over the air, especially if your station uses a lot of audio processing. In our studio we have to pot up the music quite a bit, because our special processors will suppress the music in favor of the verbiage. Often I make two mixes, one for the client wherein the music is softer so they can hear the read and another for on-air in which the music is sig-

nificantly louder. I do this because so few clients understand about signal processing and my explanation of how it will sound over the air. The relationship between the volume of your music to your read is just something you learn by doing over a period of time. I suggest that you do what you feel sounds right in the studio and monitor your station at home or in your car."

Mastering levels requires knowing where to begin, notes Philadelphia's WFIL's John Beaty. "The first step toward gaining the upper hand on sound volume is balancing all levels to 0 dB. From this point you begin clean and at least have the chance to keep levels in check."

WBGN's Chris Allen says that getting levels accurate is the most important thing a production person must accomplish. "If your levels are off, your spot is seriously flawed. You need a near perfect mix of voice and music. The music should complement the voice and not overtake it. The music fader should be set slightly lower than the voice fader. When the music drowns the words your message is lost. You have to be in control of levels; it's that simple."

Multitracking

Multitracking describes the capability to manage four to thirty-six distinct sound recordings or channels and later combine them in a mixdown to produce one integrated track.

Sophisticated multitrack recording equipment, while not yet a standard item at many radio stations, has become far more prevalent in the 1990s. WINK's Peterson observes that multitrack machines can be somewhat intimidating: "I think the most difficult thing for anyone to try and master in the production studio is the use of multitrack equipment. For some reason the sight of a multitrack mixer or recorder tends to frighten even seasoned professionals. I know the first time I ever laid eyes on one I thought, 'How am I going to figure out how to use this thing?' But once you do learn to operate a multitracker you don't know how you have lived without it. Anyone who encounters, say, an eight- or sixteen-track machine should just think of it as eight or sixteen reel-to-reel machines in one, because that's what it is. Being able to stack one source on top of another—and mix them at your discretion—makes extremely intricate pieces of production possible and, believe it or not, easier."

WUSA's Stoecker says that mastery of the multitrack unit opens the door to countless possibilities. "Do you have any idea what you can do once you've tamed the multi-tracker? Learning to mix a multitracked project with many different elements fading in and out can be nerve-racking, but once you've taken control, the possibilities are great, and you'll never want to return to multimachine mixing."

Editing

Other production directors, such as WCAU's Gerstein, cite editing as the function most difficult yet necessary to master: "Without question I feel editing is the hardest thing to genuinely master. This may sound harsh, but it is my opinion that anyone with any brains can operate today's equipment given the proper training—training that usually amounts to repetition. Editing is tough to teach. There's a lot of craft involved, especially when it comes to music editing. You don't have to use half a grease pencil to mark a single cut point, nor do you need a buzz saw to part tape. Editing is as much an art as it is a science. That's what makes it a challenge. You need to develop a soft touch, which is difficult to achieve when you're trying *so* hard to get it right the first time. With a soft touch comes confidence, and with confidence comes quality, as well as speed—both essential things. If it seems that I'm harping on the basics, it's because I am. I have seen person after person dive in headfirst without a clue as to how to properly edit. Once the basics are mastered, art is possible. A suggestion: get yourself an Edit-All chopping block. Keep it on your person at all times. It's the only one that holds tape securely in place."

Selection

A production director has hundreds of mixdown ingredients at his or her disposal. What to use, when, and how much are questions that can only be answered by a producer who is in full command of all available resources. WHTX's Lawrence Alan Gerson offers this advice: "You have to be able to see the whole picture, so to speak.

The ability to choose the appropriate bed or effect from among the hundreds available is essential. This can be a very time-consuming thing, and if you're not in touch with your inventory, good luck. The idea, of course, is to select sounds that complement one another and help sell a client's product. Knowing when and when not to use materials at your disposal takes real discretion. All those bells and whistles on the effects processor are useful when not overly exploited. Practice a little restraint. Sometimes less is more."

Each piece of sound used in a mixdown has its own special qualities and must be handled with skill and adeptness, says WXRT's Cochran: "Sound is an artist's medium just like clay and paint. It can be shaped, stretched, altered, colored, sweetened, repeated, reversed, imitated, cut up, rendered unrecognizable, whatever. There is nothing sacred or immutable about sound, however, nothing that says it has to be the way you first heard or recorded it. Work with it. Choose creatively. Dream about how it could be different. Then think about how you can make it different using what you have—the importance of knowing what your equipment can do. Go with what you think is right. If it doesn't work, you can always fall back on what you've used before. If it does work, you've got another trick in your bag. Just get in there and wrestle with it, and don't hold yourself back thinking in a linear way through a project. Focus instead on how you want the finished product to sound. For example, not all music transitions have to be edits. How about crossfades to smooth over a transition or sound effects to obscure it? Thoughtful selection makes a big difference. The most difficult thing to accept in production is the fact that you are in charge of what happens with the sound, so make it what you want it to be!"

Tom Bryant, the production manager of the nation's first and foremost country station—WSM AM/FM in Nashville—wraps up this section by reiterating a few points made by his industry colleagues on the difficulty of mastering the job of production director: "I think the whole business of radio production is difficult to master. I personally believe that good production people are born and not made, or at least enter this world with a predisposition to the job of production. In any event, it takes a long time to become totally familiar with sound effects and production libraries, as well as other available audio resources. Knowing where to find the 'right' elements to go with a particular assignment is no small feat in itself. The ability to operate multitrack equipment with a high degree of skill and speed is becoming essential. Although growing less common, physical tape editing is still important, and here again accuracy, speed, and skill are essential. Most of the time you don't have a second chance after you've taken the blade to a piece of tape, so it had better be right the first time. Editing music to make loops or shorten songs is also a vital skill."

In the immortal words of author Kurt Vonnegut, Jr.: "And so it goes." Truly, the production person must be a master of all production room trades. However, do not be overwhelmed or discouraged. Many of the skills leading to mastery in the production room reside in the chapters ahead.

CHAPTER HIGHLIGHTS

1. Market size generally determines the number of studios and equipment available in a station's audio production department.

2. The studio must be of ample size to allow for comfortable, efficient use of all equipment. An undersized studio is conducive to clutter and confusion, and it can lead to fidelity problems and technical failures.

3. A properly designed studio will deaden outside noise and reduce the reflection of inside sound (echo and reverberation).

4. The U-shaped studio, with the production person seated on a rolling swivel chair within the U, provides maximum accessibility to equipment. With the audio console at the hub of the U and the remaining equipment evenly spaced on each side, the production person can access everything through both remote and hands-on switches.

5. Production studios must contain sufficient storage space for LPs, CDs, and cassettes containing bed music and special effects; tapes for current advertisers; blank

cartridges and tapes; editing supplies (e.g., grease pencils, splicing tape, razors); and small equipment and accessories (e.g., headphones, microphones, jacks, cables).

6. Practice is the only way to develop from mere competence to creativity with production equipment. Experimentation will allow you to determine each piece of equipment's maximum capacity and limitations. Practice should be augmented with listening to the production elements at other stations.

7. Eating, drinking, and smoking in a studio represent a threat to equipment. Proper equipment maintenance includes cleaning magnetic tape heads; checking levels, phase, and tracking sync; as well as avoiding equipment abuse.

8. A multitrack machine allows a production person to record several tracks for mixing in any order or combination. This eliminates the need for integrating several (four, six, eight) separate machines and greatly increases creative possibilities.

9. Tape editing is one of the most important and most difficult production skills to develop. It often consumes the most time during complex productions; requires a soft, confident touch; and cannot be mastered without considerable practice.

10. Introducing sounds into a mix at the precise moment they are needed involves expert timing and coordination.

11. From the hundreds of mixdown ingredients at his or her disposal, a production director must determine what to use, when, and how much. Proper selection requires complete knowledge of the bed and sound effects libraries, the personality and style of the voice talent, the potential of the equipment being used, and the final sound you want to achieve.

5 The Audio Console

The audio console, most commonly referred to as a *board*, is the epicenter of the production room. This is the piece of equipment through which all audio signals are processed. Without the board, mixdown is not possible. Perhaps no other piece of equipment is more complex and intimidating-looking to the uninitiated than this one. Composed of an array of buttons, meters, slide controls, and knobs, the production board has been compared to the control panel at the NASA Launch Center, but it is far more easily operated and, with some instruction, very quickly demystified. Basically, the production studio console is designed to amplify audio and route it to various points for mixing purposes.

CONSOLE COMPONENTS

The production studio board consists primarily of inputs, keys (toggles), potentiometers (pots/faders), monitor gain controls, volume unit (V.U.) meters, cue channels, and headphone jacks.

Inputs

A primary function of the board is to route audio from one point to another. Input buttons access sound from various pieces of studio equipment and remote lines (network, telephone, mobile unit) wired into the board. For instance, if a producer wishes to record a song from an album onto a cartridge he or she must input the turntable on which the album is located and route it to the cart machine designated as the recording source.

Inputs are therefore tied to the equipment that is used in the mixdown of commercials, psa's, and whatnot.

For the sake of further illustration, assume that a production person must mix a spot onto cart that involves a reel-to-reel voice track, a piece of bed music on a cassette, and a sound effect on a record. In this situation, three pieces of equipment must be accessed by the board and then routed to a cart recorder. "Simply stated, inputs are on/off switches to equipment connected to the board, and if you don't input a piece of equipment you can't use it," says WPRO's Vic Michaels.

Depending on size, a standard broadcast board may have as few as five channels with two inputs per channel or as many as two or three dozen channels with multiple inputs. Each board possesses at least one microphone input, and many are designed with two or three. Should a production director wish to voice-track directly onto cartridge, he or she would open the mic input, and the board would route the voice to the cart deck designated to record. This process involves converting the production person's voice into electric energy, which is the function of the microphone (more on this in a forthcoming chapter). Inside the board is a device called a *preamp* (preamplifier), which boosts the incoming audio signal to a usable level. From this point on, the pro-

FIGURE 5.1 Production person working the audio console—the heart of the studio. (Courtesy Broadcast Electronics.)

47

FIGURE 5.2
Components of an audio console. (Courtesy LPB.)

MONITOR SELECTOR
The monitor selector group includes an aural phase test pushbutton, and monitor/cue muting status indicators.

PRE-FADER CUE
In addition to the conventional CCW fader cue position, a momentary pre-fader cue pushbutton allows cue monitoring while maintaining a preset fader position.

PROGRAM/AUDITION SELECTORS
Independent, illuminated ON/OFF pushbuttons allow simultaneous assignment to both Program and Audition Busses, if required. Both outputs are identical in performance.

INPUT SELECTORS
3 inputs per mixer are provided, utilizing a telephone-type lever key activating silent reed relays for maximum reliability.

REMOTE START
Each mixer position is equipped with a momentary switch which provides a contact closure for each input. The indicator lamp terminals are accessible for use as cart machine status indicators such as "run", "ready", etc. An additional set of contacts allows the optional digital timer to be reset simultaneously with a "start" command. An internal selector switch transfers the momentary start function to the program/audition selector switches for control requiring a sustained contact closure.

MASTER LEVEL CONTROLS
Selector switches to transfer the front panel master program and audition level controls to the internal controls are located internally.

OPERATORS MIC SELECTOR
A slide switch with LED status indicators offers the direction of input 1A to either the selected output buss (NORM) or to a console output for intercom use (SEND).

VU METERS AND SELECTOR
Two illuminated VU meters with LED peak indicators are standard. Each meter assembly includes a calibration amplifier and variable threshold peak control. The two meters are switchable, and additional assigned meters are optional. A maximum of 4 additional meters and/or digital clocks and timers may be specified.

AUXILIARY SELECTORS
Two 4-position switches are provided which may be used as additional input selectors, output directors, expansion of external monitor inputs, etc. Two 11-position switches can also be provided, by ordering option "CAS."

STEREO MIC PREAMP PLUG-IN
3 programming switches are provided to allow a selection of 3 gain levels, mono or stereo input operation, and external processor port selector. An input transformer center tap is also provided for phantom powering of condenser microphones.

REFERENCE OSCILLATOR
An optional reference oscillator is available, which can be converted to standard line input preamp configuration by means of a selector switch mounted on the plug-in. The oscillator can provide a switch selectable tone to left, right, or left plus right inputs.

STEREO LINE PREAMP PLUG-IN
Transformer balanced, each line preamp is switch selectable for mono or stereo input operation.

PROGRAMMING MATRIX
An internal pin-programmed matrix is used to provide the selection of monitor and cue muting for the first 5 mixer positions.

INTERNAL INPUT PADS
Internal H pads are provided in the "C" position of all microphone inputs for mic/line capability on the same mixer. Line level inputs also have strapped pad terminals to allow additional line input level adjustment.

duction director manually controls the destiny of the voice track through the use of other board components.

Keys/Toggles

Keys, or toggle switches as they are also called, allow the incoming signal to be routed to either a program or audition channel. Many boards offer this dual channel option, which lets the production person mix or feed audio into the program channel while listening to other material over the studio monitors input via the audition channel.

When the key is set to the program chan-

FIGURE 5.3
Internal view of a ten-pot board. (Courtesy Broadcast Electronics.)

nel it is important to remember that the monitor and headphone gain inputs must be in a corresponding position, that is, set to "program."

Think of the program key as the board's on/off switch. Unless the key is "open," no audio signal is accessed or routable.

Potentiometers

Each channel must have a corresponding volume control. These are called potentiometers, or simply *pots* or *faders* for short, and they control the audio level or gain of each amplifier. Pots come in two forms: rotary and vertical (linear) slide (the latter have gained greater popularity during the last couple of decades). An ascending scale denoting volume (with numbers from 0 to 10) surrounds rotary pots—zero is generally located at seven o'clock and ten at five o'clock, using a conventional timepiece as a point of reference (see Figure 5.7)—and runs the length of vertical slides (see Figure 5.8). The production person may set appropriate levels with these numeric values. The size of an audio console is measured in terms of the number of pots it possesses—an eight-pot board, twelve-pot board, and so on. In other words, the more pots, the greater the mixing capacity.

Gains

There are other pots on the board that also have volume control functions. They are referred to as gain controls. For instance, boards have a master gain that controls the overall level of loudness of the unit's output. At most stations the engineer will set or lock the master gain at a level deemed appropriate; thus, the production person does not work this board function. There are usually three other gain controls on an audio console. The monitor gain controls the loudness of the studio speakers. It does not affect the level of the board's output. The cue gain controls the loudness of the cue speakers. This lets the producer set up mixdown ingredients. The headset gain controls the volume of sound to the headsets that are plugged into the board.

V.U. Meters

V.U. stands for *volume units*. The V.U. meter measures the amount of sound being routed through the console's output. The V.U. me-

50 STUDIOS AND EQUIPMENT

FIGURE 5.4
Internal diagram of a twelve-channel audio console. (Courtesy Arrakis.)

THE AUDIO CONSOLE 51

FIGURE 5.5
Reel-to-reel (play) to cassette (record) routing through console.

FIGURE 5.6
Some boards feature an audition channel in addition to program. A key, or toggle switch, permits the production person to shift from one channel to the other.

FIGURE 5.7
Rotary pots.

FIGURE 5.8
Linear fader board. (Courtesy Broadcast Audio.)

FIGURE 5.9a
Master gain.

ter lets the operator see the loudness of sound: when it comes to measuring levels, the eye is more accurate than the ear.

An audio console may have one V.U. meter or several. For example, a board featuring an audition channel or stereo will have at least two meters. In the latter case a meter measures the audio level in the left channel while a second meter measures level in the right channel. Multitrack boards include meters for multiple channel mixing. This may mean a dozen or more individual meters.

The V.U. meter consists of a two-tiered numbered scale; one tier reveals percentage of modulation and the other displays volume units. The meter measures the audio level passing through the board. The meter's needle indicates these measurements. In most cases the outside part of the scale's arc consists of numbers ranging left to right from −20 to +3. These are volume units. The inside part of the arc represents percentage of modulation from 0 to 100. The volume unit scale is relative to the percentage scale. In other words, −2 is 80 percent modulation, and 100 on the percentage side of the scale is 0 on the V.U. side of the scale.

Audio levels should average between 60 and 100 percent modulation on peaks of frequent recurrence. The production person must avoid levels that exceed 100 percent modulation or 0 V.U. Overmodulation, sometimes called "pinning the needle" or "riding in the red," results in distortion and the erosion of fidelity. Conversely, a level that is set too low, say at 20 percent modulation or −10, may sound muddy. Thus, a watchful eye is kept on the V.U. meter. Bad levels can ruin a work of production.

THE AUDIO CONSOLE 53

FIGURE 5.9b
Cue and headphone gains.

FIGURE 5.10
Stereo meter.

FIGURE 5.11
Pinning the V.U. meter creates distortion.

FIGURE 5.12
Fluorescent V.U. meter. (Courtesy ATI.)

Raising or lowering sound when it is not natural to do so—for instance, potting up on a section of a record that is intended to be soft—is inappropriate. Many songs run the volume gamut but on average are recorded outward from 0 dB or 100 percent modulation. Therefore, one generally should avoid raising the level on parts intended to be low or potting down on parts designed to be strong or intense. It is not the production director's role to usurp that of a song's composer or arranger, at least not when it comes to levels.

During the 1980s several console manufacturers began offering boards with digital meters, two-color vacuum fluorescent bar graphs, and plasma displays. However, the standard arc/needle meter remains most prevalent in the early 1990s.

FIGURE 5.13
Board headphone jack.

Muting and Headphone Jack

The console's muting system cuts the studio monitor. By doing this when the microphone is activated, sound from the speakers is blocked and therefore not recycled—an event causing that unpleasant squealing sound known as feedback.

Since sound is muted when the mic switch is opened, the production person must have another means of hearing what he or she is doing. Headphones are the solution. In most cases, a jack is wired into the board, which permits the producer to plug in a set of headphones.

Headphones also let the person voicing copy listen to himself or herself while taping. A gain control allows the operator to raise or lower the volume of the headphones. (Headphones are discussed in Chapter 8.)

Cue

Each pot, except for those dedicated to microphones, has a cue mode or channel. The cue position is generally located below the number 0 on both rotary and slide pots. On rotaries this means in the extreme counterclockwise position and on slides at the base or bottom. A slight resistance or click will signify the cue location.

The cue mode lets the producer *preview* (hear) what is entering the board from a preselected source—turntable, cart ma-

chine, etc.—without its being routed through the board's output. In different words, the audio channeled to cue will not enter "program" until the pot is opened. This affords the producer the chance to set up production mixdown elements. For instance, elements slated for eventual introduction into a mixdown must be cued-to-roll when they are called for in the copy. With the pot in the cue position, the producer can do whatever tightening is necessary in anticipation of the mix-in.

For the sake of simplification and illustration, it can be said that the cue and audition channels constitute a console's internal system, whereas the program channel serves as its external system. The difference between the cue mode and audition mode is that in the former audio is amplified by a small speaker usually mounted inside the board. Audition uses the studio's external speaker system. Audio in the cue mode cannot be routed to a V.U. meter as it can in the audition mode.

Keep in mind that pots should not be in cue except when in use. Each additional pot in cue loads down the circuit and may diminish the amplification from the small cue speaker, thus making it hard, if not impossible, to hear what is coming through the line.

Equalizers

Some consoles feature in-board equalization. Three-band EQ, which offers high-, middle-, and low-band frequency adjustment, is the most common. Rarer are four-band equalizers with full parametric control over individual bands.

As you will read in later chapters (particularly in Chapter 9), equalizers—whether out-of-board or on-board—play an increasing role in the preparation of commercials, promos, and other production pieces. In-board EQ is a component of most multitrack consoles.

CONSOLE DESIGNS

Consoles come in a wide variety of sizes and designs. Most manufacturers, and there are many, offer boards featuring either rotary or slide faders, and most produce boards for monaural and stereo mixing purposes. The most basic of all boards is perhaps the five-pot monaural, but five-pot stereo boards are also available. The former is most likely to be found at small market AM stations, which have not shifted to stereo broadcasting. The latter is popular at smaller FM stations. However, the "five-potter" is used by larger stations with multiple production facilities, as well as in station news booths when the newscaster is responsible for producing his or her own broadcast.

Another popular board at AM stations is the dual channel mono board featuring audition and program channels. As has already been mentioned, these dual purpose boards provide stations the ability to function in two capacities simultaneously, which is usually a cost consideration. With a dual channel board an operator can send programming out over the air on the program channel while mixing a spot on the audition channel.

Stereo boards feature at least two sets of meters (left/right channels) and are available, as are mono and dual channel boards, with five pots or a dozen or more.

FIGURE 5.14
Pot in cue position.

56 STUDIOS AND EQUIPMENT

FIGURE 5.15
In-board cue speaker. (Courtesy LPB.)

FIGURE 5.16
In-board three-band EQ.

The number of pots/faders a board possesses is significantly compounded when the discussion turns to multitrack. A multitrack audio mixing console may feature as few as a dozen faders or upwards of thirty (when discussing slide boards, especially multitrack, the term *fader* is more commonly used than *pot*). Multitrack recording is growing more popular, and this piece of equipment is becoming fairly common in radio production studios, particularly at larger stations.

As evidenced by the figures in this section, consoles share many physical characteristics, but they do not all look exactly alike. Sleek, space-age designs have supplanted the blocky and behemoth styles of yesteryear. It would not be inappropriate to compare the new consoles with something out of a Hollywood sci-fi movie.

FIGURE 5.17
Five-pot stereo board. Note that all boards are labeled, since each board is wired differently from studio to studio and station to station.

The price range for audio consoles is vast. Obviously, the five-pot monaural board and the multichannel with dozens of faders are at the extremes of the price spectrum, and a stereo board is more costly than a monaural. There are dozens of console makers who offer products ranging in price from a few thousand dollars to tens of thousands of dollars. Whatever a station may want in a console is available, and console manufacturers are listed in the annual *Broadcasting/Cable Yearbook*.

LABELING

Because each board is usually designed and wired somewhat differently, the assigned inputs, channels, pots, outputs, and gain controls are all labeled. The station engi-

FIGURE 5.18
Multitrack board. (Courtesy Auditronics.)

FIGURE 5.19 Manufacturer design drawing of a modern audio console. (Courtesy Auditronics.)

neer wires inputs based upon the equipment a studio contains and assigns the channels based on a logical operating sequence. Logic is the operative term here. For instance, if a studio has two turntables the station engineer might wire one turntable to pot three and the other to pot four, rather than to pot eight. Remember, arrangement and symmetry are important for ease of handling and accessibility. Human engineering factors must be considered. Whenever possible, similar pieces of equip-

ment are typically grouped together on the board. Therefore, he or she would likely wire the turntables next to each other so that the board operator may work with a greater degree of certainty. Jumping from pot three to pot eight during a bed transition in a commercial could cause some confusion and hesitation, even if the channel input selector switch and pots were clearly labeled. At the same time, the engineer would not stack similar equipment on the same pot input. For example, putting both production turntables on the same pot would make transitions—segues, crossfades—all but impossible. You must be able to fade one turntable while introducing another. Try this when only using one pot!

Labeling boards also assists new personnel. Imagine having to memorize what every control, switch, and pot does on a large board. This would invite disaster in the production room, not to mention the on-air studio. If an individual has a fundamental understanding of how audio consoles function, he or she can (with the aid of identifying labels) learn almost any board in a relatively short time.

PRACTICAL POINTS ON USE

The care and maintenance of the console is the producer's and engineer's responsibility. While the latter individual focuses on the technical repairs and upkeep of the board, the production director is concerned with general care and preventative maintenance. If the console is not handled with respect, problems are certain to develop.

The following are some points to consider:

1. Do not handle pots and inputs roughly. Slamming or banging these will eventually result in breakage or malfunction. "In other words, handle this costly piece of equipment like you bought it out of your hard-earned paycheck," says WRX's Dave Richards.

2. As mentioned earlier, avoid eating and drinking around equipment. Spill liquids into the board, and major problems will ensue. Food crumbs and residue will also wreak havoc. The same goes for smoking: ashes can foul up the works as well as food and drinks.

3. Do not handle board controls with dirty or sticky hands. Keep in mind that others may use the studio, so keep everything as clean as possible.

4. When cleaning dust and dirt from the board, do not spray cleaner onto its surface. Liquid can penetrate the board's interior, and the cleaner's caustic ingredients can cause damage. Generally speaking, keep cleaning sprays and solvents away from studio equipment. To clean the surface of any piece of audio equipment use a damp (not wet) cloth. Use a lint-free material to remove soil and dust.

5. Do not stack items—clipboards, index cards, books, tapes, albums—on top of the control surface of the board, that is, on the inputs or faders. "Riding the board" does not mean sitting on it!

6. Avoid yanking the headphone plug from its jack. Engineers spend far too much valuable time repairing jacks and cords that have been abused.

There are many other points that can be raised concerning the sensible handling of the audio console; just ask any production director or engineer. The bottom line is that operators who treat this essential piece of production studio equipment with respect avoid many headaches.

PATCHING

Most stations have patch panels in their on-air studio, and many also do some form of patching in their production rooms. Patch panels, also referred to as patch bays and jack panels, extend a studio console's input capacity. That is to say, they permit elements not directly wired (hard-wired) into the board to be accessed for inclusion in mixdowns.

By inserting a patch cord into an input/output jack in the patch panel, a board may draw from remote locations—other studios, outside sources—and may tie in with special equipment, such as effects processors used to enhance sound.

Jacks are clearly marked (or should be) so that the operator makes the correct connection. Any source wired to the patch panel

60 STUDIOS AND EQUIPMENT

FIGURE 5.20
Patch panel.

can be connected with a patch cord. If another studio is wired to the production room patch panel, the producer can input that studio's equipment, thereby significantly expanding on the number of sources he or she has available for a particular mixdown or recording session. Many stations record programs, such as interview shows and dramatizations, by simply linking larger performance studios to the production room mixer via the patch panel.

FIGURE 5.21
Switcher. (Courtesy International Tapetronics Corporation [ITC].)

All station plugs, cords, and cables should be neatly coiled and carefully stored to prevent damage. Connectors must be handled with care—that is, never allowed to become tangled or yanked from a socket when being disconnected. Among the most common plugs and jacks found in a studio are XLRs (3-pin), RCA (phono), MINI (miniphone), TINY (tiny-telephone), and PHONE (quarter-inch).

Patch panels are being replaced at some stations with audio switchers, such as the one in Figure 5.21. Switchers are designed to replace patch bays and distribution amplifiers, thus offering a new level of flexibility for handling diverse production needs. Audio switchers allow for instantaneous routing with the push of a button.

REMOTING

Stations frequently broadcast from locations other than the control room area. These live, remote broadcasts usually are connected to a station's on-air studio board through a patch panel or switcher.

Remote broadcasts range from the simple mixer/mic setup (see Figure 5.22) to the elaborate studio-on-wheels (mobile unit), which often is as fully equipped as a station's control room.

In the past the most common means for a remote point to be linked to a station was through land-lines installed by the telephone company. This formed a broadcast loop. Today, microwave units (mini-transmitters) have supplanted earthbound lines in many markets.

Generally speaking, remote setup is largely an engineering function. However, it is the responsibility of members of the announcing staff to operate the equipment during a remote, especially at small stations. The on-duty board operator usually serves as the producer for out-of-station broadcasts. Spots and other recorded material, as well as newscasts, generally originate at the station.

CHAPTER HIGHLIGHTS

1. The audio console (board) is the central piece of production room equipment

FIGURE 5.22
The announcer or sportscaster operates the remote mixer during a live, out-of-studio broadcast. (Courtesy WGAO-FM.)

through which everything is mixed and processed. Basically, the console amplifies audio and routes it to various points for mixing.

2. The production room board generally consists of inputs, keys (toggles), potentiometers (pots/faders), monitor gain controls, volume unit (V.U.) meters, cue channels, and headphone jacks.

3. Inputs (on/off switches) access sound from various pieces of studio equipment or remote lines (network, telephone, mobile unit) that are wired into the board.

4. Toggle switches (keys) are used to route the incoming signal to either the program or the audition channel. The audition channel allows screening of materials via the studio monitors. The program channel feeds the input "live" (on-air or into production).

5. Potentiometers (pots/faders) control the board's preamp power and the volume of each channel. Pots may be either rotary or vertical slide; both types are numbered 0 to 10 (sometimes 0 to 100) to denote increasing levels of volume.

6. The master gain (also a potentiometer), which is usually locked by the engineer at a predetermined level, controls the volume of the on-air output. The monitor gain controls the loudness of the studio speakers. The cue gain sets the volume of the cue speaker(s). The headset gain sets the volume through the headsets plugged into the board.

7. Volume unit (V.U.) meters measure the amount of sound being routed through the board. A standard arc/needle V.U. meter displays two parallel numbered scales. The upper volume unit scale consists of numbers ranging (left to right) from −20 to +3, with 0 representing total modulation. The lower positioned percentage modulation scale consists of percentage numbers (left to right) from 0 to 100, 100 percent representing total modulation.

8. The studio's monitor speakers must be muted (cut off) when the mic is open to prevent feedback from occurring.

9. All nonmicrophone pots possess a cue mode, indicated on the pot just below the number 0. The cue mode lets the production person hear the source controlled by that pot without its being routed through the board's output. Unlike the audition channel, which uses the studio monitor speakers and can be leveled with a V.U. meter, the cue mode uses a small, in-board speaker that is only adequate for setting up the source for playback.

10. Consoles come in a wide variety of designs (mono/stereo, single channel/dual channel, single track/multitrack) and with varying amounts of faders (either rotary or slide pots).

11. The station engineer wires board inputs based upon the equipment a studio contains. Similar pieces of equipment (for example, two turntables) are typically grouped together on adjacent pots. When more than one piece of equipment is wired to a single pot, pieces that would not usually be used in sequence are selected. All pots are clearly labeled to avoid confusion.

12. Patch panels (patch bays, jack panels) are external units that extend a studio console's input capacity. A patch cord joins the audio console with a source wired to a patch panel input/output jack, allowing the console to access that source (for example, a piece of equipment or another studio). Patch panels are being replaced by push-button audio switchers, which allow for instantaneous routing.

13. The most common connectors found in a studio are XLRs (3-pin), RCA (phono), MINI (miniphone), TINY (tiny-telephone), and PHONE (quarter-inch).

SPOT ASSIGNMENTS

1. Input a tape or record to the board.
2. Establish a level of −1 on peaks of frequent recurrence.
3. Input a tape or record to the cue channel.
4. Open the mic input and listen to the tape or record using headphones.
5. Close the mic and reset the studio's monitor gain to an appropriate level.
6. Slowly fade the volume on the tape or record.
7. Patch a remote source into the board.
8. Establish a level for the patched source.
9. Input a turntable to the audition channel (if board has this feature).
10. Neutralize the board by disengaging all inputs and returning all faders to the zero level position.

6 Tape Recorders

Radio station production studios contain several tape recorders. There are three basic types: reel-to-reel, cartridge, and cassette. These machines have many characteristics in common, and they are all designed for the purpose of audio recording and playback.

REEL-TO-REEL MACHINES

Open reel tape recorders are the studio workhorse, due in great part to the fact that magnetic tape can be accessed for editing purposes.

The primary components of the reel-to-reel are:

1. *Feed*—spindle upon which a (supply) reel of tape is mounted
2. *Take-up*—spindle upon which an empty reel is mounted
3. *Heads*—assembly across which tape passes for erase, record, and playback purposes
4. *Tape guides*—assembly that keeps tape in line and prevents tension fluctuations
5. *Pinch roller*—rubber wheel that presses tape against the capstan
6. *Capstan*—drive shaft that regulates a tape machine's speed
7. *Take-up idler*—switch that activates the take-up reel motor

The above components constitute that part of the machine called the *transport system*.

8. *Control switches*—various switches, including on/off, reel size adjustment, speed selector, edit, record, play, stop, fast forward, and rewind
9. *Input*—pots and switches that pertain to recording levels
10. *Output*—pots and switches that pertain to playback level
11. *V.U. meters*—playback and record level monitors
12. *Earphone plug*—headphone connector
13. *Edit button*—control switch used by operator to run tape away from take-up reel for marking and cutting
14. *Cue lever (Cue arm)*—switch that lets tape make contact with heads for cueing purposes and removes tape from heads for preservation
15. *Tape timer*—counter used to locate recorded material

Recording on a Reel-to-Reel

Most of these components are activated during a simple recording. For example, if Y95's J.D. must voice track a thirty-second commercial, he will proceed to first "rack up" the reel of tape:

1. J.D. places a seven-inch reel of magnetic tape on the feed spindle and then begins the process of threading the tape to the take-up reel.
2. In order to do this he draws about two feet of tape from the feed reel. He then threads the tape through the guide and past the roller.
3. Next, he runs the tape across the heads, making certain the tape is flush against the heads, properly aligned, and not twisted.
4. Once the tape is past the head assembly, J.D. places it between the capstan and the pinch roller. (If he fails to do this, the tape will not move at the appropriate speed. This is a common error for those unfamiliar with open-reel tape recorders.)
5. J.D. then runs the tape through the tape guide of the take-up idler. The machine will not roll if this is overlooked.
6. The final preparatory step is to place the end of the tape onto the take-up reel. Although this sounds simple enough, it takes a little practice to become proficient. Do not allow excess tape to hang or dangle from the reel. This can result in disaster when the machine is spinning at high speed in fast forward or rewind modes. The excess tape can whip against the tape moving be-

64 STUDIOS AND EQUIPMENT

FIGURE 6.1
Multitrack reel-to-reel machine. (Courtesy Otari.)

tween the reel and idler arm and cause it to snap. Avoid anything other than a miniscule hang.

Once the tape is racked, he will check it to make certain it has been threaded properly. Is the tape making contact with the guides and idler arm? Is the tape twisted? An operator cannot expect good results when he or she records on the wrong side of the tape. Is the tape threaded between the capstan and the pinch roller? If not, when the operator presses *play*, the tape is going to spin ahead as if in fast forward. Is there too much tape hang? If so, the operator must take up the slack. Is the tape moving smoothly on the take-up reel?

Since J.D. is going to record, he must put the machine into the input mode. Upon checking the machine, he finds that it is set to output (playback). In his mind he has divided the reel-to-reel machine into two distinctive halves—the left side is record (input), and the right side is playback (output). He knows that in order to record he must first disengage the output side and input the record side. With this accomplished, he may now set his levels. If the output side remains engaged, he will not be able to get a level, as audio is not being fed in.

J.D. also has made certain that his take-up reel is the same size as his feed reel and that he has the reel size setting where it should be. Since he is using a seven-inch reel of tape he has the button pressed to *small*. If he were to use a ten-and-a-half-inch reel he would change this setting. He is aware, too, of the danger in using unmatched reels—that is, reels of different sizes. This throws the tension off, and can result in breaks in the tape.

Having established his levels on the machine, J.D. is ready to record the commercial. To do so he must press both the play and record buttons. On some machines this must be done simultaneously, whereas on other recorders the operator may press the record button first and the play button whenever he or she is ready to roll.

When J.D. has voiced the spot, he will want to hear it to assess his delivery. To do so he must disengage the input side of the machine and set the output, or playback, side. He then opens the output gain and engages the cue arm so that he can hear the track during rewind. When he has spun to the beginning of the voice track, he stops the machine and presses *play* (called *start* on most machines). Upon listening to the track he decides that his delivery is lacking energy, so he will cut the spot again. However, he decides to keep the first take just in case he is less pleased with the second. To do this, J.D. moves past the first take before he begins recording. Again, he disengages the playback side of the machine and inputs the record side. Since he is satisfied with the levels on the initial track he does not have to reset the record gains. After recutting the spot, J.D. returns to the playback side to hear the results. Pleased with his performance on the second take, J.D. recues the track and prepares to dub it onto cart.

The reel-to-reel machine is the piece of production equipment most often employed for voice tracking purposes: an open reel of tape may be manually edited. Despite the growing prevalence of multitrack and digital equipment, which eliminate the need for a razor and splicing tape, the majority of stations (especially smaller stations) still rely on the old hands-on method of editing. "The reel-to-reel machine is, indeed, the production studio workhorse at most stations. The bulk of our announcing

is done directly to tape, and whenever editing is to be done, whether it involves music, sound effects, or voice, it is done on the open reel machines," says WGAO's Rich Pezzuolo.

Multitracking

Reel-to-reel machines are available in full-track mono, stereo, and multitrack. The four-track reel-to-reel deck is the most common multitrack recorder at radio stations. However, larger multitrack units are finding their way into the production studio.

Radio station WFBQ's production studio operating manual states the following procedure for recording on their four-track MCI open reel machine: "1. Record each component of your spot on one of the four tracks. Usually you will record each track individually at separate times. Of course, when recording stereo music you will record both channels at once. 2. Mixdown the recorded tracks. Each track may be made to appear on its own fader on the board, so you can mix the tracks together for a final tape. 3. When recording on the four-track you must make sure only the tracks you want to record at the moment are made 'ready' to record on the machine. The other tracks must be set to 'safe' to prevent them from recording over your previous work. 4. In order to sync new tracks with previously recorded material it is necessary to use the MCI 'cue' mode. This connects the record head to the machine output. If you do not do this, your new tracks will be slightly delayed from the original tracks, since you will be listening to the playback, which is offset from the record head by a few inches. You may use cue or audition to listen to previous tracks while recording a new one. To use the cue mode, simply press this button on the MCI electronics above the transport in the overbridge. 5. You may mixdown directly to cart or to another machine. Mixdown is the process whereby your previously recorded tracks are combined into the final recording."

CARTRIDGE MACHINES

Nearly every piece of short production destined for airplay is placed onto cartridge.

Therefore, no production studio is complete without at least a couple of cartridge machines.

Cart machines come in an assortment of sizes and shapes. Manufacturers offer broadcasters single unit cart machines as well as multiple unit models (three to five decks). What makes these tape machines particularly attractive to producers is their ease of handling. They are simple to operate. No threading is necessary since a plastic cartridge containing a continuous loop of tape is used. This saves a lot of time. Moreover, cart decks (as they are also called) are designed to recue tape once it has been played, so no rewinding and searching is necessary.

A *cue-tone* (audio pulse) is impressed upon the cartridge tape when the record button is set and the transport system activated. The cue-tone is located on a second channel. When the tone is detected by the

FIGURE 6.2
Four-track reel-to-reel. (Courtesy TEAC.)

66 STUDIOS AND EQUIPMENT

FIGURE 6.3a
Three-deck cart machine. (Courtesy Broadcast Electronics.)

FIGURE 6.3b
Five-deck cart machine. (Courtesy Broadcast Electronics.)

FIGURE 6.4
Stereo record/playback cart unit and playback-only unit. (Courtesy Broadcast Electronics.)

playback head, the cart stops. Many machines come equipped with secondary and tertiary tones often used for automation sequencing purposes.

There are mono and stereo cart decks and record/playback and playback-only models. With record/playback decks a production director may mix directly onto cart. While a studio may have three or more cart decks, it may only possess one record/playback unit. Obviously, a station that carts its production must have at least one record deck. It is more likely to encounter two or more record/playback cart decks in a production room.

Cart machines do not possess erase heads. The record/playback unit has both a record and playback head, and the playback-only unit has one head—a playback head. For this reason, all carts must be erased on a bulk eraser prior to recording, or the original track remains under the new track (see the section on bulk erasers later in this chapter).

Cartridge machines are available in mono and stereo, and all record units have a V.U. meter so that levels may be established directly on the machine itself. Some models feature a fast forward control. This is particularly useful when several cuts are recorded onto a cartridge. A producer may fast forward to the cut he or she wishes accessed—another time-saver.

When a cart deck is activated, a pinch roller comes up through an opening in the bottom of the tape cartridge and presses the tape against the machine's capstan. As with reel-to-reel machines, the cart deck's capstan moves the tape at a constant speed. Pressure pads inside the cartridge keep tape pressed against the heads.

To illustrate just what occurs when a cart deck is used, we will return to Y95's production director, J.D., who must dub two sixty-second commercials onto cartridge.

Fine tuning the broadcast cartridge with 30 years of proven experience
- New feature with Dynamax Cobalt
- **Proven Fidelipac technology**

- New reel assembly eliminates tape jams
- New Teflon bearing system reduces flutter and phase jitter
- **Lubricated inverse cone orients tape vertically and initiates straight tape path well upstream of front corner post area for repeatable phasing and assured high frequency response**
- Refined tape path and elimination of center wrap post improves phase uniformity, extends head life
- **Neutral front corner post for minimum cart-to-cart phase shift**
- **Patented circular brake* aids in correct cartridge alignment, shortens tape stop time, and protects tape pack during shipping and rough handling**
- New Cobalt Tape provides extended high frequency headroom and response, bias-compatible with conventional high-output tapes
- New anti-debris pressure pads clean tape, eliminate squeal and reduce both friction and scrape flutter
- New premium grade modified acrylic resin housing extends total cartridge life, reduces flutter, improves phase uniformity

FIGURE 6.5
Components of a cartridge. (Courtesy 3M.)

Since the spots are to be rotated equally on the air, J.D. may place them on the same cartridge; thus, he will need a cart that is at least two minutes long. Cartridges hold enough tape necessary to satisfy a variety of dubbing needs. That is to say, forty-second carts are available for thirty-second spots; seventy-second carts are available for a one-minute spot; two-and-a-half-minute carts are available for two minutes' worth of material; and so on, up to seven- and eight-minute cartridges. The extra time on the cartridge gives a production person a little breathing space. For example, if a pro-

68 STUDIOS AND EQUIPMENT

FIGURE 6.6
Station WFBQ offers information on phasing carts.

FIGURE 6.7
Cart builder. Many stations build and reload their own cartridges rather than purchase them already assembled. This saves money. (Courtesy BE.)

PHASING CARTS

Proper phasing of carts before recording stereo material is essential for quality playback. This is especially critical for listeners with mono radios, where out-of-phase source material can cause severe audio degradation.

The ITC stereo recorder in the main production studio has user-adjustable record head azimuth, for optimum quality from every cart. The small toggle switch next to the "STOP" button actuates a servo motor that adjusts the record head azimuth. A phase meter is located atop the cart machine stack. Here's the easy way to optimize each cart you use:

1. Erase the cart. (You don't have to find the splice yet.)
2. Put the cart in the stereo cart machine and start it recording.
3. Throw the switch on the phase meter to the TEST position. This feeds a pink noise test signal to the cart recorder.
4. Using the servo motor switch on the ITC stereo recorder, adjust for a minimum reading on the phase meter. There will be a noticeable dip in the meter reading when you reach the point of perfect azimuth adjustment.
5. Stop the cart machine. Place the phase meter switch in the NORMAL position. Erase the tape and record as usual.

Do this with every cart you use, and soon you'll be known as a production whiz.

duction order calls for the dubbing of eight thirty-second spots onto one cart, J.D. will use a four-and-a-half-minute cartridge, allowing a few seconds of time to elapse between each cut. This results in short recue time.

Once J.D. has a two-and-a-half-minute cart in hand he will erase it to make certain the tape is clean. He then places the cart into the machine and presses the record button. This will permit him to take a level on the cart machine V.U. meters. Level es-

tablished, J.D. can start dubbing the commercials onto cartridge. To ensure a tight cue, he presses the cart and reel-to-reel machine start buttons simultaneously. He has made certain that there is a split-second pause in the audio on the reel-to-reel so as not to create a "burping" effect on the cart, which results when audio is running before the cart machine is activated.

After J.D. has dubbed the first spot onto the cartridge he allows ten to fifteen seconds to pass before hitting (figuratively speaking) the machine's stop button; he has also potted out of the reel-to-reel machine (that is, turned the fader to 0) so that uncued audio does not run onto the cartridge. Now J.D. must cue up the second spot on the reel machine and reset the record switch on the cart deck. Once this is done and the levels set, he dubs the second spot onto the cartridge. When the track ends, he fades out

FIGURE 6.8
Stereo cassette deck. Cassette machines are available in both mono and stereo. (Courtesy TEAC.)

of the reel-to-reel and waits for the cart to recue. Within fifteen seconds this happens.

To hear the carted spots, J.D. merely inputs the cart machine to the board and opens the pot, proving once again the simplicity of cartridge machine recording.

CASSETTE MACHINES

Of the three tape machines found in the production studio, the cassette generally bears the lightest work burden. Few things are ever mixed directly onto cassette. Copies for clients are typically done on cassette, and the production director may lift a sound bite (bed music, sound effect, voice track) or two from a cassette, but spots are seldom placed onto cassette for broadcast purposes. At many stations, the cassette machine is more an integral part of the on-air studio and newsroom than it is the production studio. Portable cassette decks are immensely popular in the news department for taping interviews and on-the-scene reports (called *actualities*). The station's sales department uses cassettes to play demo or spec tapes for prospective clients.

The studio cassette deck, like the cart machine, is simple to handle—no threading is necessary—but unlike the cart machine, cassettes must be manually cued. Fast forwarding and rewinding are necessary to locate recorded material unless the machine is equipped with a search feature.

Another disadvantage of many cassette decks is poor sound reproduction, due in

FIGURE 6.9
Cassette cartridges come in a variety of lengths, up to several hours.

FIGURE 6.10
Reel-to-reel machine tape heads. (Courtesy Otari.)

70 STUDIOS AND EQUIPMENT

FIGURE 6.11
Reel-to-reel tape path.

great part to small tape width (⅛ inch) and slow speed (1⅞ IPS). Some new machines offer 3¾ IPS and Dolby noise reduction, and this has improved sound reproduction significantly.

TAPE HEADS

The magnetic heads of any tape machine constitute its soul. What the machine is designed to do takes place at the head assembly. The electromagnetic heads convert electric energy into magnetic energy for recording purposes, and magnetic energy into electric energy for playback purposes.

Most tape machines have three heads: erase, record, and playback (ERP). These heads are arranged in a line starting with the erase head on the left (nearest the feed/supply reel), the record head in the middle, and the playback head at the right (nearest the take-up reel).

Cartridge machines have two heads if they are record/playback units and one head (with sometimes an additional "dummy" head to help maintain alignment) if they are playback-only machines.

The erase head does just what its name suggests. It wipes a tape clean of recorded audio by rearranging the magnetic impressions created by the record head. Remember, the record head imprints the tape by arranging the magnetic fields, and the playback head converts the thousands of magnetic fields on the tape to alternating electric impulses. This allows a listener to hear what is on the tape.

Oxide particles from the magnetic tape, as well as dirt, dust, and grease-pencil artifacts soil heads and erode sound quality. Thus a production person must clean heads frequently. This is accomplished by wiping heads with a cleaning compound (denatured alcohol). A cotton-tipped applicator (cotton swab) moistened with head cleaner is rubbed across the surface of the heads.

Another possible source of sound erosion is unaligned heads. When heads are out of their proper angle or at an incorrect height, tape does not make adequate contact, and sound reproduction deteriorates. It is the engineer's responsibility at most stations to make certain heads are properly aligned.

Standard open reel and cart machine tape heads are designed to work a ¼-inch wide tape surface, whereas cassette heads work an area half this size (⅛ inch). Multitrack machine tape heads are designed to accommodate ½-inch, 1-inch, or 2-inch tape. The ½-inch tape is generally used by four-track machines, 1-inch tape by eight-track

FIGURE 6.12a
Heads must be cleaned frequently to prevent sound degeneration.

machines, and 2-inch tape by sixteen-track machines. Heads must be larger on multi-track recorders since more recording surface is required to lay multiple tracks. Generally speaking, the more tracks a machine accommodates, the larger its heads. Four- and eight-track machines became popular in the 1980s.

The quarter-track stereo recorder, sometimes inaccurately referred to as a four-track machine, should not be confused with a multitrack unit. The typical stereo open reel machine offers two-channel recording on both sides of the ¼-inch oxide-treated surface. Actually, tracks one and three are recorded upon in one direction, and when the tape is turned over, tracks two and four are recorded upon in the opposite direction. A machine featuring quarter-track stereo lets the operator record both ways on the tape—that is, record on one side and flip the tape over and record on the other. This produces two separate and distinct sides of sound. Quarter-track machines are used (or were used—the market has dried up) far more on the consumer level than on the broadcast level. The main drawback of the quarter-track recorder is that editing is a problem. If all four quarter tracks contain audio, a razor cut on one side cannot be achieved without ruining the other side.

TAPE MACHINE SPEEDS

Reel-to-reel machines generally operate at two or more tape speeds. Nearly all record at 7½ IPS, which has become the industry standard, although most studio recording is done at a higher speed. The most common tape speeds found on open reel machines are 3¾, 7½, 15, and 30 IPS. Since the late 1980s few open reel machines have been manufactured with speeds under 7½, since lower speeds usually produce inferior sound quality. Producers also prefer to edit at higher speeds because getting a clean cut is easier. For instance, a word recorded at 7½ IPS may cover five inches of tape, whereas the same word would cover four times as much tape recorded at 30 IPS. This means there is more space in which to make a cut. Simply put, it opens things up more. (For more on this subject see Chapter 13.)

Cart decks and most cassette machines do not offer tape speed options. These machines operate at a fixed speed. Cart machines move at 7½ IPS, whereas cassette machines generally operate at a speed of 1⅞ IPS. In recent years cassette machines have been built that both play and record at higher speeds. While this improves sound reproduction, it adds to the sticker price, and this has discouraged some broadcasters. Meanwhile, the standard 1⅞ IPS

FIGURE 6.12b
This close-up illustrates how dirty heads and guides can become.

FIGURE 6.13
Tape head track configurations.

FIGURE 6.14
Quarter-track stereo recording paths.

cassette recorder has been improved in the last decade, and the use of metal particle tape has made it more valuable to stations for both production and on-air use.

MAGNETIC TAPE

Magnetic recording tape was developed by the Third Reich during World War II for use in espionage. It was not until the 1950s that magnetic tape was employed for commercial broadcast purposes.

Magnetic tape consists of an oxide layer and a base (back coating). The oxide layer constitutes the recording area. Iron oxide particles (tiny magnets) serve as the recording surface. These particles are arranged into patterns representing the audio signal. The plastic base underneath the oxide represents the tape's back coating. Two types of plastic materials are widely used to seal the recording surface and preserve the tape: polyester (mylar) and acetate. However, the former is more widely preferred than the latter. The reason for polyester's popularity lies in its strength and stability. It is more supple and is less affected by the environment than is acetate base tape, which can become brittle and therefore more prone to breakage.

The thickness of magnetic tape varies, too. A rule of thumb is the thicker the tape the stronger and better the quality. Tape is available in three thicknesses: 0.5, 1.0, and 1.5 millimeter. Broadcasters are inclined to use 1.5 mm polyester base tape because of its reliability. The amount of tape a reel contains depends on the thickness of the tape. For example, a seven-inch reel of 0.5 mm tape will hold twenty-four hundred feet of tape, twice as much as a reel of 1.5 mm tape.

FIGURE 6.15
Reel-to-reel speed control button.

FIGURE 6.16
Various sizes of tape reels.

Another rule of thumb is that more tape on a spool does not mean better tape. Thin tape stretches and breaks easily, so what may seem like a bargain may not be one at all. Just as broadcasters know enough to avoid recording at speeds under 7½ IPS, they also know enough to stay away from thin tape.

The width of magnetic tape varies also. This should be evident from the discussion of tape head sizes. Cassette tape is ⅛-inch wide, and cartridge tape is ¼-inch wide. However, reel tape comes in several different widths. Standard fulltrack and stereo reel-to-reel machines employ ¼-inch tape, whereas multitrack reel-to-reel recorders use anywhere from ¼-inch to 2-inch tape, depending on the number of tracks a machine features.

Reels also come in different sizes and, of course, the larger the reel the more tape it is likely to house. Reel sizes range from three-inch up to fourteen-inch, with five-, seven-, and ten-and-a-half-inch reels in between. It is rare to find three-inch reels of tape anymore, especially since so much recording is done at high speed. In such cases the amount of tape contained on the tiny reel would be insufficient. The small size also created tension problems for many machines. The most common reel sizes found in production are five- and seven-inch. The larger size reels are prevalent at automated stations, which air music from open reel decks.

A word of caution: avoid cheap tape. There are few so-called bargains when it comes to audio tape, and defects are often abun-

FIGURE 6.17
Automation system. Note large reels of tape. (Courtesy IGM.)

FIGURE 6.18
Eraser and splice detector. (Courtesy Dynamax.)

Labels on figure:
- Removeable circuit board All IC's socketed for ease of maintenance
- Replaceable head bridge assembly with positive alignment system
- Dual precision, full track erase heads
- Advanced cartridge hold-down system for precise, repeatable cartridge positioning
- Erase function may be disabled for splice-find-only operation
- Stop switch flashes to indicate cycle completed
- Large 2-inch air damped solenoid for low heat
- Optical cartridge ready sensor eliminates micro switch problems
- Ball bearing pressure roller for accurate splice sensing
- Cleaning switch for easy maintenance (recessed behind cartridge opening)
- Start switch lights to show cartridge in motion

dant. "Do not be seduced by low price, because what you end up with is low quality," notes WGAO-FM chief engineer Roger Turner.

Dropouts (loss of signal) and print-through (transfer of signal) resulting from poor distribution of the oxide particles and plastic coating are common in cheap tape, as is tape slippage caused by loose packing on the reel. In addition, other defects are often inherent in bargain basement magnetic tape.

BULK ERASERS

Since cartridge machines have no erase head, carts must be cleaned of unwanted magnetic fields by another means. Bulk erasers, also known as demagnetizers and degaussers, were devised for this purpose. Little more than an electromagnet, bulk erasers (when activated) wipe audio impressions from the oxide surface of tape so that it may be reused.

Bulk erasers come in a couple of models. Most production studios have platform or counter-top erasers. These are more heavy-duty and provide greater stability than the other type of bulk eraser, which is hand-held.

When using either type of bulk eraser, it is important to observe the following technique:

1. Keep the tape at a safe distance (a foot or two) away from the eraser. Putting a tape against a "bulker" as it is activated or deactivated leaves artifacts—audible clusters or mounds—on the tape that create a "swooshing" sound.
2. Turn on the eraser and slowly move the tape to it.
3. Once contact is made, slowly move the tape (cartridge) across and away from the eraser's surface.
4. Turn the cart over and repeat the process.
5. Return the cart to the bulk eraser, this time passing the exposed tape area (head section) over the magnetized surface (failure to do this may leave an unwanted cue-tone on the tape).
6. Move the cart away, and turn off the bulk eraser.

This should produce a clean cartridge. Cassette tapes may be erased in the same manner.

Reel tape may also be wiped clean by using a bulk eraser. The following technique should be used:

1. Follow steps 1 and 2 above.
2. Mount the reel on the spindle (rod) protruding from the bulk eraser.
3. Slowly rotate the tape clockwise two full turns, and remove the tape from the spindle.
4. Turn the tape over and repeat the clockwise rotation.
5. Remove the tape from the bulk eraser surface and turn off machine. Once again make certain the tape is a considerable distance from the eraser before deactivating it.

Jerky movements while erasing will create an uneven recording surface that is audibly apparent on playback. Insufficiently wiping a cart will leave artifacts behind that will affect reproduction quality. "Dirty carts hurt the air sound," observes WPRO's Michaels.

A word of caution: wrist watches should be kept at a safe distance (a couple of feet) from the electromagnetic field produced by bulk erasers. Production directors use their watch hand to hold the eraser's *on* button, therefore keeping their timepiece out of the range of the bulker's effect.

DIGITAL AUDIO TAPE (DAT)

Digital audio technology was first introduced in the 1970s, and twenty years later it is having a substantial impact on the radio industry. Today a growing number of stations have DAT (digital audio tape) recorders. A total departure from analog recording, digital involves the conversion of audio signals into coded pulses—numbers—that are read by a computer sound processor. Digital recording formats quantify numeric values rather than replicate waves. Simply put, in digital, sounds are quantized.

FIGURE 6.19
Platform-type bulk eraser.

76 STUDIOS AND EQUIPMENT

FIGURE 6.20
Among the newest technology found in production studios are DAT players. (Courtesy Panasonic.)

FIGURE 6.21
Analog waveform digitally sampled (quantized).

DAT recording is very appealing to broadcasters because it offers a greater dynamic range than analog, and it is nearly noise-free; the flutter (caused by variation in speed of tape transport) and wow common to analog are gone, and there is virtually no loss in quality during dubbing. "In addition to improved audio quality, digital audio systems can provide several other enhancements that are of specific value to the radio broadcaster. These include playback speed accuracy, stereo phase stability, fast random access, high storage densities, improved portability, and great cost-effectiveness relative to broadcast-quality analog systems. Still to be tackled, however, are some prob-

FIGURE 6.22
DAT cart deck playback unit. (Courtesy 3M.)

Standby Lamp
Indicates an auto-cueing operation is taking place. If either the fast forward/cue next or the rewind/cue last lamp is also illuminated, it indicates either a cue-to-next-cut or cut-to-previous-cut operation is taking place.

Seven-Segment LED
Serves as a power on indicator and allows numbering of the tape drives as either 0-9 or A-J.

EOM Detect Lamp
Indicates detection of the end-of-message (cut) signal on the tape.

Fail Lamp
Indicates an out-of-ordinary condition has occurred.

Read Error Lamp
Alerts the operator the tape is worn, errors are beyond correcting, and the cartridge should be replaced.

Rewind/Cue Last Switch
Used to high-speed advance the tape in the opposite direction of the message (rewind). If pressed a second time, it allows the operator to cue back to the previous cut.

Rewind/Cue Last Lamp
Indicates the machine is either in rewind, or cue-to-previous-cut condition.

Start Switch
Used to initiate the playback run or record run operations.

Start (Run) Lamp
Indicates the machine is in the playback run or record run mode.

Stop Switch
Used to stop tape movement from any function in operation and to cue the machine.

Stop (Ready) Lamp
Indicates the tape is ready to start or ready for unloading after playback. When illuminated continuously, it indicates a ready-to-start condition. When this lamp is flashing, it indicates a ready-to-unload condition.

Fast Forward/Cue Next Switch
Used to high-speed advance the tape along a message. If pressed a second time, this switch allows an operator to cue to the next cut.

AUX Detect Lamp
Indicates detection of an auxiliary signal.

Fast Forward/Cue Next Lamp
Indicates the machine is in either the fast forward or cue-to-next-cut condition.

FIGURE 6.23
DAT cart. (Courtesy 3M.)

Small Size
2.415 x 3.188 x 0.570 inch size allows easy handling and storage.

Durable Cover
Resistant to breakage during normal usage.

Textured Drive Belt
The textured finish of the drive belt increases tape control and stabilizes tape tension during high speed operation.

High Speed Drive Roller
Facilitates high speed operation while extending cartridge life.

No End-Play Hubs
Each hub has a molded-in plastic spring to ensure consistent track alignment throughout the length of the tape.

Magnetic Tape
A 3M formulated tape specifically selected for high density digital audio recording.

Stippled Baseplate
Produces a perfectly flat surface insuring consistent head to tape alignment.

Tape Cover
A plastic cover protects the tape from damage and contaminants when the cartridge is not in use.

lems in production, editing, and archival life," says Skip Pizzi of National Public Radio.

DAT is not without its critics. Complaints about cueing and audio clipping (distortion) have been registered, as has the initial cost of DAT technology. However, some stations (KSTE-FM, for instance) have found a way to overcome the cueing shortcoming by inserting an erasable start and stop tone (index tone) on a tape. This heightens precision and accuracy. As far as price is concerned, proponents of DAT technology say that the storage capacity and recording capability of digital audio far outweigh the financial consideration.

Many DAT players share certain likenesses with analog machines—controls, transport system, head configuration, and speeds. However, some DAT players feature much higher speeds and a different head assembly, and DAT players do not have erase heads. "During recording the former track is removed by a level that literally blasts it away," says Pizzi.

During recording, data are conveyed diagonally (helically) from the machine's heads to the magnetic tape surface rather than horizontally—as is the case in analog recording.

Digital audio tape differs from analog tape in a number of ways. It is much thinner—0.5 mm is the qualitative equivalent of 1.5 mm tape used with analog machines. More tracks may be written on a smaller surface using digital open reel tape. For instance, on a ¼-inch digital tape up to twelve tracks may be recorded, and ½-inch supports

twenty-eight tracks. Forty tracks may be recorded onto 1-inch wide digital tape.

DAT cassettes are about half the size of conventional analog cassettes and may contain up to four hours of material recorded at 1 IPS. However, digital tape must be handled with considerable care, as dust and dirt have an even greater impact on it than they do on analog tape.

If the trend toward DAT continues (there are some doubts), analog tape machines face possible extinction, at least in their current form. DAT poses a similar threat to CD technology, at least until CDs are able to offer recording capability. As of 1990, developments in this area suggest that it is just a matter of time before CDs may be a recording as well as playback medium.

CHAPTER HIGHLIGHTS

1. The three basic types of tape recorders used in production studios are reel-to-reel, cartridge, and cassette. The reel-to-reel machine is most often used for production because the tape is readily accessed for editing.

2. Cartridge tape machines (cart decks) use sealed cartridges of magnetic tape. These continuous loop tapes are available in various time lengths for recording and playback of short production pieces.

3. Cart decks are simple to operate, since there is no tape threading and the carts automatically recue after playing. Because cart decks do not contain an erase head, the carts must be bulk erased before reuse.

4. Cassette machines are more integral to on-air studios and newsrooms than to production studios. They are most often used for taping interviews and actualities (on-the-scene reports), playing spec tapes for prospective clients, and occasionally playing bed music or sound effects for production.

5. The magnetic head assembly of a tape machine is its central component. The electromagnetic heads convert electric energy into magnetic energy for recording purposes and convert magnetic energy into electric energy for playback.

6. Most tape machines (except cartridge) have three heads: erase, record, and playback (ERP).

7. Multitrack machine heads are usually larger than standard open reel and cart machine heads (accommodating up to 2-inch wide tape), because more surface is required to lay multiple tracks.

8. Reel-to-reel tape machines operate at two or more speeds, whereas cart and cassette machines normally operate at a fixed speed. The industry standard for reel-to-reel is 7½ IPS (inches per second), although for accuracy of editing most studio recording is done at higher speed (e.g., 30 IPS).

9. Magnetic tape may be polyester (mylar) or acetate backed, and it is available in 0.5, 1.0, and 1.5 millimeter thicknesses. Cassette tape is ⅛-inch wide; cartridge tape is ¼-inch wide; and reel-to-reel tape varies from ¼-inch to 2 inches wide.

10. DAT (digital audio tape) machines convert audio signals into coded pulses—numbers. The sound source is converted into numeric values, rather than the magnetic pulses used by traditional (analog) tape recorders. The waveform is digitized.

11. Although sharing certain mechanical likenesses with analog machines, DAT players may offer much higher tape speeds and different head assemblies. Digital tape is erased by recording over the original track by a level that literally blasts it away.

12. Digital audio tape is much thinner (0.5 mm is the standard) and more tracks may be written on a smaller surface (for example, twelve tracks fit on ¼-inch digital tape). DAT cassettes are about half the size of conventional analog cassettes and may contain up to four hours of material recorded at 1 IPS.

13. Bulk erasers (demagnetizers, degaussers) are electromagnetic devices that wipe audio from magnetic tape.

SPOT ASSIGNMENTS

1. Thread a seven-inch reel of tape to the take-up reel on an open reel machine. Make certain no tail is hanging from the take-up reel.

2. Record an announcement onto an open reel tape machine at 15 IPS.

3. Cue the announcement for playback; listen and recue for dubbing to a cartridge.

4. Record the reel-to-reel spot onto a cart.

5. Play back carted spot; allow to recue, and dub spot to a cassette.

6. Recue spot recorded onto cassette, and play back. (Is there a loss of sound quality? Remember, in analog recording, dub-downs result in sound deterioration.)

7. Remove the cassette and cartridge from the machines and bulk erase both. Place cart into a cartridge machine and press play. Is the cart completely noise-free? Is there a "swooshing" sound? If so, rebulk the cart.

8. Clean the heads of an open reel machine using denatured alcohol.

9. If a multitrack machine is available, record onto three separate tracks a voiced announcement, a piece of bed music, and a sound effect. Mixdown onto a cart.

10. Compare a DAT cassette's physical appearance to a standard analog cassette tape. Note the differences and similarities.

7 Turntables and Compact Discs

Turntables have served broadcasters from the medium's inception. During the earliest days of radio, phonographs—which played 78 rpm (revolutions per minute) records—were used to bridge the gaps between live performances. Later, in the 1930s and 1940s, stations used phonograph turntables to incorporate prerecorded material—music and sound effects—into live programs. Thus the phonograph turntable became an integral part of what is now referred to as radio's programming heyday.

In the late 1930s and 1940s, radio's first deejay, Martin Block, spun the hits of the day on large studio turntables for listeners tuned to his popular program "Make Believe Ballroom."

Turntables became a more integral part of the production room in the 1950s with the advent of long playing 33⅓ rpm albums (LPs) and 45 rpm singles. Advertising agencies, in particular, found LPs useful for pressing and distributing their clients' commercials. Their vastly improved fidelity and storage capacity (ten cuts instead of two) also inspired widespread use.

With the era of the deejay came a greater reliance on turntables. Most stations possessed at least one turntable by the end of World War II, and by 1955, at the overwhelming majority of radio outlets, turntables were the primary means for presenting programming material. Of course, the term *disc jockey* itself evolved from the relationship between the on-air person and the records he or she spun on the turntable.

Throughout the 1960s turntables performed a vital function both in the control room and the production studio. Today turntables remain an indispensable piece of equipment in most production studios, but their role in the on-air studio has diminished sharply with the advent of digital technology, primarily CDs. While digital equipment has made inroads into the radio production studio, the turntable has held its own (though the future suggests that it will eventually vanish).

TURNTABLE COMPONENTS

Turntables are comprised of five primary elements:

1. Plate
2. Power switch
3. Speed selector
4. Drive mechanism
5. Tone arm (stylus and cartridge)

Plate

Discs are placed upon a plate or platform that has a felt or rubber surface for ease of cueing, record protection, and to prevent record slippage. Broadcast turntable plates are the approximate size of an LP. Generally, the edge of an album is even with the rim of the turntable plate. Most broadcast turntable plates are made of metal or heavy plastic.

Power Switch

Turntables have an on/off switch. Some production studios wire turntables for remote start and stop (this procedure allows starting the turntable from the board). On many turntables a small light, usually red, signifies when the power is on.

Speed Selector

While some turntables offer three speeds—33⅓, 45, and 78 rpm—many recently manufactured models have eliminated the highest speed. The reason is simple: 78 rpm discs have not been produced since a few years after World War II. In fact, 45 rpm

FIGURE 7.1
Although digital equipment is prompting a gradual phaseout of turntables, it will be years before they are completely eliminated from the production studio.

records are becoming rarer by the day, as analog recording grows passé. Nearly all of the analog discs employed for production purposes are 33⅓.

In addition to a speed control switch, some models offer variable speed control switches that allow operators to slow or speed up a record by decreasing or increasing the rpms. This option lets the production person shorten or lengthen an electrical transcription to fit the needs of a particular mixdown. "In truth the variable speed switch is not used much in broadcast production. You can get some interesting effects off of it, but it's a feature more useful to dance club deejays, who like it for mixing tempos," observes WPRO's Michaels.

FIGURE 7.2
Turntable plate.

Drive Mechanism

Most older production studio turntables are driven by a rotating shaft that ultimately presses against a rubber roller (rather like the capstan and pinch roller found in tape machines). This rubber roller in turn makes contact with the inside rim of the plate to move the turntable. There are three types of drive systems: belt drive, rim drive, and direct drive. Of the three, the last two are the most popular in radio production studios because they are more durable and perform better.

To prevent a depression or ridge from forming in the rubber roller as a consequence of prolonged contact, the production person generally places the speed control lever in a neutral position when turntables are not in use. This removes pressure on the rubber roller. This is not a concern when turntables are entirely electrical.

Tone Arm

Up to this point the discussion has centered on how a turntable achieves movement. In order for it to produce sound it must have a tone arm. At one end of the tone arm (pickup arm) is a counterbalance system that, when properly adjusted, permits proper contact (pressure) with a disc. At the opposite end of the tone arm are a cartridge and stylus.

Cartridge and Stylus

The stylus rides in the record's grooves and vibrates by the rotation of the record. The cartridge is actually a transducer that changes the mechanical vibrations of the needle into an electric signal. This small signal is then amplified by a phono preamplifier prior to being sent to the board for further processing.

The stylus, or needle, is very sensitive and prone to damage. Rough treatment, such as dropping the tone arm onto a disc or scraping it across album grooves, will almost always lead to trouble. Dirt is another source of problems, since it accumulates on the needle's tip and creates a barrier to the conversion process.

The tip of a stylus is composed of very hard material, usually diamond. Nonethe-

less, it does not take much to reduce its capacity to perform its task, so care must always be taken to protect the stylus.

CUEING ON THE TURNTABLE

A couple of techniques are used to cue records: *dead-rolling* and *slip-cueing*.

Dead-rolling

As the term *dead-rolling* suggests, this approach to cueing a disc begins with no motion whatsoever—that is to say, the turntable is not rotating. However, in order to set up a cue for the purpose of a dead-roll, the turntable must first be activated. Here is the procedure necessary to cue up for a dead-roll:

1. Move the tone arm to the blank or grooveless area before the cut desired for cueing.
2. Turn on the turntable, and let the disc roll to the audio.
3. Turn off the turntable as soon as the stylus makes contact with audio.
4. With the left hand move (counter-clockwise) the disc away from the grooves of audio. This may be accomplished a couple of ways:
 a. Move the disc itself by making contact with its side. The felt surface on the plate allows discs to move freely without being damaged.
 b. Place the turntable into the neutral position, and move the plate itself. Depending on the pickup speed of the turntable (and each one is different), the disc should be moved one-eighth of a turn if an LP and one-quarter of a turn if a 45 away from the *post* (point of sound). This lets the turntable achieve its proper speed. Some turntables reach normal speed quicker than others. With certain models, normal speed is reached almost instantly. If a turntable is not given sufficient time in which to reach speed, distortion—known as *wowing*—may occur.
5. When ready, activate the turntable.

Do not be concerned that damage will occur to the needle as the result of the cueing process. Broadcast turntables and styli are especially designed for this function.

FIGURE 7.3
Standard two-speed turntable featuring 33⅓ and 45 rpm.

Slip-cueing

The slip-cueing technique requires that a production person hold a disc in place while the plate rotates, and at the moment he wishes to introduce the recording into a mixdown he or she simply releases it.

Slip-cueing, or slip-starting, a record involves a little more dexterity and timing than dead-rolling, but this method is necessary when audio must be lifted from inside a cut. In this case a tighter cue is required. For example, if a production director decides to use a thirty-second piece of instrumentation that lies deep within a four-and-a-half minute vocal, he or she must do the following:

1. Activate the turntable.
2. Move the tone arm to the desired cut.
3. Locate the cue point inside the cut.
4. Stop the disc with the left hand.

FIGURE 7.4
Turntable tone arm.

FIGURE 7.5
Broadcast quality compact disc player. (Courtesy Shure.)

5. Roll back until slightly in front of the cue point.
6. Hold disc in place.
7. Release disc when desired.

Since the turntable remains on during this process, the recording achieves its normal speed instantly when released. "When you need to make a precision cue, say you're after something tucked into a tight place, slip-starting is the most efficient way to accomplish this," says WRX's Dave Richards.

Slip-cueing generally requires that the turntable input pot on the board be opened at the same moment that the disc is released. This prevents any potential distortion or extraneous audio from marring the mixdown.

Clearly, slip-cueing demands more adeptness than dead-rolling, but with practice the technique can be mastered quickly.

FIGURE 7.6
Size of CD compared to conventional LP.

COMPACT DISCS

Compact disc players entered the radio production studio in the 1980s. Although CD players are a more integral part of the on-air studio, their value as a piece of production equipment increases daily. Observes NPR's Pizzi: "By far the largest acceptance of digital audio to date has been CD hardware, to the point where it is estimated that over half of the radio stations in the USA use CD to some extent. In major markets, this figure rises steeply. Many of these stations program music exclusively from CD, or nearly so. The practice of providing promotional copies of new releases on CD by record companies (following an earlier period of general reluctance to do so) has fueled a recent surge here. Second and third generation professional CD players are also aiding in the process of acceptance, which shows no signs of abating."

Unlike analog discs, which require actual physical contact with a recording, CD players employ a laser beam to read encoded data at a rate of 4.3218 million bits per second.

A compact disc is 4.7 inches wide and 1.2 mm thick, and players are quite light and compact as well. This feature alone makes them attractive to broadcasters. But what makes a CD player most appealing to broadcasters is its superior sound. Compact disc players offer, among other features, far greater dynamic range than standard turntables and a lower signal-to-noise ratio. They also eliminate the need for physical contact during cueing, and wowing and distortion are virtually gone.

Because digital discs are specially coated, they are much more resistant to damage than are analog discs. This is not to suggest

that CDs are impervious. They are not. In fact, the majority of CD-related problems stem from the discs themselves and not the players. Despite initial claims of the invincibility of the digital disc, experience has shown that mishandling of discs is courting disaster. CDs cannot be mistreated—used as Frisbees or placemats for peanut butter sandwiches—and still be expected to work like new. The simple fact is that while compact discs are more resistant to damage than analog discs, they can be harmed.

While a turntable tone arm moves from the outside of a disc inward as the plate revolves in a clockwise direction at 33⅓ or 45 rpms, a CD reads a disc from its core outward, moving from 500 rpm on the inside to 200 rpm on the outer edge of the disc.

Most CD players feature a variety of effect options, which can be of particular use to a production mix. However, the likelihood of CD technology entirely replacing turntables within the foreseeable future is not great. There are a number of reasons for this. First and foremost—and this is especially true for small stations—are economic factors. It costs money to introduce CD hardware into the production room. On the same note, inventory for this equipment must be acquired, and it is not cheap. Another consideration has been the fact that CD technology is not, as of 1990, a recording medium, although units with this capability have been promised by manufacturers.

Accessing cuts on a CD player is quick and simple, though excerpting segments from a track for inclusion in a mixdown can be somewhat less expedient than doing so on a conventional analog machine. Nonetheless, CD players are a major addition to the production studio. At the beginning of the 1990s, compact discs are a wonderful new source for bed music and sound effects.

Working with a CD unit is anything but complicated. Press a button and a tray ejects (on top-loaded models a door pops open). A disc is placed into the tray, and the press of the same button returns the tray and disc into the player. The operator then selects the track to be played and presses the appropriately numbered button. The audio rolls.

DISC MAINTENANCE

Handling programming materials (such as records and CDs) with care is central to maintaining a quality sound. Stations that fail to preserve their recordings invariably suffer the consequences. "Today the quality of a station's sound, even on commercials and psa's, plays a pivotal role in audience acceptance. People are very sound conscious, so you can't treat anything destined for airplay with a cavalier attitude. A production person must take time to ensure that production materials are kept in good shape," says WROR's Joe Cortese (Boston).

Analog Discs

Records (albums and 45s) are very susceptible to damage. Many things can affect the performance ability of conventional vinyl discs. For example, simple contact with a person's fingers can result in grooves being soiled by dirt and oils. When handling a record, avoid touching the grooved area. Hold an album at its edge and on its label, keeping fingers away from the playing surface. The normal accumulation or buildup of dust can cause problems, too. Food can also have a damaging effect on records. That is why most stations prohibit food and drinks in a studio. The ash from cigarettes can be especially insidious. Ash particles can leave a patina in grooves that, while not all that apparent to the eye, can reduce an album's effectiveness—another reason why many stations insist on no smoking in studios.

Albums are easily scratched, and a scratch is irreparable. Tossing records about and improper tone arm placement (dropping and dragging it across the record's surface) are a surefire way of doing damage. Heat is also the nemesis of vinyl recordings. Therefore, analog discs should be kept out of direct sunlight and away from heating sources. A warped record is useless.

Another cause of damage to discs are tone arms that are improperly balanced. This results in an abnormal amount of pressure being applied against the grooves of a disc. A worn or damaged needle may also have a similar impact.

Many over-the-counter cleaners are avail-

FIGURE 7.7
Record-care accessories. (Courtesy Stanton.)

SC4 — Regardless of how you clean your records you'll need the Stanton SC4 Stylus Cleaning Kit. SC4 adds hundreds of hours to the life of your stylus. This stylus cleaning system combines a specially formulated stylus cleaner fluid, safe for your delicate stylus parts, to dissolve stylus contamination, and a unique cleaning brush with controlled penetration bristles.

RC5 Plus — Consists of a velvet high pile brush specially designed to reach deep into the grooves and remove contaminants. Plus, a specially formulated cleaning fluid that safely dissolves oil film, loosens micro dust and other debris and at the same time reduces static charges. This special non-toxic fluid is designed to clean 150 records, both sides.

Carbon Fibre Brush — The ARC-5 Brush is constructed with aerospace carbon fibers that clean your records and leave them static free. The ARC-5 is a safe, fast and effective method of record care. It's the dry process of cleaning your records and eliminating static build up.

able to eliminate residue from the surface of a record. However, many production people perceive these products as frequently compounding the problem rather than eliminating it. Perhaps the most common type of record cleaner is the felt roller, which is run over a record's surface. The problem with this type of cleaner is that the product often ends up leaving as much dirt behind as it is supposed to remove.

A simple method for cleaning albums involves bathing them. Using mild (noncaustic) soap and lukewarm water, dirt can be removed from an album's surface. This is an effective, economical, and simple solution. If records are handled with care throughout the year, this need only be done occasionally, or when a specific need arises. Once an album has been bathed—and this should be done very gingerly—it should be gently dried with a lint free cloth (no hair dryers!).

One other point: returning an album to its jacket goes a long way toward its preservation. Letting an album lie around unprotected is tempting fate. Stacking albums atop one another, especially without covers, is also foolhardy. A little common sense can dramatically lengthen the life span and usefulness of a production record library.

Digital Discs

Actually, the proper care of digital discs is not dissimilar to that of analog discs. As with records, CDs should be held by their edges. Fingerprints and scratches can cause reading malfunctions or glitches. CDs should also be stored away from heat, such as direct sunlight or heating vents. Just as LPs are best preserved in their jackets, CDs last longer when kept in their cases.

Cleaning a disc is quite simple. To remove dirt from a disc's surface, gently wipe with a soft, damp cloth—use water only. Do not use an analog disc cleaner.

CDs should be wiped from the center outward, not in a circular motion, as is the case with vinyl recordings.

CHAPTER HIGHLIGHTS

1. Turntables have been used to play music since radio's inception. Martin Block, one of radio's first deejays, relied on turntables for his late 1930s program, "Make Believe Ballroom."

2. With the advent of long playing albums (33⅓ rpm) and 45 rpm singles, turntables became integral to production studios as well as on-air use.

3. A turntable is comprised of a plate, power switch, speed selector, drive mechanism, and tone arm (stylus and cartridge). The plate is an LP-size round platform with a rubber or felt surface (to facilitate cueing as well as protect discs) upon which the record is placed. The speed selector chooses among 33⅓, 45, and 78 rpm, although most analog production discs are 33⅓.

4. The tone arm (pickup arm) allows the turntable to produce sound. The end of the tone arm that contacts the record has a cartridge and stylus (needle); these transduce (convert) mechanical vibrations on the disc into electric energy. At the opposite end of the tone arm is a counterbalance system that regulates the amount of contact (pressure) the stylus makes with the recording.

5. Dead-rolling is a record-cueing technique that allows a record to be aired from a stopped turntable position. Slip-cueing is a technique that requires holding a disc in place while the plate rotates, releasing it when playback is desired. Although more difficult than dead-rolling, it is necessary when audio must be lifted from within a cut.

6. Unlike analog discs that require stylus contact, compact disc (CD) players employ a laser beam to read data at a rate of over four million bits per second. The laser reads a disc from its core outward, moving from 500 rpm near the center to 200 rpm at the outer edge. A CD is only 4.7 inches wide and 1.2 mm thick, but it is actually more resistant to damage than an analog disc.

7. Disc maintenance is really a matter of common sense. Since the playing surfaces of vinyl discs or CDs should be kept pristine for perfect sound reproduction, these areas should never be handled or abused. Common elements to avoid include heat, dust, hand oils, smoke (cigarette), scratches, and improper cleaning. An improperly balanced tone arm placing too much stylus pressure on the grooves or a worn/damaged stylus can damage vinyl discs.

SPOT ASSIGNMENTS

1. Cue up the third cut on an album.
2. Dead-roll and slip-cue the cut.
3. Using the slip-cue method, lift a piece of instrumentation from an album cut.
4. Clean an album using mild soap and warm water.
5. Determine whether albums are stored in a manner that ensures their preservation.
6. Compare the physical characteristics of a compact disc with a conventional LP.
7. Place a CD in the player and access track four.
8. Inspect the surface of a digital disc to determine if any dirt or damage is apparent.
9. Compare the sound reproduction of a record with that of a CD.

8 Microphones, Speakers, and Headphones

Without a doubt the most essential piece of equipment in a radio studio is the microphone. It is the very beginning of the signal chain. Without it a voice cannot reach a listener's ear—then there would be no radio medium.

SOUND

It is the function of the microphone to convert sound waves into electric energy. Sound waves are produced by the movement or vibration of air molecules. When molecules are moved together as the result of a high-pressure change in the surrounding atmosphere, they are in a state of *compression.* Conversely, when molecules are drawn apart as the consequence of a low-pressure disturbance, they undergo *rarefaction.*

These vibrations, or *frequencies,* travel from their source to the waiting microphone where they begin their journey through the audio processing chain. Thus, the sounds emitted from the studio speakers are the product of the compression and rarefaction of air molecules.

While most humans hear 40 Hz to 15 KHz, some hear up to 17 KHz, a few even higher. The greater the number of vibrations of a sound source, the higher its pitch seems to the human ear. For example, a whistle causes many vibrations of the air molecules and, therefore, is perceived as a high-pitch sound. Meanwhile, a tuba produces fewer vibrations and thus is experienced as a much lower pitch.

The more intense the sound wave or vibration, the louder it seems to the listener. The size of the wave is referred to as its *amplitude,* or volume.

A microphone takes these waves and converts them into an electrical form useful to the radio producer in the mixdown process. Microphones are available in a variety of designs and feature specific directional characteristics. A production person must know what microphone to employ in a particular recording situation.

MICROPHONE DESIGNS

A transducing element built into a microphone's head changes spoken sounds (acoustic energy) into electric energy. There are three types of microphones used by

FIGURE 8.1
In area A, air molecules are undergoing compression (clustering), and in area B, air molecules experience rarefaction (separation). A sound source produces alternating waves of compression and rarefaction.

89

90 STUDIOS AND EQUIPMENT

FIGURE 8.2
How we perceive sound: a sound source creates vibrations (sound waves) that are detected and processed by the auditory system.

FIGURE 8.3
Sound Pressure Level (SPL) chart depicting volume of different sounds in relation to human aural perception.

- 200—A Few Feet from Cannon
- 150—Hearing Loss
- 110—Power Saw
- 70—Busy Street
- 40—Soft Conversation
- 20—Empty Room
- 0—Threshold of Hearing

FIGURE 8.4a
Transduction in a moving coil microphone. The diaphragm and coils vibrate when acoustic energy reaches them, thus producing electric waves for audio processing.

TYPICAL AUDIO PRODUCTION CHAIN

FIGURE 8.4b Transduction points in a typical audio chain.

professionals: *moving coil*, *ribbon*, and *condenser*. These terms refer to a microphone's internal design or characteristics. Each type of microphone converts sound into electricity differently.

For example, the moving coil (also called *dynamic*) method has the diaphragm (a flexible membrane) connected to a conducting coil. When sounds enter the mic, the vibrations cause the coil to move through a magnetic field, creating an electrical signal. The ribbon microphone uses a thin foil element (corrugated metal ribbon) connected between two poles of a magnet to generate an electrical signal. Incoming sound vibrates the foil, thus creating the necessary effect. Meanwhile, the condenser (also called *capacitor*) design relies on vibrations of the diaphragm to cause a capacity change in a stored electrical charge, thus yielding a signal or current. The condensor mic requires an internal battery, or a phantom (outside) power source is used.

The *impedance*—the electric flow resistance—of a microphone is a factor in microphone performance. The idea is to use a mic offering low impedance, because the lower its resistance to signal flow, the less likely it will be affected by extraneous noise (such as hum and static). For this reason, low impedance, moving coil microphones are among the most widely used in broadcasting.

Directional Characteristics

Microphones are designed to pick up sound waves from specific directions. There are three basic patterns of microphone sensitivity. A mic may pick up sound from all directions—360 degrees. This type of microphone is called *omni*directional (the Latin prefix *omni* means all or any). The draw of the omni mic is three-dimensional—above, around, and below.

Mics designed to pick up sound from two directions—front and rear—are referred to as *bi*directional. The prefix *bi* (again taken from the Latin) means two or both.

The third type of microphone picks up sound primarily from a single direction. *Uni*directional microphones, as the Latin prefix suggests, pick up sound from one direction. Another term used to describe microphones with a very narrow or heart-shaped pickup pattern is *cardioid*.

Frequency Response

In addition to directional characteristics, microphones respond to sound waves differently depending on the quality and nature of their design. High-quality microphones are sensitive to a broad spectrum of frequencies (20 to 18,000 Hz).

Broadcasters desire microphones that accurately reproduce low as well as high

FIGURE 8.5
Internal system of Fostex's RP stereo microphone. (Courtesy Fostex.)

FIGURE 8.6a
Omnidirectional pickup pattern.

FIGURE 8.6b
Omnidirectional microphone. (Courtesy Shure.)

FIGURE 8.7a
Bidirectional pickup pattern.

frequency sound waves. For instance, a microphone insensitive to the full range of frequencies perceived by the human ear would insufficiently convey the depth, texture, and richness of a symphony orchestra.

As well as a microphone's design, its actual physical placement has an impact on its frequency response characteristics.

THE MICROPHONE IN USE

A microphone's field of sensitivity, or pickup, will determine its applicability. For instance, in a situation where several people are to be interviewed concurrently as they are seated at a small, round table, a producer may decide to employ an omnidi-

FIGURE 8.7b
Bidirectional microphone. (Courtesy Fostex.)

FIGURE 8.8a
Unidirectional pickup pattern.

FIGURE 8.8b
Unidirectional microphone. (Courtesy Shure.)

FIGURE 8.9
As a rule, when using two microphones (for two performers), the space between mics should be three times the distance of the mics from the persons talking. In other words, if a mic is set up a foot in front of each interviewee, then the mics should be three feet apart.

rectional microphone, thus eliminating the need for several mics, which may not be available. In a situation where there is only one person being interviewed, a bidirectional microphone may be used, since sound need only be drawn from two directions.

A unidirectional microphone is popular in situations which require the reduction of extraneous noise. For example, the control room mic is commonly unidirectional to keep noise unassociated with the on-air announcer from being processed into the airwaves. Cardioids also accentuate low-end sounds when the mic is positioned close to the sound source.

A microphone's physical nature or appearance will suggest its use as well. There are hand-held, mounted, headset, lapel, and shotgun mics to choose from. The first three are most common in radio, while the lapel and shotgun mics are widely used in television. The hand-held microphone is used in interview situations, especially when portability is the key consideration, whereas mounted mics are intended for stationary (studio) use. Mics are also mounted on stands and booms (cranes). A boom mic affords its user a certain degree of mobility, enough at least to move about the console area. Headset mics are popular with play-by-play sports reporters and news reporters who need to be free of the constraints imposed by mounted or hand-held mics.

Microphones will not tolerate excessive abuse or mishandling. Because of their intricate and often delicate internal design, they can become damaged quite easily. "Handle your mics with great care. Banging or tossing them around is asking for trouble. Broadcast studio mics aren't rock concert props. You twirl and slam a studio mic and you're out of business," observes WGAO's Rich Pezzuolo.

The distance between a mic and its user is important as well. Usually a hand's length (six to eight inches) from a microphone produces the best response. Being too close ("sucking up the mic") produces distortion, and being too far from a mic affects quality, due to the swell of extraneous noise.

Plosives (also called "p-popping") may also result from being too close to a microphone. When popping occurs at an adequate distance from a microphone, the user is advised to move slightly off-axis, that is, slightly to the left or right of the microphone.

However, talking too much off-mic—outside its pickup pattern—reduces quality. "Stay within a mic's drawing area, or you'll sound like you're speaking to your audience from the other side of a door or from inside a tunnel. If you're using a unidirectional or bidirectional mic, don't talk off to the side. Be familiar with a mic's capabilities, and use common sense. A mic, or any piece of audio equipment for that matter, is only as good as the person using it," points out KRLV's Stan Harris.

A word of caution: when testing a mic, do not tap or blow into it. This can damage a microphone's inner components. A microphone is most effectively tested through normal speech. In other words, just talk into the mic. Read a piece of copy. Saying, "testing, testing . . . one, two, three" does not produce a reliable level.

AKG acoustics

MICROPHONES

FIGURE 8.10
A variety of microphones for a variety of uses. (Courtesy AKG Acoustics.)

D-12E Microphone
Large-diaphragm cardioid dynamic microphone with high proximity effect. For miking bass drums and other low-pitched instruments, as well as for general vocal applications. Features shock suspended transducer and fixed wire-mesh windscreen. Integral XLR-type connector in microphone shaft. Includes: SA-40 stand adaptor and case.
Frequency Range: 30-15kHz
Sensitivity at 1kHz: -53dBV

D-112 Microphone
Large-diaphragm cardioid dynamic microphone handles extreme (168dB) Sound Pressure Levels. Excellent on all bass instruments. Rugged construction. Finished in non-reflective dark-gray. Includes SA-40 stand adaptor and case.
Frequency Range: 20-17kHz
Sensitivity at 1kHz: -55dBV

D-125E Microphone
Anti-feedback cardioid dynamic microphone perfect for sound reinforcement. Wire-mesh windscreen and diecast housing assure reliability. Includes: SA-40 stand adaptor and case.
Frequency Range: 100-18kHz
Sensitivity at 1kHz: 54dBV

D-130E Microphone
Rugged omnidirectional microphone for field broadcast use. Designed for newsfilm and ENG applications where durability is of utmost importance. Includes: SA-40 stand adaptor and case.
Frequency Range: 50-13kHz
Sensitivity at 1kHz: -55dBV

D-190E Microphone
Cardioid dynamic microphone with sintered bronze windscreen/pop filter. Cardioid pattern reduces feedback. Smooth frequency response makes it an excellent speech or music microphone for performing and recording use. Includes: SA-40 stand adaptor and case.
Frequency Range: 30-15kHz
Sensitivity at 1kHz: -53dBV

D-1200E Microphone
Rugged cardioid dynamic microphone. Unique B—M—S switch allows for on-mike equalization to adjust sound of mike for almost any application without sacrificing performance. Includes: SA-41 adaptor and case. (Replaces D-1000E).
Frequency Range: 25-17kHz
Sensitivity at 1kHz: -52.8dBV

D-310 Microphone
Rugged cardioid dynamic microphone for vocal music coverage in the home or studio. Shock mounted transducer, diecast housing and dual windscreen/pop filter for reliability. Includes: SA-41 stand adaptor and case.
Frequency Range: 80-18kHz
Sensitivity at 1kHz: -58dBV

D-321 Microphone
Ultra-rugged hypercardioid dynamic microphone for vocalists on the road. Patented magnet/diaphragm suspension system reduces handling noise. Diecast housing and dual windscreen/pop filter withstands repeated abuse. Captive locking screw to secure cable connector to the microphone. Includes: SA-41 stand adaptor and vinyl case.
Frequency Range: 40-20kHz
Sensitivity at 1kHz: -57dBV

D-330BT Microphone
Ultra-rugged feedback-rejecting hypercardioid design demanded by top vocalists. Unsurpassed reliability ensured by shock-mounted plug-in field-replaceable transducer, diecast housing and dual windscreen/pop filter. Two equalizer switches (3-pos. bass-rolloff, 3 pos. treble rise) for ultimate flexibility in tailoring response to specific voices and ambient acoustics. Includes: SA-41 stand adaptor and case.
Frequency Range: 50-20kHz
Sensitivity at 1kHz: -58dBV

All AKG microphones are low impedance balanced-output units fitted with a standard 3-pin XLR-type connector. Nominal output impedance is 200 ohms and is suitably matched by all low impedance (25-1000 ohms) inputs.

A couple of measures are generally taken to guarantee good microphone performance. To lessen the distortion created by the bursts of air from an announcer's mouth, windscreens (also called *pop-filters*) are placed over the microphone's head. Some mics feature built-in pop-filters (such as the AKG-222). Shock mounts are frequently added to deaden the vibrations that reach a microphone via its stand or crane. (This can happen when the surface on which a mic is mounted is bumped or tapped by an operator.)

Of course, no microphone will operate properly if sound levels are too high. Overloading a microphone nearly always results

96 STUDIOS AND EQUIPMENT

FIGURE 8.10
Continued

AKG acoustics MICROPHONES

D-70M Cardioid Microphone
Low cost musical instrument microphone. Ideal for home recording and sound reinforcement. Medium impedance (200-1000 ohms). Rugged construction with fixed 9.8' (3m) cable and 1/4" phone plug. Includes nickel plated plug-in table stand.
Frequency Range: 50-18kHz
Sensitivity at 1kHz: -58dBV

D-109 Lavalier Microphone
Lightweight lavalier dynamic microphone with matte-nickel finish. Includes 29 1/2' (9m) non-detachable cable with stripped and tinned leads at free end, nylon neck cord, tie clasp, cable spool, and case.
Frequency Range: 70-12kHz
Sensitivity at 1kHz: -59dBV

Q-15 Boom Set
Ultra-lightweight boom set, secures behind the head, with single side dynamic earphone and condenser microphone. Includes 6'4" (1.9m) non-detachable cable and H-45 cable clip. Weight 1.3 oz.

D-58E Dynamic Microphone
Differential noise-cancelling dynamic microphone for communications, paging and talk-back applications. Extremely small and lightweight.
Frequency Range: 70-12kHz
Sensitivity at 1kHz: -63dBV

D-900E Shotgun Microphone System
Shotgun dynamic microphone system. Includes W-19 windscreen, W-9A windscreen, SA-16/1 stand adaptor, SA-70/9 pistol-grip and boom suspension adaptor, H-7 pistol grip, H-70 boom suspension shock mount, MC-25 cable and CC-9 foam-lined carrying case.
Frequency Range: 60-12kHz
Sensitivity at 1kHz: -50dBV

D-510B Microphone
Omnidirectional dynamic microphone on flexible gooseneck shaft. 12 3/16" (310mm) long overall. Includes 3 3/4' (1.15m) cable and mounting hardware. Table stand not included.
Frequency Range: 125-20kHz
Sensitivity at 1kHz: -59dBV

D-541 Microphone
Cardioid dynamic microphone on flexible shaft. 13 3/4" (350mm) long overall. Includes 5' (1.6m) cable and mounting hardware. Black finish.
Frequency Range: 80-15kHz
Sensitivity at 1kHz: -55dBV

D-558B Microphone
Differential noise-cancelling dynamic microphone on flexible gooseneck shaft. 12 3/16" (310mm) long overall. Includes 3 3/4' (1.15m) cable and mounting hardware. Table stand not included.
Frequency Range: 70-15kHz
Sensitivity at 1kHz: -63dBV

D-590 Microphone
Cardioid dynamic microphone on flexible gooseneck shaft. 11 1/4' (285mm) long overall. Includes 3 3/4' (1.15m) cable and mounting hardware. Table stand not included.
Frequency Range: 160-15kHz
Sensitivity at 1kHz: -58dBV

B

in distortion. Moving-coil microphones perform best in overloading situations because their design makes them somewhat more impervious to such excesses. This is one reason why they are preferred by broadcasters. They are not invincible, however.

NPR's Skip Pizzi offers a couple of closing tips pertaining to microphone use. "Use an omni when recording close-up. It is less problematical than a cardioid, and less sensitive to plosives. Use a directional mic—for example, a cardioid shotgun—when you have to be at a distance. It will give you the

MICROPHONES, SPEAKERS, AND HEADPHONES 97

MICROPHONE ACCESSORIES/windscreens

FIGURE 8.11
Microphone windscreens. (Courtesy Shure.)

A1WS
Gray foam windscreen, controls wind noise and "pop" for the Shure 515 Series Microphones.

A2WS Series
High performance rugged wind screens with metal collar for snug fit. Effectively minimizes wind noise in outdoor locations and controls explosive breath sounds in any location. For 545, SM57 and SM77 Microphones.
A2WS Gray
A2WS-BK Black

A81WS
Unique heavy-duty windscreen, specially designed for the SM80 and SM81. Special dual-density construction overcomes even high wind noise without significantly affecting frequency response. Two distinctly different layers of material are used, each with complementary acoustical properties. Gray foam.

A58WS Series
"Color-Charged" Windscreens

Ends microphone mix-ups when soundmen color-code these eight windscreen rainbow colors with control knobs, connectors, and mic cables. Windscreens fit SM61 and SM62 Series Microphones and all Shure "ball-type" microphones for greater protection from wind noise and "pop."

A58WS Gray
A58WS-BK Black
A58WS-BL Blue
A58WS-BR Brown
A58WS-GN Green
A58WS-OR Orange
A58WS-RD Red
A58WS-WH White
A58WS-YL Yellow

A81G
Pop Filter Grille

Increases the versatility of the SM80 and SM81 by permitting their use in windy conditions with minimal pickup of rushing sounds produced by wind. By attenuating breath popping sounds it allows the SM80 and SM81 to be used in close-talking applications.
 The grille fastens securely to the microphone and can be used with the standard unidirectional cartridge or the R104A Omnidirectional Cartridge.

best results. For in-studio, a good shock-mounted, dynamic omni does the job."

SPEAKERS

While microphones transduce acoustic energy into electric current, speakers (also called monitors and loudspeakers) convert electricity into acoustic energy or sound. Studio speakers allow a production person to hear recorded material. Most production studios have two external speakers, which are generally flush-mounted on a wall in the middle or corners of a studio. The idea

FIGURE 8.12
Microphone in shock mounts. (Courtesy AKG Acoustics.)

FIGURE 8.13
Wall-mounted studio speakers. (Courtesy Fostex.)

is to place speakers where sound can be most effectively and naturally dispersed. Placing speakers directly next to one another (especially stereo speakers) or right in front of, or above, the production person's work area does not provide an adequate representation of sound.

As suggested above, a similarity exists between speakers and microphones. As transducers, both possess comparable internal parts but they apply these to a reverse effect: while mics change sound waves to electrical energy, speakers change electrical current into sound waves. Moving-coil speakers, along with moving-coil mics, are among the most widely found in radio studios, because they perform extremely well and are available at a variety of prices.

Stations select speakers that provide the best response—that is, a full and accurate representation of the frequency range. To accomplish this, speakers possess what are called *cones*. Most speakers contain three: a large cone to reproduce low frequencies *(woofer)*, a medium-size cone to reproduce midrange frequencies, and a small cone *(tweeter)* to convey high frequencies. A speaker with only one cone usually reproduces frequency in the middle range of the spectrum, and to many production people this is not adequate. Speakers with several cones are preferred because of their more comprehensive distribution of sound frequencies. WGAO's broadcast engineer Roger Turner contends: "I want the best response possible from studio speakers, and multiple tweets and woofs give me this. I want to hear everything, or as much as possible. Good speakers are an integral part of the production studio. You've got to be able to hear what you're mixing. Speakers that provide only limited response don't present the full picture. They force you to listen with your hands over your ears. Never cut corners when budgeting speakers. Low-grade speakers, if I may draw an analogy, are like watching a color video on a black and white monitor."

In order to prevent feedback when a microphone is keyed (activated), a mute is installed in the board that cuts the audio signal to studio speakers. The operator may monitor sound through a set of headphones. (Recall the discussion on muting systems in an earlier chapter.)

Also discussed earlier was the small internal speaker inside a console that allows a production director to cue mixdown elements. These speakers are small and single-coned, since high- and low-frequency response is not a concern. However, some stations do use full-size speakers for cueing purposes. Obviously, when this is the case, speakers are mounted externally, since their size would prohibit internal installation. Boards featuring an audition channel permit cueing over the regular studio speakers. "I don't like using the board's little cue speaker. It's tinny and scratchy. You don't really hear enough of what you're introducing into a mix. Having a legitimate speaker as cue gives me a much better handle on what I'm folding into a production piece," notes WGAO's Pezzuolo.

FIGURE 8.14
An array of professional headphones. (Courtesy Stanton.)

HEADPHONES

Because the studio speakers are muted when the mic switch is opened, headphones are necessary. If the main speakers were left on, feedback would likely result. The production person must hear surrounding production ingredients, such as beds and sound effects, when he or she is mixing with the microphone on. Generally, this occurs when a spot is being mixed live—that is, copy is being recorded simultaneously with production ingredients.

Headphones (also called earphones), as the term makes obvious, are worn over a

FIGURE 8.14
Continued

production person's ears and are available in a variety of sizes and styles. The trend in the 1990s is away from large and often cumbersome headphones to lightweight and streamlined ones.

Headphone selection can be a fairly personal matter, since some users prefer the feeling of being totally enveloped (by so-called monster-cans), whereas others do not like the sense of being removed or detached from their surroundings. Rather than relying on a station's headphone inventory, many announcers purchase their own.

Consoles accommodate headphones through an output or jack point. A volume control knob (gain) lets the operator raise

FIGURE 8.14
Continued

or lower the level fed into the headphones. Most tape recorders and CD players feature headphone outputs so that audio may be monitored directly from the source. Actually, headphones consist of miniature speakers.

As with any piece of equipment, headphones should be handled with care. Removing a headphone plug from an output by pulling on its wire will eventually damage both the headphones and the output jack. They should not be stored near intense heat, nor should objects be stacked on them. Most stations install hooks upon which headphones can be stored and thus better preserved.

FIGURE 8.15
Tape recorder headphone jack.

Headphones offer operators an opportunity for a more focused or concentrated listening experience and should be used as much as possible during recording sessions. "Monitoring on headphones is recommended for all audio recording," observes Pizzi: "Lightweight, open-ear—'supraural'—headphones are convenient to use for many recording situations, especially the typical interview case, where the sound source is a single voice in a relatively quiet room. A choice providing greater versatility, however, is a comfortable set of high-sensitivity closed-ear—'circumaural'—headphones. These allow critical monitoring and are much more appropriate in loud ambient noise conditions. Some of the open-ear headphones come with adapters to suit various headphone jacks of portable tape recorders. All closed-ear headphones are supplied with a ¼-inch stereo phone plug. Adapters may be purchased separately, if required."

CHAPTER HIGHLIGHTS

1. A microphone is a transducing device that changes spoken sounds (acoustic energy) into electrical energy. Descriptive of their internal design and method of converting sound into electricity, the three types of microphones are moving coil, ribbon, and condenser.

2. The moving coil (dynamic) mic has a diaphragm (flexible membrane) connected to a conducting coil. When sounds enter the mic, the vibrations cause the coil to move through a magnetic field creating an electrical signal.

3. The ribbon microphone uses a thin foil element (corrugated metal ribbon) connected between two poles of a magnet. Incoming sound vibrates the foil, generating an electrical signal.

4. The condenser (capacitor) mic relies on vibrations of the diaphragm to cause a capacity change in a stored electrical charge, yielding a signal or current.

5. High impedance (electrical flow resistance) in a microphone makes it likely to be affected by extraneous noise (for example, hum and static). Therefore, low impedance, moving coil mics are among the most widely used in broadcasting.

6. An omnidirectional mic picks up sound from all directions—above, around, and below. Bidirectional mics pick up sound from two directions—front and rear. Unidirectional mics pick up sound from only one direction—front. A cardioid mic is a unidirectional unit with a very narrow, heart-shaped pick-up pattern.

7. When using two or more mics, the space between mics should be three times the distance of the mics from the people talking.

8. Microphones may be hand-held, mounted (on a stand or boom), headset, lapel, or shotgun. Hand-held mics facilitate mobile interviews, mounted work best in a studio, headsets are popular for play-by-play, while lapel and shotgun mics are widely used in television.

9. The proper distance between a mic and its user is six to eight inches. Reading a piece of copy is the most accurate way to test a mic and set levels; blowing, tapping, and speaking single words (e.g., "testing") are unnatural sound sources.

10. A windscreen is a permeable cover placed over the mic head to lessen the distortion created by bursts of air from the announcer's mouth. Some mics feature build-in pop-filters to lessen distortion, while shock mounts are installed to deaden vibrations transmitted through the stand or boom.

11. Speakers (monitors, loudspeakers) convert electrical energy into acoustical energy. Most broadcast-quality speakers contain three cones: a large cone (woofer) to reproduce low frequencies, a medium-size cone for midrange frequencies, and a small cone (tweeter) for high frequencies.

12. Because the studio speakers are muted to avoid feedback when the mic switch is opened, the production person must use headphones attached to the console through a jack point. Volume is controlled by a console knob (gain).

13. Lightweight, open-ear (supraural) headphones are convenient when the sound source is a single voice in a relatively quiet room. A set of high-sensitivity, closed-ear (circumaural) headphones allows critical monitoring, particularly under ambient noise conditions.

SPOT ASSIGNMENTS

1. Determine the directional pattern of the microphone available to you.

2. Position yourself for normal mic use. Where is the mic in relation to you?

3. Record a piece of copy off-mic (off-axis) and consider the results on playback.

4. Record the following sentence at normal range (hand's length) from the mic: "Peter and Paul poured perfume on Penelope." Is popping evident on playback? If so, re-record until plosives do not cause distortion.

5. Ascertain the number of cones your studio loudspeakers possess.

6. Input a turntable to the speakers, and note the muting that occurs when the mic switch is opened.

7. Listen to the audio through headphones while mic switch is opened.

8. Close the mic switch, and place the turntable pot into the cue position. Raise and lower the level of the cue gain.

9 Audio Processing, Computers, and the New Tools

Audio devices that a few years ago were considered little more than bells and whistles or futuristic toys have become an integral part of the modern radio production studio. Digital audio processors ("boxes"), multitrack boards and recorders, synthesizers, and computers are here to stay. Individuals currently working in production, as well as those hoping to, must accept this fact and become acclimated to the new and evolving technologies that will play a central role in radio mixdown.

DIGITALIZATION

The radio production studio is undergoing a true metamorphosis as analog recording and playback technology is supplanted by digital. The reason for this transformation is simple—the demand for better and more evolved sound is at an all-time high. It is not enough for a station to confine its digital sound to its music playlist. Today, in order to maintain a competitive edge, a station must air commercials and other in-house production pieces that possess similar levels of sophistication and quality.

In earlier sections of this book, digital audio—namely, DAT and CD—has been discussed. These innovations of the 1980s have been embraced by radio stations in the 1990s. In the case of DAT, not all production directors have jumped on the bandwagon; many prefer to wait and see what happens with the development of recordable CDs, among other things.

Across the board, digital is perceived as the way of the future in radio production. "Without argument, the future of production is digital. Finally, the means are available for nearly flawless reproduction. No degeneration. No more pops, ticks, clicks, scratches, or flutter. No more tape hiss either. Digital is a profound breakthrough," states WKKD's Chris Todd.

WBCN's Tom Sandman concurs. "Digital is here to stay. CDs, DAT, and digital processing gear will make production time quicker, cleaner, and more efficient. It'll be years before analog tape and records are completely eliminated from the production room, but digital product is already being utilized in conjunction with older formats to speed production time, and someday everything will be digital."

The all-digital production studio is a future certainty, observes KFRU's David Morris. "It may be here before many predict it will, but it is inevitable that analog will be the terrain of historians, and digital will be the domain of the radio production person. Yes, it will be all-digital down the line—already it's close to being so in many places."

KSTP's Michael Dorwart predicts a total conversion to digital by the end of the decade. "In less than ten years the radio production room will be completely digitalized. We'll be working with CDs, DAT, and other high-end digital hardware, and analog equipment will be simply outmoded."

CD technology has had the most impact on the radio production studio to date. A survey conducted in 1989 revealed that the majority of FM stations rely on compact discs, and that many AM outlets find the new medium appealing. "Compact discs are the format of choice for production music and sound effects, and recordable CDs will be dominant, in my opinion," says WWCK's Chuck Hill.

Since the introduction of CD technology, its inability to serve as a recording medium has been perceived as a shortcoming. However, recordable CDs are being developed

FIGURE 9.1
Digital studio with sampler and "boxes." (Courtesy Radio Systems.)

and are about to enter the production studio. Many production directors agree with Hill that this added feature will make CDs the preeminent recording medium in radio. "Recordable CDs will be a real boon to radio production. A while back, Tandy Corporation announced plans for a recordable CD that is compatible with existing playback equipment. You can imagine that this will have a huge impact on broadcasters. CDs as a medium for storing commercials? Why not? No doubt, recordable CDs will replace magnetic tape as a storage medium," says Dallas, Texas, WRR's Steve Cumming.

CD library companies report exceptional business as stations invest in digital bed music and sound effects. In 1990, thirty percent of the nation's stations had spent money on digital production ingredients. KKFM's Ed Kellerman claims that CD libraries add a whole new dimension to mixdown. "Our library is First Comm's digitally recorded CD music and effects package. Its beauty comes from its versatility. Each cut has several different sixty- and thirty-second versions, plus bumpers, stingers, and tags. Not only is it less MOR [Middle of the Road] sounding, but I must have four thousand music beds and five thousand sound effects covering every different situation from ambient noises to specific sounds. CDs have definitely deepened the production repertoire."

KNIX's Al Tessitore is a major proponent of compact discs in the production room. "Not only do you get significantly enhanced audio representation, but the wealth of mixing material available is amazing. We go deep in CD in our mixdowns. For example, we own three CD bed libraries, as well as a CD sound effects library. Our spots certainly don't sound like they used to."

DAT technology has many supporters as well, and many believe this new technology will become a key element in radio production mixdown. "Digital audio tape is definitely going to play a role in production; the extent of its role is hard to predict right now, but I believe DAT will ultimately be a primary recording medium. DAT cart machines will probably become standard stuff. I also expect DAT to replace standard cassettes in production. I'm excited by both DAT and CD. They really are turning things around," contends KSTP's Dorwart.

The cost of DAT equipment remains an inhibiting factor for many stations, as do some perceived deficits in the technology.

"DAT as a storage medium is too unstable, since it is sensitive to heat and humidity. Also, accessing a particular cut, cueing it, and playing it back the second you want it is just too much of a hassle with DAT. Another thing: it doesn't stand up to repeated passes over a certain point very well either. Drop a DAT cassette and you have trouble," notes WRR's Steve Cumming.

MULTITRACKING

Multitracking equipment has been used for many years by the music recording industry, but only in the last decade or so has it made genuine inroads into the radio production studio. A growing awareness and appreciation of how multitracking can enhance mixdown has inspired many stations to invest in this audio technology. "We are in the process of remodeling our main production studio—we have three studios—to accommodate multitrack equipment. When completed, we'll have eight-track capability. This should open doors as to what can be done with SFXs, multivoicers, and multiple music bed spots," WSBT's Charles Whitaker says.

Philadelphia's WFIL is also preparing a multitrack studio. "I'll soon have a dedicated four-track studio. It will give us the kind of depth we don't have at the moment. I'm really looking forward to working with this medium," comments production manager John Beaty.

At WCLV the goal is to convert from two-channel boards to multichannel. "Because of the range and efficiency of recording studio type mixers, we're intent on making the changeover," says Robert Conrad.

Multitrack reel-to-reel machines offering anywhere from four to sixteen tracks are being purchased at an all-time high, report manufacturers, and this trend is certain to continue as stations realize what they add to a production room, observes KZST's Roland Jacoretti. "Right now we have an eight-track Otari reel-to-reel. Believe me, it has been a real plus to complex mixdowns—an invaluable tool."

KKFM's Kellerman expresses a similar sentiment. "We have an Otari eight-track half-inch tape recorder, and it's as durable as it is valuable. The eight-track lets you do creative material so much faster and better. The days of the multimachine mixdown are numbered."

The eight-track tape machine is destined to be a standard piece of broadcast production equipment, believes WHTX's Lawrence Alan Gerson. "Our MCI eight-track is used for everything from simple voice-overbed to complex multitrack production using numerous music and effects tracks. Eight-track is the workhorse of the production studio here, and I'm sure it will be viewed as such on a universal level, eventually."

Four- and eight-track reel-to-reel machines are the most common multitrackers in radio production studios, with the former slightly outnumbering the latter as of 1990. However, sales of eight-track recorders are now outnumbering four-track.

The four-track tape deck has been around longer in the radio production studio, and Greg Williams, production director of Montgomery, Alabama's WHHY, says it can add a whole new dimension to spot and feature mixing. "The four-tracker is a wonderful addition to the production room. My favorite piece of equipment is our Otari MX5050. It has eliminated the splicing block in editing and opened the door to split-track production. Overlaying voice and effects on a four-track create the best 'theater of the mind' production."

Multitrack recording requires that special attention be paid to levels, and this is compounded by the number of different tracks a production director is working with, notes WBZZ's Brian Oberle. "Our studio has a sixteen-track machine, and the most important part of its operation is maintaining proper levels. When working with a multitrack machine you can lose levels of important segments when you don't pay close attention to what's going in and out of the recorder. Multitrack mixing imposes its own demands, but what it gives back is worth it."

In the near future the radio audience's expectations will have risen to such a level that multitrack equipment will be regarded by most radio stations as a necessity, contends KXLY's Clear. "Sound quality and variety will need to be extraordinary in the not too far off future. Multitrack apparatus will be necessary, even in small markets."

COMPRESSION

There are three domains of audio: *amplitude, frequency,* and *time*. Some stations alter amplitude to create the illusion of being louder without actually changing their level. This is called *compressing the signal*. Compressors are used by production people to enhance loudness, as well as eliminate or cut out ambient noise, thus focusing on specifics of the mix. "Squeezing sound reduces dynamic range, and in so doing causes it to 'sit up' higher on the V.U.," notes NPR's Skip Pizzi.

Compression is used as a method to get listeners to take greater notice of a piece of production as well as a remedy to certain problems. Claims WCAU's Eric Gerstein: "Maybe the most important piece of equipment in our production studio, and it's not even manufactured anymore, is our Sure SE-30 gated compressor. This is the cureall, the answer to ninety-nine percent of our ills. With proper application, voices sound warmer, production is tighter, and the most basic thing of all, levels are near perfect. In a situation like mine, leveling can be nearly impossible. We're a news/talk operation. Consequently, we deal with people who are the farthest thing from broadcast professionals but who are recording things—from spots to editorial replies. The SE-30 is my baby! You can still obtain one from various supply houses around the country. By the way, the reason that the SE-30 is no longer made by Sure is that they 'improved' on it. Kind of like new Coke. In my opinion, the newer model can't be compared to the original. Compression in general makes for excellent work, but the proper use of it is the real secret. It's hard to give specific figures or ratios to work with. That's the art."

Stations often decide just to compress voices, running the compressor through the microphone circuit only. "That's one approach. We have an Orban compressor that really gives the voice punch. It's a nice positive plus in mixdown," explains WMAY's Robert Baxter.

KKFM compresses voice to keep it from sounding flat against other mixdown elements (such as CDs), which possess exceptional qualities. "We just installed two

FIGURE 9.2
Compression settings connected to microphone circuit.

FIGURE 9.3
Compressor/limiter. (Courtesy UREI.)

FIGURE 9.4
This compressor, called the Compellor, features computer-controlled dynamics for smooth, undetectable compression, increased density, and "intelligent" automatic gain riding, free of pumping and breathing. (Courtesy Aphex.)

microphone processors, which involve limiting and compression," claims Ed Kellerman. "With the former, we have limited the fluctuations in volume as well as popping *p*'s and sizzling *s*'s. While a touch of compression is good to enliven a voice, you have to be careful because too much makes a voice sound unusually narrow. A production person must read up on these devices before incorporating them into his work."

For specific details on compression and other types of audio processing, turn to the Industry Notes section of this chapter for an insightful and revealing essay by radio producer Ty Ford.

EQUALIZATION

Equalizers (EQs) work the frequency domain of audio by boosting and/or cutting lows (Hertz range) and highs (kiloHertz range).

Equalizers allow producers to correct problems. "An equalizer helps when you receive dubs from other radio stations or production houses that may not have the same EQ level as your station. You may also shelve or roll-off noise—sibilance, for example—which reduces sound quality," explains WBGN's Chris Allen.

WMAY's Robert Baxter agrees with Allen, adding, "Equalizers help you tailor the audio to meet the demands of a situation. It is hard to imagine a production studio without some EQ."

Equalizers help create parity between different elements of production, states WINK's Rick Peterson. "Our production studio EQ is primarily used to attain the same tonal quality among mix ingredients. For example, by adding or subtracting from the low-, mid-, or high-range of a signal, we can make our production sound uniform."

Equalizers perform another service in production, says WBGN's Allen. "EQs are very useful in creating special effects. Simply by varying the graph or bands we can get some interesting results. So this gives us one more sound enhancement tool. But a word to the wise: equalizers should be used with discretion and under the supervision of the production chief or engineer—someone who really knows something about them. Inexperience can produce some substandard effects."

EQs are available in-board (part of the audio console), out-of-board (separate unit), and as part of certain audio effects processors. "We use both an in-board three-band

FIGURE 9.5
Multiband peak limiter called the Studio Dominator. (Courtesy Aphex.)

FIGURE 9.6 Parametric EQ. (Courtesy N.I.H. Labs.)

EQ and separate graphic and parametric equalizers," offers WSM's Tom Bryant.

Meanwhile, WAYU EQs through an effects box, notes James Spillman. "Beyond the standard outfitting in our studio, we find our Aphex Studio Dominator to be of special use. For a very reasonable price it provides a combination of minor equalization and limiting. This gives a fuller, richer quality to our production, while maintaining accurate final levels, regardless of minor user-errors."

While most equalizers contain numeric scales to assist an operator when setting the graph slides or band pots, equalization is ultimately accomplished psycho-acoustically—with the ear.

AUDIO PROCESSORS

Most audio processors (also called effects processors or simply boxes) are time domain devices. Stations use these digital boxes to create a wide range of effects, such as reverb, echo, flange, and so on.

During the past decade, radio stations have become increasingly interested in what audio processors have to offer their mixes. Today, these boxes are a familiar item in production rooms at a significant number of stations, particularly FM stations, and it seems a certainty that the 1990s will see effects processors become a standard tool in the making of commercials, psa's, promos, and features.

"Radio mixing has become so sophisticated, and it's really just the beginning. You want that extra edge. WXRT recently bought a lot of high-tech production hardware. We have on hand a Yamaha digital reverb/delay unit, an Eventide Harmonizer, and a few other boxes. We'll no doubt purchase more, too," says Bill Cochran.

WSM, the nation's foremost Country music station, is upgrading their production

FIGURE 9.7 Multiverb effects processor. (Courtesy ART.)

facilities into the realm of digital processing as well. "For the new studios we're building we have made an initial investment in some digital-delay gear, and in the future we will most likely add an Eventide or Lexicon time compression/limiter-type unit and a synthesizer," says Bryant.

Stations that have been mixing with effects processors over a long period of time now find them indispensable. According to WIMZ's David Ball: "Our digital effects processor (Roland DEP-5) is an integral part of almost everything we produce. It's rather complex to program special effects into, but, on the whole, a nontech person can operate it pretty effectively once he or she gets the hang of it. We use the DEP to enhance voice and music on station promos, which are very essential to the image and positioning of the station in the market. Our promos must sound very good; they must be the best things on the station. We also process our station IDs, sweepers, drops, and other call letter or positioning statements that are carted. Of course, we use the processor to generate special effects in commercials, too."

WINK's Rick Peterson expresses similar enthusiasm for his audio processors: "We have a few toys, as they are called, but in reality they are anything but toys. They can make a spot come to life. First and foremost, I rely on our Eventide Harmonizer. This piece of equipment serves two main purposes. It can change the pitch of a voice, either up or down, and it can delay any signal for up to a couple of seconds. This enables us to come up with some unusual effects—strange vocals. It also enhances stereo effects. We also have a reverb unit. Again this is primarily used for voice effects. By adding reverb, we can create the illusion of someone being in a cave, elevator shaft, or huge concert hall."

K-PALM's Ford Michaels believes that the growing reliance at many stations on satellite-delivered programming will motivate many to invest in higher-end audio equipment. "The quality and sophistication of feeds is such that subscriber outlets will have to upgrade in order to match this audio. Special effects, such as the Yamaha SPX90, and parametric equalization will be de rigueur in all but the least successful operations."

It is not uncommon to find radio production studios elaborately outfitted with audio processing gear, and this is not only true for big market stations. "We're tooling our production studio with the latest technology. For example, with an Ursa Major Space Station (variable digital delay) we can reproduce any combination room acoustics and reverb/echo effects. With our Orban De-esser we can correct material from bad agencies and production houses. For instance, we can deal with the problem that occurs when dubbing tapes with bad phase. While our De-esser doesn't solve the problem completely, it makes the audio usable," explains Gary Newlon, production director for K105-FM in Lafayette, Indiana.

One of the nation's foremost AOR (Album Oriented Rock format) stations, WBCN in Boston, has been adding processed audio to promos and commercials for many years. "It's been a part of our mixes for a long time. We've been rebuilding our facilities to make mixing a more state-of-the-art and practical experience," says production director Tom Sandman, whose AKG 68K digital effects processor has been a mainstay because of its impressive versatility and ease of handling.

FIGURE 9.8
Content index of the ART Multiverb effects processor. (Courtesy ART.)

```
01 REVERB #1 HALL          37 FLANGE & REV A          69 WAREHOUSE SNARE
02 REVERB #2 ROOM          38 FLANGE & REV B          70 SNARE IN SHOWER
03 REVERB #3 VOCAL         39 GATED FLANGE +          71 STRATO KILLER
04 REVERB #4 PLATE            REV                     72 STER METAL GUITR
05 EARLY REFLECT #1        40 DELAY + REVERB          73 12 STRING GUITAR
06 EARLY REFLECT #2        41 TAP DELAY + REV         74 GUITAR DREAM
07 STEREO DELAY            42 CHORUS + REV A          75 SILKY STRAT
08 STEREO ECHO             43 CHORUS + REV B          76 THRASH FLANGE
09 VOCAL DOUBLER           44 CHORUS + GATE           77 BLUES MAN GUITAR
10 VOCAL IMAGER               REV                     78 ICE GUITAR
11 REV + VOC DELAY         45 STER DLY + CHOR A       79 60'S ROCK
12 REV + VOCAL ECHO        46 STER DLY + CHOR B       80 ER REF + CHORUS
13 RVRS REV + DELAY        47 STER DLY + FLAN A       81 ER REF + FLANGE
14 GATED REVERB #1         48 STER DLY + FLAN B       82 ER REF + DELAY
15 GATED REVERB #2         49 CHORUS + DLY +          83 PREDELAYED REV
16 GATE REV + REVERB          REV                     84 PREDELAYED GATE
17 REVERSE REVERB          50 FLANGE + DLY +          85 ECHOVERB
18 PITCH TRANSPOSER           REV                     86 PANNING DELAY
19 PTR SHIFT 5th UP        51 DEATH FLANGE            87 IMAGED CHORUS
20 MICRO PTR SHIFT         52 BARBER POLE FLAN        88 IMAGED FLANGE
21 OCTAVE SHIFT            53 SPACE SHIFT             89 PANNING CHOIR
22 PITCH SHIFT DBLE        54 ARPEGGIATED FLAN        90 DRY SWEEP SLOW
23 STEREO CHORUS A         55 ROTATING LESLIE         91 DRY SWEEP FAST
24 STEREO CHORUS B         56 CONCERT LESLIE          92 REV + DELAY +
25 STEREO FLANGE A         57 ECHOING CHORUS             PAN
26 STEREO FLANGE B         58 VARIPITCH CHORUS        93 IMAGED REVERB A
27 TAPE ECHO               59 CHORUS VIBRATO          94 IMAGED REVERB B
28 STEREO ECHOREC          60 CATHEDRAL REVERB        95 PING PONG DELAY
29 VIBRATO                 61 CONCERT REVERB          96 MULTI-TAP PAN
30 DELAYED VIBRATO         62 STUDIO PLATE REV        97 REV + M—TAP
31 TREMOLO                 63 CHOIR LOFT REV             P—PONG
32 SYMPHONIC               64 CHURCH HALL REV         98 REVERSE REV +
33 CHOIR                   65 AMBIENT PERCUSS.           PAN
34 TWIN VOICES             66 CONCERT GATE REV        99 GATE REV P—PONG
35 SOFT SLAP ECHO          67 STUDIO PLATE GAT       100 MUTE
36 STEREO PHASE            68 THUNDER SNARE
```

ROM CONTENTS AND CONTROLLABLE PARAMETERS

NOTE: PARAMETER / PRESET VALUE / RANGE

PROGRAM NAME	TYPE	1	2	3	4	5	6	7	8	9	BALANCE	OUT LVL
REV 1 HALL	REV	REV TIME / 2.6s / 0.3–99.0s	HIGH / 0.6 / 0.1–1.0	DELAY / 30.0ms / 0.1–50.0ms	HPF / THRU / THRU, 32Hz–1.0kHz	LPF / 8.0kHz / 1.0kHz–11kHz, THRU	–	–	–	–	100%	100% / 0–100%
REV 2 ROOM	REV	REV TIME / 1.5s / 0.3–99.0s	HIGH / 0.7 / 0.1–1.0	DELAY / 20.0ms / 0.1–50.0ms	HPF / THRU / THRU, 32Hz–1.0kHz	LPF / 8.0kHz / 1.0kHz–11kHz, THRU	–	–	–	–	100%	100% / 0–100%
REV 3 VOCAL	REV	REV TIME / 2.4s / 0.3–99.0s	HIGH / 0.5 / 0.1–1.0	DELAY / 45.0ms / 0.1–50.0ms	HPF / 80Hz / THRU, 32Hz–1.0kHz	LPF / 8.0kHz / 1.0kHz–11kHz, THRU	–	–	–	–	100%	100% / 0–100%
REV 4 PLATE	REV	REV TIME / 1.8s / 0.3–99.0s	HIGH / 0.7 / 0.1–1.0	DELAY / 10.0ms / 0.1–50.0ms	HPF / 40Hz / THRU, 32Hz–1.0kHz	LPF / 10.0kHz / 1.0kHz–11kHz, THRU	–	–	–	–	100%	100% / 0–100%
EARLY REF. 1	E/R 1	TYPE / HALL / HALL, RANDOM, REVERSE, PLATE	ROOM SIZE / 2.0 / 0.1–20.0	LIVENESS / 5 / 0–10	DLY / 10.0ms	THRU / LPF	–	–	–	–	100%	100% / 0–100%
EARLY REF. 2	E/R 2	TYPE / HALL, RANDOM, REVERSE, PLATE	ROOM SIZE / 2.0 / 0.1–20.0	LIVENESS / 5 / 0–10	DLY / 10.0ms / 0.1–400.0ms	THRU / 1.0kHz–11kHz, THRU	–	–	–	–	100%	100% / 0–100%
DELAY L, R	DELAY	100ms / 0.1–500.0ms	Lch F B / 0% / –99–+99%	Rch DLY / 200.0ms / 0.1–500.0ms	Rch F B / 0% / –99–+99%	HIGH / 1.0 / 0.1–1.0	–	–	–	–	100%	100% / 0–100%
STEREO ECHO	ECHO	Lch DLY / 170.0ms / 0.1–250.0ms	Lch F B / 60% / –99–+99%	Rch DLY / 178.0ms / 0.1–250.0ms	Rch F B / 58% / –99–+99%	HIGH / 0.9 / 0.1–1.0	–	–	–	–	100%	100% / 0–100%
STEREO FLANGE A	MOD.	MOD FRQ / 2.5Hz / 0.1–20.0Hz	MOD DEPTH / 50% / 0–100%	MOD DLY / 1.2ms / 0.1–100.0ms	F B GAIN / 35% / 0–99%	–	–	–	–	–	50%	100% / 0–100%
STEREO FLANGE B	MOD.	MOD FRQ / 0.5Hz / 0.1–20.0Hz	MOD DEPTH / 90% / 0–100%	MOD DLY / 1.0ms / 0.1–100.0ms	F B GAIN / 40% / 0–99%	–	–	–	–	–	75%	100% / 0–100%
CHORUS A	MOD.	MOD FRQ / 0.2Hz / 0.1–20.0Hz	DM DEPTH / 50% / 0–100%	AM DEPTH / 40% / 0–100%	–	–	–	–	–	–	100%	100% / 0–100%
CHORUS B	MOD.	MOD FRQ / 0.6Hz / 0.1–20.0Hz	MOD DEPTH / 50% / 0–100%	MOD DLY / 10% / 0–100%	–	–	–	–	–	–	100%	100% / 0–100%
STEREO PHASING	MOD.	MOD FRQ / 1.1Hz / 0.1–20.0Hz	MOD DEPTH / 100% / 0–100%	MOD DLY / 3.0ms / 0.1–8.0ms	–	–	–	–	–	–	100%	100% / 0–100%
TREMOLO	MOD.	MOD FRQ / 6.0Hz / 0.1–20.0Hz	MOD DEPTH / 50% / 0–100%	–	–	–	–	–	–	–	100%	100% / 0–100%
SYMPHONIC	MOD.	MOD FRQ / 0.7Hz / 0.1–20.0Hz	MOD DEPTH / 50% / 0–100%	–	–	–	–	–	–	–	100%	100% / 0–100%

FIGURE 9.9
Spec sheet for Yamaha processor. (Courtesy Yamaha.)

Each station has its favorite special effects processor, contends WTIC's Peter Drew: "Here we are very high on our Yamaha REV-5. It produces dozens of different sounds. It offers reverb, echos, flanging, and pitch change. Almost any aspect of each effect is variable—e.g., delays, 'reverb room'-size echo duration, left to right stereo panning. It's an excellent tool for fattening a voice-over or singer. It can be used to double a weak singer or voice or hide deficiencies and provide a fuller sound. This box has become very popular because it offers a wide range of effects at a very reasonable price. Each station has its preference, but I really like this Yamaha."

Aphex's Aural Exciter has become very prevalent throughout the industry. Aural Exciters process in both the frequency and time domains, providing users with brighter and more vivid sound. KZOU's Lee Kent is an advocate of the Aural Exciter. "The Type C Aphex Aural Exciter helps us restore some of the high-end loss without adding sibilance. It's a good device to have available in the production room. Of course, it does all this without affecting the electrical output—the level."

Another popular audio processor is the Lexicon, which is available in a variety of models. "We have a Lexicon PMC 70 digital effects generator which provides us with flanging, reverb, chorusing, delay capabilities, and so on. It's a popular model. We have another Lexicon, the 2400 Stereo Audio Time Expander. It permits us to change the running time of any material without noticeably changing the pitch," comments WFIL's John Beaty.

KKFM's Ed Kellerman uses audio processing only nominally and cautions against overuse: "We have a very simple KORG dual effects processor with sixteen presets. Adding a touch of echo fills out some people's voices. A full echo is handy for 'hot monster truck smasher' spots, and occasionally you'll need reverb or stereo flanging. Notice I said *occasionally*. The beauty of an effects processor is that it gives you sustained echo, reverb, or phase shifting when you need it. It should never be used just because you have it. There are just too many stations, especially chart rockers, that continuously junk up spots with 'puking deejay voices' and weird effects, like space chipmunks."

NPR's Skip Pizzi would agree with Kellerman. "Audio processing is designed to serve the purpose of a well-conceived idea. It should never be used merely for its own sake. It is a means to an end—not an end in itself."

SAMPLERS AND SYNTHESIZERS

In the 1960s, the Moog synthesizer launched the recording industry on the path to a new age. Today, synthesizers and samplers have opened the door to countless possibilities in the radio production studio.

The use of digital samplers in radio production has grown slowly but steadily. In the 1990s their use will be far more widespread. Samplers allow a production person to load a studio audio source (recorder, live mic . . .) into its built-in microprocessor and then manipulate the digitized data with the aid of a musical keyboard to create a multitude of effects. Samplers employ magnetic micro-floppies and are wired to an audio console so that the sounds they produce may be integrated into mixdown.

A sample is a digital recording of small bits of sound. A micro-floppy holds about sixteen seconds of data. While it is not nec-

FIGURE 9.10
Aphex Aural Exciter.
(Courtesy Aphex)

FIGURE 9.11
Lexicon multieffects processor with MIDI function. (Courtesy Lexicon.)

essary to be trained in the art of musical keyboard, it is beneficial to possess some knowledge in this area. Yet even with only a pedestrian knowledge of the music scale, a production person may learn to do things with a sampler that will significantly enhance mixdown.

WMAY's Baxter says that, for most stations, sampling keyboards are in the cards: "While we're beefing-up our studios, we expect that we'll be investing in samplers very soon. These add a whole new aspect to effects generating."

Broadcast outlets already on-line with samplers and synthesizers find them extremely useful. "More and more stations like ours are finding umpteen uses for digital sampling technology. There are so many advantages to working with samplers that they are hard to enumerate," says WUSA's Kurt Stoecker.

WBZZ's Brian Oberle confirms Stoecker's opinion. "These digital samplers are highly useful to us. They help you create your own sound bites with the use of a keyboard. Voice cuts and sound effects can both be sampled through the unit. It's fun and it's useful."

K-PALM's Michaels predicts a wider application of samplers in production rooms throughout the country: "Samplers and synths are going to make radio production a happening industry. With these things, stations will be manufacturing their own jingles and bed music for spots, promos, you name it. Local musicians will be brought in to work hand-in-hand with the production staff. In a sense it will be reminiscent of the 1940s, because producers, musicians, and technicians will be collaborating to build station audio. Of course, actors will be brought in, too. I refuse to believe voice synthesizers will ever sell Smuckers as effectively as Mason Adams does."

Many stations have found they can equip their production studio with some fairly basic synthesizers and give birth to myriad effects without spending a fortune. "We have a rather simple Casio synth which lets us create music we don't have, originate sound effects we're lacking, and enhance those we do have by doing a little shaping," comments engineer Phil Kappo.

The price of many professional-level synthesizers and samplers remains a deterrent for smaller stations, but engineer Michael Rome of Monitor Broadcasting says that even small-budget stations can get in on some of the advantages of the technology without spending much money. "For just a few dollars you can buy a Casio or Yamaha

114 STUDIOS AND EQUIPMENT

FIGURE 9.12
Voice synthesizer.
(Courtesy DEC.)

without a disc drive but with a built-in microphone that will hold one sample. With a little ingenuity, you can do a lot with these simple off-the-shelf keyboards."

MIDIS AND COMPUTERS

MIDI is an acronym for *musical instrument digital interface*. It is a control system that stores information—a language that talks to synthesizers. "MIDI is the protocol that lets the keyboard talk to the studio synthesizers," says NPR's Skip Pizzi. Many stations use a computer combined with a sequencer, which permits a production person to "record" a MIDI-controlled set of instructions onto a disc from various synthesizers for later mixdown.

MIDI is in use at only a small number of radio stations, but its application as a production medium has caught the attention of many broadcasters. "We have a MIDI-controlled synth and drum machine. MIDI boxes and computers with MIDI represent an exceptional addition to the mixing room," observes Oberle.

Computer-based production technology is still in the future for many stations, says WDBQ's Paul Hemma, adding, "The future is going to take the radio station production studio into the computer universe, no doubt, and this will bring about a sweeping change."

WBCN's Sandman predicts that computers with MIDI will transform the production room: "Someday, and not too far off, computers—PCs—with special MIDI programs will be the central mix point, and cart machines and other conventional equipment will be gone."

Other production directors share Sandman's vision. "While computers haven't made a big splash in radio production yet, I can see where using one to create mixes based upon parameters supplied by the production person will revolutionize current procedures," says Peter Drew of WTIC.

KYCK's Michael Cook believes computer-aided production will be the norm rather than the exception at stations, both large and small. "I see mixing with a VDT a very real likelihood for radio in the next few years, and eventually all production studios will be driven by the computer chip. Many high-tech changes are in store for this field."

All of this may ultimately lead to the transformation of the radio station production studio into what are termed *workstations*.

WORKSTATIONS

Digital audio workstations (DAW) are an attempt to integrate the entire production studio into a computer. Hard disc audio storage systems (HDAS), with mixing and editing capabilities, are changing the landscape of the radio mixdown environment. The age of the equipment-packed audio studio is about to give way to the new age economy of the workstation suite—the visual equivalent of a conversion from rococo to minimalist. "The direction is toward further and further integration. The production studio of the future will include computer control and digitized audio," says Skip Pizzi.

Workstations look like PCs with a few boxes, and they are beyond the budget of all but a very few well-heeled stations. This has not kept broadcasters from flocking to exhibitors' booths at NAB (National Association of Broadcasters) and other industry conventions to inspect the new technology. In fact, among the more popular products shown at these gatherings are the integrated workstations, such as AKG's DSE 7000

FIGURE 9.13
Workstation display terminal. (Courtesy New England Digital.)

FIGURE 9.14
Digital workstation. (Courtesy New England Digital.)

(RAM-based) sound editor, which features multi/track, editor, and mixer capabilities. The DSE 7000 is designed for spot and other short production work.

As audio technology becomes more integrated and computer-based, the fear that the human element will be lost is a concern to some broadcasters. "My personal feeling is the studio may become too technological. You may need sixteen different degrees just to walk into a studio. All the simplicity may be lost. Everything is so money- and time-related—how much can we save, and how fast can we get it done? Granted, you need to get things done quickly, but there has to be a human side to things, too," contends KISS-FM's Joe Lawrence.

The same concern was expressed when automation systems were installed in studios in the 1960s, yet the human element is as evident in radio today as it was then. "Technology really exists to serve human beings and not replace them," states Pizzi, who also believes that the cost of workstations will keep them from having any significant impact on the radio production room for a while at least. "Undoubtedly, the digital audio workstation will play a role in the radio station of the future, but more cost-effectiveness and specifically broadcast-related products will need to be incorporated first."

WQLR's Kenneth Lamphear sums things up this way: "Newer and newer technologies are going to be introduced into the radio production studio. That's a fact. But good production will always boil down to human talent and attention to detail no matter what the technology."

INDUSTRY NOTES BY TY FORD

The following section was written by audio processing expert and producer Ty Ford. Mr. Ford explains how equalizers, Aural Exciters, dynamics control devices, and time domain effects work and how they may be incorporated into production mixdown.

* * * *

Great audio production existed long before any of today's more sophisticated effects circuits were invented. What made the production room great then was strong writing and performance. The same is true today. Regardless of the number of effects used, or their amount, a piece of production will only be as strong as its weakest element.

The point here is that there is no box on the market that will improve a poorly written, performed, or engineered production. The best you can hope for is to be able to look back (or listen back) to earlier examples of your production and grimace at their lack of perfection and be thankful that you are doing better work than when you started. Not taking yourself too seriously helps a lot.

After you have mastered the basics of recording and mixing voices, music, and sound effects, it's time to move on to the audio processing domain. With practice, dedication, creativity, and a constantly improving ability to listen, you will emerge as a producer.

The Producer's Responsibilities

Audio producers are not casual listeners. Their sense of aural perception is part gift and part experience. The best producers start with excellent hearing and develop the ability to shift their attention to any part of a production at will. A seasoned producer is very much like an orchestra conductor who can tell when one player in a forty-

AUDIO PROCESSING, COMPUTERS, NEW TOOLS

INPUT
Input from conventional sources is handled by eight 16-bit analogue-to-digital converters. Probably the finest quality ADCs available today, SSL's unique design offers minimal distortion, especially at low signal levels, and dramatically increases subjective dynamic range. AES/EBU and multi channel MADI ports provide data transfer from existing digital systems. Additionally the hard disc storage channels can be selected as inputs for further console processing.

THE CONSOLE
The 01's 8 channels each have continuously variable four band parametric equaliser and separate high and low pass filters. They are operated by familiar rotary controls and segmented circular position displays.

Full 8 bit resolution for each control and software defined coefficient calculation provides precise adjustment. No stepping, no delay and no noise is missing.

It is a far cry from standard digital Up/Down buttons and low resolution stepped parameter control.
There lies the difference.
With the 01 the feel is analogue, the performance digital.

The stereo dynamics processor with limiter, compressor and gate/expander is assignable either pre or post eq or the main stereo bus fader. All parameters are continuously variable and the 01's 24 bit signal processing provides transparent dynamics, free of the noise and distortion generated by analogue gain control.

Channel and record levels are controlled by familiar 104mm linear faders. Again, with no stepping, no delay and no unpleasant noises from rapid movements, it is easy to forget the digital technology behind them. Extremely fast processing and clever software allows priority instructions to cut through general processing traffic.

SSL never compromise on ergonomics for the sake of manufacturing convenience. As always, control, rapid response and professional feel, are paramount.
There are separate stereo record and monitor buses with channel solo, cut and assign switching and odd/even channel linking for stereo sources to preserve eq and phase integrity. And the 01 provides 2 auxiliary sends, separate direct bus assigns for the digital input port and disc playback channels, as well as monitor source and level controls.

The system's computer provides access to a host of functions like pan-pot laws, eq curves, mute ramping times and control law shaping. Custom configurations can be stored and recalled from the built-in floppy disc drive. So engineers may recreate personal set-ups and function key macros wherever they may be working.

THE PROCESSOR
It takes a lot of processing power to achieve such instant control. Dual 68000 processors and 4MB of RAM manage three 3rd generation SSL DSP boards running at an impressive 60 MIPS. A third 68000 is dedicated to display and control processing. A choice of 2 or 4 hard discs of 380MB provide 1 or 2 hours of stereo storage via 3 channels of custom designed DMA. Because editing commands are stored separately, several hours of playing time can be created. The 01 samples at 32, 44.1 or 48kHz. External low pass filters are employed at 32kHz, with internal phase filters used for the higher rates.

EDITING
With the 01, editing is remarkably similar to traditional techniques. 'Cut and splice' editing includes full bandwidth stereo scrubbing and multiple supply bins. 'Transcription' editing takes place on 3 simultaneous stereo hard disc channels.

The difference lies in the speed and ease of operation. Instant access to all material held on disc saves seconds on every retrieval. Topping and tailing is virtually automatic, so de "erring" removing coughs and other unwanted noise is very rapid. Edit preview and reprocessing for eq or spacial changes are equally simple and quickly achieved, and there are special functions such as looping, sound file reversal, multiple file copies and sample rate conversion. Marking, Inserting, and Tape Rocking are all handled digitally.

The built-in time code generator and reader allows each track to be sychronised individually for sampling or adding effects. And the 01 locks automatically to external sources like time coded video tape and studio video systems.

Sound effects can be recalled instantly at a single keystroke and inserted. And the 01's track slipping, cutting-in and automatic dubbing facilities make post production sound editing simplicity itself.

In the recording studio the 01 can replace a second multitrack. It provides synchronous recording and editing of multiple overdub takes, full digital track bouncing and editing with instant lock-up and access times. In fact whether the task is speech editing, programme compilation, classical music assembly or a 12" single remix, the 01's editing facility is indispensable.

THE EDITING COMPUTER
Behind the ergonomic simplicity which allows single keystroke access to all main functions, is the editing computer. It allows any number of trial edits, mixes and overdubs to be constructed rapidly, monitored and stored for recall. It provides automatic EDL generation with full UNDO support at subsequent re-editing. Common repetitive tasks can be programmed onto a single function key by the user.

The display screen achieves visual simplicity, despite providing detailed information. Tasks such as selecting channel filter action, can be written into menu formats and selected without rekeying.

There is information on the number and titles of files per client, projects, of takes available and a host of other data. The recording time remaining, and the aggregate recorded times for files are all displayed.
The 01's backup system archives all hard disc data and work files onto standard VHS video cassettes. So projects are easily transferred between the 01 equipped facilities, wherever situated.

FIGURE 9.15
Solid State Logic's digital workstation features. (Courtesy SSL.)

piece orchestra hits the wrong note. This ability to shift and discriminate one's hearing is what constitutes listening, or professional listening.

Great producers also have a well-developed sense of rhythm or timing. They can identify rhythms that exist, even in non-musical productions. They can create rhythms with voice patterns and punctuate them with sound effects. The possibilities are almost endless.

The Producer's Judgment

It is the judgment of the producer that determines which effects (if any) should be used, and how they should be used. In order to get the most out of any effects box, the production person must have a good understanding of what the piece does. In addition, the person must use his or her developed sense of listening to achieve just the right balance of effects for each job.

Considerations such as monitor systems and listening environments, mono and stereo compatibility, and end-use all combine to affect the producer's judgment. A grand stereo mix using large monitors in a 24-track studio may not play well on a small speaker in a radio. A small radio speaker does not have the bass response of studio monitors, and summing stereo channels to mono can cause certain effects to cancel out.

The best producers know the audible frequency spectrum very well. With a quick listen they can tell the frequency range of a particular sound. They have learned through experience how to get the most from the people and equipment with which they work. The human element is extremely important. A great production director with

FIGURE 9.16
Affordable and flexible professional digital audio production systems such as this one provide recording and editing dialog elements, music libraries, psa's, and other items for instant-access replay either on-air or within an off-line production studio. Many stations use this particular workstation to produce various :15, :30, :45, and :60 versions of a basic ad, with different tags and IDs. To the left of the computer is the Dyaxis audio processor rack, which connects directly to studio equipment. Reprint permission courtesy of Studer Editech Corp.

average gear usually does better than a lesser one with great gear.

Most audio effects can be placed into three categories: frequency, dynamic range, and time domain. Although some processing gear is dedicated to performing a single type of processing, some are capable of altering parameters in more than one of these categories.

EQ

If your production studio does have a good monitoring system and you have the desire to improve the sound of your work, EQ is a good place to start. Learning the frequency spectrum by ear is the all-important first step. Learning how to get the most out of the equalizers you may be using is the second step.

FM radio and TV audio bandwidths are 50 Hz to 15,000 Hz, or 15 kHz. (Hz is the abbreviation for Hertz, or cycles per second; 15 kHz is read as 15 kilohertz or 15 thousand Hertz.) Although most professional audio equipment will pass audio up to 20 kHz, very few people are capable of hearing the 16 to 20 kHz range. You can conduct your own informal hearing test by listening for the horizontal oscillator operating in a black and white TV. The tone generated by this oscillator is 15,750 Hz. Color sets emit a slightly lower tone.

The first area of sound to concentrate on is the high frequencies, those between 8,000 and 16,000 cycles (or Hertz) per second. The lack of these frequencies causes the source to sound muffled or muddy. Too many of these frequencies causes the source to sound piercing and thin.

Keep in mind that muddy sound can be caused by a lack of highs or too many lows. Be aware that most tape hiss and a lot of circuit noise exist around 8 kHz. Boosting frequencies in this area will make your spots sound brighter. Add too much and you'll start hearing a lot of hiss and sibilance (splattering *s* sounds).

Achieving a hot production sound requires more than making your spots sound brighter. Getting a good voice track is the most important part of a spot. The novice producer often makes the mistake of adding low frequencies to make a voice sound more massive. While a little warmth on the bottom is good, too much makes the voice sound muddy.

Announcer vanity and the desire for a bottom-heavy voice have compromised many productions. True resonance and deep tones are the result of a relaxed set of vocal chords. Tight vocal chords, due to fatigue, nervousness, or the drinking of cold liquids, reduce the natural resonance of the voice.

If you're mixing voice and music, the overall EQ of both should be similar. While mixing sources with different EQ curves can be used for effect, most of the time the idea is to get as coherent a mix as possible. Having a boomy bass voice track and a squeaky, thinned-out music track sounds as unnatural as a full frequency symphony with a telephone EQ.

When choosing a music track for a voiceover, listen for instruments that may interfere with the voice track. Brass and reed horns and many other instruments may fight the voice track. When this happens the three standard options are: 1) pick another track; 2) lower the level of the track in question; or 3) use an equalizer to *notch*—that is, reduce—the frequencies of the music track that fight the voice track.

How Equalizers Work

Equalizers are circuits that allow modification of the frequency response of a signal. In their simplest form they may be designed to block a certain band of frequencies from

passing through a circuit. An equalizer that blocks the passage of low frequencies is usually called a high-pass or low-cut filter. An equalizer designed to block all frequencies above a desired point is called a low-pass or high-cut filter. These filter switches are normally found on both mixers and some microphones.

The typical applications of a high-pass filter would be to block, cut, or roll off undesirable lower frequencies, such as 60 Hz and 120 Hz hum from poorly grounded circuits or extraneous acoustic or mechanical noises like wind and noise from nearby machinery. Low-pass filters are normally used to block high-frequency noises, such as circuit noise and tape hiss.

Since the filters are either in or out, there are no in-between settings. To get those in-between settings you need adjustable shelving EQ, which usually comes in either of two configurations, step-switched or continuously variable. The term *shelving* refers to the ability of an equalizer to control the amount of a specific range of frequencies in a linear fashion, usually at the bottom or top of the audible frequency spectrum. All frequencies that are part of the shelved area are affected equally when adjusted.

Step-switched EQs let you choose several frequencies at which a preset amount of roll-off will begin. Typically your choices will be between 50 Hz, 100 Hz, or 200 Hz on the low end and 5 KHz or 10 Khz on the top.

Both low-pass and high-pass filters are commonly used in ENG (electronic news gathering). Since most of the audio is voice only, and since most voices have little if any energy below 100 Hz or above 12 KHz, blocking the frequencies above and below the voice frequencies usually makes the voice easier to understand.

Continuous or sweep EQ allows you to vary the ascent of a chosen frequency or range of frequencies with the turn of a knob. The tone controls on a typical stereo preamp function this way.

The graphic equalizer provides even more control by dividing the audible frequency spectrum into a number of bands, usually measured in octaves or fractions of octaves. The more bands, the more precise the control. The musical concept of octaves becomes apparent when you look at the face of a graphic octave equalizer. The bands 25 Hz, 50 Hz, 100 Hz, 200 Hz, 400 Hz, 800 Hz, 1,600 Hz, 3,200 Hz, 6,400 Hz, and 12,800 Hz are each one octave apart. To calculate the octaves of any frequency simply divide or multiply by two.

A parametric equalizer provides even greater control of the parameters of the frequency spectrum by allowing you to choose a band of frequencies, the width (or Q) of that band of frequencies, and how much or little of that band of frequencies passes through the equalizer. Most parametric equalizers offer control of the entire audio spectrum using three or four bands that overlap slightly.

One unique application of the parametric equalizer is in finding problem frequencies. If, for example, you hear a frequency or range of frequencies that seems to ring out louder than the other frequencies, start by deciding in which band the sound occurs. First turn the frequency boost control of that band all the way up. Then sweep the band of frequencies until the sound you are listening for jumps out. Experiment with the bandwidth or Q control to determine how wide the bandwidth of the objectionable sound is. Once you have determined its parameters, reduce the gain until those frequencies sound proper in the mix.

The operation just described is an example of subtractive EQ. Frequencies that stood out too much were reduced. Additive EQ works the opposite way. In the above example, the production person might have chosen to boost some of the other frequencies to balance the frequency response. Consider that turning down the bass or turning up the treble can have similar effects on the overall EQ balance. In most cases it is better to take a little off the bottom and add a little on the top than it is to simply boost the higher frequencies or cut the lows. The idea is to get as consistent and linear an envelope as possible. Keep in mind that boosting any frequencies too much will cause those frequencies to distort.

Aural Exciters

Aphex Aural Exciters, which give a range of control over the transients and harmonics of the source audio, are also frequency domain devices. These circuits are designed to alter the transient response of the audio

by adding small amounts of generated harmonics back into the "dry" signal. Because the transients are given greater detail and harmonic content, the overall sound is perceived as being brighter.

Because the energy level of the harmonic content is smaller than that of the fundamental, it can be recombined with the unprocessed audio without an appreciable overall level increase. Because the Aphex Aural Exciter generates harmonics that are higher in frequency than the original signal, it can also increase the frequency response of the audio that passes through it.

Although a similar effect can be approximated by using a conventional equalizer, it must be remembered that equalizers treat fundamental and harmonics equally. Attempts to duplicate the sound of an Aural Exciter with an equalizer may exceed the headroom of the circuit.

Dynamics Control Devices

Originally these devices were used to keep radio stations from exceeding modulation limits set by the Federal Communications Commission.

Examples of dynamic control are abundant in today's media. A simple scan of the FM dial will usually reveal that some stations are louder than others. The philosophy that louder is better has resulted in the creation of an industry whose main purpose is to develop and sell to broadcasters audio processors that increase and decrease dynamic range.

Loudness wars break out in a radio market when stations attempt to sound louder than their competition. The control versus fidelity trade-off becomes the loudness versus fidelity trade-off. This competition is the driving force for designers whose job it is to develop circuits that are both loud and clean.

The theory is simple. For purposes of this discussion, let's say that on a scale of 1 to 10, an unprocessed music passage that registers a 10 during the loudest parts and only a 1 during the quietest parts has full dynamic range. Any audio in excess of a 10 is too great for the circuit to handle and causes distortion. Any audio below 1 is unacceptably quiet because it gets lost in the noise of the circuit. Our usable dynamic range then is between 1 and 10.

Let's make the quieter passage of music louder by turning them up three numbers. If their original range was 1 to 3, their new range is 3 to 6. This works until passages that used to register 8 to 10 occur. Because they are also turned up three numbers, their new range is 11 to 13. These passages will be distorted because they exceed the usable dynamic range originally set at 1 to 10.

In order to pass the louder music without exceeding the usable dynamic range we have to turn the gain back down three numbers to where we started.

This method of dynamics control is called *riding gain*. Eyes and hands serve as control circuits. While keeping an eye on the meter to make sure the audio stays within the 1 to 10 range, we turn up the quiet passages and turn down the loud passages to achieve the loudest possible result.

This simple system works well if you know the material and can anticipate the changes, or if the changes occur slowly. If the changes are too quick and complex for the eye and hand to control, the only manual option is to set a more conservative level.

Compressors, limiters, expanders, and noise gates all change the dynamic range of the audio that passes through them by using circuitry that adjusts to level changes much more quickly than is humanly possible.

Compressors increase loudness by automatically turning down audio passages that exceed a preset threshold. When the level falls below the threshold no gain reduction occurs.

Limiters are designed to prevent any audio from exceeding a certain level regardless of how loud it gets. These circuits usually act more quickly than compressor circuits.

It is important to realize that, although they function similarly, these devices impart their own by-product sound to the audio that passes through them. Compressors of different designs do the job differently, and the resultant sound is different. The same is true for limiters, expanders, and gates.

Some equipment manufacturers simplify circuits by limiting user variable controls or the degree of control. Often marketed as "smart circuits," they are designed to prevent radical settings that result in bad audio.

As a rule, the more sophisticated the control circuits and the more variables offered, the more expensive the device. Expensive control devices, however, don't guarantee cleaner sounding audio. Even top of the line circuitry can be adjusted to sound terrible.

Compressors and Limiters. In addition to variable threshold settings, dynamic range devices may offer attack, release, and ratio settings. The attack control determines how quickly the circuit responds to incoming audio. The faster the attack time the more quickly the circuit begins its control of the incoming audio.

Overly compressed or limited audio often lacks in high frequency content. An overly compressed or limited snare drum sounds dull because the early part of its sound wave, usually much higher in energy and containing more high frequencies, is artificially reduced by the action of the compression or limiting circuit.

As compression or limiting is applied to a sound source while it is being mixed with other sources, it will be perceived as being turned down. As a result, some producers turn up the output of the compressor with the knowledge that it will keep occasional loud passages from exceeding the headroom of the circuit. Some producers follow compression and limiting with a small boost in high-frequency EQ to compensate for any loss in brightness resulting from the processing of the audio.

The release time of a circuit is the amount of time it continues to process the audio after the signal returns across the threshold. Slow release times hold or sustain the audio. Quick release times usually result in sound with more punch because the compression or limiting effect happens over a shorter period of time.

The amount of gain reduction a compressor or limiter provides is often presented as a ratio. No gain reduction would be read as a 1:1 ratio. A ratio of 3:1 means that for any increase of 3 dB, audio that exceeds the threshold will increase only 1 dB.

The main difference between compressors and limiters is the ratio at which they operate. Compressors operate at ratios up to 10:1; limiters operate from 10:1 and above.

The test of a good compressor or limiter is how it handles high ratios and short release times. Early circuits and even some of the simpler second generation circuits handle dynamics so obviously that you can hear the volume changes. This side effect is called *pumping*.

Hole punching is another side effect. It occurs during overly processed music passages, when one element of a mix triggers the gain reduction circuit by exceeding the threshold. The circuit, triggered by the sound that exceeded the threshold, responds by turning down all of the audio as well.

Typically, hole punching occurs when a heavy bass line or drum-hit triggers the gain reduction circuits. In the most severe cases the rest of the music track seems to disappear, eclipsed by the instrument that triggered the gain reduction.

It should be noted that while breathing (pumping) and hole punching, when used to extremes, are the mark of bad audio, some producers use more moderate amounts as an effect.

In the analog domain the current solution to the problem is to divide the audio bandwidth into three or four sections. Because each band is smaller and less complex, the circuit doesn't have to work as hard. Multiband processors usually cost more because of the extra circuitry. Another step toward quality is the development and use of improved solid state circuits, which respond more quickly and accurately to the audio that passes through them.

Expanders and Gates. Expanders, as the name implies, do the opposite of what compressors do. Audio that falls below a preset threshold is automatically turned down even farther. An expander is used to restore the full dynamic range of compressed audio or to reduce low-level noise during quiet passages.

Gates open or close at preset thresholds to allow or block audio completely. In radio production, gates are often used in voice sessions where two or more people use separate mics in the same studio. Individual gates can be put in line with each mic. The thresholds are set to open only when talent number one speaks into mic number one, and talent number two speaks into mic number two. If the adjustments are made correctly, talent number one's voice will not be loud enough to open the gate on mic

number two, and vice versa. Because all mics in the room are turned off or "gated out" unless someone is speaking directly into them, the primary speaker's voice will not be picked up at a distance by the other mics.

This technique eliminates the hollow off-mic sound that normally occurs without gating and also eliminates the circuit noise produced by multiple mic preamps.

Combined Circuitry

Manufacturers often combine more than one kind of circuit in a chassis, such as compressor/limiters, compressor/expanders (or "companders"), and even EQ.

Not all of these devices are designed so that all functions may be used simultaneously. For example, most compressor/limiters will either compress or limit, but won't do both at the same time.

Time Domain Effects

Reverb, echo, delay, flanging, chorusing, and acoustic simulation, whether analog or digital, all fall into the category of time domain effects. These devices combine delayed portions of the source audio with the original to achieve their effects.

Digital audio has made possible an entire generation of time domain effects. These effects are the result of computerized acoustical analyses of existing spaces, which result in complex algorithms or mathematical formulas. These formulas attempt to replicate the original reflection patterns that give a space its sound. Once the analog sound is digitized, the bits are applied to the algorithm formulas. If the computer chips that do the number crunching compromise some of the values by quantizing or rounding off figures, the sound you get will fall short of the original model. Typical by-products of quantization are noise and a metallic ring on the trailing edge of the affected audio.

Both reverb and echo are complex types of delayed sound. (Delay simply refers to the difference in time between the reflected and original sounds.) In order to have a delayed effect, the circuit combines the "dry," or unprocessed, audio with the "wet," or processed, audio. Without the source audio as a reference, the effect is lost. It is the combination of the original and delayed audio that produces the effect. The slight differences in timing between the source and affected audio create the hollow or tubular sounds normally associated with these devices.

Although reverb and echo are terms used interchangeably, they are very different. A reverberated sound rings out and is perceived as one long sound that eventually dies out. Visualize reverb as a body diving into a very still pool of water. As the body enters the water, a pattern of ripples is created that expands until it hits the side of the pool and is reflected. The ripples continue until they hit the other side of the pool or die out. The size and shape of the pool determine the amount, complexity, and randomness of the reflections, or "wet" sound. Usually the larger and more complex the area, the longer the reverb time.

In contrast, echo waves have more discrete and individual reflections. Say "hello" into a reverb device and you hear the word ring out over a period of time long enough to give you the perception that you are in a very large place. The same "hello" spoken into an echo device will reflect the word intact, like a tennis ball bouncing off a backboard. The perception of the size of the space will be determined by the time it takes for the echo to bounce back to your ears. Echo effects are usually designed so that the user can control the time between the original sound and the first echo as well as the number of echos heard.

BBE's Sonic Maximizer uses a combination of frequency selective delay and *companding* (compressing or expanding voice modulation) to achieve brightness and increased definition of the audio that passes through it. The high frequencies appear to have better definition and presence because the mid and low frequencies are time released, slightly after the highs. This delaying technique gives high frequencies a head start through the circuitry and speakers (and to your ears).

In addition to the delayed release of parts of the source audio, there is also a compressor/expander circuit that controls the level of the higher frequencies of the processed audio and a simpler circuit that allows tailoring of the bass frequencies.

Audio Logic's PA-88 and PA-86 psychoacoustic processors are both based on the

same central circuitry. In simplest terms, each channel is processed with an out-of-phase version of itself that has been slightly delayed. The frequency range at which this effect occurs is user selectable. The audible effect is that high frequencies are more apparent.

In the strictest sense, any device that alters the original waveform of a signal is distorting it. However, because distortion normally carries a negative connotation, some people prefer to use the terms *waveform modification* and *audio processing*.

Avoiding Mistakes

Because the use of any audio processing gear alters the original sound, adjustments become subjective. There are, however, certain givens about which most people agree.

- Use restraint. At first, most people have a tendency to overuse effects. The fascination with the effect overshadows the context in which it is used. The exaggerated results are like a huge billboard that announces, "I have a new toy!"
- Check overall EQ balance by listening to the finished product over a monitor system that replicates the end-use monitor system.
- Be aware that what may sound like too much effect applied to a voice track when heard by itself may sound right when the music is mixed in. In fact, if the music eats up too much of the effect on the voice, you may need to add a little more.
- Always check the mono compatibility of your mix. Many stereo effects change radically or disappear when played in mono. In addition, those special effects you panned out to the far left and right may need to be brought back in a little so that they hold their relative level in a mono mix.
- Know that, as an organic being, your perception of what you hear may change. Don't be surprised when the mix you did today sounds different tomorrow. It's an especially good idea for new production people to check their mixes several times. A few extra listens are a good way to avoid a lot of embarrassment.
- Realize that listening, while often taken for granted, is very much a learned experience. The more experience you have, the more discriminating your ear becomes.

CHAPTER HIGHLIGHTS

1. Compact disc format is favored at the majority of stations for production music and sound effects. When recordable CD technology becomes available, CDs may replace analog discs and magnetic tape as radio's primary recording and storage medium.

2. Multimachine mixdowns are being simplified with the introduction of multitrack machines. They facilitate the inclusion of multiple music beds, voices, and special effects into a single piece of production, while eliminating the splicing block for editing.

3. Stations frequently use a compressor to create the illusion of being louder without actually changing their level. Applied mostly to voice, rather than music, properly utilized compression makes voices sound warmer, tightens production, maintains near-perfect levels, and commands listener attention.

4. Equalizers (EQ) are used to increase or decrease audio lows (Hertz range sound) and highs (kiloHertz range) to eliminate user or production errors while maintaining accurate final levels. Although EQs provide numeric scales for setting the graph slides or band pots, equalization is ultimately achieved by the ear.

5. Audio processors (effects processors, boxes) are time domain devices that create a wide range of effects. Audio processors can—to mention only a few features—create a left-to-right stereo panning effect, double a weak voice/singer, provide flanging and chorusing, and change the running time of any material without noticeably changing the pitch.

6. Digital samplers allow a production person to load an audio source (for example, a recorder or live mic) into its built-in microprocessor and then manipulate the digitized data with the aid of a keyboard to create a multitude of effects. Samplers employ magnetic micro-floppies and are wired to an audio console so that the sounds they create can be integrated into mixdown.

7. MIDI (musical instrument digital in-

terface) is a control system that stores information and communicates with synthesizers. Many stations use a computer combined with a sequencer, which permits a production person to record a MIDI-controlled set of instructions onto a disc from various synthesizers for eventual mixdown purposes.

8. Digital audio workstations attempt to integrate the entire production studio into a computer. Looking like a PC with a few boxes, the workstations are available in different designs.

9. Equalizers are circuits that allow modification of the frequency response of a signal.

10. A graphic equalizer divides the audible frequency spectrum into a number of bands, usually measured in octaves or fractions of octaves, which can be controlled separately.

11. A parametric equalizer allows you to choose a band of frequencies, the width of that band of frequencies, and how much or how little of that band of frequencies will pass through the equalizer.

12. Aural Exciters are frequency domain devices that give range control over the transients and harmonics of the audio source.

13. Compressors, limiters, expanders, and noise gates all change the dynamic range of the audio passing through them by using circuitry that adjusts to level changes much more quickly than is humanly possible.

14. Compressors increase loudness by automatically turning down audio passages that exceed a preset threshold.

15. Limiters prevent any audio from exceeding a certain preset level, regardless of how loud it gets.

16. Expanders are used to restore the full dynamic range of compressed audio or to reduce low-level noise during quiet passages.

17. Gates open and close at preset thresholds to allow or block audio completely.

10 Ingredients of the Mix

Music and sound effects (SFX) play a vital role in most production mixes. Effectively used, they heighten and extend the impact of the spoken word.

MUSIC

In the parlance of the radio production room, music used to accompany a voice track is referred to as bed music. Why bed music? Simply explained, the term can be taken quite literally to mean that a voice track is placed on top of the music. The music is under and around the voice—supporting the voice.

Choosing an appropriate piece of bed music requires a special knowledge and understanding of three key factors: copy, sponsor, and format.

Copy

A production person must know what a piece of copy is about. In other words, the goal or objective of the written message must be totally apparent. Then and only then should a producer attempt to embellish copy with music. If the meaning of the copy is vague or unclear, music will have little positive effect and may even make matters worse.

In most instances, copy precedes bed selection. The copy suggests the bed. For example, a piece of copy written for a luxury resort hotel nestled in the romantic Poconos should provide a production person with a good sense of the kind of music to choose. Read and digest the essence of the written word before deciding on the music designed to extend its impact. Let the flavor of the copy serve as a guide when it comes to deciding what type of bed music to employ.

Sponsor

Knowing something about the sponsor is helpful when choosing background for a spot. For instance, what type of image has the business cultivated? Up-scale? Austere? Low-brow? Who are the sponsor's targeted clientele? What type of spots have been done for the sponsor previously? Has the client favored a particular type of sound? Mixing a commercial without some sponsor familiarity puts the production person at a disadvantage. A client's preference in music certainly should be acknowledged, if not reflected, in a spot.

Format

Very few stations sanction the use of bed music that is not consistent with the music programmed. Actually, this makes the job of choosing bed music somewhat simpler. Later in this chapter the strictures imposed on the use of bed music will be discussed more fully, and in Part IV this subject is taken up in much greater detail. Suffice it to say for now that music that does not fit a station's format is generally considered inappropriate on a spot. There are exceptions, of course.

BED TIME

The amount of bed music on a spot depends on the length of the written copy and the nature of the message. A piece of copy that times out to sixty seconds when voiced leaves no space for intro (open) or outro (close) bed music. In this case, if a bed is called for, it will start and end with the voice track. In another example, if a voice track times out to fifty-six seconds, the producer has *pad* time—space in which to establish a bed. He or she may decide to use the available four seconds for bed music by

125

evenly distributing it—two seconds in and two seconds out. If the copy calls for a second bed for the sake of transition, the production person may use two of the available four seconds for this purpose, then graft one second's worth of bed at both ends of the spot. There are any number of configurations.

The tone and mood in a piece of copy often plays a role in determining how bed music is used and how much is used. For instance, a copywriter desiring a certain effect may decide to let a piece of music do the talking. Therefore, the copywriter composes a sixty-second spot that may be voiced in forty seconds. An excerpt from the spot may look something like this:

(Down-tempo bed—5 sec.) ARE YOU TIRED OF HIBERNATING FROM THE ICY WINDS THAT DIVIDE AND CONQUER, FROM THE SLIPPERY ROADS AND SIDEWALKS THAT MAKE STANDING UP AN OLYMPIC EVENT? WELL, IT'S TIME TO LEAVE YOUR WINTER DEN AND COME OUT AND SMELL THE FLOWERS OF THE ISLANDS IN THE STREAM. (Up-beat bed—5 sec.) SUMMER IS ONLY THREE HOURS AWAY. (Bed up—2 sec.) NOW YOU CAN . . .

Obviously, in the above example, bed music plays a significant role in conveying the message to the listener. The copywriter's decision to use extensive bedding is valid, but the use of bed music for the sake of using bed music just cheats a client. Bed music should only be used when it has something to add, when it makes a genuine contribution. (There will be more on the use of bed music in later sections.)

BED SOURCES

Bed music may be derived from several sources. Most stations receive demos. These are albums or CDs that record companies send stations in the hope of getting airplay. In reality, very few of these reach station playlists. A production director who is on the lookout for fresh bed music will audition unused demos. This music may be used by the station, since all stations pay annual fees to music licensing services, such as AS-CAP and BMI.

Stations receive a wide range of music demos. Among the most useful to a production person are movie sound tracks. They rarely make a station's playlist, but they almost always contain interesting compositions, some of which may be off-the-wall but perfect for a particular mixdown. Sound tracks typically span a broad emotional (dramatic) spectrum, so they are good for that odd or quirky sound bite a piece of copy demands.

Conventional or mainstream albums or CDs are also an excellent source for bed music. Auditioning each cut or track will invariably yield something of use. Instrumental recordings are by far the best source of bed music. Unlike vocal recordings that frequently require editing, recordings that feature all instrumentals can be especially rich in bed music. In recent years, a whole catalog of instrumentals has emerged in the form of New Age music. While fans of the sound would likely take exception to their favorite music serving as bed material, in all honesty it does provide producers with a great source from which to derive background.

For the sake of illustration, here is a fictitious account of the steps a production person might go through in the process of bedding a spot:

K-LITE's production director, Jane Brown, is given a sixty-second commercial that calls for three beds. The first bed is to convey a sense of motion or movement, because the spot opens with copy about highway travel. A third of the way into the spot, the copy discusses the pleasures of shopping in the city's new and luxurious mall; thus, a music bed that captures the ambience of the mall is desired. Finally, a bed that communicates the feeling of outer space is needed, because the closing line of copy states that shopping at the new mall is an "OUT OF THE WORLD EXPERIENCE."

Jane must locate these very different types of beds. Since the station PD has just given her a stack of unused demos, she decides to audition the records in the hope of hitting upon something appropriate for the spot. Three cuts into a sound track album she finds music that is perfect for her third bed requirement, and on the reverse side of the album she locates music just right for the opening bed. However, she has no luck finding usable music for the spot's sec-

ond bed, and this is after searching through all five of the new demo albums.

The next thing K-LITE's production director does is thumb through her bed music card file to secure the second bed. In short order she succeeds in locating an available bed that will fit the spot nicely. (The indexing of bed music is discussed in subsequent sections of this chapter.)

The actual mixdown of the spot is the next stop.

Bed Libraries

The alternative to in-house bed music is to use packaged (prerecorded) libraries, which are available from several companies (Aircraft Music, CBS Sound Library, Century 21 Programming, Sound Ideas, and so on). Bed library companies record original tracks and/or remix from existing masters, concentrating on the quality of the audio by using state-of-the-art equipment. One of the primary selling points for many bed music companies is the superior fidelity of their product. Stations seldom can equal the quality that bed producers are able to offer.

In scope, bed libraries run from basic to elaborate. For example, Stock Music Sales sells several album sets for under one hundred dollars; each set contains eighty-six music backgrounds. More extensive libraries are available, which include hundreds of beds for use in a wide variety of situations. These beds are timed to lengths needed for spot mixdown—sixty, thirty, twenty, fifteen, and ten seconds. Longer beds (two to five minutes)—for use on features—are often included as part of the library package. From the perspective of the station production person, this is very attractive, since editing (cutting to length) is not required. Obviously, this is a time-saving consideration.

Most bed libraries come with manuals so that a bed may be located quickly and easily. Some small and inexpensive libraries list this information on a record's label or on a CD case or album jacket.

In the 1970s and 1980s, bed music libraries achieved a level of sophistication that they had not been noted for previously. Too often, what stations received from bed companies was bland, uninspired, and out of step with current music. This is not so today, notes Century 21 Programming president Dave Scott: "We offer compositions that meet the needs of the most contemporary type of station."

Important, too, is the fact that many libraries, such as Century 21's, update their music periodically. This keeps beds on a par with current trends and provides producers with fresh material with which to work.

Bed libraries come in album and compact disc formats, and some companies market their product on digital audio tape as well. Record (LP) libraries remain the least expensive. Some bed companies have ceased producing onto vinyl because the market has shrunk—the consequence of the shift to digital hardware.

Stations may buy or lease bed libraries. In the former instance a station engages in a buy-out deal with the bed music firm, which then hands over all the rights to the library. In a buy-out, no contracts or future obligations exist, and a station may use the library to its heart's content. When stations lease the rights to use a library, the bed company retains proprietorship and charges the station an annual charge or a pay-per-use fee (a needle drop charge). Since several of the better libraries cost many thousands of dollars, a station that opts to lease may do so in order to get the best, while avoiding the significant outlay of cash a buy-out would require.

Making Beds

In the 1990s there is a growing trend toward in-studio manufacturing of beds. Technology has made it possible, and often desirable, to forego the conventional routes for acquiring background music, observes independent producer Ty Ford. "It is no longer necessary to rely on the music department's rejects or store-bought libraries. At a relatively low cost, a production studio can create original, high-quality bed music."

Samplers and MIDIs (discussed in detail in Chapter 9) make this possible. At the touch of a finger a nearly endless supply of sounds may be created. "Some station production directors have bought off-the-shelf digital music keyboards for use in their studios," observes WPRO's Vic Michaels. The bottom line is that "home-grown" background is more prevalent than ever before,

128 STUDIOS AND EQUIPMENT

FIGURE 10.1a
Bed libraries offer a full range of sounds. (Courtesy Century 21 Programming.)

The World's Best Selling Radio CD Library: Because it's the Biggest and Best!

CD production library

Here's *the* arsenal of 1,485 instrumentals and effects that commercial producers have been starving for. You'll get 15 Compact Discs with 900 tracks (including both 30- & 60-second versions), 325 random-length accents or themes, 260 stereo sound effects, plus an instant-access CD player. And your music will stay as fresh as tomorrow, because hundreds of new tracks are delivered every year.

Join the winners like Gannett, CBS, Westinghouse, Clear Channel, Edens, Moffat, Scripps/Howard, Susquehanna, New City, Shamrock, Buckley, and other major groups making money with Century 21's CD Production Library®.

Cuts 1 and 5 of the demonstration disc let you hear how the Compact Disc Production Library® will skyrocket *your* production into the 21st Century.

Rock radio has waited a long time for a library that's laser hot...and excites like lightning. It's Century 21 Programming's

LASER LIGHTNING

It's all rock, all digital, and it all sounds like today's hits! Laser Lightning® is big: you'll get 1,778 terrific production music beds & effects on 15 Compact Discs.

It comes complete with a quick-access CD player, 1,160 rockin' instrumental themes in 60- and 30-second lengths, 368 sizzlin' new sound effects, plus 250 punctuators and stagings for rock-'n-roll morning jocks.

Tune into Cut 2 of the demonstration disc to hear how Laser Lightning® will beam you light-years ahead of your competition. Then scan Cuts 6 through 9 for samples of musical morning mayhem, then CHR, AOR and Urban Contemporary commercial backgrounds.

Today's freshest mix of new digital CD production music:

Generation Three

While other companies are finally delivering their first production libraries on Compact Discs, Century 21 Programming breaks the sound barrier for the third time! Generation Three® is power-packed with 910 mass appeal instrumentals, including 494 commercial-length beds (in both 60- and 30-second versions), 260 ID's and accents, 156 longer themes and 368 sound effects on 15 digital CDs.

You'll create spots & promos that sound great, without any of the surface noise or deterioration of vinyl records. You'll start with Century 21's instant-access CD player & storage rack with 6 Generation Three® CDs bursting out with 648 initial cuts. Then, we'll supercharge your music 3 more times each year with additional Compact Discs.

Generation Three® is sampled on Cuts 3 & 10 on the CD.

as the result of the medium's growing interest and involvement with synthesizers.

STRICTURES

A production director seldom has carte blanche when it comes to using beds. As mentioned earlier, a production person must take a station's format into consideration when selecting a bed. For obvious reasons the programming department of a classical music station would likely object to the use of a heavy metal bed. This would clash with the station's overall sound, and thus be regarded as an affront to listeners. (Part IV of this text examines in detail how a station's format influences the mixdown process.)

A common rule at many stations is that playlisted music—that is, songs a station schedules for normal airplay—cannot be used to bed copy. Behind this policy is the contention that bedding playlisted tunes would have the effect of reducing their appeal and impact when they come up in normal rotation. As a bed, part of a song may be aired dozens of times during the course of a week, while it may come up only once or twice a week in regular rotation. Overexposing a piece of music in this fashion can seriously diminish play value. Perhaps the primary reason stations oppose using playlisted music in commercials is the concern that it will aggravate listeners, who want to hear a popular or favorite song in its entirety—not piecemeal under an announcer's voice.

MAXIMUM POWER
When New York's Power 95 turned up the energy of their CHR sound, this is the package that added the sizzle.

SKYWAVE
Our latest package for Z-100 New York. It's the new industry standard for CHR jingles. Bright, powerful, and loaded with creative effects!

LASER IMAGE
Fast, up and energized for today's hot Hitradio CHR formats. Created for Long Island's WBLI.

Coast to Coast
The rich, full A/C sound heard on Coast 103, KOST Los Angeles. Includes short ID's as well as special "love songs" cuts.

FUN COUNTRY
Proud identification for contemporary country stations. The latest in our successful series of packages created for KUSA St. Louis.

Magic Music 5
Combine soft rock and light jazz, and you get just the right sound for today's new age. Created for Magic 103, WMGK Philadelphia.

BE KOOL
Great jingles for oldies stations who aren't living in the past. Contemporary logos, as well as oldies cuts. Heard on Denver's KOOL 105.

Sportsradio
When WFAN New York became America's first all-sports station, they came to JAM for this outstanding musical image package.

THE WEEKEND music REVIEW
Every weekend, Dan Ingram hosts this 3-hour program featuring today's A/C hits, #1 songs from the past, celebrity guests, and fun!

FIGURE 10.1b (Courtesy JAM Creative Productions.)

Therefore, a station's music product is often regarded as sacrosanct—hallowed ground never to be trod upon by commercial copy—and as such it is kept in a separate area of the station, away from the daily machinations of the production person.

In the final analysis, it is the station's program director who approves the use of bed music, because it is he or she who is ultimately responsible for the station's overall sound. This does not mean that the PD must preview every bed that is used. The production director knows what is acceptable and what is not through format policy established by the programming department. It is the production chief's responsibility to use bed music that enriches both the station's sound and the sponsor's message.

INDEXING BEDS

A commercial station uses hundreds of beds, and it must have a system for keeping track of this material. Computers are excellent for this purpose. Stations may devise their own software or purchase inventory control software from companies that serve the computer needs of broadcasters.

Bed library packages come indexed or cataloged either in the form of floppy discs, index cards, or inventory manuals. Homemade beds require cataloging on the station level. When a station does not have a computer file available for the purpose of storing bed information, it develops its own system. Recording bed information on in-

dex cards (usually on a Rolodex) is a popular approach.

A production director may decide to categorize cuts according to mood, arrangement, and genre. *Mood* may be defined as a bed's attitude or feeling—for instance, upbeat and happy or downbeat and pensive—covering the full emotional spectrum. A tune's *arrangement* has to do with the amount of orchestration it possesses. Is it full (many instruments) or simple (one or two instruments)? Categorizing a bed according to *genre* or subject also helps the production director determine its usefulness. A bed may be classified as dramatic, comical, romantic, geographical, horrific, and so on.

If K-LITE's production director comes across a cut on a *Friday the 13th, Part 23* sound track that slashes the studio air with its piercing and pulsating rhythms, she may index it as follows:

:60 Intense, full—Horror

The love ballad, and every movie has one (even horror flicks), with its soft, sweet violin strains, may be indexed this way:

:30 Easy, simple—Romantic

Note that the length of each bed is listed on the index card. Additional information would include the number of the disc, so that it may be quickly located in the studio, and the side (if an album) and cut or track number of the bed indexed.

When a bed is assigned to an account, that information may also be added to the index card (in erasable pencil), along with the start and end dates of the client's flight (air schedule). Thus a bed index card may end up looking like this:

:30 Easy, simple—Romantic
Album # 431, Side 1, Cut 2
Account: Peg's Daisy House
Dates used: Jan. 18–Mar. 17.

When the bed is assigned to a different account, the production director will either remove the old card and make a new one for the next account or simply erase the old account's name and the dates pertaining to its run. The reassigning of bed music must take into consideration just how closely associated with the old account the bed became. Beds are usually given a cooling off period after extended use. No sponsor wants a bed to remind listeners of another sponsor. In fact, beds are often permanently assigned to sponsors who purchase frequent air schedules. Besides, clients usually like sticking with a piece of music because it strengthens their identity.

In addition to creating a system for bed music accountability, some stations retain copies of every commercial produced in-house. A master log, as it is called, contains a listing of each spot on master tape reels. The log reflects information pertaining to master reel number, account name, announcer on spot, cut number, length of spot, and cart number. (A number is assigned to each carted spot so that it may be quickly located in the control room. A cart's number is reflected on the program log, on which spots, psa's, news, and features are listed.)

Master tapes are stored in the production studio for easy reference. For production people, salespeople, and copywriters, they

FIGURE 10.2
Store-bought (canned) libraries provide stations with catalog information.

```
RADIO TUNING    :30
   Album 10    Side 1    Band 23

RAILROAD CROSSING: bell at crossing with train in
background   1:08
   Album 3     Side 2    Band 15

RAILROAD CROSSING: bell at crossing   :31
   Album 3     Side 2    Band 16

REFRIGERATOR DOORS    :10
   Album 8     Side 1    Band 9

RESTAURANT (large) background    1:22
   Album 6     Side 1    Band 16

RESTAURANT KITCHEN    :57
   Album 6     Side 1    Band 14

RESTROOM STALL DOOR    :09
   Album 10    Side 1    Band 17

RESTROOM TOWEL DISPENSER    :09
   Album 10    Side 1    Band 20

REVOLVER: cocking   :08
   Album 8     Side 2    Band 24

RIFLE: cocking   :08
   Album 8     Side 2    Band 23

RIFLE (small caliber) random fire   :11
   Album 8     Side 2    Band 31

RIVER RAPIDS    1:28
   Album 6     Side 2    Band 7

ROLLER COASTER    1:15
   Album 5     Side 1    Band 12
```

serve as historical documents pertaining to the use of bed music and the mixdown approaches taken on spots. A sponsor also may decide to use a spot aired a previous year, in which case the production director need only dub it from the master reel onto cart—providing, of course, that quality has not deteriorated.

SOUND EFFECTS

Sound effects have been used in commercials nearly as long as commercials have been broadcast. Early radio producers found they could advance the impact of the spoken word by adding relevant sounds: an announcer spoke of the pleasures of an ocean cruise, and the sounds of tropical birds and gentle surf were added to sweeten the listener's mental images. Through the effective blending of sounds and words the audience was transported to the deck of a cruise ship anchored in an exotic port of call.

During radio's heyday stations manufactured in-house the majority of the sounds they needed for a program or commercial. Although recordings of sounds were available on 78 rpm discs, the selection and variety were limited, and the quality was not always up to necessary standards. Thus, as discussed in Chapter 1, stations assembled objects that could be used in the creation of sounds. Large stations and the networks hired sound effects people to devise the sounds called for in scripts.

With the advent of the long-playing album in the 1950s came sound effects libraries, which all but eliminated the need to originate or create sounds at the station level.

Today most sound effects are derived from packagers, who offer libraries that contain anywhere from very basic effects to elaborate and unusual effects. Costs for libraries also span a wide range, anywhere from one or two hundred dollars to a few thousand dollars. Size and quality have a direct bearing on the price of a library. Most sound effect libraries are available on albums and CDs, with the latter generally costing significantly more than the former. With the emphasis on fidelity at most stations, CD libraries are selling fast. "Old, mono sound effects don't add much to a multitrack mixdown. Depth shouldn't end with effects. If you have state-of-the-art production equipment, you should have state-of-the-art mix ingredients," observes WGAO's Rich Pezzuolo.

While a sound effects library may be used for the majority of production mixdown needs, station production directors draw on other sources as well. Many pop recordings contain interesting and unusual sounds that can enrich a station's effects inventory. Sound tracks are another outstanding source for sound effects. By drawing from demo albums and CDs, the production director adds an important dimension to the station's library of sounds.

As is the case with bed music, a growing number of stations use synthesizers and effects processors to create sounds in-house. Proponents of this approach predict that the day will arrive when store-bought libraries will be used to supplement a station's production room synths and processors. Whatever happens, it is clear that these new audio devices are going to have an important impact on the way things are produced in radio.

INDEXING SOUND EFFECTS

Again, computers are a tremendous asset when it comes to organizing and storing information, and many stations employ them for the purpose of maintaining their sound effects file.

As is the case when a computer is unavailable to inventory bed music, production directors often resort to index cards or a log book to document their effects material. An index card containing the sound of an explosion may appear like this:

:18 Explosion—Album 26
Side 2, Cut 4

The length and type of effect, the number of the album on which it may be found, and the side and cut on the album that contains the sound are listed on the index card. Sound effects index cards are typically arranged in alphabetical order according to the type or nature of the sound. Details might be added to an index card if they are considered useful.

FIGURE 10.3
A good sound effects library adds great depth to the production room. (Courtesy BBC Sound Effects.)

Like store-bought bed music libraries, packaged sound effects libraries provide stations with indexing material.

STORAGE

It was said earlier in this text that storage shelves, cabinets, and drawers are built into the production studio so that personnel may gain quick and easy access to mixdown ingredients, such as bed music and sound effects. Aside from the importance of having production material handy, the idea is to separate mixdown albums and CDs from those designated for regular airplay.

The organization of mixdown ingredients is the responsibility of the production director. If material is not arranged in an orderly and sensible manner, but stored haphazardly, it is difficult to locate on a moment's notice, and in the production studio time is of the essence. A production person can ill-afford to spend twenty minutes hunting for a bed that has been indexed but misfiled.

Most production studios retain previously aired tapes, such as those sent from agencies, in what is termed a *tape morgue.* These five- and seven-inch reels of tape are stored alphabetically (according to sponsor) on shelves designed specifically for this purpose. Over a period of time the number of agency tapes can become quite substantial, and they must be thinned. Most stations do not retain previously aired spots for more than a year, unless an agency has indicated plans for future use. Agencies seldom request that tapes be returned. Tapes removed from the storage shelves are often erased and used for station dubbing and demo purposes, and those that are not put to use are simply discarded.

CHAPTER HIGHLIGHTS

1. Effectively used, music and sound effects (SFX) heighten and extend the impact of the spoken word.

2. Choosing an appropriate piece of bed music (music used to accompany a voice

FIGURE 10.4
A sensible system for storing mixdown ingredients saves time and energy.

FIGURE 10.5 Production room tape morgue.

track) requires understanding of the copy, sponsor, and station format.

3. The amount of bed music used in a spot depends on copy length and the nature of the message. Music should never be a filler; it should only be used in place of voice when it makes a genuine contribution.

4. Bed music sources include unused demos (albums and CDs supplied by record companies for possible airplay), movie sound tracks, mainstream albums and CDs (especially instrumentals), and packaged (prerecorded) libraries. Playlisted music (songs a station schedules for normal airplay) should not be used to bed copy.

5. The introduction of samplers (synthesizers) and MIDIs into the production room has made it possible for stations to produce their own low-cost, high-quality bed music.

6. Bed music may be cataloged according to mood (attitude or feeling it creates in the listener), arrangement (amount of orchestration it possesses), genre (e.g., dramatic, comical, romantic, etc.), and length (precise running time). Also included would be the disc or album number, the side (if album), and the track number.

7. Beds are usually given a cooling-off period after use before being assigned to a new client, so listeners will not identify the sound with the earlier sponsor.

8. If a station retains a copy of every commercial produced in-house (on master reels), a master log will be maintained to list each spot and its location.

9. Sound effects enhance the impact of the spoken word by adding relevant sounds. Effects are derived from packaged libraries, pop recordings, sound tracks, demo albums and CDs, as well as synthesizers and effects processors.

10. A sound effects index would list the type of effect, length, album or CD number, side (if album), and cut number.

SPOT ASSIGNMENTS

1. Assess a piece of copy to determine the type of bed that would be most appropriate.

2. Consider the impact of announcer delivery on bed selection.

3. Locate a bed on a demo or pop music album that would be appropriate for a sponsor selling high-quality dining room furniture.

4. Audition a sound track album for bed music.

5. Analyze the use of bed music aired by a local radio station.

6. Index a new piece of bed music using the approach described in this chapter.

7. Visit a station that uses a computer to index and store bed music.

8. Locate the following sound effects in a prepackaged library: train whistle, artillery fire, door slamming, cuckoo clock, restaurant crowd, baby crying, thunder storm, and teletype printer.

9. Select a bed and sound effect that could be used on a spot promoting a Halloween fun house.

10. Determine when a spot might be enhanced by precluding the use of a bed or sound effect.

11. Examine how a production studio stores its bed music and sound effects.

III PLANNING, MIXING, AND EDITING

11 Preproduction Planning

Prior to the actual mixdown of a piece of production there are several steps that must be taken: Copy must be written, delivery rehearsed, ingredients assembled, and the sequence for the use of equipment must be established. Effective preproduction planning saves time and guarantees results.

WRITING COPY

It has been stated that the type or nature of an account will suggest the approach to be taken in a spot. For example, a discount tire store would probably not use rhyming verse backed by a harpsichord unless, of course, it was taking a novel slant to the presentation of its message. The first step in the development of a spot is to get the words—the verbal message—right, and having knowledge of the sponsor's business or product is a distinct "advantage."

The nature of the radio medium imposes limits and specific demands on written copy. While this is not a text about copywriting, it is appropriate to examine aspects of writing that bear on the mixdown experience. There is a saying that good writing makes for good production, and there is truth to this, because poorly written copy can seldom be overcome by even the most brilliant mixdown.

There are some basic rules about style that should be observed when preparing radio copy:

1. *Use a conversational style.* Keep words simple and accessible. Writing for the air is quite different from writing for the printed page. Using language that is too formal or sophisticated may actually reduce the intelligibility of a script. Why? Because a broadcast message is fleeting and intangible. Listeners do not have time to linger over a broadcast text as they do with published material. Remember, the average radio commercial message lasts thirty or sixty seconds, and when it is over, it is gone, unlike the paper or magazine ad that may be reexamined and reread innumerable times.

In an earlier book by this author *(Production in Format Radio Handbook)*, the program director of WCKS-FM, Michael Lowe, offered the following advice: "Write like you talk, but maintain economy and direction. Avoid 'printese.' You can't write a spot like you write something for a newspaper. This is true of any kind of radio writing, actually. The listener does not have a chance to absorb formal language in a radio commercial, at least in most formats. Keep words within the realm of common usage."

Because a commercial is presented in real time, usually as listeners are involved in an activity, such as driving, it is wise to select words that will be immediately grasped. For instance, using the word *unfamiliar* would be preferable to the word *obscure*. It is not a matter of talking down to an audience, but rather talking in the most accessible style possible given the unique characteristics of the medium.

For this reason, too, information such as names, phone numbers, and addresses are often repeated. Again, a radio message is evanescent, and by repeating information, a listener has a better chance of retaining it.

2. *Grammar and syntax are no less important because copy is broadcast.* A misplaced modifier or comma can reduce the intelligibility of the spoken message by altering its meaning. In order to keep copy clear and direct, avoid complex sentence structure. The simple declarative sentence reaches the listener with greater efficacy than a sentence linked by a series of conjunctions. Copy does not have to read like a preschool text, but it should not emulate *War and Peace* either. Good sentence structure is the cornerstone of any piece of writing.

3. *Descriptions should be kept as simple and direct as possible.* For instance, here are two ways to say the same thing. It should be clear which would work best over the air:

DROP BY FINNIGAN'S LUMBER. TAKE CHARTLEY TO FOX. TURN LEFT AT THE LIGHT FOR ONE MILE TO BELDON AVENUE. TAKE A RIGHT TO 19 FISHER STREET. IF YOU'RE COMING FROM SOUTH MILLTOWN, HEAD NORTH ON . . .

or

DROP BY FINNIGAN'S LUMBER. WE'RE ACROSS FROM THE LIBRARY AT 19 FISHER STREET.

Using familiar landmarks when possible saves copy space and reduces listener confusion. Again, broadcast copy does not hang around for a leisurely interpretation. It must stick the first time, or its value is lost.

4. *Numbers should be kept to a minimum in radio copy.* For reasons already stated, numbers are hard to grasp and retain when presented over the airwaves. Again, a spot goes by quickly—that is why it is called a spot—and listeners are usually involved in activities that keep them from being fully attentive. A long list of numbers (for example, merchandise prices) seldom stays with a listener. Numbers are hard to assimilate when they are spoken.

When numbers appear in written copy they are condensed, or spelled out, for the sake of the announcer. An announcer is going to find it easier to read the phrase "155 THOUSAND" than the number "155,000." When dealing with large numbers in copy, this alpha/numeric approach aids in clarity and comprehension. Large numbers intimidate, if not baffle, most of us. Having a simple set of numbers (155) linked to a word (thousand) is easier to cope with.

5. *Difficult or unfamiliar words should be phoneticized.* Broadcasters have been spelling words the way they are pronounced since the beginning of radio. The important thing in radio is *saying* a word correctly, and words often do not sound the way they are formally spelled. Try announcing the following word: "FO'C'SLE." It is not easy if the word is not familiar. Thus, it is spelled phonetically as in the following line of commercial copy:

THE SEAFOOD AT THE FO'C'SLE (FOKE-SIL) RESTAURANT IS THE BEST CATCH IN TOWN.

Note that the word phoneticized is placed in parentheses immediately following the actual spelling of the word. Obviously the proper pronunciation of a word should be verified before it is phoneticized. Names tend to be the most problematical, and the best way to ascertain the accurate pronunciation of a particular word in a piece of copy or script is to consult the source of the word, which in most cases is the copywriter or the sponsor. The dictionary also reveals how a word is spoken, as in this example from *Webster's New World Dictionary:* "Fo'c'sle (fōk's'l)."

The way the word is phoneticized in the radio copy bears a strong resemblance to the way it is presented for speech in the dictionary. News wire services, such as Associated Press (AP) and United Press International (UPI), phoneticize uncommon words as a standard practice, and each provides subscribers with a daily pronunciation guide, which can be useful to a copywriter who may be incorporating current events into a piece of copy or script.

6. *Keep excessive and false claims out of commercial copy.* Making statements that are exaggerated and blown out of proportion can return to haunt everyone involved. Hyperbole reflects on the station as well as the advertiser. Remember, honesty always sells best. If an advertiser has a good product, all a copywriter needs to do is get that fact across to the listener. The same holds true for public service announcements.

Needless to say, radio copywriting is very demanding, and the preceding is little more than a brief introduction to some of the basics concerning style. (Many of these suggestions are repeated in Chapter 15 as a prelude to a discussion concerning the effects that formats have on copy preparation. Consult Suggested Further Reading for books devoted to radio writing.)

Copy Format

Two factors have a primary influence on the way a piece of copy actually looks: timing

FIGURE 11.1 Wire service pronunciation guide employing phonetic spelling. (Courtesy UPI.)

```
BBI.VXX. ZCUPIUPF

Z0328XXBI.
              D V WORLD-PRONO-GUIDE.0485
    -20-
   AOUN. MICHEL (MEE'-SHEHL AW-OON'), GENERAL, LEBANON MILITARY LEADER
   APARTHEID (UH-PAHR'-TAYT), RACIAL SEPARATION POLICY IN SOUTH AFRICA
   ARAFAT, YASSER (YAH'-SEHR AHR-AH-FAHT'). HEAD OF THE P-L-O
   BARCO. VIRGILIO (VEHR-HEE'-LEE-OH BAHR'-KOH). COLOMBIAN PRESIDENT
   BEIJING (BAY-JIHNG'). CHINA
   BERRI, NABIH, (NAH'-BEE BEH'-REE) SHIITE MOSLEM MILITIA LEADER IN
LEBANON
   COWPER (KOO'-PEHR). STEVE. ALASKA DEMOCRATIC GOVERNOR
   DENG XIAOPING (DUHNG HSEE-OW-PEENG). CHINESE LEADER
   FADLALLAH, AYATOLLAH MOHAMMED HUSSEIN (AH-YAH-TOH-LAH'
MOH-HAH'-MEHD HOO-SAYN' FAHD-LAH'-LAH). SPIRITUAL GUIDE OF THE HEZBOLLAH
   GORBACHEV. MIKHAIL (MEEK'-HIGH-YEHL GOHRB'-AH-CHAWF), SOVIET
PRESIDENT
   HEZBOLLAH (HEHZ-BOH'-LAH), ISLAMIC PARTY IN LEBANON (''PARTY OF
GOD'')
   JUMBLATT, WALID (WAH-LEED' JOOM-BLAHT'). LEBANESE DRUZE (DROOZ) AND
SOCIALIST LEADER
   MEDELLIN (MEHD-UH-LEEN') CARTEL, ILLEGAL DRUG ORGANIZATION NAMED
AFTER COLOMBIAN CITY
   OBEID. SHEIKH ABDUL KARIM (SHAYK AHB-DOOL KAH-REEM' OH-BAYD'),
KIDNAPPED BY ISRAEL
   PEREZ DE CUELLAR, JAVIER (HAH-VYEHR' PEH'-REHZ DEH KWEH'-YAHR), U-N
SECRETARY GENERAL
   RABIN, YITZHAK (YIHTS'-HAHK RAH-BEEN'). ISRAELI DEFENSE MINISTER
   RAFSANJANI. HASHEMI (HAH-SHEH'-MEE RAHF-SAHN-JAHN'-NEE), IRANIAN
PRESIDENT
   SHAMIR, YITZHAK (YIHTS'-HAHK SHAH-MEER'). ISRAELI PRIME MINISTER
   SHIITE (SHEE'-IGHT), MOSLEM SECT
   SRI LANKA (SREE LAHNK'-UH), FORMERLY CEYLON
   TIANANMEN (TYEHN-AHN-MEHN) SQUARE, THE CENTRAL SQUARE IN BEIJING
   TUTU (TOO'-TOO). DESMOND. BLACK ANGLICAN ARCHBISHOP IN SOUTH
AFRICA. RECIPIENT OF 1984 NOBEL PEACE PRIZE

POLISH POLITICS
   GEREMEK, BRONISLAW (BROH-NEE'-SWAHV GEH-REH'-MEHK), POLISH
PARLIAMENTARY CAUCUS CHAIRMAN
   JARUZELSKI. WOJCIECH (WOY'-CHEE-EHK YAHR'-UH-ZEHL'-SKEE), POLISH
PRESIDENT
   JOSWIAK, JERZY (YEHR'-ZEE YAHZ'-VEE-AK), POLISH DEMOCRATIC PARTY
LEADER
   KISZCZAK. CZESLAW (CHEHS'-WAHV KEESH'-CHAK), FORMER POLISH PRIME
MINISTER
   KURON, JACEK (YAH'-CHEHK KOOR'-UHN), SOLIDARITY DEPUTY AND ADVISER
TO SOLIDARITY LABOR COALITION
   MALINOWSKI (MAHL-IH-NUHF'-SKEE), ROMAN, POLISH PEASANT PARTY LEADER
   MAZOWIECKI. TADEUSZ (TUH-DEE'-OOSH MAH-ZOH-VYEHT'-SKEE) SOLIDARITY
EDITOR AND PRIME MINISTER-DESIGNATE
   RAKOWSKI. MIECZYSLAW (MEE'-SHEH-SWAHV RAH-KUHF'-SKEE), POLISH
COMMUNIST PARTY LEADER AND FORMER PRIME MINISTER
   WALESA. LECH (LEHK VAH-WEHN'-SAH), SOLIDARITY UNION LEADER

---------
UPI 08-20-89 04:34 AED
```

and readability. First of all, all copy is written to length, that is, it must fall within certain time limits—ten, fifteen, thirty, sixty seconds, and so on. How is this done? There are several methods. A copywriter may count words to ascertain length. For example, twenty-five words amount to approximately ten seconds of copy, sixty-five words produce a thirty-second spot, and one hundred and twenty-five words yield a one-minute announcement.

However, the most widely employed method for determining the length of copy involves counting lines (not sentences). Us-

140 PLANNING, MIXING, AND EDITING

FIGURE 11.2
The time consumed by sound effects and bed music are subtracted from the length of the spot, therefore reducing the amount of copy needed. (Courtesy KRXY.)

```
Y108
KRXY FM 108 AM 1600

CLIENT  WM DISTRIBUTING/ROBBIE NEVELL        FOR  EMI/MANHATTAN
AM____  FM  X   AIR DATES FROM ____ TO____ LENGTH :60 CART # 585

 1  BLUE SPRUCE BRINGS YOU GREAT SPRING SAVINGS WITH THE HOT NEW
 2  DEBUT RELEASE BY ROBBIE NEVELL, CALLED ROBBIE NEVELL, FROM
 3  EMI/MANHATTAN, NOW FOR SIX-TWENTY-NINE, CASSETTE OR LP!
 4  (MUSIC UP: "CEST LA VIE" - ROBBIE NEVELL)
 5  ROBBIE NEVELL, THE NEW, UP-AND-COMING ARTIST FROM EMI/MANHATTAN...
 6  YOU'LL WANT TO KEEP YOUR EYES AND EARS ON HIM...WITH HIS DEBUT
 7  ALBUM ROBBIE NEVELL.  PRODUCED BY ALEX SADKIN...THE TOP PRODUCER
 8  WHO'S BROUGHT YOU HITS BY THE THOMPSON TWINS, FOREIGNER, DURAN
 9  DURAN, SIMPLY RED AND MORE.
10  (MUSIC UP: "CEST LA VIE" - ROBBIE NEVELL)
11  ROBBIE NEVELL, A REKNOWNED SONGWRITER WHO'S WRITTEN HITS FOR
12  EL DEBARGE, THE POINTER SISTERS AND SHEENA EASTON, HAS A SURE
13  FIRE WINNER FOR HIMSELF WITH HIS DEBUT RELEASE ROBBIE NEVELL...
14  FEATURING THE TOP TEN SINGEL "CEST LA VIE"...AND THE NEW
15  SINGLE ON IT'S WAY TO THE TOP OF THE CHARTS, "DOMINOES".
16  (MUSIC UP: "DOMINOES" - ROBBIE NEVELL)
17  ROBBIE NEVELL'S DEBUT ALBUM, ROBBIE NEVELL, FROM EMI/MANHATTAN
18  FOR SIX-TWENTY-NINE, CASSETTE OR LP AT BLUE SPRUCE 27875 HIGHWAY
19  74 IN EVERGREEN, 1153 HIGHWAY 74 IN BERGEN PARK, AND 23697 CONIFER
20  ROAD IN ASPEN PARK!  (MUSIC OUT: "DOMINOES" - ROBBIE NEVELL)

THIS ANNOUNCEMENT WAS BROADCAST _____ TIMES, AS ENTERED IN THE STATION'S PROGRAM LOG.  THE
TIMES THIS ANNOUNCEMENT WAS BROADCAST WERE BILLED TO THIS STATION'S CLIENT ON OUR INVOICE(S)
NUMBERED/DATED _____ AT HIS EARNED RATE OF:

$_____ EACH FOR _____ ANNOUNCEMENTS, FOR A TOTAL OF $_____
$_____ EACH FOR _____ ANNOUNCEMENTS, FOR A TOTAL OF $_____
$_____ EACH FOR _____ ANNOUNCEMENTS, FOR A TOTAL OF $_____

                                        Signature of Station Official
                                        LESLIE K. HUGHES  CONTINUITY DIRECTOR KRXY AM/FM
(Notarize above)                        Typed Name and Title        Station
7075 West Hampden Avenue • Denver, Colorado 80227 • (303) 989-1075
```

ing one-inch margins on a standard-size (8½ × 11) piece of paper, a line of copy delivered at a normal pace comes out to roughly three seconds. Therefore, to write a thirty-second spot a copywriter would have to generate nine to ten lines of copy and double that for a sixty-second spot.

Of course, the use of sound effects and bed music may reduce the actual amount of copy needed. Should a spot incorporate three seconds of a car motor, two seconds of thunder, and four seconds of transitional bed music, a copywriter would only need to create sixteen to seventeen lines of copy

PREPRODUCTION PLANNING 141

to make a one-minute spot. The nine seconds allocated to sound effects and bed music are deducted from the one minute, leaving the copywriter with fifty-one seconds to fill.

For the sake of readability, copy is always double-spaced and typed in uppercase (capital) letters. Separating lines with a blank line makes copy easier to read, which is also the reason why all words are capitalized. Copy is always typed or word-processed. Handwritten copy is unacceptable for obvious reasons. Neatness also counts: no type-overs or line-outs, please.

Available Resources

A copywriter should be aware of any limitations that exist in the production studio. Putting something in a piece of copy that is not available in the studio creates obvious complications. Calling for bed music off a compact disc when there is no CD player is self-defeating. This seldom happens when the production director originates station copy, but it is apt to occur when copy is written by someone not involved at the actual mixdown stage—someone not directly involved in the studios.

Everyone who writes copy at a station should be aware of what equipment and mix ingredients exist in the production facility. To labor under the false assumption that something is available is to run the risk of losing valuable time, and, remember, the product of radio is time.

DELIVERY PREPARATION

An important step in the preproduction planning process is reviewing and rehearsing copy for delivery. Very few individuals can read copy cold and deliver it perfectly. Most announcers, including seasoned veterans, would not even attempt to tape a spot without first reading it over. A simple checklist that includes the following subsections can maximize delivery. These subsections—Interpretation, Articulation, Inflection, Pronunciation, and Voice Quality—are excerpted from the author's text *Broadcast Voice Performance,* which deal with preparing for a voice-tracking session.

FIGURE 11.3
Even seasoned pros rehearse copy delivery.

Interpretation

The importance of accurate interpretation of copy cannot be stressed enough. The experts emphasize the necessity of fully knowing and understanding the message before attempting a delivery. Cold readings seldom capture the essence of a commercial.

Misinterpretation often arises from a lack of familiarity with copy. In other words, the voice performer does not "deep" read a piece of copy before hitting the mic switch. A cursory reading is dangerous, even for old pros.

It is the obligation and responsibility of the copy performer to bring to the audience what the writer intended. This means reviewing written material and digesting its design and structure before attempting to communicate it over the airwaves.

Inexperienced voice performers frequently make the mistake of focusing exclusively on their "sound," not aware that how they sound is directly tied to the way they interpret copy. They read without "realizing." Put another way, they deliver copy ignorant of its meaning. The result is un-

conscious communication (though the word "communication" hardly fits), which rarely leaves a positive impression on the receiver.

A broadcast voice performer must work from the "center" out when interpreting a written message. Surface reading leaves meaning untouched. Involvement is necessary for effective delivery.

Articulation

How an announcer says something is as important as the plait, trellis, and weave of the voice itself. Proper articulation and enunciation add substance to the voice. *Webster's Dictionary* defines a person who is articulate as one who expresses himself or herself easily and clearly. Few people can achieve this state with clenched teeth, rigid jaw, or closed lips. It calls for movement and animation.

To begin with, a voice performer should take notice of how the mouth is utilized while speaking. Words are formed in the mouth and must be given enough room to take flight. Few words are understood when they are muttered. When not effectively constructed by the tongue, lips, jaw, words lose their import. Several excellent speech texts devote considerable print to the correct articulation of word components, such as consonants, vowels, and diphthongs.

To improve articulation and enunciation—practice! Emote. Be expressive, even deliberately dramatic, when vocalizing prior to actual taping or broadcast. Unclear speech, unless caused by a physical impediment, generally stems from deficient use or misapplication of the mouth and jaw muscles. Slurred or mumbled words are roadblocks to audience comprehension, and thus anathema to the broadcast voice performer.

Inflection

An announcer improves his or her "listenability" by varying tone and pitch. Moving the voice's pitch from low to high or vice versa creates color and conveys emotion.

To overcome a monotone delivery, voice performers are encouraged to tape record material (anything from a commercial or news story to a passage from *Hamlet* or a Neil Simon play) and assess it on playback. Repetitious or unvaried inflection can be overcome through awareness and work.

A word of caution: avoid exaggerated inflection. It sounds affected and pretentious.

Pronunciation

Inaccurate pronunciation of words reduces intelligibility, and if an announcer is unintelligible he serves no one.

Pronunciation problems can stem from several factors. Poor articulation of word parts (syllables, vowels, consonants) affects pronunciation. A lazy mouth (resulting in the slurring of words) cuts down on clear pronunciation. Effective articulation enhances pronunciation.

Perhaps the most common pronunciation problems stem from ignorance, that is, a lack of familiarity with a word or name. Announcers have a responsibility to broadcast with accuracy and must take every step possible to ensure that they are doing so. This means checking pronunciation when encountering strange and unfamiliar words. Guessing is not good enough. There is no excuse for not consulting a dictionary or another person concerning correct pronunciation.

Voice Quality

It is the goal of the professional broadcast announcer to maximize the listenability of his or her voice. Most people can cultivate their voices to a level that is pleasing and appealing to listeners.

There are numerous ways to improve voice quality, that is, to strengthen a weak or thin voice. For example, correct breathing helps enormously. Allow lungs to be replenished with oxygen after pauses. Do so in a gentle, rhythmic, and even manner. Do not gasp or force air into the lungs, but breathe in naturally and plentifully. The lack of oxygen when speaking accentuates voice quality deficits.

Become more aware (not self-conscious) of breathing—inhaling and exhaling. Determine the lung's capacity. The voice box, like a trumpet, is activated by the surge of air passing through it. Needless to say, the high notes of a trumpet cannot be reached without sufficient wind emanating from the player. The same can be said of the announcer. Shallow or uneven breathing af-

fects voice quality. Air fuels and enriches the voice.

Poor breathing may be linked to bad posture. Check posture while sitting in front of a microphone. Do not slouch or slump over or sit as taut as a military academy plebe. In these configurations the lungs and diaphragm are twisted and contorted. It is impossible to inhale deeply and fully when the torso is bent over. Sitting too rigidly or erectly tightens the diaphragm and tenses the muscles. Again, this inhibits free and natural breathing.

A relaxed voice sounds best, too. A nervous or agitated voice loses its depth, range, and texture. The voice has considerable range, but tension diminishes it. Performers must learn to relax before taping. There are several exercises useful in "loosening-up." Tightness in the neck or shoulders can be relieved by slowly rotating the upper body, including the head, for a minute or two. Casually flexing the shoulder muscles also helps, as does letting the jaw hang open loosely and shaking the arms. Breathing should be deep during this exercise. Some people find it helpful to keep their eyes shut while engaged in this routine. Plain old stretching exercises also aid in relaxation.

Pacing ("speed-of-read") should be monitored. Acceleration affects voice quality; the faster an announcer speaks, the higher his or her voice sounds. Create the environment most conducive to maximum voice quality. Rapid-fire delivery does little to enhance the natural qualities of a voice.

Delivery Checklist

In summation, before "keying the mic," review the criteria that constitute an effective delivery, and ask the following questions:

1. Is the voice properly primed so that the finest qualities it possesses will emerge in the delivery?
2. Is the message in the copy fully understandable?
3. Will all the words in the copy be completely intelligible when verbally conveyed?
4. Are words richly intoned or monotone?
5. Are there any doubts as to the accurate pronunciation of names and uncommon words?

Once these questions have been conscientiously addressed, hit the mic switch, and lay the track, as they say.

ASSEMBLING MIXDOWN INGREDIENTS

With the copy written and voice track recorded, it is time to collect whatever software is needed for mixdown. As indicated, at most stations both bed and sound effects material are close at hand, so it is a matter of locating what the copy specifically calls for. For the sake of clarification, let us return to K-LITE's production director, Jane Brown, who is to mix an announcement that requires two beds and two sound effects. The copy indicates one uptempo bed and another that is very soft and slow. Since the station's production studio has yet to go on-line with a computer, she searches the studio's index file for the music needed. Eventually she finds both beds, the index cards indicating the albums where they are found. In a couple of minutes, Jane has located the bed music. Next, sound effects must be collected for the mixdown. She thumbs through the alphabetized sound effects card file until locating what is cited in the copy. Within a few short minutes, all that is required of the mixdown has been assembled. Now the final stage of the preproduction process may be undertaken.

SEQUENCING AND SETUP

It must now be decided how to set up production elements for accessibility and ease of movement during multimachine mixdown. Production voice tracks, beds, and SFX are best arranged in a linear and logical order (working outward from the board or vice versa) based on the position or location of equipment. For instance, if Jane's spot—which includes a single voice track, two music beds, and two sound effects—were to be mixed in a U-shaped studio with equipment distributed proportionately on left and right, the following sequencing would be appropriate:

1. Music beds are cued up on both turntables. Jane designates the turntable on her right for the copy's first bed.

2. Both sound effects have been dubbed onto cart, since the studio has only two turntables, and the effects library is on vinyl. Besides, with the effects on cart, the production director has consolidated the movement they will require during actual mixdown. She places the sound effects cart into the right cart deck.

3. The voice track tape is threaded onto the left reel-to-reel machine. Her first impulse was to place the tape onto the right open reel machine, thereby confining all the production elements on one side. After some thought, she decided it might create some confusion to have everything clustered together.

4. The final element to be sequenced is the recording point. In this case, the spot is to be recorded onto a seventy-second cartridge. Jane places a clean (erased) cartridge into the left cart machine and presses the record button. This does not activate the machine, but simply places it into the correct mode prior to pressing the start button.

Based upon where the production ingredients appear in the copy, the mixdown would occur as follows:

1. Record cart start
2. Right turntable start
3. Left reel-to-reel start
4. Right cart start
5. Left turntable start
6. Right cart start

In effect, the copy asks that a bed be heard first, followed by announcer, a sound effect, a second bed, and a second sound effect. While this may appear relatively simple, the actual number of individual or separate movements occurring in sixty seconds is surprising to the uninitiated. A dozen movements will be required of the production director during this very brief span of time, and this is why intelligent sequencing is important. In a studio that may possess twenty or more pieces of equipment, deciding on what to use and where is a crucial activity. Organization is central to a smooth and effective mixdown. Here is the sequence of moves this particular mixdown would involve:

1. Start left (record) cart machine
2. Start right turntable (TT) (bed 1)
3. Start left reel-to-reel (RTR) (voice track)
4. Pot down right TT (bed 1)
5. Start right cart machine (SFX 1)
6. Start left TT (bed 2)
7. Pot out right TT (bed 1)
8. Pot down left TT (bed 2)
9. Start right cart machine (SFX 2)
10. Fade out left TT (bed 2)
11. Pot out left RTR (voice track)
12. Press stop and start buttons on left cart machine (record) for recue.

Remember, many audio consoles feature remote start/stop buttons. This eliminates the need for actual physical contact with equipment, but the sequence of the mixdown must be clearly established in the production director's mind, or a mismix is likely to occur, and that means starting over.

Incidentally, the preceding multimachine mixdown would be regarded as a fairly routine production job. Imagine how the number of movements would be compounded if, for example, the copy called for two voices, three beds, and five sound effects. Of course, multitrack recording would vastly simplify this process.

To reiterate what was stated at the beginning of this chapter, preproduction planning saves time and enhances results.

CHAPTER HIGHLIGHTS

1. Prior to actual mixdown, copy must be written, delivery rehearsed, ingredients assembled, and the sequence of equipment use established.

2. Effective copy begins with an understanding of the sponsor's product and clientele. When preparing copy:

a. Use a conversational style; select words that will be immediately grasped.

b. Key information must be repeated to ensure listener retention.

c. Use simple declarative sentences, with proper grammar and syntax.

d. Keep descriptions and directions simple.

e. Numbers should be kept to a minimum because they are hard to grasp and retain when spoken. On written copy, an alpha/numeric presentation (e.g., "155 THOUSAND") aids the announcer.

f. Difficult or unfamiliar words should be phoneticized.

g. Keep excessive and false claims out of commercial copy.

3. All copy is written to length; it must fall within certain time limits, after deductions are made for time devoted exclusively to sound effects or bed music.

4. Using 6½-inch wide lines, each line of typewritten copy delivered at a normal pace takes about three seconds. Nine-to-ten lines equals a thirty-second spot.

5. Copy is always double-spaced and typed in uppercase (all capital) letters.

6. A copywriter should only request mixdown elements within the capabilities of the production facility.

7. It is the obligation of the copy performer to bring to the audience what the writer intended. This requires reviewing copy and digesting its design and structure before attempting to communicate it.

8. Proper articulation and enunciation add substance to the voice, and they are only mastered through considerable practice.

9. An announcer must vary pitch and tone to avoid a monotonal presentation. However, exaggerated inflection sounds affected.

10. Avoid such common pronunciation problems as poor articulation, lazy mouth (slurring), and lack of familiarity with a word or name.

11. Voice quality can be improved by proper breathing techniques, correct posture, relaxation prior to announcing, and steady pacing of the delivery.

12. Once the copy is written and the voice track is recorded, the remaining mixdown elements (e.g., music beds, sound effects) should be assembled.

13. In a studio that may possess twenty or more pieces of equipment, deciding what to use and where is a crucial activity to ensure accessibility and ease of movement. Organization is central to a smooth and effective mixdown.

SPOT ASSIGNMENTS

1. Listen carefully to the commercials that are aired during a one-hour period on a local radio station, and keep count of the number of thirty's and sixty's broadcast.

2. Prepare a thirty-second commercial that includes five seconds of sound effects.

3. Analyze your choice of words to ascertain their relatability level.

4. Check copy for proper pronunciation and syntax, and phoneticize words that are difficult to pronounce.

5. Rehearse the delivery of the commercial assessing your voice quality, interpretation, articulation, inflection, and pronunciation.

6. Based upon the studio equipment available to you, sequence the elements of the spot for mixdown.

7. Determine how many actual moves it will take to produce your spot.

8. Consider how your mix would be simplified with multitrack recording equipment.

12 Mixing Time

This chapter details a step-by-step examination of what is involved in the mixdown of a commercial, such as Jane Brown's sixty-second spot described in the previous chapter. To mix the single voice, two bed, two sound effect spot, the production director must use six pieces of studio equipment: audio console, reel-to-reel machine, two turntables, and two cartridge machines. Here is what takes place at each equipment point.

AUDIO CONSOLE

There are two things that must be checked at the console point before commencing mixdown. Obviously, the power switch must be on. At most stations, studio boards are kept activated or powered continuously, so nothing needs to be done in this regard, unless the console is off.

As already discussed in Chapter 5, in order for audio to be heard, the monitor speakers must be brought into the board via their input switch and gain control.

Once these things have been done, the production person may move on to the next piece of equipment to be used in the mixdown. Of course, the board is directly affected by the involvement of each piece of equipment.

REEL-TO-REEL MACHINE

The voice track tape must be, to use the vernacular, "racked up," that is, placed onto the feed transport deck and threaded over to the empty take-up reel. It is important that the tape is not twisted (the recording surface must make contact with the machine's heads), and it must be lined up carefully, too. If the tape does not make proper contact with the magnetic heads, playback will be affected.

Once the tape has been wound around the hub of the take-up reel, extraneous tape is drawn in to avoid tail-hang, which can snap tape during fast forward and rewind. This point was made in Chapter 6 but bears repeating.

With the tape correctly threaded, the voice track must then be located. This may be accomplished several ways:

1. Leader tape may be used. It provides a producer with a visual cue. Approximately two feet of leader tape are spliced onto the voice tape just before each track. Leader is made of plastic, comes in a variety of colors, including clear, and is the same width as magnetic tape. While a very effective way to locate tracks or cuts, the use of leader tape involves time, and it also requires that tape be physically altered. Some production people are reluctant to cut into tape for this purpose. "You can overcut tape and end up with something not too useful. A voice track work tape that is all chopped up creates obvious problems," observes WROR's Joe Cortese.

2. Many, if not most, broadcast-quality open reel machines feature digital counters that measure the depth or passage of tape either in terms of real time or footage. For example, at the standard broadcast speed of 7½ IPS, a time counter would indicate "10 secs" when seventy-five inches of tape has moved across the heads. Conversely, a counter that measures feet would reveal that 6.3 feet of tape have been transported to the take-up reel. In either case, the producer may maintain a record of where the counter is when the voice track is cued, thereby ensuring quick and easy access during mixdown. Many machines have memory (auto-locator or search-to-cue), which allows the production person to program cues. With this, the recorder will automatically return to preset points established by the production person.

3. A less scientific or foolproof technique for locating a cut involves simply inserting a tiny piece of paper between the tape at the cue position. This method, although widely practiced, is not highly recom-

mended for reasons easily imagined. For one thing, when the machine is in the fast forward or rewind mode, the reels move at very high speed, and unless an operator has extremely fast reflexes the marker will fly out of the tape before the machine can be stopped, thus requiring that a hunt for the voice track be undertaken anyway. Other reasons to avoid using this method are that the paper may become jammed in a part of the machine or may even cause the tape to snap.

4. Maybe the most common approach to locating recorded material on an open reel deck is listening, and this requires the participation of the audio console. In order to hear what is on the voice track reel using the studio monitors, the reel-to-reel machine must be routed into the board through the appropriate input and fader. At the same time, the reel-to-reel itself must be set up for playback (output). As stated in Chapter 6, in order to play back what is on a tape, the record (input) button must be disengaged and the playback (output) button engaged. In more confusing but intriguing terms, this could be stated: Take out the input and put in the output. Huh?! Next, open the output pot so that current is fed to the board. At the board's reel-to-reel input, open the fader until the desired level is obtained. Remember, the monitor (gain control) pot also affects the volume of loudness emanating from the studio speakers, so do not pin the V.U. meter needle, or distortion will result. To locate the voice track from this point on it is a matter of engaging the reel machine's fast forward mode and listening. Most machines have a cue lever, which allows the tape to make contact with the heads in fast forward or rewind. When this is the case, the cue lever must be engaged or nothing will be heard. As stated before, this feature is designed to reduce the wear and tear on the heads as much as it is to help a production person locate a cut.

Once the cut has been located, a mixdown level must be established on the board's V.U. meter. While the levels of other components (beds, SFX) of the mixdown will be adjusted (raised or lowered) during the sixty seconds that it takes to record the spot, the voice track level will remain constant. After the level is set, the production person will recue the tape so that it is ready for roll.

FIGURE 12.1
Audio console power switch.

TURNTABLE

Since the sound effects have already been dubbed to cart, the albums containing the bed music may be cued up. The production person has placed the first bed on the right turntable and the second on the left turntable. Both turntables have been set to roll at 33⅓ rpm. The first bed is the fourth cut on the album. The production person—for the sake of our example we will return to K-LITE's Jane Brown—starts the turntable

FIGURE 12.2
Leader tape is primarily used to help locate tracks on a reel of tape.

and lifts the tone arm from its resting place, setting it down in the vicinity (between the grooves of the third and fourth cuts) of the cut to be used. Meanwhile, the right turntable input and fader on the console have been opened so that a level may be established. Once this is accomplished, the cut is cued by moving the disc (counterclockwise) approximately a fifth of a turn away from the stylus at the moment audio (music) is detected. At this moment, while restraining the record by pressing the fingers against its outside edge (not the surface), the power to the turntable is shut off. Bed one is cued and ready for roll. The turntable pot has been left open at the level desired.

Jane Brown now turns her attention to the left turntable and the second bed, which is on side B of the album, three cuts in. To her chagrin she finds that the cut needed has been damaged by *cue burn.* Cue burn occurs when the turntable needle has been moved across the opening grooves of an album cut to excess. The grooves are simply broken down, producing a crackling sound. Jane finds that she can extract what is needed by going into the cut some thirty seconds. This, however, will require very careful cueing, perhaps slip-cueing. Before the cue is set, she gets her level. This achieved, she decides to dead-roll the cut. This involves a carefully timed roll-back to prevent wowing when the bed is introduced into the mixdown. In this case, the left turntable input fader is kept down until the bed is called for. At that time, the fader is opened to the established level a microsecond after the turntable is activated. Having decided on the exact point from which to dead-roll, Jane turns off the turntable and directs her attention to the next mixdown element.

PLAYBACK CART MACHINE

The cartridge containing the two sound effects is placed into the right cart machine. When it is in place, the stop button lights up, indicating to the production person that the cart is ready to be played.

As with the other elements, an appropriate mixdown level must be established; thus the right cart machine board input and fader are opened. Jane presses the start button, and the first sound effect pours from the studio monitors. She sets a level.

Within a couple of seconds after the first effect, the cart machine stops, indicating that the next sound effect is cued and ready to be played. It is played, and a level for it is also ascertained. The second effect turns out to be about ten percent louder than the first, so during mixdown she must make an adjustment so that this effect is not perceptibly hotter than the surrounding audio.

After the second effect is played, the cartridge recues to the first sound effect and stops. It is ready for inclusion in the mixdown.

FIGURE 12.3 Production person setting level on bed music to be incorporated into mixdown. (Courtesy Broadcast Audio Corporation.)

FIGURE 12.4 Playback-only cart machine to be used in mixdown. (Courtesy Broadcast Electronics.)

RECORD CART MACHINE

The cartridge onto which the sixty-second commercial will be recorded is placed into the left cart machine, and the record button is pressed. The left cart machine board input must be out (disengaged) or feedback may be recorded. With this last step, the conditions are set for mixdown. Jane gathers up her energy and concentration and begins mixdown.

POSTMIXDOWN

In 59.5 seconds the spot is recorded onto cart. The first mixdown is a "take." No problems. Everything falls into place perfectly. Jane is satisfied, but playback will tell the whole story. Often things are heard on playback that are not detected during the actual mixdown, which can be a frenetic experience.

Her impression of the mixdown is confirmed on playback. The spot is "in the can," as they say. She prepares a label and places it on the cartridge, and it is added to the stack of carts awaiting delivery to the control room at day's end.

Meanwhile, the machines must be cleared for the next production job. Jane removes the bed music albums from the turntables and returns them to their places on the shelves. The sound effects cartridge is taken from the machine and demagnetized so that it is ready for future use. She returns it to the cart bin, placing it in the section for seventy-second cartridges.

Finally, the voice track tape is removed from the reel-to-reel machine. At this particular station, a master tape is not maintained, so nothing is saved—except for copy, which is filed. The carted spot may be held a certain length of time after its airing, depending on instructions from the salesperson. The reel is returned to the shelf designated for work tapes.

Before Jane moves on to another assignment, she cleans the heads on the tape machines.

TIMING ELEMENTS

The preceding commercial consisted of three basic elements: voice, beds, and effects. All total, there were five components to the spot: a voice track, two beds, and two sound effects. Each was timed so that the spot would add up to close to 60 seconds—in this case 59.5 seconds. As it was written, the copy allowed for 7 seconds' worth of inserts, which appear as follows: SFX one (2 seconds), bed two (2 seconds), and SFX two (3 seconds).

The voice track announcer, George Lopez, had to deliver the copy in 53 seconds for it to time-out to a sixty. In order to allow for the insertion of the production components, he paused for the time specified after each bed and sound effect. Thus Jane ended up with a 52.5-second voice track with three timed insert points.

The spot opened with bed one and the voice rolling simultaneously. Seven seconds into the voice track was the 2-second pause for the first sound effect. Twenty-two seconds into the voice track was the 2-second pause for the introduction of the second bed, and 39 seconds into the voice track was the final pause—3 seconds for the second sound effect. The spot ended cold, that is, with the second bed faded out on the last few words of the copy.

The time required of each production component breaks down as follows:

FIGURE 12.5
A label is placed on the cart of the finished product.

FIGURE 12.6
Digital timers. (Courtesy Autogram.)

Model 200C (Panel Mount)

Model 200D (Stand Alone Cabinet)

FIGURE 12.7
Graphic representation of mixdown elements in a sixty-second commercial.

Time	Music	SFX	Copy
00:00	Bed 1		"GOING TO A CAR..."
00:07		Squeal of car brakes	
00:22	Bed 2		
00:24			"FOR A WORLD OF..."
00:39		Car ignition	

1. Bed one: 22 seconds. The bed was maintained under the voice even as the first sound effect was entered into the mix.

2. SFX one: 5 seconds. The sound effect was established for 2 seconds and then potted under the voice track for an additional 3 seconds.

3. Bed two: 36.5 seconds. The second bed was established for 2 seconds and ran under the voice to its fade-out point 1 second before the last word of copy.

4. SFX two: 3 seconds. Established up and out.

A commercial is a body of time. Dissected, this spot appears like this:

Voice track: 52.5 seconds (7 seconds to pause, 22 seconds to pause, 39 seconds to pause)
Bed one: 22 seconds (under 22 seconds)
SFX one: 5 seconds (up 2 seconds and under 3 seconds)
Bed two: 36.5 seconds (up 2 seconds and under 34.5 seconds)
SFX two: 3 seconds (up 3 seconds)

When Jane assembled the components of the spot, she timed each so that they would fit the copy. In general, the copywriters contact production people to determine the length of sound effects, so that they know how much actual copy to write. Again, the amount of time consumed by beds and effects has a direct impact on how much copy is written—52.5 seconds of copy (voice), 2 seconds of bed music, and 5 seconds of SFX equal a 59.5 second commercial.

It seems fitting to conclude this chapter with the following quote from Sir Francis Bacon: "To choose time is to save time."

CHAPTER HIGHLIGHTS

1. Before using the audio console, be sure the power switch is on. Input the monitor speakers and set their level with the appropriate gain control.

2. When racking up a tape on a reel-to-reel machine, be sure the tape is not twisted or misaligned, so the recording surface makes proper contact with the machine's heads.

3. There are several methods for quickly locating a track on a reel of tape:
 a. Splice about two feet of leader tape (clear or color-coded) just before each cut to be used on the reel.
 b. Use the digital counter to cue each cut. If the machine has a memory (autolocator or search-to-cue), the recorder will automatically return to preset cue points.
 c. Although not advised, some producers place a tiny piece of paper between the tape at cue positions.
 d. Listen.

4. Regardless how the cue points on the reel of tape are pinpointed, the tracks must be played through the board so proper levels can be established before use. While the levels of other components (beds, SFX) of the mixdown will be adjusted (raised or lowered) during the recording process, the voice track level will remain constant.

5. Once bed music has been properly leveled and cued, the turntable pot should be left open at the desired level so the music may be input instantly. However, if the music must be dead-rolled from within the cut, rather than at the beginning, the pot must be kept down until a microsecond after the turntable is activated, then opened to the established level.

6. When a cart in a cartridge machine is ready to play, the stop button lights up. Levels for each element on the cart must be separately established so the final mixdown sounds consistent. That means the production person may need to change the cart machine pot level after each cut is played.

7. When recording to a cart machine, the board input for that machine must be disengaged to avoid feedback or (in some cases) reverb.

8. When the mixdown is a take (acceptable as is, "in the can"), the production person is responsible for returning all of the mixdown elements (albums, effects, and so forth) to their proper places, for erasing and filing all tapes and carts, as well as for properly labeling the finished cart.

SPOT ASSIGNMENTS

1. Determine if the console power switch is left on all the time.

2. Disengage (neutralize) all inputs and pots on the audio console, and place all faders at zero.

3. Set up board so that the turntables may be heard through the studio loud speakers.

4. Place albums on turntables and segue from one to the other.

5. Locate and time two beds that might be used in a sixty-second commercial.

6. Set up the board so that a reel-to-reel machine may be heard through the studio speakers.

7. How many record/playback cart machines are available in your studio?

8. Rack up a used reel of seven-inch magnetic tape, and time the first cut of audio you encounter.

9. Engage the cue arm of the open reel deck, and press *fast forward*. Count the number of cuts on the tape.

10. Locate the third and seventh cuts on a reel of tape.

11. Dub one thirty-second bed onto a cartridge.

12. Set up the board so that the carted bed may be played back through the studio speakers.

13. Erase the cart and record two sound effects onto it. Check to make sure the cart machine input on the board is disengaged.

14. Examine the digital counter on the studio's open reel decks. Do they have an auto-locator feature?

15. How many lines of copy would be written for a sixty-second announcement containing five seconds of SFX and a three-second transitional bed?

13 Editing

In Chapter 4, editing was discussed within the context of aesthetics, since many production people feel that sophisticated editing is an art form. While this may be true, editing is also a part of the production room experience for very practical reasons. In this chapter, both the mechanics and the aesthetics of editing will be examined.

PURPOSE OF EDITING

Tape is edited for a variety of reasons. Here are a few common situations that require editing:

1. Words that date a piece of copy must be removed. Rather than recut a spot that was voiced by an announcer who is unavailable, the production director determines that by eliminating the words "STARTING NEXT TUESDAY" the copy will be airable.
2. At the point where the words are removed, the production director decides to add, for embellishment, two seconds of applause. He or she records the applause sound on a separate tape and splices it onto the voice track.
3. Later in the day, the production director discovers that a commercial received from an outside source runs long. At sixty-three seconds it cannot be carted, since the station has a policy that forbids the broadcast of spots exceeding sixty-one seconds. He or she has a few options: (1) return the spot to the salesperson, requesting a replacement; (2) shorten the spot by using the variable speed control on the reel-to-reel machine; or (3) cut the words "THAT NUMBER ONCE AGAIN IS." By opting for cutting these five words, the spot times-out to exactly sixty-one seconds.
4. A salesperson has requested that dubs of a spot be sent to two other stations. In preparing the copies for distribution, the production director adds two feet of leader tape at the beginning of both five-inch reels. This is a common practice. It not only looks professional but safeguards the dubs located near the front of the tape. The leader tape will prevent the recorded material from being damaged.
5. Seldom does a day go by when the production director does not have to repair a tape that has snapped for one reason or another. (This is one of the more simple editing tasks facing a production person.)

There are countless reasons why tape is edited, but the preceding are among the more familiar to production people. In the instances cited above, editing was used to update copy, add a production element to a spot, shorten the length of a commercial, add leader tape to two outgoing dubs, and repair snapped tape. This is the kind of editing that takes place during the course of a routine production day.

EDITING/SPLICING

For the sake of clarification, the terms *editing* and *splicing* should be defined. They are frequently used interchangeably, but they really have two distinct meanings. When a tape is edited, its recorded surface is altered in some way, as in the instance above when the production director was forced to eliminate the words "STARTING NEXT TUESDAY" from a voice track. Editing changes the sequence or arrangement of audio. Recorded material is edited from a track by removing a piece of tape with a razor. The two ends of the tape are then reunited or reconnected through the act of splicing. Thus, an edit is invariably followed by a splice. "You cut, you patch," notes radio producer Fred Curtis.

Of course, when editing is accomplished electronically or digitally (which will be discussed later in this chapter), the mechanical splicing stage is eliminated.

EDITING 153

TOOLS OF THE EDIT

In order to perform an edit or to splice tape, the following items are necessary: single-edge razor blade, splicing tape, grease pencil, and edit block.

Razor

A single-edge razor blade is used (a double-edge razor can cause bodily harm and, therefore, should never be used for this purpose). Razors may be purchased through audio supply houses or at hardware stores. (Since painters use single-edge razors to clean paint from surfaces, they also may be acquired at most paint stores.) Razor blades generally come wrapped to protect users, and it is a good practice to rewrap a razor after each use.

Razors become dull after a certain amount of use. Attempting to cut tape with a dull razor leads to problems. Razors are inexpensive, so it is anything but extravagant to retire a blade after a couple of dozen cuts.

A word of caution: razors should not be left lying around the studio when they are not in use. An unattended blade can cause damage to both equipment and people and for this reason should be stored in a designated area.

Splicing Tape

In order to reconnect magnetic recording tape, a special adhesive is used. Splicing tape, as it is called, is available in most audio supply stores and comes in two forms: precut and spool. This specially designed tape is the only type adequate for the bonding of magnetic tape; standard adhesives, like Scotch Tape, do not possess the qualities necessary. For instance, splicing tape is manufactured in sizes that perfectly fit the width of recording tape—¼, ½, 1, and 2 inches. Actually the width of splicing tape is slightly less than that of magnetic tape so that it fits more snugly. For example, splicing tape for ¼-inch magnetic tape is ⁷⁄₃₂ of an inch wide.

While precut tape makes splicing somewhat easier, it is very costly compared to spooled tape. For this reason most stations use the latter, which is placed in a dispenser that features a serrated edge for cutting.

Grease Pencil

When tape is edited, the point of the cut needs to be marked. Since the tape is moved from the playback head to the edit block during this process, the point at which the cut is to be made must be accented for reference, or it will likely be misplaced.

A grease pencil (also called a China marker) allows edit marking to take place without damage to the recording tape or heads. The soft tip of the grease pencil makes it the only utensil appropriate for this purpose.

Grease pencils are available in most art supply stores and often can be found in office supply stores as well. Light colored grease pencils are used to provide a contrast with the dark surface of magnetic recording tape.

Edit Block

Tape is cut on an edit block (also called a splice, cutting, or chopping block). Most reel-to-reel machines possess an edit block, which is usually affixed to the head cover. Edit blocks are generally difficult to acquire through retail outlets, so stations must re-

FIGURE 13.1
Splicing tape in a dispenser.

FIGURE 13.2
China marker used in manual editing.

FIGURE 13.3
A worn edit block can make getting a clean cut next to impossible.

sort to broadcast supply houses. Edit blocks must be replaced after extensive use, since the cutting areas become worn and damaged, resulting in jagged and uneven incisions.

THE EDIT

For the purpose of illustrating the editing experience, the following scenario is offered: K-HITS's production director, Cedric Hall, must eliminate the words "ALL-WOOL SWEATERS REDUCED TO $14.95" from the following voice track excerpt:

BARTON'S SLASHES PRICES TO SAVE YOU MONEY. LISTEN! DRESS SHIRTS REGULARLY $19.99 NOW $12.99, PERMANENT PRESS SLACKS $29.99 NOW $16.99, ALL-WOOL SWEATERS REDUCED TO $14.95, AND SPORTS JACKETS PRICED AS LOW AS $39.95.

The first step is to locate this passage of audio—to get a bead, so to speak, on its exact physical location. Once the section has been played back, Cedric rewinds the tape to its beginning. Now he must target the cut. He runs past the first few words of the passage several times to get a feel for the edit and then finally positions the tape at the exact point where the first cut will be made. Resting against the machine's playback head is the space between the words "16.99" and "ALL-WOOL." If the recorded copy could be visualized, it would be seen positioned against the playback head as in Figure 13.4.

With a grease pencil, he marks the tape against the playback head. Marking the tape at another head (erase or record) would result in the cut being made well past the desired edit point. When marking the tape, Cedric is careful not to make contact with the head itself. It is important, however, to make a clear and distinctive mark on the tape, or the point of the cut may be lost. This may be accomplished without covering a vast surface, or "globbing on," the grease pencil.

FIGURE 13.4 Words visualized against the playback head of the reel-to-reel machine.

It is standard practice at most stations to clean tape heads after extensive editing. There is little else that dirties or gums up heads more effectively than grease pencil, and no matter how careful a production person may be, grease particles inevitably remain behind.

When the production director at K-HITS marks the tape, he does so at a point exactly midway between the words "$16.99" and "ALL-WOOL." He does this to preserve the natural pacing, or breathing, of the delivery. Making a cut exactly after the last syllable of the word "NINETY-NINE" and directly in front of "ALL" would sound abrupt and clipped. It would reveal the edit, because it would not sound natural. Visualize the difference in Figure 13.4. The goal is to preserve the integrity of the delivery's rhythm and pacing.

Cedric must now mark the second point of incision, which happens to fall between the words "$14.99" and "AND."

After marking for the edit, he draws tape from the reels so that he will have necessary slack when removing the unwanted copy between the grease marks. He now moves the tape away from the head area to the editing block.

The next step involves the actual cutting of the tape. Cedric places the part of the tape containing the first grease mark into the recessed track of the edit block directly across the diagonal groove. The tape is cut diagonally because this produces a strong and clean edit. (See Figure 13.5.)

When making the cut, Cedric moves the razor blade through the tape and diagonal groove in a steady and fluid motion. This prevents pulling and tearing, which can occur as the result of an abrupt movement. (Never hack away at the tape.)

After the first cut, the production director locates the second grease mark and repeats the procedure. Rather than discarding the extracted tape, he places it off to the side until he ascertains whether the edit was a success. If he has miscalculated and cut the tape at the wrong place, he can always splice it back onto the reel and make another attempt.

The two ends of tape must now be connected. This is done by placing both ends in the cutting block track and moving them together until they make contact. The idea is to butt the ends so that there is no gap or overlap; the ends must be perfectly flush. If the splice is made with the tape overlapping, problems may ensue. For instance, the overlapping tape may catch onto a part of the machine—head assembly area, tension arms, etc.—and cause the splice to come apart. Meanwhile, a splice with a gap between the tape ends can produce an unwanted audio response, such as clicking or dropout.

K-HITS' production director connects the tape so that there is neither overlap or gap, and now he must splice the ends together. From the spool in the dispenser he draws approximately three-quarters of an inch of splicing tape. Using too much tape or too little tape creates the potential for problems. Placing a long strip of splicing tape onto magnetic tape reduces its suppleness (its ability to bend and make full and adequate contact with the heads). This is especially true over a long period of time when the splice adhesive may harden and grow stiff. Figure 13.8 illustrates what may happen in this case.

Conversely, using too little splicing tape significantly increases the potential for breakage. Simply put, the splice will come

FIGURE 13.5
The diagonal groove is used more frequently than the vertical groove, which is used for especially tight cuts. Manual editing requires the use of a single-edge razor blade.

FIGURE 13.6
Do not discard extracted tape until it is determined whether or not the edit works.

apart when there is not enough tape to hold it together. Three-quarters of an inch of splicing tape is about the right size to prevent either of these mishaps.

Cedric carefully places the splicing tape over the point at which both ends meet. He makes certain that the splicing tape is centered so that there is an even amount of adhesive on both sides of the diagonal cut. He checks again to make certain he is placing the splicing tape on the nonrecording side of the magnetic tape. It is possible for tape to become twisted during this procedure, so it is wise to double-check.

Once the splicing tape is in place, he removes any air trapped between the adhesive and recording tape by gently rubbing the back surface of the splice. Cedric has aligned the splicing tape in such a way that there is no overhang. Misaligned splicing tape is another potential cause of trouble, because overhanging tape may adhere to the surface of the machine, causing breakage. The adhesive also may leave a sticky residue on anything with which it makes contact—usually the heads.

The splicing accomplished, the tape is carefully removed from the track of the edit block. Again, an abrupt tug may cause the tape to snap.

The production director will now listen to the results of his work. In order to do this, he returns the tape to the head area, and reels slack in so that full contact is made. The play button is pressed, and, to the production director's satisfaction, the outcome is a success. The revised spot may be carted.

For editing that involves the removal of a

FIGURE 13.7
Avoid overlapping and gapped tape.

FIGURE 13.8
Too much splicing tape may cause problems, such as incomplete contact with the heads.

158 PLANNING, MIXING, AND EDITING

FIGURE 13.9
Splicing tape must be properly aligned to avoid overhang.

FIGURE 13.10
The edit mode is useful when cutting a large amount of tape from a reel.

substantial amount of tape, K-HITS's production chief would use the reel machine's *edit* button. This feature is especially handy for this purpose. In the preceding illustration, only a couple of feet of tape were removed, because the passage deleted consisted of just a few words. In the case where a large section of voiced copy is to be eliminated, several feet may need to be extracted. This makes moving from the first edit mark to the second quite awkward, as the tape between the two points must be drawn from the reels in order to be accessed and cut. To do this, the first mark must be relocated and then the second mark must be manually drawn from the feed reel.

This is a slow and arduous process. Thus the edit button is employed. Should Cedric need to remove ten feet of tape from the reel, he has only to make a cut at the first mark, turn on the edit switch, draw enough tape from the feed reel and run it between the machine's capstan and pinch-roller, and press the play button. The cut end rolls freely from the machine at playback speed. When the second edit mark crosses the head, the machine may be stopped and the edit undertaken.

As was mentioned in Chapter 2, recording over splices is best avoided. After a period of time, even the cleanest splices exhibit fatigue, and this will become evident on playback.

RAZORLESS EDITING

Not all editing is done with a razor and splicing tape. In the 1990s, in many sectors the conventional approach to editing tape

is losing ground to "non-destructive" digital and multitrack methods. However, even those stations without the means to totally abandon the old "chop and glue" technique of editing have another option available—electronic editing. Electronic editing eliminates the need for physical contact with the tape. The components of a spot may be assembled or inserted by dubbing from a source unit to a record unit.

Assemble editing involves the sequential recording of elements or ingredients. For instance, suppose that a spot calls for three sound effects, two beds, and a stinger, and these are recorded onto a master tape in the order in which they appear. To accomplish an assemble edit, the production person merely dubs an element onto the master tape, presses the tape machine's pause button (when the dub is recorded) and repeats this same procedure until the spot is fully composed, or assembled.

Insert editing involves recording a component of a mixdown into an area of a finished spot. For example, a producer wishes to replace the sounds of one type of chimes with another set of chimes at a point twenty-six seconds into the mix. This may be done by recording over the old track with the new. That is to say, the old sound effect is replaced with the new by inserting the new one within the exact space occupied by the old effect. This kind of editing is very exacting, and the danger of damaging other parts of the mixdown is very real. A slight miscalculation, and irreparable harm can be done to a spot.

Multitrack editing is another form of razorless or electronic editing. In multitrack editing a production ingredient is added to (or eliminated from) a separate track. For example, in contrast to the insert editing of new chimes discussed above, a production person using this method of editing will record the new sound effect onto an available track, perhaps even over the old effect, and then roll the track when called for in the mixdown.

Digital audio workstations, which rely on computer technology, are currently used in many production houses and on the network radio level. This tapeless approach involves loading audio—either analog or digital—into a RAM or hard disc and making edits via a monitor (with the aid of a mouse or keyboard). While this technology is presently quite costly, and therefore not viable for many stations, it is making some inroads into major market production studios.

At the rate that electronic editing forms are being embraced by production directors, it is fairly safe to assume that the razor blade will eventually achieve the status of an artifact. The days of physical editing appear to be numbered, although this mode currently remains the most prevalent form of tape editing in the industry.

CHAPTER HIGHLIGHTS

1. Editing is the process by which material may be added to or deleted from a previously recorded audio tape, without having to rerecord the entire production piece. Manual editing involves cutting the original tape to remove a portion or to insert a piece of recorded tape. Reconnecting the two ends of the cut tape is called splicing.

2. The proper tools for manual editing include a single-edge razor blade, splicing tape, a grease pencil (China marker), and a cutting (edit) block. Splicing tape comes in special widths to conform with varied audio tape widths, and it possesses a special adhesive to assure a permanent bond of the spliced tape ends. The grease pencil will

FIGURE 13.11
Assemble editing involves inputting source machines to a record unit with a pause mode.

FIGURE 13.12
Insert editing on standard two-channel reel-to-reel machines involves recording the new element directly over the surface of the old element. Here a new SFX is recorded over an old SFX.

160 PLANNING, MIXING, AND EDITING

Track 1	VOICE
Track 2	BED #1
Track 3	SFX
Track 4	BED #2

Before

Track 1	VOICE
Track 2	BED #1
Track 3	SFX #1
Track 4	SFX #2

After

FIGURE 13.13
Editing in multitrack involves adding or deleting tracks. Here BED 2 is replaced by SFX 2 on track 4.

not damage magnetic tape or the tape heads, and it is available in light colors to contrast sharply with the tape. The metal edit block is either a part of the reel-to-reel machine or affixed to the countertop near the machine.

3. Electronic editing takes several forms and eliminates the need for mechanical splicing. Assemble editing involves sequentially dubbing the elements of a spot from source machines to a record unit with a pause mode. Insert editing requires recording the new element directly over the surface of the element to be replaced. In multitrack editing a production ingredient is added to (or eliminated from) a separate track, which is then incorporated into a mixdown.

4. Digital audio workstations rely on computer technology. This tapeless approach involves loading audio (either analog or digital) into a RAM or hard disc, then making edits via a monitor with the aid of a mouse or keyboard.

SPOT ASSIGNMENTS

1. Record a line of copy, and select a word to edit from it.

2. Locate the first cut point, and mark the tape.

3. Make the second cut mark, and remove the section of tape using diagonal incisions.

4. Splice the ends of the tape together using three-quarters of an inch of splicing tape.

5. Swap the first word in the line of remaining copy with the last word.

6. Eliminate the entire line of copy by employing the machine's edit button.

7. Rerecord the line of copy with a three-second sound effect inserted at midpoint.

8. Insert edit a new sound effect over the existing one.

9. Splice a stinger onto the end of the copy.

10. Record the following mixdown ingredients onto a multitrack machine, placing each on a different track: two beds, three sound effects, and a thirty-second voice track. When this is accomplished, change one bed and two effects by recording over the tracks of those elements to be replaced.

IV PRODUCTION IN FORMAT RADIO

14 Production in a New Era

Not long after World War II, television was launched, and radio's golden age came to a premature end. By 1950, the visual medium had secured an impressive hold on the American public, and radio was floundering in a sea of confusion and uncertainty. What to do to curb the exodus to television was the question that every radio executive pondered. Meanwhile, huge gaps were left in the network radio schedules as producers, writers, and performers were recruited by the new industry—a device one popular magazine referred to as "radio with pictures" and another as "radio vision."

In the early 1950s the future seemed to hold little promise for radio, and certain media observers were predicting its demise. One observer foretold of a time (in the then "not too distant future") when radio would, at the very best, attract only five to ten percent of its former audience. The listeners, he surmised, would be people primarily interested in agricultural news and stock market statistics.

Radio, however, was not about to throw in the towel without a fight. Thus it began to move along the road to recovery. In 1952 the tide began to turn as radio broadcasters reassessed their programming approach. It was apparent that competing with television by mirroring its offerings was a dead end. When presented with the option of viewing a program or listening to a program, the audience invariably opted for the former. To air a mystery at 8:00 P.M. because television was doing so proved unrewarding. Radio had to shift gears and move in another direction. The programming formula it employed prior to the advent of television no longer attracted the listeners and sponsors necessary for its economic survival.

SPECIALIZATION

What radio did was devise a new programming strategy. Rather than attempting to serve the full demographic spectrum (that is, trying to be something for everyone simultaneously), stations decided to target a specific segment of the listening audience in order to attract advertisers who wished to reach that audience. This marked the second coming of radio—the age of specialization.

The idea behind this concept was simple. Individual stations knew they could no longer hope to attract large numbers from different parts of the demographic rainbow. Television had robbed them of this ability. Now they had to be content to draw their numbers from a portion of the listening pie, and to do this they had to offer very specific programming. For example, a station after a youth audience would air pop songs and promotions geared to this particular group. Conversely, a station determined to draw older listeners would modify its programming accordingly.

A technological innovation by Bell Laboratory scientists contributed to radio's rehabilitation. The transistor made radio receivers smaller and therefore more portable and mobile. Now radio not only provided more personalized programming, but it could be with the listener in almost every situation—beach, picnic, or stroll.

Meanwhile, during this period of readjustment, radio was becoming more local in nature. After the Second World War the FCC made frequencies available in less densely populated areas. Small cities and towns were now serviced by their own radio outlets rather than by those broadcasting from metropolitan centers. This also contributed to radio's sense of intimacy.

Radio offered electronic companionship on a personal level, and the public re-

FIGURE 14.1
A new technology enters the production room. (Courtesy WTIC.)

sponded. By the mid-1950s, the medium had made substantial strides toward a full and lasting recovery.

POP CHART RADIO

The final, and perhaps most important, ingredient of radio's rejuvenation came from the music industry—rock 'n' roll. In 1955, Bill Haley and his Comets topped the charts with "Rock Around the Clock," and they were soon joined by other rock artists such as Chuck Berry and Elvis Presley. It was not long thereafter that rock radio was born on the national level. Deejay Alan Freed had first introduced the precursor of pop rock over the airwaves in Ohio and New Jersey, and it was he who coined the term *rock 'n' roll.* Rock music would be given its most prominent exposure, however, on the medium's first legitimate format—Top 40.

As the legend is told, Top 40 radio was inspired by the proverb "necessity is the mother of invention." During the mid-1950s two young Omaha, Nebraska, radio programmers, Todd Storz and Bill Stewart, had tried in vain to raise their station's standing in the ratings. In the six-station market, their station remained at the bottom. At the end of each day, they would commiserate over a drink at their favorite bar. It was there that they observed an interesting and portentous phenomenon, one that would have a significant impact on their lives and on the radio industry.

They noted with interest that the patrons dropped money into the tavern's jukebox to hear the same new songs over and over again. The thought occurred to the programmers that if people were willing to pay good money to hear the most recent songs played on a jukebox, they would likely tune a station that broadcast their favorites in a similar manner. They applied this concept to their station, and within a year it rose to the number one position.

Soon Storz was marketing his novel programming approach around the country, and dozens of other outlets were emulating his formula. By 1957, Top 40 radio had a unique hold on the youth market.

At its inception, Top 40 playlists reflected the traditional rather than the innovative. Among the most popular artists were old-line balladeers such as Perry Como, Eddie Fisher, Kitty Kallen, Frank Sinatra, and Patti Page, but as the rockers took hold of the hearts of America's youth, the charts became dominated by the new sound. In no time, the pop record charts looked like a who's who of rock 'n' roll, and the term Top 40 became synonymous with rock music. The age of rock 'n' roll had arrived.

Despite the obvious success that these stations had in drawing young listeners, advertisers were reluctant to sign on. Across the country, church and civic groups were condemning rock music as the tool of the devil, suggesting that it would incite young people to act with moral abandon. The opposition threatened to boycott sponsors of rock 'n' roll stations. For a short while, this threat had a dampening effect, but the tremendous popularity of rock radio could not be denied, and eventually advertisers were lining up to buy air schedules on the mighty doowoppers.

Top 40 stations depended on the steady stream of 45 rpm's, which recording companies sent them as demos, to fill their airtime. To kids these tiny platters represented a great time at an affordable price. LPs (33⅓ rpm's), which had arrived on the scene a few years earlier, were rarely played at pop chart stations.

If the rock music of the period could be described as raw and energetic, so could the deejays who spun the records. Jocks sought to relate to young listeners through

FIGURE 14.2
Rock deejay legend Cousin Brucie. (Courtesy Bruce Morrow.)

language that reflected youthful moods and attitudes about daily life: "HEY, KIDDO, GET OUT OF THE SACK AND GET TO SCHOOL. IT'S A DRAG, I DIG, BUT NO DIPLOMA, NO JOB, BOB!"

Some of pop radio's greatest deejays of the period—Murray the K, Alan Freed, and Cousin Brucie—assumed guru status to the legions of teens tuned to their shows, and when they appeared at record hops, their fans would show up in droves.

ROCK SPOTS

The energy and intensity that Top 40 deejays communicated during their shows was conveyed in their recorded announcements as well. All the resources available were employed to snag the attention of the ever-drifting adolescent mind. Spots were often designed to jolt listeners from the distracted state.

Adding reverb to spots was almost a standard practice. Rowdy and frenetic deliveries (in the vernacular that best related to the teen audience) sprang from the small transistor radio speakers owned by most kids.

Top 40 production room sound effects libraries were worn thin as mixdowns became more elaborate, even gimmicky. In many instances sound effects were used gratuitously—dropped in for the sake of the sounds themselves with little concern for their justification.

Doowop radio was programmed on the assumption that the audience would remain tuned if inundated with hit songs, jivey jock patter, exciting giveaways, and entertaining commercials. Since commercial breaks were regarded by many programmers as the primary cause for tune-out, the more amusing a spot, the better. Frequently the goal was to make a commercial not sound like a commercial. Unfortunately, especially for the sponsor, this approach often left the listener with no impression of what was actually being pitched.

Recorded messages seldom were mixed without some form of rock bed. Gradually, Top 40 stations found that stopping the music for any kind of discourse—whether a sixty-second commercial or a five-second weather update—was risky because it inspired station hopping. Thus, the rhythms continued unabated, except during news broadcasts.

Even with the emphasis on heavily produced commercials, the live spot remained popular at Top 40 outlets. Sponsors were often very eager to have a popular deejay read their messages on the air. It was a form of endorsement that went a long way toward boosting sales. Moreover, a deejay frequently spent more than the allotted time on the spot, getting caught up in his or her own verbiage.

Among the most popular types of commercials in the last half of the 1950s were the jingle, testimonial, dramatization, and straight-sell. While these spot genres were prevalent during the medium's heyday, they assumed a different quality as they were modified to reflect format specialization.

Agencies that used jingles to promote their client's products over the airwaves had to acknowledge the fact that while a jingle might sound fine on one station it might not work as effectively on another. In many cases this meant more work and expense. An agency with an account targeting a broad demographic (eighteen to forty-nine age range) might decide to produce two versions of a jingle—one intended to fit pop music stations and another geared for stations emphasizing adult sounds.

The age of format specialization meant that commercials had to conform to a station's overall sound. If a commercial did not fit, if it did not *match flow* (a term used to describe the harmonious integration of programming elements), it was perceived as a tune-out factor, and both sponsors and programmers were wary of this consequence.

ADULT STATIONS

As the first decade of radio's restoration ended and the 1960s began, other formats were added to the listening roster. In response to the growing dominance of youth oriented radio, some stations offered programming that appealed specifically to the over-thirty crowd. Whereas Top 40 rocked and rolled its fans, Beautiful Music stations soothed and sedated their listeners, and if adults desired news and information, they had merely to move the dial to those stations formatting news and talk around the clock.

By 1965, the radio listening public was offered an impressive variety of formats from which to choose. While Top 40 continued to reign supreme with the nation's youth, Middle-of-the-Road (MOR) and Beautiful Music (BM) stations claimed the biggest share of the adult market. Music listeners could also opt for Country and Classical stations, although the latter were primarily available on the FM band.

THE FM SOUND

Although FM radio had been available to the public since after World War II, it was slow in finding an audience—the kind of audience that attracted advertisers. Two things most inhibited the growth of FM: television and AM radio. In the 1950s, the average consumer was investing in television receivers and embracing the new brand of radio offered by AM. The public remained relatively apathetic about the superior fidelity of FM, and stereo—still in the process of development—was several years away. The idea of component systems offering two-channel audio only excited the hardcore audiophile.

Throughout the 1950s and 1960s, FM was generally perceived as that "other" radio band—the one that played Beethoven and poetry. While this was not entirely true, for the most part FM did cultivate an "alternative" or fine arts image, and this did limit its appeal. Although FM's listenership was small in number, it was extremely loyal. One reason for this is that few AM stations offered anything out of the mainstream. Another reason for FM's strong hold on its listeners was its ability to provide static-free reception.

When stereophonic sound was introduced in the early 1960s, FM broadcasters recognized its value to their medium. Among the first consumer markets for stereo recordings were the classical music buffs who tuned FM, and FM's wider channel width made it adaptable to the two-channel system.

The conversion to stereo certainly added to FM's appeal, and a ruling by the FCC in 1965 provided further impetus to the growth of the medium. Concerned that FM's progress was being hampered, at least in part,

by uninspired and unoriginal programming, it required that AM/FM operations in cities of one hundred thousand or more residents not simulcast for at least half of their broadcast day. This meant that stations holding both an AM and FM license in the same market had to program independent of one another for a substantial part of their daily schedule.

In the 1950s and 1960s AM stations that possessed an FM license typically adopted the simulcast method of broadcasting as a cost-cutting measure, since the FM side of the operation seldom generated enough income to justify a separate facility. Alarmed by the prospect of having to invest money in something with so little potential for return, these combo operations often resorted to the use of automation equipment for their FM broadcasts.

Of all the formats, Beautiful Music lent itself best to the automated approach. Its "more music and less talk" emphasis was perfectly designed for the "sweep and cluster" method of programming used in automation. Large reels of music mounted on several machines permitted a station to operate independently for hours at a time. Music was offered in ten- to fifteen-minute sweeps or blocks followed by a cluster (called a *spot set*) of two to four commercials.

A substantial number of these automated Beautiful Music stations broadcast in stereo. The combination of extended segments of uninterrupted music aired in stereophonic sound proved alluring to a sizable share of the adult listening audience, and within a couple of years an impressive number of these stations were vying with their AM counterparts for standings in the ratings surveys. This surprised some broadcasters, who had perceived automation as merely a solution to the problem of what to do to keep their FMs from siphoning off their AM's profits.

Nearly all the commercials on automated stations were prerecorded and carted, since little live announcing was done. For the most part, production was kept simple. The majority of spots on these early automated BMs consisted of a voice and single bed. In contrast to the pop music formats, which possessed a strong affinity for the heavily produced spot, the idea at the adult, more music FM stations was to soft sell spots.

The no-frills spot mix was the most common work to come out of Beautiful Music production studios throughout the 1960s.

FM PROGRESSES

Beautiful Music was the first truly successful commercial format on FM, but it was not to be the programming approach that started the medium on the path to its ultimate ratings dominance.

What would open the door to even greater possibilities for FM was a format that had its genesis in pop music—Progressive Rock. If anything, this new programming concept sprang from a desire to break with convention. At WOR (New York) the goal in 1966 was to offer listeners a new type of radio. To achieve this end, early Progressives did not employ a primary format; instead they aired a variety of musical forms. The thinking was: offer the best music—the crème de la crème—and people who love music will tune, even if a classical piece is presented after a jazz cut.

A year later in California the Progressive format approach was taken in yet another direction. A programmer called Big Daddy Donahue implemented an album rock for-

FIGURE 14.3
Early automation system. (Courtesy WABC.)

mat; the idea was to playlist the vast canon of rock music ignored by Top 40. Donahue observed that while the pop chart stations played the hit cuts off albums, they did not go deeper, and to him this was a serious affront to the artist and the listening audience as well.

Donahue's station concentrated on the obscure and unconventional, as well as on album cuts that were avoided by mainstream stations because of their length and nonchart status. The standard playing time for a pop tune in the 1960s was two-and-a-half minutes, and Top 40 had come to structure its entire air product around these musical increments.

Just as the Progressive format served as a near perfect counterpoint to Top 40 in terms of music presentation, the Progressive format approach to production also could not have contrasted more with that of Top 40. Commercials were delivered in a style antithetical to the "hype and holler" found on chart rockers. Progressive rock stations employed a "super laid-back," one-on-one conversational delivery in commercials, promos, and psa's, and the number of production ingredients was kept to a minimum. The most prevalent approach to Progressive spots involved the use of a single bed with a low-key voice-over. These were stations intent on not mirroring the qualities that so characterized the "formula" stations. Progressive stations perceived themselves as "au naturel" and, as such, a new form of radio broadcasting.

Many of these stations began to take their cues from certain counterculture movements especially popular among students and young adults. Thus another variation of the Progressive format emerged in the form of Underground radio. At these stations the objective was to convey a sense of opposition to the so-called establishment. Deejays spoke out against conservative attitudes and views and encouraged listeners to "do their own thing."

Underground radio fancied itself the rebel of the airwaves. This positioning did not exactly win the hearts of sponsors, and those who did use Underground outlets as an advertising medium were not bothered by their off-beat, often irreverent, approach to production. Since these stations encouraged the impression that they were above the profit motive, they often treated commercial material with a certain degree of contempt. An example:

ROSIE'S HAS OKAY FOOD, AND THE SERVICE ISN'T TOO BAD ON TUESDAY AFTERNOONS. GET THERE EARLY AND GET A CLEAN TABLE. (SFX: Dishes crashing) WATCH OUT FOR GLASS IN YOUR HASH THOUGH. (SFX: Woman shouting angrily) SORRY, ROSIE. I WAS JUST KIDDING, MAN. HEY, YOU WANT A REAL MEAL AT A REAL DEAL? DROP BY ROSIE'S ON FULLER. (In whisper) SHE MIGHT EVEN BE NICE TO YOU. IT'S NO ACCIDENT ROSIE'S IS ON FULLER STREET. FOR HALF THE PRICE YOU GET A WHOLE TUMMY FULLER THAN ANYWHERE ELSE.

Yet another permutation of the original Progressive rock format surfaced in the late 1960s as the consequence of the drug movement. Stations seeking to ingratiate themselves with youth enamored of the drug experience focused on rock music with either an implied or explicit drug statement. These stations became known as Acid and Psychedelic rockers. Although the terms were often used interchangeably, a distinction did exist between the two. Acid stations were characterized by decibel shattering, electric guitar riffs (à la Jimi Hendrix), while Psychedelic outlets broadcast music that suggested a magical carpet ride through a surreal landscape. The Beatles albums *Magical Mystery Tour* and *Sgt. Pepper's Lonely Hearts Club Band* were typical fare at Psychedelic stations.

As might be concluded, spot production in these formats shared qualities in common. Since both formats aired a preponderance of music with drug themes or motifs, announcements frequently gave the impression that they were put together by production people "under the influence" themselves. In the parlance of the day, spots were "far-out." Deliveries were anything but conventional, that is to say, announcing styles ran from the mellow and mumble side of the scale to the bizarre and cinematic. Spots often left the listener with the impression that the folks at the station were "on" something—tripped-out or stoned.

SOUNDS OF THE 70S

The Progressive-Underground-Acid-Psychedelic rockers of the 1960s became the more formularized Album Oriented Rock (AOR)

stations of the 1970s. Meanwhile, Top 40 had experienced changes in the 1960s as the consequence of the squeaky-tight on-air approach set forth by pop radio programming wizard Bill Drake, but in the 1970s stations that had been "Draked" began to assume a more laid-back posture. In other words, while AOR moved in the direction of tighter playlists and a more formularized sound, Top 40 loosened its tie a bit.

This adjustment was apparent in spot production in both formats. AOR commercials sounded slicker, and for the most part began to reflect the qualities held in esteem by mainstream adult and pop stations. Conversely, Top 40 spots were not all being mixed in a way designed to pummel listeners into a state of complete submission. The conversational, one-on-one approach so common to FM album rockers began to take hold on Top 40, which in the early 1970s was still a strong AM ratings contender.

The first half of the decade witnessed the beginning of a trend that would result in a shift of the music radio listening audience from AM to FM. What set the wheels of change in motion was the fact that FM broadcasters opened their frequencies to the pop rock hits, and when they did, listeners who had traditionally been loyal to AM responded in significant numbers. Soon the pop chart format was a successful resident in the FM neighborhood. In fact, by the mid-1970s many of the country's most prestigious pop rockers were broadcasting over FM channels.

Other formats contributed to FM's rise as well. Mellow rock stations, featuring soft rock album cuts and chart tunes, carved out an impressive slice of the listening audience pie. Mellow rock was served up by FM stations, and their on-air presentation style bore a strong resemblance to Beautiful Music outlets, which offered uninterrupted blocks of music and clustered announcements. As with the BMs, a number of Mellow rock facilities operated by automation.

Mellow was the forerunner of the 1980s' most listened to format—Adult Contemporary—and its production style lives on today at many of these stations. Mellow production was as low-key as the term implies. Announcers delivered copy in a very unaffected, conversational manner. Hype was taboo. Spots were produced without a lot of fanfare—meaning that heavy production numbers were uncommon. *Simpatico* was the operative term.

In the mid-1970s, the Country format became more prominent on FM, although it remained a popular AM offering as well. Country music had become more diffused and worldly as the consequence of a new breed of performers, many of whom enjoyed great crossover appeal in other formats. By 1975, there were several different categories of Country music—Rebel Rock, Countrypolitan, Urban Country, Easy Country, Country Hits, and so forth—being aired across the nation, and stations presented their particular brand of country in a variety of ways. For example, Easy Country outlets often adopted Beautiful Music programming techniques, whereas Country Hit stations emulated the Top 40 formula. Country radio's diversification inspired increased listenership and ratings and made it a far more prominent medium.

Commerical production styles in Country reflected this diversification. For instance, Country Hit stations mirrored the high-intensity sound of Top 40 commercials. Rebel Rock station spots had an AOR flavor, and Easy Country mixdowns often sounded cloned from Beautiful Music.

Disco, one of the hottest but short-lived formats, made its debut in the latter part of the 1970s. As quickly as it took hold of the radio marketplace, it fell from grace, but in 1979 it was the format that seemed to matter the most as station after station converted to Disco hits. That year, the nation's sixth radio market (Boston) boasted no less than three Disco outlets. A year later the nation's thirst for disco music was sated, and stations began abandoning the sound.

The same year that all-Disco emerged, broadcast history was made as FM equaled AM in listenership, and the enthusiasm for disco music may have played a role in putting FM over the top the following year. By the end of the decade, FM was clearly the preferred broadcast service of music radio listeners. In 1979, a survey revealed that FM attracted fifty-one percent of the radio audience. AM's dominance was clearly over.

FORMATICS IN THE 1980S AND 1990S

Several formats entering the 1980s were about to undergo a facelift. The short, glo-

rious tenure of Disco was over and Top 40, AOR, and Beautiful Music were all experiencing audience erosion.

Although the disco music craze had all but fizzled out by the early 1980s, not all stations looked for something totally new to reclaim ratings numbers. Many of these stations recognized the basic appeal of dance-based music, especially to inner city youths, and adjusted their formats to include a broader variety of contemporary pop sounds. Out of this reconstitution came the Urban Contemporary format.

On the Top 40 front, programmer Mike Joseph and other prominent chart radio innovators saw a great need to reinvent the wheel. To many, Top 40 had become too unfocused and vague. In the early 1980s, the Hot Hits schematic was applied to the Top 40 format. This involved paring down playlists and airing tunes from the most dynamic stratum of the chart hierarchy—songs at the very pinnacle of the popularity pyramid. The redefining of Top 40 resulted in a new moniker as well. After more than two-and-a-half decades, Top 40 became Contemporary Hit Radio (CHR), and with the crossover of many of AOR's traditional artists to the pop charts, the format's reclamation was complete. In short order, CHR stations reasserted their ratings dominance.

Another long established format, Beautiful Music, was diagnosed as suffering from a number of ills. By the late 1970s it was evident that the format's listenership was on the decline, and programming analysts concluded that a change was needed. BM had done little by way of updating its playlist and image since its rise in the early 1960s. It was targeting the same listeners, and, in the words of one astute observer, "the format's audience was literally dying off."

Twenty years earlier the format was pulling strong numbers in the over-fifty demographic. Twenty years later it was playing essentially the same music, ignoring the fact that the fifty-year-old in 1980 had been a young adult when the format was launched, and, as such, was a generation removed from the format's initial audience. In order to attract a younger audience, the format had to shed its geriatric image. To accomplish this, playlists were updated and BM's penchant for lush, subdued instrumentals was overcome. More contemporary vocals were added to the schedule.

Meanwhile, announcer delivery (both on-air and in spots) was humanized. "The stilted announcing style that so typified the format was replaced by real people, who sounded warm and accessible instead of starchy and rigid," says programming consultant Donna Halper.

On the AM side, in the 1980s and early 1990s, one word can pretty much describe the programming—*talk*. Music has become nearly extinct on the AM band. With only a few exceptions, news and talk are what keep the medium from going under.

While stereo has been suggested as a means for retrieving some of the lost music audience, as of 1990 only a limited number of AM stations have added stereo processing to their signals. Meanwhile, skeptics of AM stereo argue that it does little to give the beleaguered medium genuine parity with FM's superior fidelity. If AM is to regain its music audience, say critics, it must not only improve on the quality of its signal, but it must offer programming that will motivate listeners to flip the band selector switch.

OVERVIEW: PROGRAMMING AND PRODUCTION

Each time a format is modified or remodeled, the production room is affected, perhaps only minutely, but affected nonetheless. It is the goal of the following chapters to show just how a station's format impacts the entire mixdown process. Since commercials, psa's, and promos are a prominent part of a station's sound, it follows that they must complement that sound. They must reflect the station's general programming philosophy, rather than clash with it. Simply stated, a commercial on a Classical station should not sound as if it were better suited for a Country station. Successful production cannot be achieved unless a production person understands and appreciates the characteristics and qualities that constitute a station's programming product.

INDUSTRY NOTES BY JAY WILLIAMS

Jay Williams, president of Broadcasting Unlimited, offers his perspectives on the role of production in format radio.

* * * *

"With the advent of researched music, more music and limited personalities, and similar formatics, production is what creates the image of the radio station and separates one station from another.

"Commercials and promos in format radio take up to eighteen minutes of airtime an hour. They comprise a major part of a station's programming, and like the music, spots must be tailored to blend, mix, and contrast—not break format—with the station's sound. Traditional Beautiful Music stations (now soft ACs or Easy Listening) were the first to tightly control spot production. Soft music beds, melodic voices, and toned-down copy became the rule. The concept was that the commercials were part—along with the music and announcers—of the 'total station environment.' This concept is no less true today—in any format. What makes one CHR station stand out from another? Outstanding production is often the answer. Any station, especially in a major market, can hire one or two great jocks. But that won't assure ratings for a station that must program 168 hours of programming a week, only a fraction of which can be manned by great talent. What drives the image of the station and separates it from the competition (which may employ the same format and play the same music) is the station's production.

"Spot production has changed dramatically; technology and tighter formats have made production more professional. Four-track production studios are common, and 8-, 16-, and 32-track studios are now found in most major and medium markets. This, along with similar advances in television and computers, has created a demand among consumers (and radio listeners) for a faster-paced environment. A recent Diet Coke TV ad had 117 different shots in a single thirty-second commercial. Radio production, even on soft-formatted stations, is tighter and "more produced." Further, in response to the trend for tighter formatics and consistent with a 'more music' image prevalent in most formats, production is carefully and cleanly tailored. No longer are spots bedded with a needle tracking over a nondistinguished production bed. Production flow into the music or next programming element is carefully considered. We have forced our minds to work faster and to take in more information. Computer screens and television and video games are just some examples of the technology fueling this trend. As listeners and viewers, our learned response seems to be that of impatience when things move too slowly, and impatience leads to tune-out."

CHAPTER HIGHLIGHTS

1. Radio's golden age came to a premature end by 1950, when television had become the preeminent home entertainment medium. Beside audience, television was recruiting the best producers, writers, and performers.

2. To regain its audience, radio devised a new programming strategy, specialization, which targeted a specific segment of the listening audience in order to attract advertisers who wished to reach those people.

3. By the mid-50s, rock 'n' roll (term coined by deejay Alan Freed) aided radio's rejuvenation. Rock music deejays reflected the mood and attitude toward daily life of their young listeners, adapting their language and syntax.

4. Recorded messages featured rock music beds, reverb, elaborate sound effects, and frenetic deliveries in the teen vernacular to keep the audience's attention.

5. Among the most popular types of commercials in the last half of the 1950s were the jingle, testimonial, dramatization, and straight-sell. Live spots remained popular as a form of indirect deejay endorsement.

6. The age of format specialization meant that commercials had to conform to a station's overall sound, they had to match flow (harmoniously integrate with other programming elements).

7. By 1965, the radio audience could choose from a variety of formats—such as Middle-of-the-Road, Beautiful Music, Country, Classical, All News—that appealed to listeners over eighteen.

8. When stereophonic sound was introduced in the early 1960s, FM's wider channel made it adaptable to the two-channel system. Coupled with its static-free reception, stereo made FM the choice of serious music listeners.

9. Many FM outlets turned to automation as a cost-reducing solution to the loss of simulcasting. Commercials on the automated (usually Beautiful Music) stations featured soft-sell, no-frills spot mixes.

10. The Progressive format started the FM medium on a new path. For commercials, promos, and psa's, Progressive stations employed a laid-back, one-on-one conversational delivery, and production ingredients were kept to a minimum.

11. When FM began programming pop rock hits, the audience shifted significantly from AM to FM.

12. In the 80s and 90s, AM has relied on talk-based formats to ensure financial stability.

13. According to Jay Williams, president of Broadcasting Unlimited, "Production is what creates the image of the radio station and separates one station from another."

15 Rock Radio Production

Over forty percent of the radio listening audience tunes to stations featuring some form of rock music. Based on this fact, it might be concluded that the playlists of these stations bear a striking similarity to one another. This is not the case, however. Nor is it the case that all stations airing rock 'n' roll approach spot production in the same manner.

There are several different rock formats, and each has its own unique sound. This chapter examines how these rock programming formulas impact the mixdown process. First, however, a reexamination of copy formatics is appropriate.

COPY FORMATICS

The basic copy format criteria are universal and are not affected by a station's particular programming approach. When composing copy, the following rules should be observed. While a number of these points were made in Chapter 11, they deserve repeating here.

1. In order to determine the length (timing) of a piece of copy, count the lines, applying the general rule of thumb that one line of copy takes approximately three seconds to deliver. When sound effects are added, the amount of time they consume (when established independent of voice) is deducted from the total time. For example, if a thirty-second spot included two seconds of applause, followed by a three-second drum roll, the copywriter would have to compose fewer lines to reach thirty seconds. In this case, the sound effects constitute five seconds of the total time, and five seconds equals about two lines of copy. Thus, instead of writing ten lines of copy, eight lines would be sufficient. Keep in mind that this method for timing a message is based on a moderately paced delivery. Obviously, an announcer employing a rapid-fire delivery would undermine this formula.

2. One-inch margins should be set up on both sides of the copy paper. Running words off the page not only looks sloppy but can create problems for the announcer. One-inch margins also provide a copywriter with the basis for gauging the length of a piece of copy, as discussed above.

3. Double-space between lines of copy. This is done to make copy easier to read and decipher. Double-spacing makes it easier for an announcer to recover his or her place in the copy if looking away is necessary. Lines are less apt to run together.

4. Uppercase (all capitals) type should be used. This makes copy easier to read.

5. Proper punctuation is necessary. A comma in the wrong place can derail the message. Commas and periods are the primary punctuation symbols used in radio copy. Ellipses and semicolons are seldom employed. The goal is to keep grammar and punctuation simple but accurate.

6. Simple sentence syntax is preferred over elaborate syntax. Lengthy compound or complex sentence structure reduces intelligibility. Sentences should be direct and concise. This increases listener understanding and retention. The goal is to keep sentences uncomplicated while not talking down to the audience.

7. Choose words carefully. Remember that radio announcements are designed to be heard, not read, and commercials go by quickly. Using an uncommon word creates uncertainty and can draw listeners away from the intended message. A conversational style is preferred. In other words, write as you speak.

8. Avoid numbers, if possible. Because radio is used in a host of different settings not always conducive to writing down information, broadcasting a series of numbers in a piece of copy may accomplish little. When large numbers appear in copy,

the alpha/numeric approach is used. For example, "23,000" is written "23 THOUSAND." This makes large numbers easier to interpret. If a phone number is to be given, it should be repeated. Due to several factors, some of which have already been discussed, it is difficult for the radio listener to retain numeric data.

9. Place sound effects information in parentheses at the point in the copy where the sound is to occur. Sound effects instructions appear in both upper and lowercase so as to contrast with the copy text: "ANNOUNCING THE GREATEST SALE OF ALL TIMES (SFX: Trumpet fanfare—2 sec.) THAT'S RIGHT! YOU WON'T FIND PRICES ANY LOWER THAN OURS . . ."

10. Spell difficult or uncommon words phonetically. By spelling words the way they are properly pronounced the danger of mispronunciation is lessened.

The suggestions made here and in Chapter 11 are of a very practical nature. For information on books devoted to a full study of copywriting, consult the Suggested Further Reading section at the back of the book.

CONTEMPORARY HIT RADIO (CHR)

Contemporary Hit Radio, formerly referred to as Top 40, attracts the most listeners of all rock-based stations. In 1990 nearly twenty percent of the radio audience tuned to CHR outlets, which computes to nearly half of the rock music tuners. CHR stations claim a fairly broad demographic (twelve to thirty-four year-olds), although the rating reports generally indicate that listenership is concentrated in the twelve to twenty-two year-old age group. Many CHR stations experience the station-hopping or button-punching syndrome and, as a consequence, cannot claim an extended hold on their young listeners. This is a concern to some advertisers, who are troubled by the transient nature of the CHR audience. Nonetheless, CHR is second only to Adult Contemporary in the national ratings surveys, and this fact is very appealing to sponsors.

CHR stations concentrate on airing the fastest-selling pop records. In other words, the music that is being purchased at the nation's record stores is what primarily constitutes CHR playlists.

Of all formats, CHR is least likely to subscribe to the sweep method for the presentation of music, although broadcasting several tunes in a row is used to hook listeners at different times of the day. This is a "busy" format, especially oriented toward contests and promotions. The idea is to keep the listener excited and engaged. Lifestyle giveaways are a mainstay. For instance: "THE SEVENTH LISTENER TO CALL WINS TICKETS TO SEE . . ."; "IF YOUR NAME IS PICKED FROM THE K-HIT TRIP TRUNK YOU AND A FRIEND ARE ON YOUR WAY TO . . ."; "IT'S TIME FOR HIT-94'S PIZZA PARTY PAYOFF. IF YOU'RE THE TWENTIETH CALLER, WE'LL SEND YOU A . . ."; and so on.

News reports generally take a backseat to music, high-energy jock discourse, and contests. While few CHR stations avoid news altogether, compared to most other formats the amount aired is relatively low. Since the inception of the format as Top 40, there has been a general wariness toward news, which has been perceived by programmers as a tune-out factor. There was very little broadcasters could do about this, however, since—until recently—the FCC required all stations to air a certain percentage of news daily.

This changed in the 1980s as the commission scrapped the news requirement as part of their movement to deregulate the industry. Surprisingly, this did not result in the abolishment of news in the highly youth oriented CHR format. Even at these stations the need to offer listeners some information was acknowledged, if only in the form of news headlines and capsule reports.

While syndicated countdown shows are popular in this format, few other features make it to the airwaves, since programmers are reluctant to depart from the charts. Sports programs are nearly nonexistent on pop chart stations, although deejays often make a point of mentioning relevant scores.

CHR is a very production-minded format. What follows are criteria observed by CHR production people when engaged in the mixdown process.

CHR Copy

Due to the age group most attracted to CHR stations, language should be kept fairly basic, notes Lee Kent of KZOU in Little Rock,

ROCK RADIO PRODUCTION 175

FIGURE 15.1
CHR programming clock and content breakdown. (Courtesy KSYZ.)

KSYZ Days

3p – 7p – MON-FRI
2a – 1p – SATURDAY
12m – 12n – SUNDAY

▲ OPTIONAL WEEKDAY TIME CHECK/TALK OPPORTUNITY

I'M STUCK ON 108

FILL SEQUENCE A
PLAY 15 "B" CURRENT
PLAY 13 ACCA JINGLE
PLAY 04 OLDIE
PLAY 14 RECURRENT

FILL SEQUENCE B
PLAY 13 ACCA JX
PLAY 04 OLDIE
PLAY 14 RECURRENT
PLAY 03 OLDIE

KSYZ MORNING/AFTERNOON FORMAT

SEQUENCE	SOURCE	TIME/EVENT	SEQUENCE	SOURCE	TIME/EVENT
1850	PLAY 12	:55 LIVE WEATHER	1875	PLAY 12	:25 LIVE MUSIC TEASE
1851	NEXT C	Commercial Cluster	1876	NEXT C	Commercial Cluster
1852	PLAY 13	DUMMY CART (Live ID)	1877	PLAY 13	CANNED PROMO/GREAT 108 JINGLE
1853	-------		1878	-------	
1854	PLAY 12	CURRENT MUSIC SWEEP (A/B/R)	1879	PLAY 12	CURRENT MUSIC SWEEP (A/B/ACCA)
* 1855	-------		* 1880	-------	
1856	PLAY 12	:10 LIVE PSA	1881	NEXT B	OLDIE (PLAY 03/04)
1857	NEXT C	Commercial Cluster	* 1882	-------	
1858	PLAY 13	KSYZ JINGLE	1883	NEXT 12	:40 LIVE PROMO
1859	NEXT B	OLDIE (PLAY 03/04)	1884	NEXT C	Commercial Cluster
* 1860	-------		1885	PLAY 13	KSYZ JINGLE
1861	PLAY 14	"A" CURRENT	1886	-------	

Arkansas. "Copy is carefully aimed at our demographic cell, which supposedly is twelve to thirty-four, but we skew our pitch to the twelve-year-old mind-set. Except for agency spots, and we don't have much control over them, our locally originated copy will be more energy-conscious and less detail oriented than in other formats."

FIGURE 15.2
CHR copy. (Courtesy KRXY.)

99 KAYS — Middle Georgia's Music FM
WMAZ AM 940

1314 GRAY HIGHWAY
P.O. BOX 5008
MACON, GEORGIA 31213

AM / (912) 741-9494 FM / (912) 741-9999

WMAZ COPY / BROADCAST COPY / WAYS COPY

Spot Length: :60
Effective Date: _____
Client: PENN. HOUSE GALLERY / THE HOUSE OF OAK
Copy By: RAMAGE

USE 10 SEC. JINGLE FOR INTRO:

AMERICA'S PREMIER LINE OF SOLID CHERRY, OAK, AND PINE FURNITURE AWAIT YOU AT THE PENNSYLVANIA HOUSE GALLERY. FROM THE MOMENT YOU FIRST ENTER THE PENNSYLVANIA HOUSE GALLERY, THE FEELING OF ELEGANCE OVERWHELMS THE SENSES. THE AROMA OF SOLID CHERRY, OAK AND PINE FILL THE AIR. THE SMOOTH TOUCH OF FINE WOOD LETS YOU KNOW YOU'RE SHOPPING AT A FINE QUALITY SHOWROOM GALLERY. THE PENNSYLVANIA GALLERY OFFERS FINE FURNISHINGS IN CHIPPENDALE AND QUEEN ANNE DESIGNS FROM COUNTRY TO ELEGANTLY FORMAL SETTINGS. DISCOVER AN EMACULATE GALLERY FULL OF FINE DECORATIVE PIECES AND ACCESSORIES FOR YOUR BEDROOM, LIVING ROOM, DINNING ROOM, OR ANY ROOM OF YOUR HOME. THE DISCOVERY BEGINS AT THE HOUSE OF OAK-PENNSYLVANIA HOUSE GALLERY...ACROSS FROM MACON MALL NEAR TOYS 'R US.

On the subject of detail, Kent warns against using numbers in CHR copy. "Telephone numbers are blown past in spots, except when the client insists on numbers, and even then we press for their elimination. A typical CHR station is taken along with the listener to outside events, and a phone or pad and pencil is seldom within arm's reach, so mentioning a phone number once or twice amounts to a few seconds of wasted time in an otherwise well-produced spot."

Copy should be hip and relatable, while at the same time satisfying the goal of the client, says Dean Lambert of Lincoln, Nebraska, station KFRX. "Needless to say, but I'll say it anyway, you write copy that communicates to the CHR listener and meets the sponsor's needs. We match the KFRX audience with the client's products and

services. Traffic at the point of purchase increases, and if everything goes right, sales are made."

The tone of CHR copy should always be upbeat, contends WAZY's Fred Stuart. "This is a fun format. You have to keep things casual and positive. Don't be downbeat in copy; the kids will tune out."

At WOVV-FM in Fort Pierce, Florida, Chris Mac's objective is to write quality, professional announcements every time. "You have an obligation, a responsibility, to write firstrate material. If you don't, it shows, especially when the nationally produced spots come on. The New York agencies use top talent in writing, voices, and jingles. If we do not do our best to match that quality, then the listeners perceive a difference. That difference is usually interpreted in a negative way, i.e., by pushing the button or tuning out mentally."

CHR Delivery

The one word that has been most closely associated with the CHR format is *energy*. In the 1970s, the pop chart radio delivery shed some of its hyperkinetic layers, and the result was a less strident and aggressive sound. This alteration was fostered by the prevalence of the conversational delivery style at stations featuring Album Oriented Rock, Soft Rock, and Adult Contemporary.

Upbeat, energetic deliveries best describe what CHR programmer Dean Lambert wants on the air: "In relation to AOR or AC, for example, our delivery on spots is not as relaxed or conversational. We don't scream, however, but stop sets [commercial breaks] must not signal the listener to change the dial. Therefore, a commercial break must somehow be made less of a tune-out risk. In my opinion, there are two ways to do this: 1) Make the stop set 'flow,' that is, play the more powerful spots first and decrease in intensity as you move through the cluster; and 2) Make the delivery and mixdown as compatible with the station's format as possible. With respect to flow, I color-code spots according to intensity of delivery and production values and have the announcers play the more intense first."

Whereas Lambert's preference is toward a higher-intensity delivery style, KDVV's creative director, Kimberly Skinner, requires announcers to relate in a personal and intimate manner. "I program an AM Oldies and an FM CHR, and I insist that spots be delivered with the idea in mind that you are talking to one person. Talk as if you're sitting next to your listener in their car. Following this idea, you must talk to your listener in the appropriate way, so if the average listener of our FM station is twenty-five, you talk in his or her language, and if the average age of our AM listener is fifty-five, you use their language."

Echoing Skinner's sentiments on delivery, WBJW's Ken Dixon says that CHR announcers must be capable of upbeat as well as subdued deliveries. "Ours is a high-energy format, so our deliveries tend to be more upbeat than that of many other stations in our market. However, our audience here is so broad-based that we also attract advertisers whose messages are more low-key. It's important that the announcers be able to respond to the occasional need for a more subtle delivery approach."

At KZOU, Lee Kent says that announcers are coached to create deliveries that contrast with the backgrounds on commercials. "Announcers here at the ZOO are directed in their deliveries. A continual contrast between vocal and background material is sought at all times. For example, spots with busy backgrounds are written to be delivered smoothly, and spots with smooth backgrounds are written to be delivered hotter. This contrast throws the listener off-balance and creates high retention. It also provides us with some contrast with the station promos, which are produced hot all the time."

CHR Mixdown

As mentioned previously, this is a production-intensive format. The exciting pace cannot slow because of a sluggish or lackluster spot set, notes WAZY's Stuart: "You have to maintain as tight and dynamic a format with production as you do with music. All spots are carefully rated by tempo, quality, and message. For instance, well-produced agency spots like Coke, Pepsi, and Budweiser are always first in a spot set. A more serious, downbeat spot would be placed last in the set. Also, sixty's first and thirty's last. Not only do I keep a tight reign on what goes out of the live, on-air studio, but I also monitor everything that comes

out of the production room. All of our jocks are relatively good in production. They have some technical savvy. We do lots of involved tech production with music and effects. The production must sound as hot, as *up*, as contemporary, as our music—all the time, every day."

KZOU's Kent concurs with Stuart: "CHR production has to be tight. It is, here. For example, breathing is removed for the most part to keep the excitement going and to prevent the listener from taking a break as well during the spot. Being a CHR station, we are highly processed in the audio air chain. Therefore, our production must match this processing. If we overcompress the commercial material, the air processor tends to flatten out the audio too much, resulting in the loss of dynamic range on spots. The use of an Aural Exciter in the production room helps to restore some of the high-end lost on the air chain side with added sibilance—that is, if mixed properly. We go to great lengths to hold our young listeners with our production mixes."

Production must be especially designed in CHR to hold the listener, claims KDVV's Skinner: "Taking into consideration that listeners of different formats listen in different ways, you understand the first rule of radio production. Production needs to cater to each type of listener. For instance, listeners of our AM Oldies format are less likely to tune out during breaks. They are more loyal to the individual station. Listeners to our FM CHR format are more apt to tune out during a commercial break. Statistics show almost fifty percent of CHR listeners are lost during a commercial encounter. This means we can't get away with generic commercials on our FM station. The spots need to grab the listener's attention in the first three seconds, and hold it. The use of special sound effects, music, and production techniques is more common for spots on the FM side. For the AM, a straightforward approach works best. You have to 'frill up' for the kids."

Very targetted forms of production emanate from CHRs, contends KFRX's Lambert: "In this format, production has to be especially keyed. You can't be cavalier about spot mix in CHR. A commercial must really come across with a sound and message just right for the ears of our demos. Look, the account exec has sold the client on the station already, so obviously our target audience is their desired patron. Now the job is left up to us to communicate in a way that is appealing. You have to be careful, though. There is such a thing as overkill—that is, overproduction. You have to know where you're going with a spot in the format you're working. For instance, the difference between my copy and that of our sister station, which is a full-service Adult Contemporary, is that it can contain more words. Our delivery is faster, so we can read more copy. CHR listeners are used to listening to information at a faster pace.

The music and special effects in spots enhance, but do not make, spots. I always try to use a music bed. I think that's important in this format, but sound effects and characterization should be used selectively. I don't care for scenario spots on radio, because they do not involve the listener. A conversation between people on a spot may or may not inspire a listener to eavesdrop."

In summation, CHR stations air commercials with copy that does not talk down to their youthful listeners but is sensitive to their lack of worldliness. Deliveries are, for the most part, highly energetic and attention grabbing, and mixdowns reveal an affinity for more production ingredients and audio processing.

ALBUM ORIENTED ROCK (AOR)

According to the industry trade news magazine *Radio and Records*'s Format Reach Chart, which measures the distribution of listeners in each format, Album Oriented Rock stations are second only to CHRs in drawing rock music listeners. This format assumes several presentation styles. There are AORs that concentrate exclusively on what they term *cutting-edge* music, those that focus on classic rock tunes, and those that traverse both playlists, forming a hybrid of new and old—"from the classics to the cutting-edge," as Boston's AOR WBCN boasts.

KEZO-FM in Omaha, Nebraska, takes a similar approach, says program director Bruce MacGregor. "In addition to current hit rock cuts, we are able to go deeper on albums, both past and present. This depth

keeps our repetition low and time spent listening higher than CHR. We span twenty-five years of music in our library, so we don't rely on current releases only. Our mix is about sixty-five to seventy percent new and the balance old."

AOR was the first rock format to sweep music, and this remains its primary approach today, although, as in most other formats, morning drive-time demands usually reduce the amount of uninterrupted music aired. Greater attention to mix is given to sweeps in AOR, believes KPNY's Paul Browning. "Unlike CHRs that'll go from a ballad to a high rocker because of their position on the charts, we try to establish a sort of 'sound motif.' Blends and transitions have always been important in album rock. We draw from the CHR single charts to augment our playlists and to keep things fresh and current, but we maintain continuity. We don't just drop in a hit because the clock says it's time. It has to mesh with the sweep, or it waits."

For the most part, news broadcasts are kept to a minimum outside of AM drive-time, and at many AORs news is dropped altogether evenings and overnight. The five-minute news summary format is widely employed during the day, but some AORs keep news confined to one to two minute headline updates. Sports broadcasts are rare in this format, but brief tidbits (such as scores) are sprinkled in around the clock. Sports features during drive periods are more common than in other rock formats, since AOR is particularly strong in males sixteen to twenty-four, a demographic group that takes a keen interest in sports activities.

Personalities play a substantial role in AOR, at least to a greater extent than they do in CHR. While most formats allow for considerable deejay presence in the mornings, AOR is less inclined to go the anonymity—the "shut up and spin the records"—route. This was not always the case. In the 1970s, some AORs even experimented with automation, but the nonpersonality approach proved largely unsuccessful, supporting the contention of many AOR programmers that the music host or deejay is a vital ingredient of this format's air product.

Lifestyle promotions and contests are another major on-air ingredient of AOR, notes WHJY's top-rated morning personality and program director Carolyn Fox: "Contests and promotions must be geared to the lifestyle and interests of our listeners. Our audience is into concerts and all kinds of activities, so contests should reflect that, as well as the prizes given away. The idea is to engage the listener and attract new ones. AOR is an extremely promotion-oriented format. You don't give away something just to give something away. It has to mean something to have any impact. It can be something as simple as two tickets to a hot concert. While we're not talking Mercedes Benz here, the fact that you're giving something away that can't be had elsewhere leaves a hell of a favorable impression. There should always be a strong tie-in between promotions and the audience. To make this connection you have to really know and understand your audience."

Of any rock format, AOR is more inclined to air special features. In the 1980s, AOR stations were very much involved in live broadcasts of benefit concerts, such as "Live Aid." In the 1990s, AOR stations subscribe to a number of weekly satellite features, and when the opportunities exist to air live concerts, these stations are usually quick to do so.

FIGURE 15.3
AOR daypart clock.
(Courtesy WGAO.)

AOR Copy

In days of old, when the AOR format was more free-form in presentation, a "the crazier the better" philosophy prevailed in the copy department. Today, AOR is more mainstream, or less far-out. This is not to say that creativity in copy is discouraged or avoided. In fact, the contrary is true. AOR stations are noted for innovativeness in their copy.

At WWCK, programmer Chuck Hill wants copy to make a strong impression on listeners. "Copy should be thought-provoking. It shouldn't just slip by unnoticed. You can capture the AOR listener's attention with the right approach and words. In terms of our promos, we take the approach that the less copy the better. We build promos with highly imagistic production values—audio drop-ins from old and new TV shows, movies, and so on."

WBCN's production director Tom Sandman observes that AOR's in particular rely on music to sell a spot, and when this is the approach, text is subordinated. "We mix a lot of concert, club, and record spots here. When the music itself is the selling point of the spot, we keep the copy short to fit in as much music as possible. In other words, we let the music do the talking, so to speak."

Humor plays a large role in spots at WBCN, says Sandman. "We try to catch the listener with humor, but we never let it get in the way of the message itself. We don't try to be funny in a spot simply to be funny. The comedy must bond with the message and carry it to fruition."

AOR copywriters must prepare messages for a diversity of accounts. It used to be that waterbed stores and leather goods shops were the primary underwriters of album rock programming, but this changed in the 1970s, as the format realigned and tightened. Today, it is no more uncommon to hear a commercial for a bank than it is for a drag race.

Despite the wide range of accounts on AOR, most still prefer to avoid high-intensity messages common to other rock formats. "There is a general rule to keep hype out of spots and announcements here. We'll leave that to the Top 40 fellows," comments WWCK's Hill.

Nonetheless, raucous spots are not unknown to AORs, says former AOR programmer Joe Krause. "Occasionally, you have to let it rip, but for the most part, you don't compose scream copy in this format." Krause is particularly interested in maintaining a high degree of relevancy in copy. "Keep it honest. I'm very particular. I'll even change a piece of copy that reads 'COME TO OUR STORE.' It's not our business. We don't own the store, so we shouldn't give the impression that we are personally involved in the place. I think a good copywriter has to maintain a proper perspective and keep on top of the little things to do a truly effective job."

AOR Delivery

In the previous chapter it was stated that the album rock format was born out of a general disdain for the pop-hype common to AM chart music stations. This resulted in deliveries that at times verged on the catatonic in their attempt to contrast with the Top 40 shouters. The idea was to convey a relaxed, honest, and natural sound. Early AOR (Progressive) announcers did not want to sound like announcers, at least not in the traditional sense. Their goal was to come across like the guy in the next seat—unpretentious and normal.

In the 1970s, as FM embraced a more mainstream sound and won larger followings, AOR programmers reassessed announcing styles, insisting on greater animation for one thing. Gone were the days of the meandering, sometimes mumbled commercial delivery. As AOR attracted a more diverse list of advertising clientele, it felt compelled to sharpen its act, or at least emulate a more conventional sound.

This is not to imply that album rockers tossed aside their innovative, one-on-one delivery approach, but they did crank up the energy level a couple of notches.

In Washington, D.C., WWDC's program director Don Davis strives for a bright, upbeat, conversational style in his AOR station's spots. "Announcer delivery in this format should be fresh, energetic, but natural and intimate, not contrived or forced. AOR's on-air sound is less aggressive, for the most part, than other rock formats, and this same relaxed, cool approach must be evident in commercials, psa's, and the like."

Youthful and *up* are keywords in AOR, notes WBCN's Sandman. "You have to con-

FIGURE 15.4
AOR copy. (Courtesy KKDJ.)

```
Advertiser Category:   JOURNEY PROMO
Script Number:         START
Length of Spot:        :60
```

:10 — DUE TO THE OVERWHELMING RESPONSE FOR JOURNEY TICKETS, KKDJ HAS ANOTHER BIRTHDAY SURPRISE FOR YOU -- BY POPULAR DEMAND, KKDJ HAS ARRANGED TO BRING JOURNEY BACK TO SELLAND ARENA FOR A SECOND SHOW, FRIDAY NIGHT, JANUARY

:20 — SECOND. NOW'S YOUR CHANCE TO GRAB GREAT SEATS TO THIS ADDITIONAL SHOW. IN THE MEANTIME, WE'VE STILL GOT TICKETS TO GIVE AWAY TO THE FIRST JOURNEY SHOW, DECEMBER 29TH AT SELLAND. SO,

:30 — AS ALWAYS, STAY LISTENING AND BE THE 16TH CALLER ANYTIME YOU HEAR US PLAY JOURNEY AND WE'LL GIVE YOU TICKETS TO THE FIRST SHOW. PLUS -- GET THIS --

:40 — WE TALKED TO STEVE PERRY AND HE WANTS TO INVITE SIXTEEN OF OUR TICKET WINNERS BACKSTAGE AFTER THE SHOW TO SAY HI! SO, IF YOU WIN TICKETS FROM US, YOU

:50 — COULD BE CHOSEN TO GO BACKSTAGE, TOO! DETAILS COMING UP ON A SPECTACULAR NIGHT WITH JOURNEY, FROM THE HOME OF ROCK 'N ROLL...106-KKDJ!

:60 —

vey honest vitality in delivery. We try to be creative in spots, so we do whatever we can. When it's appropriate we'll do impressions, for example. You have to sound with-it, without conveying insincerity."

AOR Mixdown

Like CHR, AOR mixdowns are inclined to bed spots with music. Again, this has to do with maintaining overall programming flow,

as well as spot set flow. No one particular approach characterizes AOR spot production, however, other than this general statement. Music-heavy spots, as already mentioned, are very common in this format. Clubs, record stores, concerts, and lifestyle activity spots are abundant. This means that the production director spends a considerable amount of time selecting and mixing music.

Beds almost always consist of upbeat, rock music. Rarely do AORs back spots with music outside the format; the one exception would be agency spots that employ more generic beds.

As in most formats, if a client requests a specific piece of music for a spot, which does not gel with programming, it is usually rejected, observes AOR programmer Mel Meyers. "A client will sometimes want to use a certain musical piece that may be too extreme for our sound. We have to be sensitive to this. The producer must serve as a quality control checkpoint. Just because a client wants to use the *Rocky* theme on his butcher block furniture ad because it is his favorite tune doesn't mean it should be used."

One of the more routine types of spots in AOR is the concert promo. A technique known as *telescoping* is used to expose the listener to as much of an artist's songbook or repertoire as possible. For instance, let's say that Bruce Springsteen is slated to appear at the local arena, and AOR station KBBB-FM is to promote this fact. The following spot is put together. Notice that ten excerpts or sound bites are integrated into the mixdown:

Announcer 1: GET READY TO RUN TO THE CIVIC CENTER . . .
Music: "Born to Run" (up and under)
Announcer 2: MJK PRODUCTIONS BRINGS YOU BRUCE SPRINGSTEEN IN CONCERT AT THE FARTOWN CIVIC CENTER . . .
Music: "Tunnel of Love," "Jungle Land," "Pink Cadillac," "Reason To Believe."
Announcer 1: JUNE 10TH FOR ONE INCREDIBLE PERFORMANCE ONLY, IT'S THE BOSSMAN HIMSELF. TICKETS MAY BE PURCHASED AT THE CIVIC CENTER BOX OFFICE OR AT BELL VIEWS . . .
Music: "Brilliant Disguise," "Hungry Heart," "Nebraska," "Dancing in the Dark."
Announcer 2: IT'S SPRINGSTEEN IN CONCERT JUNE 10TH AT THE FARTOWN CIVIC CENTER . . .
Music: "Born in the U.S.A." (up and out).

Each song is aired to the point that it is clearly recognizable—perhaps three to five seconds. The excerpts are spliced together to showcase an artist's canon of work. Typically, the most well known songs in a performer's repertoire are used. This results in quicker recognition and a stronger impression. In this type of spot, the music is the copy.

Recall what WBCN's Sandman said about this type of spot. To repeat: "When the music itself is the selling point of the spot, we keep the copy short to fit in as much music as possible . . . we let the music do the talking."

Sandman also emphasizes the importance of creativity in AOR mixdowns. "At WBCN we've always placed a high priority on creative production—attention-getting spots and promos that make the listener respond (buy, call, attend). An artfully produced message should sell, motivate, entertain, reinforce, and inform. Some spots do all of these things. Too many don't. A production piece is only limited by the production person's imagination and innovativeness."

Audio processing and sound sweetening equipment are as popular in AOR production studios as in CHR, and this format has always placed a great deal of emphasis on fidelity. Having been born on the FM band, high quality stereo has always been an integral part of the AOR programming package.

URBAN CONTEMPORARY

In 1990, Urban Contemporary stations attracted eight percent of the total radio listening audience. UC is the phoenix that rose from the ashes of Disco in 1980. This programming formula attracts large numbers of young (sixteen to twenty-eight year-old) Blacks, Hispanics, and whites and can

FIGURE 15.5 UC programming clock. (Courtesy KTIZ.)

rightfully boast the most ethnically diverse demographic group in radio. It is America's great melting pot format. UC has particularly large followings in northern industrial areas, such as Detroit, Washington, New York, Philadelphia, and Boston.

In many respects Urban Contemporary resembles CHR in its on-air presentation. For example, both formats feature a highly energized sound, from music to deejays, and both formats focus on chart topping tunes.

UC music cuts a pretty wide path but ultimately is dance-based; the number one criterion in selecting music is that it be *danceable*. Remixes of CHR and AOR hits are playlisted in this format, which also has a strong affinity for longer, or extended, cuts.

Unlike CHR, Urban stations favor the sweep method. The idea is to keep the audience on the dance track. Breaking for spots after each song is perceived as a potential source of derailment since the UC listener is prone to button punch (although not to the extent of the CHR listener).

Of all the pop chart rockers, UC is the trendiest. Even more than CHR, UC is plugged into what is hottest at the moment, not only in music but in movies, television, and fashion. Because of this penchant for the chic and in, UCs strive for the hippest sound possible in all areas of programming—jingles to jocks.

This is a very tight and highly produced format that works hard at reflecting the lifestyle of its audience. Contests and promotions are as ubiquitous on UCs as they are on CHRs, and more than anything else prizes are activity (leisure time) oriented—tickets to clubs, concerts, and sporting events are popular.

Upbeat and *festive* are the two words that

most accurately describe the UC sound. As is the case on CHR stations, news reports are subordinated by the main mission of UC, which is to (in the words of one programmer) "keep the party going." News is increased during the morning daypart, but typically reduced to headline or update form in other dayparts. Many UCs offer the standard five-minute hourly newscast during the day, but eliminate hard news altogether in the evening.

The UC audience tends to be a little more sports-minded than CHR, but this seldom means that UCs broadcast games. Sports in this format usually take the form of miniupdates, which highlight games and center on relevant scores.

Lifestyle features are popular. For example, Boston UC KISS-108 offers listeners daily television soap opera summaries and the latest Hollywood gossip from a live Tinseltown correspondent.

More than any format, other than the Black format itself, UCs highlight the works of Black artists. Keep in mind that this is a format that originally targeted inner-city youth. However, over the years its appeal has broadened substantially, and young people in the middle-class suburbs now constitute a significant part of the UC demographic.

UC Copy

Since this is a format particularly enamored of current trends, it follows that copy should reflect this, observes UC programmer Lynn Tolliver: "You have to keep up on things. In this format perhaps more than in others you must stay on top of what is currently in vogue in terms of language and styles. Get this into copy, and you more effectively relate to the listener. Copy should echo what is on the format's street. It's in the music and in pop culture wherever you turn. Sometimes using just the right slang word, term, phrase, or buzzword can induce the listener to pay attention. In other words, it's important to write in the language—the vernacular—of the UC audience. That way it's more accessible and intelligible to those tuned in."

UC programmers, like their counterparts in other formats, prefer copy be composed of direct, uncomplicated sentences, despite the acknowledged need for a savvy style. The objective is to convey hipness in a comprehensible way, using good American English.

Since UC sponsors run the gamut, copywriters in this format are called upon to write a variety of spots. Innovative and humorous copy works well because the UC audience is particularly receptive to the unusual, if not bizarre. However, a direct, uncomplicated prose style works best because of the very kinetic nature of the young UC listener. In other words, the lines must stick the first time.

In conclusion, a statement this author made in an earlier text, *Production in Format Radio Handbook*, seems worth repeating here: "Urban Contemporary commercials that drag because they are written in a style that is too wordy, flat, or formal are as welcome as hot tar on a ballroom dance floor."

UC Delivery

Another comparison can be made between UC and CHR announcing styles. Both formats want copy delivered in an upbeat, festive, and with-it fashion. Energy and excitement must be conveyed. The music moves with a constant dance beat, so announcers must match the flow of the beds in commercials and other surrounding nonmusic elements to reflect this rhythm.

Not all UCs take as high-intensity an approach to delivery as the majority of CHRs do, however. In fact, some come close to mirroring AOR, assuming a somewhat more laid-back, yet no less enthusiastic on-air presentation.

The big voice, while not absent from UCs, is no more a desired criterion than a unique voice quality and delivery style. Again, this is one format that is receptive to the offbeat sound, as long as that sound communicates effectively to the UC ear.

Boston UC KISS-108 is a good case in point. None of their top personalities—Matt Seigel, Dale Dorman, or Sonny Joe White—would be cited as possessing a great radio voice, but each brings his own particularly distinctive and listenable sound to the station's airwaves.

UC Mixdown

In this format, the operative term when it comes to mixdown is *music*. A cappella

spots are rare. "You have to keep the beat beating," notes UC programmer Elroy Smith. In other words, commercials should not serve as roadblocks to the ebullient rhythms of the hot clock. Therefore, beds play a central role in the mixdown of spots and promos.

UC producers will bed spots with a greater diversity of music than will CHR. This does not necessarily mean Liberace, Chet Atkins, or Bach, but rather music that complements the more eclectic UC playlist. For example, hard rock, jazz, and reggae are not uncommon backgrounds.

As stated previously, many different types of businesses wanting to reach a young audience find Urban Contemporary stations effective buys. Among the most frequent advertisers on UC stations are clubs, concert promoters, record stores, and clothing outlets.

Since this is the original techno-pop format, audio processing is often a very integral component of spot and promo mixes. MIDIs and synths also play a significant role in many UC production rooms.

VINTAGE ROCK

There are three programming approaches to Vintage Rock radio—Oldies, Classic Hits, and Classic Rock—and each moves along its own distinctive path. Of the three, the Oldies format has been around the longest. An innovation of programmers Bill Drake and Chuck Blore, Oldies was introduced to the listening public in the 1960s.

Today, Oldies stations reside on both sides of the AM and FM bands. In fact, the Oldies format has done well by many AMs during a period when few have experienced success with music programming.

Oldies stations concentrate on music from the infancy of rock 'n' roll—the 1950s and 1960s. One Oldies outlet in the Midwest promotes itself as the station that offers listeners music "from Chuck Berry to the Beatles," and this would be a fairly representative playlist period for most operations featuring this format.

Oldies stations draw from the pop charts of the past and often attempt to replicate the early Top 40 sound by recreating the doowop atmosphere of the time. Very nostalgia and trivia oriented, Oldies attempt to evoke an image of an age when Ike was in the White House and Annette was on the "boob tube." Fun through musical reminiscences might describe the aim of Oldies stations.

Music is served up a couple of ways. Some Oldies outlets, especially those on AM, take the song/break approach typical of Top 40 during the period from which the music is taken. Others sweep their songs and cluster their announcements in spot sets.

Of the three Vintage Rock formats, Oldies generally place more emphasis on news and information, and many Oldies outlets air sports events. For example, Providence, Rhode Island, Oldies station WICE-AM broadcasts a complete schedule of college and major league sports events. In fact, of all the rock radio formats, Oldies can be said to be the most sports oriented.

The Oldies format draws the oldest listening cell (demographic) of all rock formats as well. While Oldies broadcasters claim a fairly vast age reach, surveys reveal that the majority of listeners are over thirty-five.

FIGURE 15.6
An Oldies morning-drive clock. Notice that there are positions for twelve songs, as well as ten minutes allocated for news and sports. (Courtesy KRLA-AM.)

FIGURE 15.7 Promotions play a major role at Oldies stations, as this piece illustrates. (Courtesy WHK-AM.)

Oldies stations have a penchant for features that embrace the period from which they derive their music. Programs such as "Cousin Brucie's Cruisin' America" are extremely popular with listeners, as are other syndicated Oldies programs by such golden icons as Wolfman Jack and Dick Clark.

The Classic Hits programming formula entered the airwaves nearly two decades after the debut of Oldies. The primary impetus behind the emergence of this Vintage Rock variation was the public's sudden intrigue with the music and culture of the late 1960s and early 1970s. This was nurtured by such films as *The Big Chill*, which reintroduced the public to the Motown sound and other rock tunes of a decade earlier.

Classic Hits stations primarily draw from the Top 40 charts of 1965 through 1980, though some air tunes that predate this period. Meanwhile, a growing number of Classic Hits station playlists give equal weight to chart toppers from the entire rock era.

Classic stations tend to attract a slightly younger demographic than Oldies, due primarily to a greater emphasis on more recent rock. As a consequence of this, news is offered somewhat less abundantly than it is on Oldies stations. However, it should be restated that information programming does play a more pronounced role in Vintage Rock than it does at outlets airing contemporary rock.

Like Oldies stations, Classic Hits stations exhibit an enthusiasm for features that highlight the era from which their music comes, and there are myriad syndicated programs available to Classic programmers.

Classic Rock arrived on the scene around the same time as Classic Hits—the early 1980s—and for much the same reason, a public craving for the rock sounds of the late 1960s and 1970s. In the case of Classic Rock, however, this meant a presentation of the heavier or harder rock of that era. Whereas Classic Hits offered groups like Three Dog Night and the Eagles, Classic Rockers went the Jimi Hendrix and Led Zeppelin route.

The primary age demographic of Classic Rock is comparable to Classic Hits—twenty-five to thirty-nine—but both do very well in the eighteen to twenty-four age group. Both Vintage formats, particularly Classic Hits, have caused some erosion in the CHR numbers in recent years.

Classic Rock stations resemble AORs in their overall presentation. The sweep and spot set formula is prominent, and news and sports programming is relatively light. The industry trade news magazine *Radio and Records* lumps all three Vintage Rock variations under the single heading "Gold" in their Format Reach Chart.

Vintage Rock Copy

Since the Vintage Rock demographics are adult, copy is written in a straightforward, intelligent style. That is to say, it does not attempt to be as hip and "now" as copy written for contemporary rock audiences. This does not mean that Oldies writing is

stuffy, dull, or geriatric. The contrary is true. Humor, for example, is very desirable in spots, says Jack Davison, general manager, KYSM AM/FM, Mankato, Minnesota. "We compose a lot of humorous copy. It keeps the mood upbeat, and that is good in Oldies. We do, however, target adults here, so the humor can't be adolescent in nature."

Indianapolis station WKLR-FM's production chief Greg Cooper expresses a similar perspective. "Locally written copy has to have an adult appeal because of the format's upper demo [demographic] reach, so when we do humor, for example, we take the high road rather than the low."

Oldies listeners come from a diversity of backgrounds. They are not "greasers" because they enjoy doowop, notes Russ Eckerea, production director of Minnesota's KWWK. "We air Oldies on our AM. Because of the high-end demos of our community, which is the home of the renowned Mayo Clinic and a host of other high-tech businesses that employ doctors and engineers, we must prep sophisticated spots and announcements. Writing has to be intelligent."

Usually the Oldies motif is avoided in spots. Thus, jargon and slang of the period is seldom written into copy. "We avoid clichés and worn-out slang associated with the era. No Oldies gimmickry as a general rule. This is not a novelty format, so every spot shouldn't suggest that it is," says KGTO's Gary Reynolds.

Vintage Delivery

A subtle difference in the delivery styles in Vintage Rock exists. For instance, Classic Hits stations are inclined toward a slightly more high-intensity presentation than are Oldies and Classic Rock.

Basically, all three Vintage approaches are after an energetic delivery style. "This is a fun format, so deliveries must be uptempo while not raucous," observes Oldies programmer Jack Davison of KYSM AM/FM in Mankato, Minnesota.

KDVV's Kimberly Skinner concurs. "The listener tunes Oldies for a good time. So be *UP*. Again, communicate in a personal way to get your point across. Talk as if the mic were a person. As I mentioned earlier, communicate as if you are sitting next to a good friend."

It should be stated that there are Oldies stations that endeavor to recreate the doowop, big-daddy sound of early Top 40 in its entirety, and this means in spot deliveries, too. The thinking is that the Oldies audience will respond in an even more positive way when they are reminded of the deejay greats of old. This is not to say that stations assuming this strategy hire only Cousin Brucie and Wolfman Jack soundalikes, but an obvious value is placed on the ability to recreate the announcing style of the period.

Vintage Rock Mixdown

Whereas Classic Hits and Classic Rock producers commonly bed spots with music representative of the period from which their station playlists are built, Oldies stations tend to avoid doing so. "We definitely don't bed spots with original versions of songs that are a regular component of our playlist," says WKLR's Greg Cooper.

Many Oldies production people believe that to keep the sound of spots fresh it is best to use generic instrumentals with a contemporary flavor. Many believe that bedding Oldies spots with vintage music creates format burnout as well as distracting listeners from the message of the commercial. "I think you're better off using the nondescript stuff, with a bright, uptempo sound," contends programmer Gary Reynolds.

Meanwhile, KWWK's Eckerea finds Middle-of-the-Road (MOR) music effective. "On our Oldies station, we avoid beds that mirror our regular music, so middle-of-the-road instrumentals work rather nicely."

While some Vintage Rockers hold to a policy that excludes current rock sounds as background material, others—particularly Classic Hits stations—are not as rigid in this respect. At those operations that oppose bedding with current rock, the underlying reason is to avoid reminding listeners of the existence of the contemporary rock formats. Vintage programmers who hold to this belief consider the contemporary rock music under messages as analogous to Chevy commercials with Ford jingles.

All Vintage Rock formats are very production-minded. As a result, the full range of production resources available are employed in mixes. "Whatever gets the job done," is how one Vintage Rock production

director puts it. There are few taboos in the Vintage Rock production room. However, this does not imply that every Vintage mixdown is an elaborate production piece. "Sure, we'll use whatever we need to get a spot across—sound effects, beds, production techniques—but in Oldies, in particular, we have found that a straightforward mix is very effective," notes Vintage producer Irv McKenna.

Audio processing of spots is more popular in Classic Hits and Classic Rock than it is at Oldies stations. WKLR's Cooper explains why this is true at his station: "Our production mixes are not geared to the high-tech synth sound because processed spots and promos in Oldies, at least here, do not really click with the older music we feature. This may be perceived as a purist's approach, but we're concerned with the full picture, and combining 1950s audio with cutting-edge digital technology creates an anachronistic effect."

The preceding observations have been designed to increase the reader's appreciation of the role of station formatics in the production room. They should by no means be considered a comprehensive assessment or survey of all the variables unique to the Rock Radio mixdown experience. The same can be said of the observations appearing in the remaining chapters of this text.

CHAPTER HIGHLIGHTS

1. Copy format criteria (setup/layout) are universal and are not affected by a station's particular programming.
2. Contemporary Hit Radio (CHR) is the most popular rock-based format and is second only to Adult Contemporary (AC) in total listenership.
3. CHR production reflects the intended audience:
 a. Copy is energy-conscious (upbeat tone) and less detail oriented.
 b. Announcer delivery is enthusiastic but not screaming.
 c. CHR is production-intensive, with carefully paced spots using involved production (music, effects, audio processing).
4. Album Oriented Rock (AOR) stations are second only to CHR stations for drawing rock listeners. Presentation styles range from all cutting-edge music to classic rock, with a hybrid of the two being quite popular.
5. AOR stations are noted for innovative copy that is thought-provoking. Words are often deemphasized in favor of images, music, humor—but seldom hype.
6. AOR delivery is bright, upbeat, and conversational.
7. Music-heavy spots are very common in AOR, as are attention to fidelity and the use of audio processing.
8. Urban Contemporary (UC) stations attract eight percent of the total listening audience, boasting the most ethnically diverse young (sixteen to twenty-eight age range) demographics.
9. UC copy reflects the most current language, trends, and styles. Announcers deliver the copy in an upbeat, festive, with-it fashion, matching the constant dance beat of the music beds.
10. Music beds are central to UC spots and promos, as are audio processing, digital synthesizers, and special effects.
11. Vintage Rock programming consists of Oldies, Classic Hits, and Classic Rock. All Vintage Rock formats use straightforward, intelligent copy appealing to their adult audience. An upbeat mood, some humor, and contemporary language (rarely jargon from the 50s and 60s) are employed.
12. Vintage announcers apply an energetic delivery style, with Classic Hits inclined toward a slightly higher intensity. All Vintage outlets utilize the full range of production resources available for mixes.

SPOT ASSIGNMENTS

Spot assignments for this chapter and subsequent chapters in Part IV may be found at the conclusion of Chapter 18.

16 Adult Radio Production

Despite the immense popularity of rock radio among young people, adult music radio stations may claim an even larger following (this includes formats such as Classical and Easy Listening, which are discussed in the next chapter). In fact, the top radio audience winner is an adult music format featuring contemporary music—Adult Contemporary.

Like rock radio, adult radio imposes its own unique demands on production.

ADULT CONTEMPORARY

An earlier chapter mentioned that Adult Contemporary had its genesis in several different formats. This is the veritable off-shoot format, having evolved out of Middle-of-the-Road (MOR), Mellow Rock (MR), and Beautiful Music (BM), as well as something in the 1960s called Chicken Rock.

In the 1980s, AC was the dominant ratings getter, and the most prevalent format in markets of all sizes. It was, and remains in 1990, the most common music format on AM, and the most widely offered format on either broadcast band in small markets. Its universality—that is, its broad-base demographics—makes it the format of choice by small market programmers.

While ACs target the twenty-four to thirty-nine year-old, this format attracts listeners on both ends of the demographic spectrum. This is largely due to the different styles of presentation found in AC. For example, there are Lite ACs, which concentrate on softer contemporary sounds; Hot ACs, which stress more upbeat, chart-oriented tunes; and Full-Service ACs, which mix a good deal of talk and information with contemporary adult music.

Lite Adult Contemporary stations resemble Easy Listening. Lite ACs are music intensive and both sweep and cluster. Announcing is kept to a minimum, as are all other nonmusic elements. This approach usually results in the reduction of news programming, except during drive-time periods, and contests and promotions are offered in less abundance than on other ACs.

It is fairly typical of this format that the later into the broadcast day the softer the music. Late evenings are usually the province of dream-inducing sounds on Lite ACs. At this hour, this AC format variation is particularly reminiscent of Easy Listening (see Chapter 17).

Hot Adult Contemporary, as the name suggests, broadcasts uptempo sounds to the point that it is sometimes confused with CHR. While Hot ACs do playlist tunes on the current pop charts, they give older hits (1970s) more of the spotlight. The mix of newer music has had the effect of bringing younger listeners into the fold. However, Hot ACs tend to generate most interest in the same demographic area as do Lite ACs—twenty-four to thirty-nine—but with stronger numbers at the lower end of the scale.

Unlike their Lite AC cousins, many Hot ACs confine music sweeping to late night, taking the song/break approach during other dayparts, and since *uptempo* is the operative term, jingles, jocks, and station promos often have a CHR feel.

Hot ACs find contests an important part of their air package, but news and sports often enjoy secondary status outside of drive-time segments. On the other hand, lifestyle features may be generously sprinkled throughout the broadcast schedule.

The third variation of the AC theme, Full-Service Adult Contemporary, is a direct descendant of old-line Middle-of-the-Road stations and is the most popular form of AC on the AM band.

At Full-Service stations, music and talk (in the form of news and information) often share equal billing. In terms of music pre-

FIGURE 16.1
AC program clock.
(Courtesy WKGW.)

sentation, Full-Service ACs offer the lightest amount of the three AC approaches. In fact, it is commonplace for music to be suspended entirely during drive-time periods, especially during the morning drive. News and information programming typically play a prominent role throughout the Full-Service broadcast day, and other ACs taking this route will schedule talk programs at night.

Sports is also a part of the Full-Service AC programming menu. Many stations are affiliated with major league teams and broadcast a full schedule of games, as well as other athletic events. The Full-Service AC demographic is skewed toward over-thirty-year-old males, many of whom are ardent sports fans. Of all the AC programming formats, Full-Service caters to the eldest audience—thirty-four to forty-nine.

Full-Service AC is the home of the high-visibility radio personality. The nature of this programming approach makes greater on-air announcer involvement a must. Some of the most popular and successful deejays in the country may be heard plying their wares over the Full-Service AC airwaves. Talk is an integral part of this format.

This is not the case in Lite AC, which, as already suggested, prefers a music emphasis. Hot ACs, on the other hand, often take a middle path between the two, allowing for a moderate level of deejay presence.

Adult Contemporary Copy

The writing style in AC copy must reflect the sophistication and maturity of the audience. For this reason, vocabulary may be of a slightly higher order than on pop-rock stations. At the same time, the super-hip lingo used in CHR/UC/AOR copy is regarded as out of place in Adult Contemporary.

It is important to write to reflect the lifestyle of your listener, claims K-PALM's Ford Michaels. "In AC this means to steer clear of slang, colloquialisms, and clichés, à la 'YOUR ONE-STOP SHOP FOR ALL YOUR BLANKITY-BLANK NEEDS.' When has any retailer ever asked a distributor for a gross of needs," observes Michaels, who notes, too, that hard-sell writing is discouraged. "We're a Lite AC, so super hard-sell copy is offensive. You don't sell anything to listeners when you run across their grain."

Generally speaking, the so-called hyped spot is uncommon in AC, especially in the Lite presentation. Rather than develop a hard pitch, WKKD's Chris Todd would rather focus on creativity: "AC requires a smoother, innovative kind of copywriting, for starters. You have to regard the variables of AC—audience, music, etc.—before composing copy. At other stations where I've worked, salesreps wrote all the copy, and announcers simply announced, but our production process is a little different. Salespeople simply sell, and the majority of our copy is written by our announcing staff. While it's true that copy information comes to us secondhand on production orders, and there are occasional communication lapses that result in revisions and corrections, it is also a fact that many announcers choose radio as a means of expressing their innate creative side. Writing creative copy is often an outlet for these talented folks. Writing copy that just accosts the listener does little to satisfy the writer or the AC listener."

At K-PALM, copy is written by salesreps, but this does not mean creativity is lacking, says Ford Michaels. "In AC you try to give the listener a little more. Our sales staff ac-

FIGURE 16.2
AC promo copy.
(Courtesy WXLO.)

the music station!
WXLO 104.5 FM

Worcester Center, Worcester, MA 01608 (617)752-1045

SPONSOR _____CLAMBAKE_____ TIME _____ CART # _____
START DATE _____4/25_____ END DATE _____

SPECIAL INSTRUCTIONS:

COPY

1 WE'RE READY TO GIVE YOU THE PARTY OF THE SUMMER -- AT
2 YOUR OWN HOME! WXLO WANTS YOU TO INVITE ALL YOUR FRIENDS
3 FOR FUN AND GREAT FOOD. EACH WEEK, WE'RE GOING TO GIVE
4 AWAY A CLAMBAKE FOR 15...COMPLETE WITH RICH CLAM CHOWDER
5 STEAMERS, LOBSTER FROM LEGAL SEAFOOD PLUS A PARTY PACK
6 FROM MILLER GENUINE DRAFT. IT'S YOUR OWN CLAMBAKE AND
7 WXLO BRINGS THE FOOD. ALL YOU DO IS DRAW A LOBSTER ON
8 A POSTCARD AND SEND IT TO CLAMBAKE, WXLO RADIO,
9 WORCESTER CENTER. AND WHEN YOU WIN ALL YOU HAVE TO DO
10 IS INVITE YOUR FRIENDS -- WE'LL DO THE REST. CLAMBAKES
11 EVERY WEEK ALL SUMMER LONG, FROM 104.5 FM...WXLO.
12
13
14
15
16
17
18
19

tually shares copywriting duties with our production director, and the collaboration frequently enriches a spot."

AC copy should be clear, concise, and intelligent, contends Paul Hemma of Dubuque's WDBQ. "We insist on tightly written copy that says as much as possible in the fewest words possible. Our writers are

critiqued by sales and programming people on a regular basis to ensure consistent quality for our advertisers and our listeners."

Adult Contemporary Delivery

AC spot delivery will vary depending on programming approach. Whereas Hot AC leans toward the more charged and effervescent, Lite ACs pursue a less animated style. This is not saying that the latter is devoid of energy or enthusiasm (the opposite is true), but a high-intensity delivery is out of step with Lite AC's programming elements.

The Full-Service AC delivery is chatty, that is, conversational, although spot delivery often runs the gamut between high-intensity and low-key. Because of the broader music and programming coverage of Full-Service there is more latitude in vocal presentation on spots, psa's, and promos. Of course, the content or message of copy most significantly determines delivery approach.

WTIC's production director Peter Drew raises an important—and universally applicable—point about spot delivery. "Announcer delivery on produced in-house spots will parallel the on-air delivery of a deejay during the course of his or her show. This has to do with the industry-wide concept of match-flow and is not an exclusive formula of ACs. Bottom line is voice: tracks must be in format."

Because the format is designed to attract adults, KKYY's production director John Nixon feels the relaxed, unaffected style of announcing is most desirable. "People tune AC to escape the hysteria and enjoy our brand of music programming. A relaxed, unpretentious, conversational announcing style is consistent with our objective to provide our listeners with good, mature Adult Contemporary hits."

Mike Nutzger of WGAR echoes Nixon: "Remember to communicate in an adult manner. Be yourself. That's the best way to communicate with this audience."

ACs mix spots for a variety of sponsors. In fact, this format may claim the most diverse list of advertisers. This places certain demands on a station's announcing staff, says K-PALM's Michaels. "All our announcers cut several spots every day, so versatility is important. Sometimes the sheer volume of voice tracks expected of announcers requires a degree of vocal calisthenics. AC delivery requests can be a real challenge."

WKKD's Chris Todd says that considerable talent and flexibility are necessary at his AC outlet. "We do a lot of *schtick* spots here—situation, humor, whatever—so announcers have got to be first-rate performers."

In conclusion, not only must announcers possess good vocal skills—such as articulation, inflection, intonation, pitch, interpretation, diction, and pronunciation—but they also must have a repertoire of deliveries to draw upon to meet client requests.

Adult Contemporary Mixdown

Audio processing gear is a part of AC mixes more for the purpose of enhancing sound quality than for the sake of special effects. AC has always been extremely concerned with fidelity, notes K-PALM's Michaels: "The quality of our signal, as well as our mixes, must sound 'L.A.' This market [Palm Springs, California] is a very international and sophisticated one, with lots of show-biz professionals as listeners. Ours must be a quality sound from start to finish. We EQ spots to get the most response we can. I've listened to us on alarm clock radios, cheap and top-end car stereos, home stereos, ghetto boxes, desktop radios, ceiling speakers, music on telephone hold systems, cable TV, and this makes spots hum. EQ the mic left up at 400 Hz to 4 kHz, right channel up at 200 Hz to 6 kHz, and off some at 2 kHz—about seventy percent. Send that through a reverb and out to tape. The next thing to do is take that and the bed (mostly Media General/Tanner discs) down at 350 Hz to 2500 Hz and up at 6500 left, and down at 250 to 3000 and up near 7500, and ship it all through a much different reverb at a higher percentage. The Optimod 8100A we use into the STL allows us to really punch up the bed without screwing up the voice track. We get lots of bang without lots of bucks, a situation that enables us to far outdistance many of our competitors in terms of dynamic range. You can't squeeze your audio, especially in AC, and sell it effectively to the listener. Don't panic! These are settings. A little experience on the EQ, and you will turn out a better mixdown." (For more on EQ, consult Chapter 9.)

Again, audio processing is primarily used

to enhance the sound quality of spots in this format, a format that tends to favor a less jazzed-up approach in mixdown. Put a different way, there should be no intergalactic explosions, laser zapping, or synthed voices beamed from the dark recesses of a black hole on AC commercials and promos. This does not mean that AC does not let its production hair down every so often, letting rip with a high-tech sound effect or two, but in general it leaves these effects to the rock formats.

AC programmer Paul Hemma warns against overproducing in AC. "A dense spot, one that is too busy or overmixed tends to stand out unfavorably here. That's not to say we're bare bones in our mixes. We do count on slick beds, especially for newscast intros, station IDs, and other special programs, but you shouldn't get carried away on AC spots. This doesn't mean we're opposed to richly produced spots. We just keep our heads about mixing."

On the same theme, AC beds should never be intrusive, says AC programmer Mike Nutzger. "Bed music should not distract the listener or deviate greatly from what the listener is accustomed to hearing on the station. For instance, an Adult Contemporary station would not use music by Van Halen behind a commercial."

Using hard rock behind a spot on an adult music station would be the equivalent of breaking format, observes KKYY's Nixon: "Don't violate your programming philosophy by permitting nonformatted music to bed spots. That's foolish. At Y-95, we do bed all our spots. Since our primary product is music, I try to make sure that all commercials produced in-house include a music bed. No voice-only spots. We subscribe to a production library called Trendsetter from Media General. It's designed to have the right sound for today's contemporary station programming for adults. By using these beds in conjunction with a low-key, friendly, one-on-one announcing style, we can remain in key with our overall air sound. This is our production objective or philosophy. Many spots which come from agencies or other radio stations don't have the sound we like to present our listeners. We deal with this by structuring each spot set in the following way: the best-sounding spots first, worst sounding last. Each spot is given a numeric code—5 for best-sounding, such as a full-singing jingle or concert commercial, and 1 is for a cold spot, that is, voice-only. Spots are then aired in descending order, meaning you break a sweep with your highest number and work down (5, 4, 3, 2, 1). In this way we can provide the best transition between song and spot."

Because a commercial is not a station's number one programming product, it does not mean it should be subordinated or glossed over, says WKKD's Chris Todd. "The philosophy at this AC is that each commercial is a separate ten-, thirty-, or sixty-second program. As a suburban station in a major market, successful and respected in the suburbs but virtually unknown beyond our immediate coverage area, we are not on the buylists of most agencies, so each local advertiser becomes that much more important. We go out of our way to create an advertising identity for each client, because only if they prosper will our station prosper. This means that you invest a lot of time, energy, and imagination on each mix. Within the context of the format, we use the full complement of production elements available to us to make a spot that truly sparkles. At KKD I'm given a tremendous amount of creative freedom and leeway—maybe that's why I've been here a decade."

According to WPEZ's program director Gary Moss, "A spot is as much the radio station as the music, so it should be afforded the same attention and care. You can lose the AC listener in seconds by airing a commercial that is annoying or boring."

What Moss and other AC professionals are suggesting is that production should be invested with some of the same enthusiasm and interest that composers give to the music that is aired in this format.

COUNTRY

Country may rightfully claim to be the senior music format on radio, having made its debut in the 1920s. Nashville station WSM-AM has been broadcasting music from the Grand Ol' Opry almost from the medium's inception.

Up until the 1960s, the Country music format found the bulk of its audience below the Mason-Dixon Line. Country music was

southern, and that was all there was to it, or so was the belief of many broadcasters outside of the area. Rarely was Country music heard over the airwaves in northern metropolitan areas, although the Midwest was a good market for the format, which also was referred to as Country and Western (C and W), revealing its broader reach.

Nonetheless, Country's stronghold was the South, and although the format enjoys national success today, the South remains the primary home of country music. For instance, whereas Adult Contemporary is the dominant sound aired by small northern market stations, country music is offered by the majority of nonmetro stations in the South.

The impetus behind the wider acceptance of Country radio was the crossover appeal of several country artists (Johnny Cash, Glen Campbell, Johnny Hartford, Bobby Goldsboro) during the 1960s. Songs that originally climbed the country music charts made the jump to Top 40 because of their more contemporary, less traditional sound. In fact, a number of singers traditionally associated with country music achieved the top position on the national pop charts.

During the 1970s, the mainstream rock music charts were further influenced by country's Rebel Rock sound. Groups like the Allman Brothers, Lynrd Skynrd, and Marshall Tucker were clearly Southern performers working the rock 'n' roll side of the street and influencing rockers from other parts of the map, such as the Eagles.

By the 1980s, the Country format had developed a number of offshoots and offered listeners a variety of approaches, which continue to be aired in the 1990s. Among the most successful presentations of Country are Contemporary Country, Traditional Country, and MOR Country.

Contemporary Country stations offer variations such as Lite (or Easy) Country and Hit Country. In the first instance, music is aired in a manner reminiscent of Lite AC and Easy Listening stations. The more music and less talk formula is adhered to. Sweeps of soft and easy country hits are playlisted, and announcers often assume a

FIGURE 16.3
Country clock. (Courtesy WTCM.)

Green—Oldie
Green x—Golden Oldie
Orange—Recurrent
A,B,C—Music codification symbols
Wx—Weather

*Optional stop set for slow spot hour

background or supporting role. A growing number of Lite Country outlets are automated or satellite-fed, and news and information are therefore minimized.

Hit Country, as might be inferred, follows a path similar to that of other pop chart stations, in that the concentration is on the best-selling songs. Hit Country works at communicating energy and excitement, and, because of this, contests and promotions are plentiful. "I couldn't name another format that goes into promotions as much as we do here. We do remotes, appearances, and whatever else it takes to generate attention," says Gregory Raab of Detroit's WCXI.

News and sports are a bit more evident in this Country variation than they are in Lite Country, but they seldom take precedence over the music. The announcer or deejay is also more visible in Hit Country than in Lite.

The age demos for Country, in general, are very broad. However, Lite Country—along with Traditional and MOR Country—draws a slightly older demo than Hit Country. The Organization of Country Radio Broadcasters claims that the age spread of people tuning Country stations is the widest of all formats. Lite and Hot Country stations are the most popular Country formulas in the Northeast and on the West Coast, whereas Traditional and MOR Country are strong in the South and Midwest.

The old-line, Traditional Country format has been around the longest. These are stations that attract listeners who have a taste for the country classics—the bluegrass and Grant Ol' Opry sound typified by artists like Porter Waggoner, Roy Acuff, Hank Williams, and Patsy Cline, to name only a few.

Generally speaking, Traditional stations air plenty of news and information and lean toward personality. Some Traditionals sweep their music, but the song/break/song method is more prevalent, since talk is regarded as an integral element of programming. Traditional Country programmers are after an upbeat and vital sound, even though they dip back into the music vaults of yesterday for the music they playlist. Both Country oldies as well as new records rooted in the Country tradition are an important part of what these stations air.

While the Traditional Country format is especially popular in the deep South, it attracts the fewest number of listeners in the northern industrial centers, which is why it is seldom available in those areas.

MOR Country reached the peak of its popularity in the 1960s, but with the diversification of country music and the emergency of country music specialty formats, it has experienced a gradual softening in its numbers.

MOR Country stations avoid extremes in their music—in other words, no extremely upbeat or extremely soft or mellow tunes are played. The idea is to eliminate material from the opposite ends of the country music spectrum so as not to alienate anyone; thus, MOR Country stations provide music for the vast midsection of "Country" America.

The full-service approach is common in MOR Country. "We provide our listeners with a variety of news, information, and entertainment features, in addition to our music that runs the field from big band country to western songs to pop chart MOR tunes," says WDLC programmer Bruce Allen.

Like Traditional Country stations, MORs have a taste for bright, cheery personalities, and they are disinclined to serve up music in lengthy sweeps. They also offer many contests and promotions.

Country Copy

For years, Country stations were perceived by outsiders (nonlisteners) as the "home of the hicks," notes programming consultant Donna Halper. "Country stations suffered from an image problem until the crossover boom in the 1960s and the new sophistication they acquired in the 1970s in terms of on-air presentation."

In general, Country copy has always tried to reflect the overall amicability and warmth of the format, but this does not mean that the goal is to give every client a "country cousin" commercial, observes Jeff Ller of Salinas, California station KTOM. "There really is no attempt here to put forth a country sound in commercials, per se. We just strive for intelligent copy that relates to our type of listener and sells the sponsor's goods."

In other words, the "y'all come on down, cousin" style of writing is primarily characteristic of the past. "No 'Hee-Haw' stuff. You may get creative with humor and may

FIGURE 16.4
Country station copy.
(Courtesy KMSL.)

```
KMSL FM — 100
724 SO. JACKSON
MAGNOLIA, ARKANSAS 71753
PHONE (501) 234-7790

Advertiser: Ivan Smith Furniture
Begin: _____  End: _____
Prepared by: _____
Spot No.: _____

BOB:   Hey, Lori, what's going on at Ivan Smith Furniture, every-
       where I go people are talking about it. All I hear is Ivan
       Smith and sale prices.

LORI:  Well, Bob, everybody is talking about Ivan Smith because their
       anniversary sale is still going on, and everything is sale
       priced--at substantial savings, too. Like an England sofa
       and love seat--the regular price is $1300, it's sale priced
       now for $888.

BOB:   Gosh, that's a savings of $412!!

LORI:  Yeah, and you can also buy a Broyhill bedroom suite for
       $649, normally priced at $900--and that's a savings of...

BOTH:  $251.00!!

BOB:   At those prices I'd love to do some refurnishing, but you
       know I just spent all my extra money on my new sports car.

LORI:  Bob, Ivan Smith has easy credit terms that are no hassel,
       so you can just finance it, and if you need some new appliances,
       Ivan Smith has a full line of Hotpoint appliances.

BOB:   So, I can still have my sports car, and new furniture, too,
       with easy financing.

LORI:  Yep.

BOB:   Now I know why everybody is talking about Ivan Smith Furniture
       and that's where I'm going right now, to Ivan Smith on North
       Jackson in Magnolia.

This announcement was broadcast _44_ times as entered in the station's program log. The times
this announcement was broadcast were billed to this station's client on our statement
dated _____ at his earned rate of:

$ _____ each for _44_ announcements, for a total of $ _____.
$ _____ each for _____ announcements, for a total of $ _____.

Sworn & subscribed to me this
_____ day of _____ 19 ___
                                              _____
_____                           Bookkeeper, KMSL FM
Notary
```

use the down-home-in-the-holler style, but using hayseed or hillbilly parlance doesn't fit our Country image anymore," notes programmer Dave Ross.

If a term were used to characterize Country copy, it would be *down-to-earth*. This is not a format prone to pretention. Copy must convey honesty and friendliness to be effective.

In the opinion of Country radio programmer Michael Cook, keeping close ties with the sponsor is the best way to create successful copy. "This keeps you in touch with the subject matter in the copy, and all writ-

ers need to maintain contact with their subjects to communicate with power and effectiveness. To get the right feeling about a sponsor and to have a good sense about what he is trying to sell, you have to maintain a tie."

Since the Country radio market has become so vast and—in terms of age and economics—the demographics so broad (in the past one-and-a-half decades, Country has attracted many more listeners from the upper-end of the income scale, although it still pulls strongest from the blue-collar pool), copy is written for every conceivable type of sponsor; all the rules applicable to good copywriting apply to this format as to any other.

Country Delivery

Having a southern accent is not regarded as an asset when it comes to Country delivery. To think so would be a misconception based on the old assertion that Country radio broadcasts for, and is operated by, an army of "Billy-Bobs," who drive pickup trucks with rifle racks. Not so, says WQHK's Steve Brelsford. "This is a modern, sophisticated format. Announcers don't talk countryish or *twang* when they pitch."

The nonregional, generic delivery style serves as a model in Country, as it does in other formats. This does not mean that a southern accent will never be detected on a Country spot or that a slight drawl results in dismissal. It is a fact that some Country spots sound countryish down deep in the South, but on the whole, even announcers broadcasting from the South's heartland strive for a nonregional, generic delivery.

The conversational style is most evident in Country spots, but a station's particular brand of Country comes into play. As might be expected, stations walking the Easy Listening path prefer a low-key delivery. Hype or hard-sell on Lite Country outlets would be as out of place as a high-intensity delivery in any other soft format.

Hit Country generally pulls out the stops and allows hard-sell deliveries, but not quite to the degree that CHR does. Meanwhile, Traditional and MOR Country are fairly liberal when it comes to delivery, yet both show a preference for the medium-intensity, bright, one-on-one approach.

KTOM's Ller observes, "You have to come across as human in Country. Beyond that, you have to hit your mark in the time department. Voice tracks must stay within the clock, be they thirty's, sixty's, or whatever. Another thing we feel important here is to spread spots around so that one voice is not always heard."

In a previous book, *Radio Programming: Consultancy and Formatics*, this author commented that Country is the most people oriented of all formats, meaning that Country tends to convey a greater sense of family or neighborliness than do other formats. Given that there may be some truth to this observation, it would follow that a Country delivery should possess qualities that create a bond between an announcer and his or her audience, rather than a gulf.

Country Mixdown

Mixdowns in Country run from the simple to the lavish. The votes are split concerning the use of country music to background voice tracks. While some outlets feel that country instrumentals are most resonant with the format, others insist that they dilute the sound and weaken the playlist. "We try to match background music with all other programming elements so that a harmony is achieved," says KYCK's Michael Cook.

KNIX's Tessitore says that the programming department allows for the use of all types of beds, country included. "Of course, we don't air real CHR stuff. It would sound pretty foreign to our audience. But we will permit most anything to be used as background—beds, effects, and so on—as long as it's in good taste. Within reason, we use whatever music or effect helps get the message across. A lot of our spots are bedded with country, but certainly not all. The goal is to keep things sounding fresh."

Lite Country outlets favor beds with a more benign beat and rhythm than Hit Country, and Traditional and MOR generally impose no specific strictures on tempo or pace, but tend to avoid anything too current or harsh.

The sophistication of today's Country format factors in the use of audio processing in the production studio. Equalizers, exciters, compressors, expanders, and the entire complement of time domain effects—flangers, echoes, delays, reverbs, and

the like—are used to make Country production ear-grabbing and more exciting.

MIDDLE-OF-THE-ROAD

MOR predates television and the age of radio programming specialization, and some broadcasters would probably argue against its classification as a format at all because of its highly generalized programming. This is the quintessential "not too anything" format, especially when it comes to music presentation, although some MORs have taken to narrowing their playlists in the past decade.

Variations on the format would include full-service and block/variety. No matter how the format is broken down, it comes out a hybrid of sorts. For example, basic MORs air a cross section of well-established non-rock and share their programming clock with a host of other nonmusic elements, such as news, deejay patter, and sports.

Of course, stations employing the full-service schematic do it all, providing their listeners with news, talk, features, and music, too. The full-service variation is the most prevalent form of MOR and can safely claim to be the busiest of all formats.

The block/variety approach has provided fuel for the argument that MOR is unclassifiable as a format per se, since it holds to no primary or exclusive programming track. In many respects variety/block MORs use the same approach taken by the vast majority of noncommercial or alternative radio outlets found on FM—what is sometimes referred to (perhaps disparagingly) as "smorgasbord radio."

The magazine or diversified MOR formula has been gaining some ground as a commercial programming venture and has surfaced on the FM band in a handful of communities. WDST general manager Jerome Gillman explains the thinking behind his block/variety FM located in Woodstock, New York. "The sole criterion here is that the music be good. We emphasize music in general, rather than air one type exclusively, around the clock. Our format is very distinctive and unique in this market. WDST serves up jazz, classical, rock, country, rhythm and blues, and talk, as well as reading, comedy, and children's programming. We're very eclectic."

FIGURE 16.5
Full-Service MOR clock. (Courtesy WASR.)

MOR is a major draw on the AM band. Consultant Donna Halper observes, "MOR is keeping AM radio alive today. It attracts tremendous cumes [unduplicated listeners] and shares in many major markets because it provides an essential service. Due to its longevity as a format, people have come to believe and trust in it."

In the mid-1980s, an Arbitron (Arbitron is an audience measurement service) radio survey revealed MOR to be the second highest rated format on AM, while it could only claim eleventh place on FM. In the 1990s, Vintage music programming has resulted in erosion of MOR's position on AM.

Other MOR format characteristics include a predilection for sports and features, as well as personalities. In the first instance, many MORs air sports talk shows and contract to air major league games. Sports programming is less evident on block/variety stations and most prevalent on full-service MORs.

Features are a very prominent programming ingredient in this and other MOR formats. Features are usually geared for a mature adult audience, focusing on topics of interest to this group. For example, programs that deal with health, finance, travel, and world issues fair well in MOR, because this is a format that is inclined to appeal to a more serious or involved type of listener.

Of all the formats found on the radio dial, MOR is the most keen on high-visibility announcers. Some of the most popular and successful personalities on radio make MOR their home. "A warm, glib, yet inoffensive personality works best here," says Brian Bruns, program director of KODY-AM. "The announcer must be someone who genuinely relates to the listener—a friend who cares. We tried the straight announcer style once, but it didn't work in our brand of radio. MOR is too ingredient rich for low-profile announcing. We're live, not automated. The op-assist (operator-assisted automation) approach is incompatible here."

The majority of MORs talk throughout drive periods, especially mornings. The AM drive news and info block is a major income generator at more MOR stations and often is a strong ratings grabber in metro areas.

Phone-in talk shows prevail at night at an overwhelming number of MOR stations, and these too have done very well in the ratings. The syndicated or network talk program is a common offering, although most MORs that work the talk lines keep the focus on local topics and issues as much as possible.

Over the years the formats that have posed the most competition to MOR include News, Talk, Adult Contemporary, and Easy Listening. Country also tugs at MOR numbers. To reiterate an earlier point, format diversification and program specialization have caused MOR's star to fade somewhat.

Programmers believe that this decline can be averted by giving the audience what other formats do not. According to Janet Bailey, programmer at WKBR-AM: "We're in a unique situation here. Our primary adversaries are other nonrock formats. We differentiate our format by positioning as foreground rather than background. This is achieved through a variety of methods, including promotions like concerts, keyed specifically to our music. Our secondary competition comes from News/Talk, because it's aimed at a similar demo. Rather than go head-to-head with this format, we try to emphasize drive-time information in order to cut down on the quarter hours we share with them."

MOR does claim a fairly broad demographic (twenty-four to fifty-four), although some media observers argue that the format attracts the oldest radio listeners. According to national programmer Dick Ellis, "Realistically speaking, MOR has an over-fifty listening cell."

MOR Copy

Due to the mature demos MOR attracts, hip slang and jive jargon are best avoided. This does not mean that commercials and other types of copy should be stodgy, stuffy, or old-fashioned. Writing should be literate, light, and witty—not weighty. The mature listener enjoys a clever turn of phrase.

MOR copy can be made more effective by using references relevant to the life experiences of the audience, or, stated more succinctly: speak in the tongue of those tuning in. Create copy that conforms with the audience's sense of the world—that gels with its historical perspective or view.

Creativity is no less appreciated in MOR than in any other format, and a copywriter is as likely to be asked to write a hard-sell spot as a soft-sell spot—and a humorous spot as well as a dramatized spot.

Since MOR is the land of the high-profile radio personality, clients often request spots be done by a particular on-air celebrity. When this is the case, copy is tailored to suit the style of the person requested. For example, should the chosen personality possess a quaint, down-home style of delivery rather than a sophisticated, urbane sound, copy will be composed with that in mind. The copywriter should exploit to the fullest an MOR personality's unique delivery strengths.

MOR Delivery

From the preceding statement it may be accurately deduced that a myriad delivery styles are used in MOR production, save for the decibel-devouring performances sometimes encountered over the rock radio airwaves. But it must also be stated that the natural conversational style of delivery serves as the primary model in MOR. This being the "not too anything" format, an easy, natural vocal presentation fits well, notes programmer Paul Douglas. "Nothing outlandish in the adult format, but on the whole MOR doesn't constrict delivery the way a lot of others do. Just listen to us, then tune a contemporary hit station, for example. Of course, it all comes down to who you're programming for. Being real gets the message across effectively in our format."

Metro market MORs continue to display a preference for the big voice. According to many MOR programmers, a deep, resonant voice conveys maturity and credibility—two things the MOR listener can relate to.

MOR Mixdown

Given that extremes are rare in MOR, it follows that stations offering this format do not background, or bed, voices with heavy rock music, although nearly every other type of music is used for this purpose, albeit usually watered down. That is to say, if a country bed is used, it is not a thick piece—meaning no heavy banjo-strumming or hee-haw stuff.

This is the *middle*-of-the-road format, so using beds that are too uptempo, lethargic, unusual, or exotic may create an unwanted departure from the tried and true. The *road* is fairly wide, however, so there is much background to choose from when mixing in MOR.

Before leaving this chapter some general reminders concerning the use of sound effects (this was discussed in previous chapters) seem appropriate. When introducing a sound effect into a mix do not *telegraph* it—do not give the impression that effects are rolling on cue. Sounds should arise or appear naturally, as they do in everyday life. Here is an example in copy form of the right and wrong way to mix an effect:

Correct:
 (SFX: Footsteps) HERE COMES MOLLY, NOW.
Incorrect:
 HERE COMES MOLLY, NOW. (SFX: Footsteps)

The latter example would create the impression that an invisible director has thrown Molly a cue to walk, and this comes across as contrived. Molly is approaching the speaker when he or she makes the observation "HERE COMES MOLLY, NOW." Here is another example:

Correct:
 (SFX: Howling wind) WHAT A TERRIBLE STORM!
Incorrect:
 WHAT A TERRIBLE STORM! (SFX: Howling wind)

Remember, sounds occur naturally and should never seem scripted. Effects should not be used simply for the sake of using them. There should always be "sound" reasoning behind the employment of effects. They exist to enhance the spoken word, to help create an image in the listener's mind.

In addition, sound effects should be used sparingly. The intelligent application of sound can heighten the meaning of words, but extravagant use can actually destroy the message in a script. In other words, do not drown copy in sound effects. Too many sounds distract the listener from the point of the written word. The overproduced spot does little more than amuse the production person.

One last point: sound effects should be selected carefully and sensibly. If a spot calls

for a standard door bell, choosing an effect that gives the listener the impression someone is ringing the door chimes at Buckingham Palace is going to create the wrong mental image and thus corrupt the meaning of the copy.

The bottom line is: use common sense when working with sound effects. Many times they can make or break a spot.

CHAPTER HIGHLIGHTS

1. Taken collectively, adult music radio formats claim an even larger following than rock radio. Adult Contemporary (AC) draws the largest audience and is common on both AM and FM. There are Lite ACs, Hot ACs, and Full-Service ACs.

2. AC targets the twenty-four to thirty-nine year-old, but it draws well throughout the demographic spectrum because of its different styles of presentation at different stations.

3. AC copy must reflect the maturity and sophistication of the audience. Hard-sell techniques are avoided. Spot delivery varies depending on programming approach: Hot AC is charged and effervescent, Lite AC is relaxed and unaffected, Full-Service AC is conversational.

4. Because ACs may claim the most diverse list of advertisers, mixdowns require versatility. Audio processing is used more to enhance (sweeten) sound quality than for special effects. Bed music is never intrusive, and overmixed spots are avoided.

5. The Country music format made its debut in the 1920s, and its greatest appeal has always been in the South and West. The crossover appeal of major artists has broadened Country's appeal since the 1960s. By the 1980s several Country offshoots (Contemporary Country, Traditional Country, Lite Country) offered listeners a variety.

6. Country copy tries to reflect the overall amicability and warmth of the music, employing a down-to-earth tone and vocabulary. Copy is delivered in a nonregional, generic style with a conversational, personable tone.

7. Country mixdowns run from simple to lavish, depending on the sponsor. The full range of audio processing and time domain effects are employed when needed. Stations are evenly divided on using country or other music to bed spots, and the tempo used varies according to the type of Country outlet.

8. Middle-of-the-Road (MOR) also predates television and the age of radio programming specialization. Basic MORs air a cross section of well-established standards (nonrock) and include a host of nonmusic elements (news, sports, features).

9. MOR copy is literate, light, and witty—reflecting its mature audience. Since on-air personalities are high-profile, copy must blend with their image and delivery style as well. For the same reason, delivery styles vary according to the voice being used.

10. The varied bed music used is always unobtrusive and carefully blended with the station's sound.

SPOT ASSIGNMENTS

Spot assignments for this chapter may be found at the conclusion of Chapter 18.

17 "Good Music" Radio Production

"Good Music" was the term most commonly associated with the Classical and Beautiful Music formats in the 1960s. A number of things inspired this decidedly subjective nomenclature. First, both formats resided almost exclusively on the FM band, which in the early 1960s was widely regarded (and disregarded by some) as the fine arts radio service. Second, both of these formats were the first to be broadcast in static-free stereo, so they achieved a unique status among fidelity-conscious listeners—*audiophiles,* as they were called. Lastly, these formats were perceived as a refuge—an island surrounded by a hostile sea—by those listeners wishing to escape what they felt to be the banality and cacophony of pop/rock radio. Thus, in the eyes of many, Classical and Beautiful Music were the "good music" alternatives. Implicit in this assertion was the attitude that whatever else radio offered in the way of music was bad or, at the very least, substandard.

Today, the term "good music" is less frequently used to describe these stations, but the idea remains, at least as far as those who tune them are concerned. Audience surveys, such as *Radio and Record*'s, estimate that fourteen percent of the listener pie goes to Easy Listening, Classical, and Nostalgia. (Because of the many characteristics Nostalgia shares with Easy Listening and Classical, it will be listed in this chapter.)

EASY LISTENING

Easy Listening (EL) ranks fifth in the country in listenership, and in many cities it tops the ratings charts. In the late 1970s, EL outlets were referred to as Beautiful Music until they experienced a decline in their fortunes. A revitalization plan gave Beautiful Music a new name and sound, as well as a much needed expansion in numbers.

Today ELs still sweep music as did their BM precursors. This is still the ultimate continuous music format—the granddaddy of them all—so nonmusic elements are mixed into programming with great delicacy. As stated in Chapter 14, EL/BM was the format that conceived of the "more music and less talk" formula.

In this flow-conscious format, personalities seldom find a niche. A low-profile announcer presence is understandable considering the music emphasis and the fact that many ELs are satellite and/or automation driven. The term *live-assist* (live announcer with automation) stems from this fact and is telling about the amount of announcer on-air involvement.

About the only time announcer presence is increased is during morning drive-time. At many ELs, the morning drive person assumes near personality status, yet seldom to the extent found in most other formats. During other dayparts, the on-mic person all but vanishes from the airwaves.

News, too, gets greater play mornings, although it ranks highest in importance after music programming. Hourly news updates in five-minute increments give the EL listener about as much news as he or she wants. It is common practice to drop news altogether evenings and overnights. This keeps the focus where EL programmers feel it should be during these dayparts—on the music.

Sports programming is virtually nonexistent in EL, and features (with the exception of some well-placed public affairs programs) are scarce. ELs occasionally schedule music specials and series that mirror their regular playlist, but more often than not they adhere to a long-established rule that discourages deviation.

On-air contests and promotions typically avoid the dramatics common in other formats. Instead, ELs prefer to strengthen their image through off-air promotion using bill-

"GOOD MUSIC" RADIO PRODUCTION 203

The listeners you're after tune in to WRCH/FM and WRCQ/AM

We've got more of Greater Hartford's most powerful spenders — adults in the 35 to 64 age bracket — listening to our Beautiful Music and Big Band radio stations than ever before.

The Spring '83 *Arbitron* figures confirm that our sister stations, WRCH/FM and WRCQ/AM, are continuing to draw a leading share of the mature adult audience — just the affluent and quickly-growing market you're after for your advertising message.

We're playing their songs — and they're listening. Sing them your song on WRCH/FM 100 and WRCQ/AM 910 — and tune in to sales.

Our average quarter hour listenership ascends the scales:

Mon-Fri 35-64 Adults Fall 1982 Spring 1983

Time	Fall 1982	Spring 1983
6AM-10AM	12,000	16,400
10AM-3PM	16,500	25,900
3PM-7PM	13,700	17,600
7PM-12M	3,700	4,400
In fact, for the total broadcast week: Mon-Sun 6AM-12M	10,700	15,500

Source: Fall 1982, Spring 1983 Arbitron. Subject to limitations.

WRCH/WRCQ
FM 100 / AM 910

FIGURE 17.1
Easy Listening station promo piece. (Courtesy WRCH.)

FIGURE 17.2
EL clock. (Courtesy WHER.)

or arrangement possessed by both tunes. It could be argued, however, that EL playlists are skewed to the less current songs. The reason for this is that the format prefers to air music that is immediately identifiable by its older demographic. (Easy Listening's primary cell is forty and over, although proponents of the format claim that it has respectable numbers between twenty-five and thirty-nine. Whether this is the case or not, ELs could not survive without the older audience.)

With few exceptions, Easy Listening is located on FM, and it can claim among the most loyal audience in radio. Once an EL listener tunes in, he or she generally settles in. These are not button-pushers or station-hoppers. ELs often hold listeners for years.

In the 1980s, Easy Listening saw some of its audience share dwindle as a consequence of an influx of Lite Adult Contemporary outlets, which tap the younger end of EL's demographic.

Easy Listening Copy

Obviously, hard-sell copy would be antithetical in a format stressing "easy." D'anne Inman, production director at KTRX-FM in Springfield, Missouri, says, "The goal is to compose copy that possesses the same soft and easy feel as in our music. Because we are Easy Listening, our commercials are much more soft-sell than they are in other formats. In keeping with this we don't write copy for two voices, which we believe often breaks flow."

WPCH's Vance Dillard imposes rigid standards on copy at his Easy Listening station in Atlanta, Georgia. "We have particularly high standards when it comes to copy, which I suppose can be summed up in one word—*intelligent*. Nothing obnoxious enters the airwaves."

Sensationalism is a felony in EL copy, notes WGER's Bill Harnsberger. "Overblown and harsh language simply is unacceptable here at Lite 'n' Easy 106."

Because ELs choose to walk the high ground when it comes to copy does not mean writing has to be flat and uninteresting, explains Harnsberger. "Because we're an Easy Listening station, our commercials and promos need to be written in a softer, less frantic style than they do on CHR or AOR stations. However, there's no rule that

boards, newspapers, and television. When ELs engage in contests they are of a more subtle nature and are typically "ticket and trip" oriented, although giveaways can be quite extravagant. Many expensive automobiles and even pieces of real estate have been awarded to lucky listeners.

Instrumentals constitute the core of playlists at a large percentage of Easy Listening stations, but certainly not to the degree that they did before the format's overhaul in the late 1970s.

At more and more ELs, vocals are becoming an equally important part of music programming. In fact, some stations insist that vocals outnumber instrumentals. They believe that this makes them more foreground and less subliminal—more vital and active sounding.

On the whole, ELs mix it up, devoting airtime to each type of recording. ELs build their playlist on the easy standards of the last fifty years, and this earns the format the distinction of covering the most musical territory of any programming genre, with the exception of Classical. It is not uncommon to hear a ballad from the 1940s followed by one from the 1980s. The unifying characteristic would be the "easy" sound

says we have to make our spots boring. No matter what the format is, a spot is a pitch. It must sell. I'm quite proud of the fact that we have the most creative production department in the market. We use a lot of humor in our spots to engage the listener and sell the sponsor's product."

Novelty spots are rarely written in this format, observes WJCL's Al Jennings. "Easy Listening stations target a mature demo that is more affluent and well educated in our particular market. Cutesy commercials are often a turn-off to this group. Of course, one benefit of our type of listener is that we use words of three and four syllables without fear that they are flying over the listener's head."

Jargon and slang are seldom incorporated into EL copy, which (as the experts have indicated) should be attention getting without going overboard and intelligent without forgetting that it exists to sell something.

Easy Listening Delivery

If one format were chosen to provide the sharpest contrast with the delivery style of Easy Listening, it would be CHR. Chapter 14 mentioned that the existence of EL was, in part, spurred on by Top 40, whose supercharged, high-energy sound actually made obvious the need for a format that offered listeners something quite different.

Thus, Easy Listening (Beautiful Music) became the radio headquarters of the soothing voice. According to Kenneth Lamphear, operations manager of WQLR-FM in Kalamazoo, Michigan: "If you could only say one thing about EL delivery it would be that it is never shouted. Obviously the commercial sound, the pitch, has to be consonant with the format. This means no screaming spots. Unlike a lot of ELs, many of our spots are read live over the air as opposed to being carted. We feel live copy enhances the Easy Listening format. It gives us a sound that other stations do not offer and helps diffuse the notion that we're just an automated (elevator) music service. Of course, this also has the effect of lightening the load in the production studio."

The opposite approach is taken at WBAQ. Paul Artman, Jr., says, "We go the less live path so we spend more time in the voice track suite. Having an automated EL format has allowed us better utilization of production facilities without adding on. In different words, less live radio, but more time in the production room. When it comes to delivery, we rely heavily on good quality voices that are easily understood. We employ a slower pace when reading copy."

Pacing is something that ranks high on the list of delivery criteria in EL, says WJCL's Al Jennings. "Tempo in spots must always be considered. You don't want to be three beats in front of the music. Sometimes we are pressed into doing more uptempo (hyped) material, but that is not by choice. A nice even-tempoed spot relates best to a mature audience. A mature voice belongs in this format."

Easy Listening has become less conservative or formal in its delivery since its renovation in the late 1970s. Now the low-key, conversational style is most apparent in EL spots, notes WWLV's Dave Richard. "Because of the relaxed nature of Easy Listening our commercials are done so the spoken word matches the music. This means we insist on a relaxed, warm, and friendly reading of continuity. Whenever possible spots are delivered in a conversational, non-rushed manner. We avoid impersonations and dialects, too. We're pretty straightforward. We take production very seriously at LOVE. Deliveries must be complementary. They must work within the context of what we present our audience outside of spots sets."

A one-sentence want ad for an EL announcer written by WGER's Bill Harnsberger would state: "Looking for an announcer who communicates without yelling."

The announcing credo in this format is *easy does it.*

Easy Listening Mixdown

EL stations could almost be divided into two groups: those that favor background on spots and those that do not. Stations that bed spots contend that it helps maintain flow. "We use background on spots for a couple of reasons. First, it helps keep things moving. It prevents lag or drag. Secondly, we use music and sound effects simply because they help paint a more vivid image in the listener's mind, which means the listener will be more inclined to visit the client, who in turn will be more inclined to keep

buying us because he is getting response to his ad," says Harnsberger.

Those ELs that shy away from background do so because they fear clutter, states long-time programmer Enzo DeDominicis. "In my opinion, atmosphere should be created with words in this format, not beds and effects. They tend to clutter things. Keep it simple in EL."

Another reason for mixing without background in this format is to create a live sound, something of particular concern to programmers working with automation. "Bedding everything creates a canned quality—not what you want when automated. So spots without beds can help create the illusion of being live," says DeDominicis.

When spots are bedded, the music is invariably generic. Usually no distinctive musical styles are apparent, which means that country, rock, reggae, and so on are ruled out as beds. "Light instrumentals are most commonly used under voice tracks. You don't mix into spots music that wouldn't be airable. There's plenty of EL background material," comments WBAQ's Artman.

WAYL's Bruce Hanson adds "Nothing intrusive should be encountered by listeners. In EL, we're always concerned about elements that might disturb a long TSL [time spent listening] tuner. Therefore, we mix ingredients that jive with one another."

Many EL stations perceive sound effects as basically unfriendly matter to be left out of mixes. "Sound effects and jingles are regarded as annoyance factors here, so they are rarely worked into commercials," says Dave Richard.

When audio processing is employed in the EL production room it relates more to sound quality than to the creation of an effect; ELs have been using equalizers and limiters for many years.

CLASSICAL

A full schedule of classical music was offered to the listening public as far back as the 1930s. One of the first stations to do so was New York's WQXR-AM, which years later aired classical on FM as well.

Today Classical radio claims about one percent of the audience but can boast one of the most loyal followings of any format, as well as the crème de la crème of advertising accounts. Since Classical radio's demographics are what is called *high-end*, this format attracts many blue chip accounts. It is not unusual to hear spots for investment firms and Mercedes Benzes on Classical stations.

The high-end demos netted by this programming genre include the most educated and professional using radio. The average age of the Classical listener falls somewhere between thirty and forty-five, but, like Country, Classical can point to surveys that attest to the fact that their brand of radio attracts both young and old alike.

FM has been the primary residence for stations airing Classical. The reason for this is twofold. First, Classical fans have been sensitive about the quality and fidelity of their music from the start, so FM, with its static-free sound, was the natural band from which to broadcast. Second, with its modest numbers, Classical held little interest for AM station owners, who in the 1950s and 1960s enjoyed great ratings and financial success with pop and mainstream formats.

Today only a few dozen commercial stations program Classical exclusively. However, classical music fans can find what they want on noncommercial outlets. In fact, classical music is a primary offering at most Public radio stations which, in a number of markets, do as well (if not better) in attracting listeners than commercial Classicals. For instance, Public radio station WGBH in Boston airs a very successful block of classical music each morning from 7:00 A.M. to noon called "Morning Pro Musica." This program is aired simultaneously at many other Public stations around the Northeast.

Classical stations are intent on airing lengthy segments of music, and since most classical pieces or selections (rarely referred to as cuts) are by their nature long, this is easily accomplished. The length of classical pieces becomes a consideration during drive-time periods on commercial stations which, unlike Public stations, must market these dayparts to sponsors. Due to the increase in commercial material, these Classicals often focus on shorter works to accommodate spot loads. To some degree this gives noncommercial (noncom) Classicals a slight competitive advantage, because they do not have to interrupt programming to generate advertiser revenue. Once commercial Classicals are out from under the

FIGURE 17.3 Classical radio program clock. (Courtesy WGMS.)

heavy spot loads common to prime-time slots, they, too, playlist pieces of greater length. This is not to suggest that all Classicals airing spots confine themselves to abbreviated pieces. Some air lengthy selections and let the spot set fall where it may.

Outside of drive periods, the music is the thing, and a couple of approaches take centerstage. A number of Classicals skew their playlists toward the most well known works, avoiding the more obscure compositions and composers. These stations also tend to favor the more upbeat and showy pieces, rather than the darker and more ponderous. Some classical music aficionados have referred to these stations in somewhat disparaging terms as "pop-Bachs."

Meanwhile, the majority of Classical station playlists reflect the quality of a work more than its tone, tempo, length, or recognizability level.

Despite the fact that music is the reigning programming element in Classical, news gets plenty of airtime. Although Classical is less inclined to hand over large segments of drive-time to news, it does allow for extended coverage, and news is typically accorded airspace hourly, throughout the day and into the evening. (The Classical audience is more attuned to world events and issues than the audiences belonging to other formats and, therefore, more interested in news and information features, such as stock market reports.)

On the other hand, sports is seldom encountered in a form other than that of a brief update included as part of a news report.

When Classicals air features they invariably are of a musical nature, such as live broadcasts of concerts or syndicated classical programs. Contests and promotions are a part of Classical programming, but certainly not to the extent that they are in other formats.

The uniqueness of Classical all but eliminates competition from other music oriented formats, but All-News stations occasionally do cause a softening in Classical numbers. Aware of this, many Classical stations have beefed up the amount of news they program.

Classical Copy

Some of the most sophisticated copy written for radio comes from Classical stations. Why? It should not be hard to figure out, since this format's audience's educational level is the highest of all formats. This does not mean that copywriters compose in iambic pentameter or use a stream-of-consciousness narrative style. Radio writing is radio writing, and that means that all the qualities inherent in the nature of the medium must be taken into consideration, regardless of format.

At the same time, it does mean that the language in Classical copy may be of a slightly higher order than that used in, say, Urban Contemporary or CHR. Rule out printese and pretense, but write with intelligence, says Steve Cumming of Dallas station WRR-FM. "You're dealing with bright, well-educated people in this format. So to maintain credibility, you need to communicate on the appropriate level."

This also means observing the basics, Cumming says. "When it comes to copy, we also have to be more careful. Grammar and syntax must be carefully considered. Again, our listeners are a well-educated lot, who know better. Many are not afraid to take us to task when we don't get it right. Credibility is very important to us and to this format as a whole, so it is not unusual for an announcer to pay a visit to the copywriter's desk to clarify something."

Gimmicky copy is avoided, while humor is welcome as long as it is tasteful. At the same time, exaggerated claims and hyperbole common to hard-sell spots are left out of Classical copy. In this format, hype and hard sell give way to the conversational narrative style.

Since Classical copy generally is written for a slow to medium paced delivery, fewer actual lines of text need be composed, points out WCRB's Dave Tucker. "No pressure copy is written here. Nothing hyped or rushed. In fact, if you compared it to spots written for other formats, you would find that our copy is an average of a couple of lines shorter—say eight or nine lines for a thirty and eighteen lines for a sixty. This allows for pacing that is in rhythm with our programming."

Again, Classical copy is written for a variety of accounts, most of which are out to reach an upscale audience. In this format, the goal is to write intelligently but not intellectually. Professors and doctors are not the only people tuned to Classical radio.

Classical Delivery

This is one of the most demanding formats when it comes to announcer pronunciation skills. The reason for this is that much of the language that goes out over the air has a foreign origin, even in commercials and promos. As WRR's Cumming puts it: "As production manager, I encounter plenty of prospective announcers who think that because they are in a Classical station our standards are lower than those at the rocker down the road. After their audition, which includes goodly portions of French, German, Italian, and Russian, they have a different attitude. Even if you can pronounce the words, you still must have a natural, friendly style while doing so. Do you sound like a super-jock? That is, do you use inflections and intonations that a rock jock would use? Hopefully not, but if so, you're not going to work here."

No punch, but some zing and vitality are appreciated by the Classical listener, who also admires an unaffected and honest style of announcing. "Be real. Let your skill and intelligence come through. Don't cloak it in pretense, and never sound haughty or arrogant. Audiences do not appreciate being talked down to. Also, know what you are talking about. Ignorance shows," says Cumming.

Being attuned to the Classical audience's mind-set is another key to delivery, observes Cumming: "Know your audience. I can't make this point strongly enough. Know them on a personal basis. I sing with the Dallas Symphony Chorus, so I regularly hang out with people who love the music I play on the air. Know how your audience thinks. Otherwise, how do you expect to talk to them? The same thing applies to announcing in commercials. However, just about every announcer I know modifies his style when doing a spot. They tend to 'announce' more in these situations, but an announcer should never forget that communicating to another human being is the goal when the mic switch is opened."

Long-time Classical programmer Carlo Princi says that the one-on-one style, ac-

FIGURE 17.4 Classical copy. (Courtesy WGMS.)

```
WASHINGTON'S GOOD MUSIC STATIONS
WGMS 570AM~103.5FM
One Central Plaza, 11300 Rockville Pike, Rockville, MD 20852      (301) 468-1800

                              THOROBRED MOTORCARS

Once upon a time Italy created a masterpiece legend: the Maserati.
A legend on the Grand Prix circuit and a legend on the road.  Test
drive the new Maserati Biturbo at Thorobred Motorcars, the exclusive
Maserati dealer in Washington dealer in Washington and Northern
Virginia.  The Biturbo is quite simply the most exciting 4-passenger
sports sedan you've ever driven.  Sink into the luxury of soft
Italian glove leather upholstery...then feel the power of the twin
turbo engine that accelerates from 0 to 60 in 6.8 seconds...so fast
it leaves the Porsche 944 and BMW's far behind.  It's $26,000
worth of pure excitement backed by a 2 year, 24,000 mile factory
warranty.  A 7 year financing plan is available.  See the
Maserati Biturbo at Thorobred Motorcars, at the corner of Wilson
and Washington Boulevards in Arlington.  Call them at 522-4844.
522-4844.  And drive away in a Maserati Biturbo.

                              RKO RADIO
                              RKO General, Inc.
```

cented with a pinch of formality, meshes well with the surrounding elements. "There is a certain formality necessary in an announcer's tone of voice that says, 'We're Classical radio,' but you don't want to sound too rigid or stiff. Announcers must be relaxed but authoritative, not officious. They should project their own personalities and display their human side."

Classical Mixdown

This is not a format known to favor heavily produced spots. "Having worked in production at other stations, such as rock and jazz, I can say that Classical prefers a simpler sound. I mean, less flash," says Cumming. WCLV's Conrad supports Cumming's statement. "Most Classical production is

uncomplicated—few sound effects or multiple beds. This helps maintain the low-key atmosphere in keeping with this format."

Being very quality-conscious, Classical stations utilize the newest technology available in the production room. Says Cumming: "At WRR here in Dallas we work an Otari MX50 eight-track to produce intricate spots. Compact discs figure heavily in music and sound effects for production. We purchased the Sound Ideas CD sound effects package a couple of years back. I've been here in Dallas a few years now, preceded by five years at WCLV in Cleveland. Since both stations are Classical, there was an interest in digital technology very early on. In fact, this format was the first to commit to the CD medium. It was in 1983, I believe. CDs, plus DBX noise reduction for analog tape, are important elements in production at both stations. In addition to this, recording in the field on Beta video cassettes—either in live situations or from satellite feeds—helps us achieve a much cleaner broadcast sound. Classical listeners are much more likely to own high-end playback equipment than are your typical CHR or rock format listeners, and this must be factored into mixdown, too."

WCLV's Conrad perceives the production room as a screening center to prevent inappropriate material from entering the airwaves. "The production studio serves as an early warning center for spots that come in from elsewhere and might not be right for our subdued environment. The last thing you need is an outside spot that clashes with your on-air sound because it was designed for a pop-music format."

There are two schools of thought pertaining to the use of bed music in this format. One group believes bedding spots with classical music offends listeners. They see the sanctity of the work as being compromised or violated by using it under copy. "Classical listeners are very particular about their music. They do not like to have it tampered with," Princi notes.

Stations not backing copy with classical music opt for light, nondescript tracks or even some mild jazz or folk. Meanwhile, stations that do use classical music to bed spots feel that in doing so programming continuity is maintained. "Because of WCRB's solid fine music format twenty-four hours a day, bed music must be classical. It doesn't make sense to air classical and bed with contemporary," contends Tucker.

Of course, each station establishes its own policy regarding the use of bed music and sound effects, and all do so with their station's format in mind.

NOSTALGIA

Nostalgia programming has been reaching the radio audience since the late 1970s. Introduced by programmer Al Ham, Nostalgia concentrates on music popular in the 1930s through 1950. However, more recent compositions that are considered complementary to the Nostalgia sound are also playlisted.

Nostalgia stations are also referred to as Big Band because of their affinity for the recordings of the popular orchestras prior to the age of rock.

At its inception, Nostalgia took up residence on the AM band, which was looking for something new to stem the tide of listeners to FM. Nostalgia seemed particularly suited for AM, since the majority of the recordings constituting its playlist were mixed monaurally in an era that predated high-fidelity and stereo. For instance, it mattered little if a Glen Miller song were aired over AM or FM. It sounded about the same on either, so AM felt a degree of parity with FM when broadcasting Nostalgia. However, in the 1980s Nostalgia found an audience on FM; many recordings from the period have been digitally remastered for the sake of upgrading their fidelity, and this has stirred interest on FM.

Nostalgia is a highly syndicated format; therefore, a considerable number of stations are automated and/or satellite driven. Due in great part to this fact, Nostalgias sweep music (although even the handful of stations not tied to automation systems or syndicators are inclined to do this as well).

Attracting an over-fifty crowd, Nostalgia enjoys a very loyal following and one of the highest TSLs (time spent listening) in radio. However, this format rarely appears among the top-ranked stations in any market. Seldom is Nostalgia aired outside of larger metro markets or outside areas with large numbers of older demographics.

Many Nostalgia stations highlight personalities who are very well versed in the

era from which the format takes its tunes. "Our air staff not only remembers the hits of the bygone days but spends hours preparing and researching our music history to come up with time bits (sound bites) of interesting trivia. We believe in Nostalgia and deliver the most entertainment every hour, every day. Personalities are central to our air product. We must be doing it right, because KORK has been enjoying top ratings on the AM dial in this market since the early 1980s," says programmer Jim Austin.

An even larger number of Nostalgias downplay announcer presence, preferring to spotlight only the music. This latter approach is especially compatible with the outlets that derive their music product from outside.

Because Nostalgia targets mature demographics, there is a built-in market for news programming, which the format acknowledges in the form of increased drive-time coverage and hourly newscasts. However, since the format's mission is to provide the listener with vintage music, news and information features are accorded an appropriate amount of airtime. As a rule, automated and syndicated stations air less news than those Nostalgias that originate their own programming, but, again, live Nostalgias constitute a minority.

When Nostalgia stations air features they usually spotlight musical artists of the period. Programs starring the great balladeers (Sinatra, Como, Bennett . . .) and bands (Dorsey, Miller, Goodman . . .) tend to stimulate the interest of both the audience and the advertiser.

The formats most competitive with Nostalgia include Easy Listening, Lite Adult Contemporary, and News/Talk.

Nostalgia Copy

Nostalgia copy will reminisce, but it does not rely on references or allusions to the period that provides its music. However, recreating a feel for the "old days" through copy is effective when not overdone. A carefully placed piece of jargon or a phrase from the 1940s or thereabouts can heighten a commercial's impact, as can an allusion to the pop culture icons or symbols of the age.

For the most part, however, Nostalgia copy is created without digging into the dusty vaults of yesteryear for words and ideas. Nostalgia copy is as much a part of the present as that aired in contemporary formats, minus the modern patois. For example, a lot of the language acceptable in UC copy, for instance, would require translation in Nostalgia.

Nostalgia copy is also noticeably free of gimmickry, although humor is used, albeit on a mature level. "Silliness may work in other formats, but seldom here," says programmer Chuck Tuttle. Therefore, clean, straight copy aimed at an over-fifty crowd is the norm. Clearly, Nostalgia listeners would find little to interest them in disco club or record store commercials, though copywriters in this format script for many different kinds of businesses.

Nostalgia Delivery

Granted, voice quality (timbre and texture) is a consideration in any format, but a listening survey in the 1980s revealed that the Nostalgia format has a particular affection for the deep, resonant voice. Aside from this, a moderate to soft, one-on-one delivery style is most common in Nostalgia. High-pressure spots are very rare, indeed. The delivery approach in Nostalgia would be most comparable to that found in Easy Listening and Adult Contemporary, especially Lite AC.

Nostalgia Mixdown

This is not a production-intensive format. Of course, there are those occasions in every format—Nostalgia included—when a production director is faced with a demanding and challenging mixdown.

When spots are bedded in Nostalgia, music from the period (or representative of the period) is generally used, although generic beds possessing casual tempos are acceptable at most stations. While some Nostalgias are not opposed to bedding copy with light contemporary rhythms, others take exception to mixing with anything outside the realm of their musical heritage.

Since a high percentage of Nostalgias are automated/syndicated, there is a tendency to minimize the use of beds. Again, the goal at these stations is to create the sense of live broadcasting through locally produced spots. Placing a bed behind a voice track betrays the recorded nature of such spots.

The use of audio processing equipment in production has increased slightly in Nostalgia but is used primarily as a means of upgrading sound quality.

CHAPTER HIGHLIGHTS

1. The Classical and Beautiful Music formats were called "good music" formats in the 1960s because they resided almost exclusively on the FM band, were the first to be broadcast in static-free stereo, and were an escape from pop/rock radio.

2. Easy Listening, Classical, and Nostalgia collectively draw fourteen percent of the listeners. EL ranks fifth nationally; it evolved out of the earlier Beautiful Music format.

3. EL copy possesses the same soft and easy feel as the music, using creativity rather than hard-sell to satisfy sponsors. The audience is typically fairly affluent and well-educated.

4. EL copy delivery utilizes a soothing voice and a non-rushed pace (evenly tempoed).

5. EL stations are evenly divided between those that bed spots (to maintain flow) and those that do not (to avoid clutter and create the illusion of a live broadcast). ELs are always concerned about intrusive elements that might disturb a long TSL (time spent listening) tuner.

6. Classical radio claims a very loyal one percent of all listeners. Because Classical adherents tend to be affluent, the stations collar many of the blue-chip advertisers. The average demographic is thirty to forty-five.

7. There are only a few dozen commercial Classical outlets, but many Public (noncommercial) radio stations program classical successfully.

8. Most Classical production is uncomplicated—few sound effects or multiple beds. Being quality conscious, the newest production technology is used. CDs are favored for production and on-air. Stations not backing copy with classical music opt for light, nondescript tracks.

9. Nostalgia programming playlists 1930s through 1950s music, with a few more recent compositions complementary to Nostalgia included.

10. Nostalgia copy subtly recreates a feel for the era while adhering to the usual copywriting basics. Clean, straight copy aimed at an over-fifty crowd is the norm.

11. A moderate, one-on-one delivery style is most common in Nostalgia. A deep, resonant voice is favored.

12. Predictably, this is not a production-intensive format. Audio processing is used primarily to upgrade sound quality.

13. Most spots are bedded with music from the period, although generic beds with casual tempos are acceptable. To simulate live broadcasting, many spots are not bedded at all.

SPOT ASSIGNMENTS

Spot assignments for this chapter may be found at the conclusion of Chapter 18.

18 Nonmusic Radio Production

Over seven percent of the radio audience dial stations that do not air music. These stations broadcast a variety of talk-based formats, such as News, Talk, News/Talk, and Religion. The number of nonmusic formats has been on the rise since the 1980s, with the introduction of all-Sports and all-Business, among others. Nonmusic formats have been a mainstay of AM during a time when its fortunes have been on the decline. According to consultant Dwight Douglas, president of Burkhart/Douglas and Associates, "News and Talk may be the savior formats for AM in the 1990s."

NEWS

It is an interesting fact that the innovator of the format that features "less talk and more music" also conceived of the first format to air all talk and no music. Gordon McLendon was certainly a programmer of unique vision during the early years of radio's age of specialization. Having found success with Beautiful Music, he did so again by offering the listening public all-News.

In the early 1960s, McLendon launched his round-the-clock news format on a powerful station called X-TRA, located just over the border in Mexico. The venture proved an unqualified success as the station made solid appearances in several southern California ratings surveys.

Soon thereafter, McLendon introduced his News format on the domestic level. In 1964, Chicago station WNWS ("News") began airing a full schedule of all-News. The station's success with the format inspired other metro market operations around the country to go the nonmusic path.

Today only a few dozen stations (namely AM) program all-News. The reason is quite simple: News is the most expensive format in radio. The cost of staffing is the primary reason. All-News stations require extensive on-air and support personnel. Unlike music stations that can get by with as few as one operator (deejay), all-News involves several on-air newscasters per shift, not to mention writers and field reporters. The cost of equipping an all-News operation is another contributing factor.

The exhorbitant tab on all-News keeps it out of most small markets, although a handful of important medium-metro markets provide listeners with the all-News option.

News is typically presented in rotating blocks of ten to twenty minutes, and a different newscaster will anchor each block. For instance, a schedule may look like this during morning drive-time:

	6:00 A.M.
:00 to :20	Sutherland
:20 to :40	Speerstra
:40 to :60	Hilliard
	7:00 A.M.
:00 to :20	Speerstra
:20 to :40	Hilliard
:40 to :60	Sutherland
	8:00 A.M.
:00 to :20	Hilliard
:20 to :40	Sutherland
:40 to :60	Speerstra
	9:00 A.M.
:00 to :20	Sutherland
:20 to :40	Hilliard
:40 to :60	Speerstra

Large metro market stations often have two anchors (co-anchors) per segment.

News stories are generally ranked and slotted according to their importance and their relevance to the station's listening area, and while some all-News stations set out to cover as much news as possible—a sort of Top 40 news formula—others are concerned with depth and substance and are not afraid to devote extensive coverage to a news story they consider possesses special merit or value.

213

FIGURE 18.1
News station format clock. (Courtesy WTOP.)

Features constitute an important programming element. All-News stations invest heavily in traffic, weather, and stock market reports, and meteorologists are hired to prepare weather information (although few stations contract weather persons on an exclusive basis). Interview and issues programs are accorded significant airtime as well.

Sports programs flesh out the schedule at many all-News outlets. However, some programmers are opposed to devoting lengthy segments of airtime to sports, because they feel it softens their news image. These same stations insist that any and all features have a solid news tie-in, because from their perspective sports and lifestyle-based informational programs dilute the impact of the essential product.

Commercials, psa's, and promos are clustered in spot sets, which allow all-News to schedule news in uninterrupted blocks, something akin to music station sweeps.

Of all the talk oriented formats, all-News attracts the youngest demographic, which even then is comparable to the ages of those tuning adult music stations, such as Lite AC and Easy Listening. In the main, all-News is strongest in the thirty-nine to fifty-four year-old male listener cell.

TALK

Radio began experimenting with telephone talk shows in the 1950s after a breakthrough in telephone line reception. However, it was in 1960 that the Talk format made its debut. It was Los Angeles station KABC-AM that took the daring plunge into a whole new realm of radio programming. At that time, the idea of a station doing only talk seemed pretty unorthodox, if not radical, but KABC soon found its audience.

At the center of the Talk programming approach is the telephone conversation *(two-way talk back)*, and because a Talk program can be accomplished with a small staff—talk host *(talkmaster)* and producer—this format is considerably less expensive than all-News. Of course, this is not to say all-Talk stations work with a minimum of personnel. Some major market Talkers employ upwards of a half dozen people during their key programs or dayparts.

The Talk format has grown to be one of the dominant offerings of AM in the 1990s, in both medium and large markets. It is not strange for two or more stations to be programming Talk in major cities.

In the late 1980s, a few FM outlets began airing Talk segments, but few had actually gone all-Talk. However, as the competition heats up it is not inconceivable that Talk, as well as News, will make inroads into the FM neighborhood.

What draws listeners to Talk radio is the feeling of connectedness it engenders. This sense of community was captured by the slogan "The last neighborhood in America" in Oliver Stone's movie *Talk Radio*. The Talk format provides listeners an opportunity to become involved—to be heard. Talk radio serves as an electronic podium—a public forum—and because the emphasis at most Talk stations is on local issues, it does become a sort of communal—neighborhood—experience. "More than any other station, the one presenting Talk is the voice of the community. Talk stations are involved," says Mike Edwards of St. Paul, Minnesota, station KSTP.

While the thrust of the conversation in Talk is local, world issues are not ignored, especially when they have a bearing on the quality of life on the locale that a station

serves. Syndicated and network talk programs deal with broad issues that have an impact on the home front, and these satellite-delivered programs augment the schedules, especially at night, of the majority of Talk stations. One of the most popular network (Mutual) talkmasters is Larry King, whose late night program is carried by several hundred stations.

While some Talk stations prefer to deal with topics in a more conservative light, others allow their hosts to pull out all the stops, so to speak. At the latter outlets, controversy is welcomed, and no topic is taboo—the more sensational, the better. Hosts on these stations have been accused of everything from inciting riots to encouraging citywide sickouts, and more than one listener has claimed to have been verbally abused by an overzealous talkmaster.

Those stations that prefer a more subtle or subdued style of talk would rather hosts deal with topics of a less volatile nature—what one programmer refers to as "feeding from the bowl of substance rather than from the trough of scatology."

At many Talk stations, hosts achieve local celebrity and pull big audiences. In the 1980s a trend began whereby individuals who achieved a level of fame in areas such as politics and show business were hired to host programs. For example, two former mayors (controversial characters in their own right)—Frank Rizzo of Philadelphia and Buddy Cianci of Providence—worked the airwaves at WCAU and WHJJ, respectively.

News is a key ingredient at nearly every Talk station. In fact, a large number of stations hand over their microphones to the news department for the entire span of morning (and sometimes afternoon) drive. Outside of prime time, Talk stations continue to emphasize news. Rather than the traditional "nickel news" (five-minute newscast) each hour aired by most stations, Talkers frequently graft five minutes of local and regional news onto the hourly network feed.

Sports programming constitutes a prominent part of the air schedule at the majority of Talk outlets. In fact, Talk radio is the most sports-minded of any radio format. Programmers believe that sports features complement Talk programming. Sports talk shows rank among the most popular offerings at Talk stations.

Informational features focusing on health, science, economics, and culture round out the fare in all-Talk, which attracts the largest segment of its audience from the over-forty age group.

FIGURE 18.2
Talk programming clock. (Courtesy WKDR.)

NEWS AND TALK HYBRIDS

Many stations find that combining Talk with News is an effective way of garnering audience interest. Thus, more stations assume a News/Talk profile than a purely News or Talk one.

The News/Talk format was first aired over KGO in San Francisco in the 1960s and soon became the nonmusic ratings leader. One of the things that contributed to the success of this hybrid format, at least from the broadcast manager's perspective, was the fact that it was less expensive to run than all-News. Another contributing factor was that news and two-way talk programs complemented each other and did not upset continuity and disturb flow. For programmers, perhaps the most appealing aspect of the union was that News/Talk drew broader demographics than either all-News or all-Talk.

Sports programs and informational features are a major part of this format which, like other nonmusic formats, broadcasts almost exclusively from the AM band.

Another News hybrid combines music with lengthy blocks of information. This format variation emerged in the early 1980s and is variously referred to as News Plus, News Variety, Music and Information, and so on.

Stations embracing this programming strategy believe that scheduling music during various dayparts makes them more viable in their particular markets; however, their news programming is accorded the greatest promotion. These are first and foremost news outlets.

News Plus stations typically mirror Adult Contemporary when they shift over to music. Midday and evening hours are the most likely to be allocated to music programming, which is replete with deejays and other music radio ingredients.

When the conversion to music takes place, news is treated with great deference, since it is this format's ultimate stock in trade. Ten minutes of news hourly is not exceptional during music segments.

WBCM's program director Conrad Michaels sums up the goal of this hybrid format: "We offer an abundance of news and information that is pertinent to our service area, as well as agriculture updates, elaborate weather reports (agricultural, marine, inland), entertaining and in-depth features, and music geared for our thirty-plus audience."

In recent years other hybrids have been tested in the form of News/Sports, Talk/Music, and Business Plus.

NEWS AND/OR TALK COPY

In general, there is more writing done in nonmusic formats, so the presentation of commercial copy, psa's, and promos is approached in a serious, professional manner. For one thing, copy never attempts to emulate a news story. In other words, News and/or Talk stations do not try to deceive their listeners into paying attention to a commercial by making it sound like a news story:

THIS JUST IN TO OUR NEWS ROOM! ARNOLD'S USED CARS IS PUTTING YOU IN THE DRIVER'S SEAT OF A GREAT SECOND VEHICLE AT A PRICE YOU WON'T BELIEVE . . .

This would jeopardize credibility and be tantamount to crying wolf. If a news station must guard against anything, it is the loss of credibility, and compromising the integrity of the news desk by selling used cars or anything else threatens a News station's very existence. KSTP's operations director, Michael Dorwart, comments, "Straightforward copy without manipulative intent or hype maintains the right posture. Copy should possess a quality of dignity in this format especially. It should be clean and honest."

Programmers contend that since News and/or Talk are foreground formats, spots get greater focus. This means copy must be prepared with considerable care and attention, says Richard Clear of Spokane, Washington, station KXLY. "Copywriting in Talk is very demanding. People really listen, so it has to be on the bull's-eye. A commercial can easily get lost if it doesn't have anything special going for it. Composing is not easy in this format. Selecting the hot words that will snag the listener's ear is the challenge. We're talking about writing in a format that is basically all copy."

News and/or Talk copywriters are composing for a diversity of sponsors, who spend money to reach a more mature demographic, observes News/Talk production director David Morris. "First of all, our advertisers tend to be more upscale, and they are after adults. So copy is written with this in mind. Our demos are a little older and somewhat more worldly, so we can write with a higher degree of sophistication than the local teen-rocker."

On the whole, News and/or Talk copy allows for wider vocabulary. Copy is intelligent, yet not grandiloquent. To repeat what has already been repeated: radio requires copy that is instantly accessible—comprehensible.

While these are rather conservative formats, which walk a fairly straight path in copy, they are not averse to well-written humor or dramatization as long as the spots are resonant with the surrounding programming elements.

NEWS AND/OR TALK DELIVERY

While it is widely accepted that newscasters/reporters should not be used on spots, talk hosts frequently cut copy. As stated earlier, there is a fear that credibility will be sacrificed if a news voice is heard on spots. While it is very important that talkmasters retain their credibility as well, their presence on certain types of commercials is not regarded as a threat to this. This attitude stems in part from the feeling that newspeople must maintain an image of impartiality, whereas most talk hosts express personal opinions on nearly everything during their broadcasts. However, many stations impose strictures on the type of sponsors talk hosts voice for. Stations are reluctant to permit their talk people to record copy for "low-line" advertisers (fast food restaurants, car washes, etc.), although it is not totally uncommon to hear talk show hosts reading live copy for a wide range of sponsors (occasionally even fast food restaurants and car washes).

Emulating news-type deliveries in spots is not encouraged, says KXLY's Clear, who adds, however, that voicers (voice tracks) should spark interest in the listener. "The right tone and inflection help get a spot over. If you don't get the listeners to listen, you are squandering the advertiser's dollars. The use of the dramatic pause and creative inflection hook the listener, but never get too newsy in your delivery."

KSTP's Dorwart agrees with Clear. "Delivery should command attention, but in News/Talk this is accomplished in a relaxed and mature way. Said another way, voices should be clear and adult."

The majority of copy in News and/or Talk is delivered in a style that is unaffected and earnest, and although an energetic presentation is valued, hype and excessive intensity are noticeably absent in these formats.

NEWS AND/OR TALK MIXDOWN

Two philosophies have evolved concerning the use of background music in these Talk-only formats. On one side of the coin there are those stations that believe music beds enhance their sound by breaking up the tedium of morning to night conversation and oratory. From the programmer's perspective, production music serves as a form of seasoning that helps keep the air product fresh and savory.

On the other side of the coin are those stations that minimize the use of bed music. KSTP is one such station, says Dorwart: "We refrain from using music unless it adds something really significant to a spot or if the client traditionally uses a jingle or piece of music synonymous with his business. Otherwise, we don't do much with background, out of concern for maintaining an unimpeded sound. At a News/Talk station the potential for clutter is great. Adding unnecessary ingredients adds congestion, which inhibits flow. We try to eliminate clutter at every opportunity. When you allocate fifteen minutes an hour to commercial material you must be very watchful that you are not building a series of barriers. We are constantly trying to create interesting spots without going overboard on mixdown. It will take time, though, and time is something that is in chronically short supply. Unfortunately, too many spots are needed on a rush basis to be able to devote the time needed to create a good piece of production, but as a professional you always do your level best."

On the subject of background, KXLY's Clear says it is used sparingly at his station as well. "We cold voice spots to cart machine more often than not. When we use a music bed it must reflect what we are—News/Talk—and what the copy conveys, and it must do this without coming across as cartoonish or harsh."

Bedded spots are in the minority at KFRU as well, notes Morris. "Mixdown is much less music oriented in this format than in most others, I believe. People don't tune us for music, so why should we heap it on them in recorded announcements?"

When bed music is employed in News and/or Talk spots it is generally of an Adult Contemporary variety—uptempo and bright, and never too contemporary. Rock is rarely chosen to back voice tracks, although jazz, New Age, and even classical can be heard in nonmusic radio production.

Audio processing plays little role in the News and/or Talk mixdown. "There is less

need for things like digital effects and synths in this format, although once in a blue moon we dabble in such things," says programmer Melody Chandler.

NEWS PRODUCTION

Most stations, regardless of format (music or nonmusic), devote a part of their air schedule to programs designed to address topics, issues, and concerns of particular interest to listeners within the reach of their signals.

The five-minute newscast (usually at the top of the hour) is the most prevalent form of news presentation in radio today—especially in music formats. A typical hourly newscast may appear something like this:

> Intro: (theme up and under)
> Local stories: 1½ to 2 min.
> Nat'l/World stories: 1 to 1½ min.
> Sports: 30 to 45 secs.
> Spot break: 60 sec.
> Weather: 20 sec.
> Outro: (theme under, up, and out)

Stations with a significant news emphasis may air longer blocks of news, and most stations (regardless of format) will intensify news coverage during drive-time periods.

Within these news segments, stories often consist of actualities, which are brief reports on a particular event usually recorded on the scene. These segments add authority and credibility to newscasts and make them more arresting to a reader. These news-related sound bites may run any length, but usually do not exceed fifteen to twenty seconds. The idea is to maintain flow, even in newscasts.

The newscaster sandwiches the actuality, generally providing the context of the story and closure after it has run. An actuality may consist entirely of a quote of someone on the scene, such as a government official, police or fire officer, or eyewitness—this type of report is called a *sound bite*. In this case, the newscaster's comments will be fairly detailed (see sample below). However, an actuality may also consist of a verbal report from the reporter producing the actuality that includes a quote from a witness or official at the scene. Obviously, the newscaster's role is more limited for such stories.

An actuality may be obtained on the scene or in-studio. In the former instance, a reporter tape records (onto cassette) a source on location; in the latter case, a reporter tapes an actuality from a network, wire service, or telephone feed point in the newsroom. An actuality recorded outside of the station often needs to be edited to fit the needs of a broadcast. It is the reporter's responsibility to select the appropriate segments of audio for airing.

In a typical actuality, after recording an on the scene actuality, the newsperson returns to the station and makes the necessary edits, incorporating the actuality into the news copy, as in the following example:

A FOUR-ALARM BLAZE IN CENTERDALE LEFT SEVERAL FAMILIES HOMELESS LAST NIGHT. A MOTHER OF THREE CHILDREN VICTIMIZED BY THE FLAMES TELLS OF THE HORRORS:
 (Actuality—22 secs. ". . . it was terrible.")
MRS. CONNORS AND HER CHILDREN, ALONG WITH FIVE OTHER FAMILIES, WERE GIVEN SHELTER IN THE TREMONT HIGH SCHOOL GYM. FIRE OFFICIALS ARE STILL INVESTIGATING THE CAUSE OF THE FIRE. ARSON IS SUSPECTED.

The actuality consists only of the mother's quote, and is framed by the newscaster. When she reaches the appropriate point in the copy, the newscaster punches in the cart containing the quote. She can see from her news copy the approximate length of the actuality and the last three words of the segment (these are in quotation marks and serve as a prompt for the newscaster).

A typical newsroom contains wire service machines (UPI/AP) and recording equipment, such as reel-to-reel, cassette, and cartridge machines. Police and weather monitors and portable field equipment (cassette players and microphones) are also a part of the newsroom inventory.

At smaller stations, deejays usually handle the on-air news duties. In this situation news is primarily a "rip 'n' read" function: the deejay or announcer takes the most recent news copy from the wire service machine and delivers it verbatim. Actualities are seldom incorporated into these newscasts, because time and resources do not permit their inclusion.

```
BN----MXXL

ZO965XXN---
            R D WORLD-6TH-BRIEFS 0241
    --26--
      A WHITE HOUSE SPOKESMAN SAYS THE ADMINISTRATION IS TENTATIVELY
    AGREEING TO AN EIGHT-POINT-EIGHT-BILLION-DOLLAR ANTI-DRUG PROGRAM. THE
    PACKAGE INCLUDES 900-MILLION DOLLARS MORE THAN PRESIDENT BUSH REQUESTED.
    DEMOCRATS HAVE EARMARKED THE ADDITIONAL MONEY FOR TREATMENT AND
    EDUCATION.
    --26--
      COLOMBIAN POLICE SAY A BOMB EXPLODED IN AN AMERICAN-OWNED HOTEL IN
    THE  RESORT TOWN OF CARTAGENA (KAHR-TUH-HAYN'-YUH) MONDAY NIGHT, KILLING
    TWO DOCTORS ATTENDING A CONVENTION THERE. A SECOND BLAST RIPPED THROUGH
    A CARTAGENA BANK, LEAVING THREE PEOPLE WOUNDED. AND A THIRD BOMB LEVELED
    A GOVERNMENT-AFFILIATED ENERGY COMPANY IN THE CAPITAL CITY OF BOGOTA
    (BOH'-GOH-TAH'). NO ONE WAS INJURED IN THAT BLAST.
    --26--
      VICE PRESIDENT QUAYLE ARRIVED IN MANILA ONLY TO BE MET BY LEFTIST
    PROTESTERS WHO BURNED HIM IN EFFIGY ALONG WITH AN AMERICAN FLAG. SOME
    500 LEFTIST PROTESTERS CARRYING SIGNS THAT READ ''QUAYLE GO HOME WITH
    YOUR BASES'' FILLED THE MANILA AIRPORT UNTIL THEY WERE DRIVEN AWAY
    PEACEFULLY BY RIOT POLICE. QUAYLE WILL HOLD TALKS WITH PRESIDENT AQUINO
    (AH-KEE'-NOH) ON VITAL U-S MILITARY BASES IN THE PHILIPPINES. POLICE
    HAVE BEEN PLACED ON ALERT FOR POSSIBLE DISTURBANCES DURING QUAYLE'S
    TWO-DAY VISIT.

    ----------
    UPI 09-26-89 10:32 AED
```

FIGURE 18.3 Wire service copy. Larger stations with dedicated news staff may rewrite and/or adapt this copy for their own purposes; at smaller stations announcers may read these stories verbatim. (Courtesy UPI.)

Newscasts at larger stations benefit from the presence of personnel hired exclusively to work in the news department. At these outlets news is more production oriented. News copy is written and/or rewritten, actualities recorded, and live reports scheduled for broadcast.

PUBLIC AFFAIRS PRODUCTION

A station's news department generally is responsible for recording local news and public affairs features. This typically involves in-studio (voice-track suite) or on-location taping of interview subjects and the collection of sound bites from various sources (locations, wire services, effects libraries).

The final mix of news and public affairs programs may fall to the station's production person or a member of the news staff. For example, at imaginary station K-HITS the public affairs director (a member of the news department) prepares a weekly, thirty-minute program called "Mass Reaction." This individual assumes the full responsibility for the program's mixdown.

What follows is the production breakdown sheet for a particular installment of the program:

Mass Reaction—May 24

:00	Intro theme: 14 sec.
2:14	SFX: Gunfire/police siren: 8 sec.
2:30	Interview: 90 sec.
4:16	Music bed: 24 sec. (up and under)
5:21	Actuality: 48 sec.
9:57	Break theme
12:00	Return theme
13:10	Interview: 3 minutes 50 sec.
17:00	SFX: Crowd riot: 36 sec.
17:45	Music bed: 50 sec. (up and under)
22:11	Break theme
23:15	Return theme
24:30	Interview: 3 minutes
29:45	Outro theme: 15 sec.

Obviously, the public affairs director must possess excellent production skills to undertake the preceding mixdown. As a rule, all members of a station's on-air staff (deejays, news and sports people) must be adept in the use of the production facility.

However, in the majority of instances, elaborate mixdowns are the province of a station's production department. A production person frequently collaborates with a member of the programming or news department in the preparation of recorded material destined for broadcast.

INTERVIEW PRODUCTION

Interviews are broadcast to the listening public in both live and prerecorded formats. In the former instance, the telephone often serves as the primary means by which the person conducting the interview communicates with the interviewee.

Talk shows across the country rely on the telephone to reach guests who would otherwise be unavailable. Individuals conducting phone interviews must determine (in advance of airtime) whether the quality of the line is adequate for broadcast purposes. In most cases the phone line is wired directly to a board input. When this is not done, a patch panel or switcher is employed to route the line to the board and operator. The telephone feed may be processed through an equalizer to improve sound dynamics. Proper levels must be established as well.

In live, in-studio phone conversations a tape delay device is used to prevent obscene and inappropriate language and comments from entering the airwaves. A program is recorded live and aired a few seconds later. It is the board operator's responsibility to activate the delay's "kill switch" when calls require censoring. Stations airing live conversations with members of the audience are required by the FCC to take measures that protect listeners from offensive material.

In-studio interviews require that microphones be set up and sound-checked for each guest. Many stations make it a practice to tape live interviews so that portions may be used in newscasts as actualities. The editing of interviews for news broadcasts is a newsroom function.

FIGURE 18.4
On-air News/Talk studio.

NONMUSIC RADIO PRODUCTION 221

a

b

c

d

e

f

FIGURE 18.5a
Hand signals are commonly used in radio, particularly in interviews and other live productions. This signal means "start."

FIGURE 18.5b
Hand signal meaning "cut."

FIGURE 18.5c
Hand signal meaning two minute (or two second) cue.

FIGURE 18.5d
Hand signal meaning one minute (or one second) cue.

FIGURE 18.5e
Hand signal meaning "wrap it."

FIGURE 18.5f
Hand signal meaning "stretch it."

The taping of both live and prerecorded interview programs is typically the responsibility of the interviewer, although at larger stations this person may be relieved of board and recording chores by a producer or technician.

RELIGIOUS PROGRAMMING

Stations have been broadcasting religion since the beginning of radio. Live broadcasts were being offered as early as 1919, and in the early 1920s several stations were devoted to airing "the word," among them WMBI (founded by Aimee Semple McPherson of the Moody Bible Institute) in Chicago, KFOU in Miami, and KPBC in California.

It is the goal of Religious stations to spread religious ideas, and these stations do so in a couple of ways. First of all, there are stations exclusively devoted to the Christian message. These constitute the largest number of Religious stations.

Meanwhile, dozens of Religious stations open their airwaves to other than Christian sects. For example, Boston's WROL programs Hebrew and Moslem, as well as Christian, material. However, Christian features far outnumber features of different faiths.

Stations that are not Christian centered often parcel out blocks of the program clock to organizations that wish to convey their special messages in the form of lectures and discussions. Music is usually incidental in this Religious programming approach—that is to say, these stations seldom devote dayparts to the exclusive airing of music. Therefore, these stations may be referred to as Religious Talk, since the bulk of their on-air schedule is of a nonmusic variety. These stations are in the minority, however.

The majority of Religious stations air lengthy segments of music, and these are usually Christian outlets. The playlists of Christian stations are made up of songs that invariably contain an inspirational, life-affirming message. These stations usually focus on a specific brand of music, such as rock, contemporary, or country. Consequently they may choose to call themselves Christian (Jesus) Rock, Contemporary Christian, or MOR Religious, among other names.

Religious stations airing music will reflect their secular counterparts in that deejays or hosts will spin the hits and add commentary—personal observations and pertinent information. Religious deejays, as in any format, are expected to bond with the surrounding programming elements, and so a very upbeat and positive presentation is expected.

The spot set method for scheduling commercials is widely used by Religious stations regardless of whether they broadcast music or talk. However, a sizable percentage of commercial Religious outlets do not air spots per se, but rather lease airtime to those religious organizations seeking a broadcast pulpit. For example, an organization may buy a half hour's time during the evening (7:30 to 8:00). A station taking this approach will base their rates on what is called the *donor pool*. In other words, if a station is effective in generating donations for a program, it can ask for substantial fees.

Even on those Religious stations emphasizing music, features play a larger role than they do in other music formats. Obviously, the most common type of nonmusic program on these stations has a religious theme, and it is quite routine for them to set aside considerable blocks of time for religious commentary and dialog broadcasts. A Religious music station broadcast schedule might appear something like this:

WIHS

9:00	The Word of God
9:30	Music
11:00	The Gospel's Truth
12:00	Lunch with the Rev. Devol
1:00	Music
2:00	The Voice of Prophecy
2:15	World Missions
2:30	Music
4:00	Back to the Bible
4:30	Country Gospel Music
4:45	Father Ray Program
5:00	News of the World
5:30	Homeward Music
7:00	The Yankee Kitchen
8:00	Music

News, as may be deduced from this schedule, may be confined to one or two points of the broadcast day, or it may be logged hourly in five-minute segments, as it is on many music stations. A significant number of Religious stations heavy-up on news and information programming during

drive-time, and a fair number are affiliated with a network.

In addition to the hundreds of commercial Religious stations, there are dozens of noncommercial FM stations devoted to religious programming. These stations, like the commercial cousins, may dedicate their broadcast day to inspirational music, emphasize talk-based features, or present a combination of both.

In general, Religious stations consider themselves in a category of their own and do not look at other formats with competitive eyes. "No other format competes with us. Folks who want a Religious station know where to go. Ours is a very loyal audience. We offer a very specific service," says WFME's Art Thompson.

Over five hundred stations embrace Religious as their primary format, and these outlets are most likely to be tuned on AM frequencies. Religion has proven to be a very lucrative format, indeed. Well over a billion dollars annually are earned by Religious broadcasters.

Religious Copy and Delivery

It would make sense in this format that candor is most prized in copy. Hyperbolic claims are frowned upon. Honesty is insisted upon in a format where moral and spiritual values are the very fuel that drive it.

Although it might be thought that commercials will have a Christian theme or motif, this is more the exception than the rule. In point of fact, many Religious stations have a policy against any commercial references to "Him" or the "Word." At those stations that are more relaxed in this respect, it is not strange to hear a term of praise or adoration for God in a commercial.

Not all commercials are as blatant in their references, but the following is an actual excerpt from a spot aired at a station, whose call letters will go unmentioned:

BROTHERS AND SISTERS, ARE YOU AWARE THAT THE GOD-FEARING FOLKS AT ADAM'S AUTO HAVE PRICES THAT WOULD SEEM POSSIBLE ONLY IN THE GREAT HEREAFTER? WELL, SAY HALLELUJAH, BECAUSE YOUR PRAYERS HAVE BEEN ANSWERED . . .

The music format of a Religious station influences delivery style to some extent, although Christian Rock stations infrequently endorse the kind of hyper-intense deliveries familiar to many mainstream rock stations. While a Religious station may playlist heavy metal, for the most part spot deliveries are on the conservative side. No "GET YOUR BUNS DOWN TO THE HOTTEST ROCK 'N' ROLL CLUB IN TOWN AND BOOGIE TILL YOU BLEED" kind of stuff (done with a ferocity that would cause a meltdown at a nuclear power plant) is welcomed.

In the majority of cases, Religious programmers place sincerity and warmth above sheer voice quality. They value truth in delivery over timbre, but are still interested in a richly resonant and textured voice.

The one-on-one delivery style rates highest at Religious outlets, and energy and enthusiasm are by no means in short supply.

Religious Mixdown

When it comes to mixdown, Religious stations that are primarily nonmusic have a tendency to assume a minimalist's position. They rarely engage in elaborate mixes. The simple is more to their taste. While a single music bed or an occasional effect is used, these stations lean toward the cold voice—that is, a voice with no background.

Conversely, Religious outlets formatting music mix as heavily as general formats; they bed spots with melodies resembling in tone and tempo those on their playlists.

All in all, Religious is not as production-intensive as many other formats, although some extremely sophisticated and finely crafted spots and promos can be heard in this format.

Aside from equalization, audio processing is not a customary aspect of Religious mixdown—at least as of 1989. But as discussed earlier, sound enhancement equipment is playing a greater and greater role in the mix of commercials in nearly every format in the 1990s.

CHAPTER HIGHLIGHTS

1. Talk-based format stations draw seven percent of the radio audience. They are a mainstay of AM programming.

2. As of 1990, only a few dozen AM stations program all-News; it is the most ex-

pensive format to maintain because of the need for an extensive on-air and support staff, as well as the cost of equipment and services. All-News draws strongest in the thirty-nine to fifty-four year-old male listener cell.

3. As all-Talk became one of the dominant AM offerings in the late 1980s a few FM outlets began airing the format as well.

4. The News/Talk hybrid format has become the nonmusic ratings leader. The combination appeals to a broader demographic.

5. Copy for News and/or Talk stations is extensive, and it is approached in a serious, professional manner. News stations must guard against the loss of credibility, so hype and hard-sell are avoided when possible. The predominantly all-copy spots must be geared to an informed, mature audience.

6. While newscasters do not voice spots (to avoid loss of credibility), talk hosts frequently do. The preferred delivery style is clear, adult, unaffected, and sincere.

7. Most spots are cold-voiced (no bed music). When beds are used, they are usually of an AC variety—uptempo and bright, never too contemporary. Audio processing (except EQ) is seldom a mixdown factor.

8. Live Religious programs were broadcast as early as 1919. The majority of stations are devoted to a single Christian message, while a few program several different religions.

9. Religious copy favors candor and a tone of honesty. Delivery styles are generally conservative, emphasizing sincerity and warmth.

10. Nonmusic Religious outlets stress very simple mixdowns, preferring a cold-voiced spot or a single music bed. Music Religious stations bed spots with songs similar in tone and tempo to the music programmed. Aside from equalization, audio processing is not a key ingredient.

SPOT ASSIGNMENTS (Chapters 15 Through 18)

1. Listen and analyze production in the rock formats AOR, CHR, and UC.

2. Discuss how they differ from one another in their approach to spot mixdown.

3. Write a thirty-second Easy Listening commercial.

4. Voice a short promo for an AOR station.

5. Select a bed for the promo.

6. List the songs aired during a one-hour period on an Oldies station, and compare it to the playlist of a Classic Hits station.

7. Monitor two hours of the midday daypart on an Adult Contemporary station, and assess delivery styles on locally produced commercials.

8. Critique the use of bed music on a Classical station.

9. Compare the application of time domain effects in the commercials and promos aired by the following types of stations: CHR, Country, and Easy Listening.

10. Locate three music beds that would be appropriate for a promo on a Nostalgia station.

11. Cite an example of a commercial, psa, or promo that clashes with surrounding programming elements, and determine why this is so.

12. Listen and determine which format is the least production minded.

13. Compare/contrast how the local commercial Classical and the noncommercial Classical present music during morning drive-time.

14. Search the FM band for any nonmusic formats.

15. Listen to an AM Adult Contemporary station and then one on the FM band, and list any differences in production styles or techniques evident between the two.

16. What two formats seem the farthest apart in their approaches to mixdown? Explain your reasoning.

17. Listen to a station (any format) for a full day, and chronicle the production weaknesses (bad splices/edits, poor levels, incompatible elements, fidelity inconsistencies, etc.) in commercials, psa's, features, and promos.

18. Listen to station positioners and determine what they reveal about their station's production approach.

19. Analyze a newscast from a production perspective. Is a recorded theme used to intro and outro the newscast? Is the news read by a deejay or newsperson? From what source are actualities derived? How effectively are sound bites integrated into the newscast?

V PRODUCTION IN NONCOMMERCIAL RADIO

19 Mixing Between 88 and 92 MHz

The American radio medium began as a noncommercial venture. In the ten years prior to WEAF's experiment with toll broadcasting in 1922, dozens of stations operated without the help of advertiser support, although many were sustained by benefactors, such as electronics manufacturers, newspapers, civic and church groups, and colleges and universities. In fact, at one point institutions of higher learning held as many frequencies as commercial enterprises.

Amount the first to transmit a signal into the ether were colleges, and, since they did not seek advertisers, they can rightfully claim participation in the launching of the noncommercial medium. Included on the list of pioneer noncoms are 9XM at the University of Wisconsin (1915) and 3XJ at St. Joseph's College (1912). The former is considered by broadcast historians to be the first noncommercial educational station. In 1922, 9XM became WHA, and to this day it remains one of the nation's premier noncoms.

At the start, noncommercial stations operated on the AM band. Between 1920 and 1935, some two hundred noncoms were providing listeners with broadcasts, but as radio frequencies became hot commercial commodities, the number dwindled, and by the late 1930s only a handful remained on the air.

With the establishment of the FM band, new life was breathed into the noncommercial medium. In 1938, the first noncommercial outlet began to broadcast on FM, and when the FCC shifted the FM band to 88 to 108 MHz, it set aside the lower twenty channels (88 to 92 MHz) for the exclusive propagation of noncommercial signals.

In 1948, the FCC established a category for low-power noncoms. Class Ds, as they are called, operate at ten watts of power or less and usually send a signal no farther than two to three miles. Schools were among the first to apply for Class D status because of the relatively small expense required to operate such a station. Furthermore, the commission was mindful of these licensees, most of whom relied on student volunteers to work their mics. Clearly, they were monitored somewhat less stringently than their commercial counterparts, although the rules for the latter were just as applicable to the former, in terms of operating with the public's interest in mind. After all, a broadcast license was a broadcast license, regardless of transmitting power.

Throughout the 1950s and 1960s, Class Ds represented the noncommercial medium in this country, but this changed with the 1967 Public Broadcasting Act. This legislation gave birth to the Corporation for Public Broadcasting (CPB) in 1968, which in 1970 gave rise to National Public Radio (NPR). From that point on, noncoms were perceived as a more viable and formidable entity within the broadcast industry.

The Corporation for Public Broadcasting is a private, nonprofit corporation authorized by Congress to encourage and promote the development of noncommercial telecommunications services for the nation, including both public radio and public television.

Meanwhile, National Public Radio is a private, noncommercial network that produces and distributes programming, operates the public radio satellite interconnection system, and provides technical services and representation.

According to Jim Miskimen, president Virginia Public Radio, "For a noncommercial station to be eligible for CPB underwriting it must have a minimum of five full-time professional employees and facilities that meet broadcast standards; it must operate a minimum of eighteen hours a day (year-round); originate a significant, locally produced programming service designed

FIGURE 19.1
Virginia Public Radio mission statement.

90.7 fm WMRA

James Madison University Harrisonburg, Virginia 22807
Public Radio for the Shenandoah Valley
(703) 568-6221

MISSION

OF

VIRGINIA PUBLIC RADIO ASSOCIATION

The mission of the Virginia Public Radio Association shall be:

a) To promote and develop public radio broadcasting within the Commonwealth of Virginia;

b) To obtain financial support for public radio stations located in and serving the Commonwealth of Virginia;

c) To receive and disseminate among its members information of interest to members in all areas pertinent to the aims of public radio broadcasting;

d) To work in conjunction with the appropriate agencies in matters of benefit to all parties;

e) To make each other aware of attractive statewide programming and to work together to take advantage of such opportunities which we agree are feasible and desirable to undertake;

f) To broaden the awareness of public radio activities throughout the state for the benefit of residents of the Commonwealth of Virginia.

College of Fine Arts and Communication

to serve the community of license; and it must have an annual income or budget of one hundred and thirty thousand dollars."

There are in excess of thirteen hundred noncommercial stations operating in this country, three hundred of which are NPR members. CPB claims that over eighty-two percent of the nation is served by Public radio, while over twelve million people tune during an average week.

COLLEGE RADIO

Noncommercial stations fall into one of three categories: Public radio, College radio, or Community radio. Of the three categories, College radio may claim the largest numbers, at least in terms of broadcast frequencies. Over eight hundred educational institutions hold broadcast licenses. Most

FIGURE 19.2
James Madison University station WMRA's mission statement. (Courtesy WMRA.)

90.7 fm WMRA

James Madison University Harrisonburg, Virginia 22807
Public Radio for the Shenandoah Valley
(703) 568-6221

MISSION STATEMENT

WMRA-FM has a mandate from its licensee, James Madison University, and from the Master Plan of the Virginia Public Telecommunications Council, to provide individuals within the Shenandoah Valley of Virginia with a non-commercial, public broadcasting service. The traditional mandate is to provide programming for the tastes, needs and interests of listeners not otherwise served.

OBJECTIVES

WMRA-FM has as the following objectives:

1. To provide quality radio programming which serves the needs, interests and tastes of listeners not otherwise served by another area radio station within the Shenandoah Valley.

2. To serve as a training center, working within the instructional components of James Madison, the Valley of Virginia Consortium of Higher Education and other educational activities within the Shenandoah Valley.

3. To serve the public relations objectives of James Madison University through the development of quality local, public programming and through the continuing cultivation of contacts established through such efforts.

College of Fine Arts and Communication

of the outlets operate at power considerably lower than NPR affiliates. However, during the 1980s the majority of college stations boosted power to avoid sharing their frequencies or losing them entirely.

In the late 1970s, CPB challenged the efficacy of many college stations, mostly those operating as Class Ds. Its contention was that these low power (ten watt) facilities possessed pitiably weak signals and broadcast erratically, sometimes operating a few hours a day and on occasion not at all. The Corporation for Public Broadcasting felt that it or other broadcasters could better serve the listening public with enhanced technical parameters and lengthier (fuller) broadcast schedules. However, rather than cause the demise of these low-power col-

lege (and high school) operations, CPB's proposal actually inspired them to upgrade, thus assuring their longevity.

As stated at the beginning of this chapter, colleges have been involved in radio from the start. However, College radio as a programming service was launched in 1940 at Brown University. In its original form the medium was a campus-only endeavor. Wires were run from one receiving point to another to establish what the founders of the Intercollegiate Broadcasting System (IBS), George Abraham and David Borst, referred to as a "gaspipe network." In his book *The Gaspipe Networks*, which recollects the inception of College radio, Louis Block observes, "At first the Brown broadcasting and communications systems consisted of wire lines connected to the radios of participating students on campus, and this complicated arrangement required a crew to string the lines, make the connections, and maintain the system. As more and more students became interested, lines were strung to all points of the campus."

Within a few short years, many college broadcasters gave up their wiring modus operandi for over-the-air broadcasting as Class Ds, and the majority became members of IBS, which maintains its status as a nonprofit organization designed to function as an informational resource center, as well as a source for consultation. Today, approximately six hundred and fifty colleges and high schools are members of IBS.

The Intercollegiate Broadcasting System perceives the role of College radio as twofold—to serve the needs of the listener and to serve the needs of the student broadcaster. In the first instance, many college broadcasters believe themselves charged with the altruistic duty of providing the audience with programming not found elsewhere—what College radio broadcasters call "alternative" programming. According to Jeff Tellis, president of IBS: "College radio constantly defies attempts to categorize its programming into neat little boxes like most other formats. That's part of what makes college stations exciting to work with and tune. They're often spontaneous and seemingly unplanned. You don't always know what's coming next. At its best, College radio is an alternative in the true sense of the word. It can and usually does provide another choice—something that isn't available elsewhere at all, or at least not in quite the same way. On College radio can be found virtually every type and kind of radio programming one can imagine, and probably a few that go well beyond those bounds. Whereas most commercial stations tend to have a single music format focused on constant repetition of a music playlist of one size or another, most college stations tend to play different kinds of music at different times of the week, many at different times of the day. The kinds of music may include everything from classics to contemporary, blues, rock, folk, jazz, progressive, eclectic, acoustic, heavy metal, old, new, and in-between."

A recent survey conducted by Mark Tolstedt of the University of Wisconsin revealed that approximately ninety percent of the nation's college stations are music oriented, with playlists featuring a vast array of musical genres.

The other key role of College radio is to train and educate future broadcasters. "The hardest part about managing a noncommercial, student-run station is the need to balance the learning experience with the desire to sound consistently professional. You have to allow the students to take risks, to make mistakes, but you also must impress upon them the power they possess with an open microphone," observes Fran Berger, director of radio at Boston's Emerson College.

FIGURE 19.3
James Madison University students hosting a daily news program on WMRA-FM. (Photo by Onnie Bailey.)

FIGURE 19.4
Records call number key. (Courtesy of college station KXMS-FM.)

```
                              KXMS OPERATIONS MANUAL: page 9
                    RECORDS CALL NUMBER KEY

The following key to record call numbers will help students locate
recordings in the station library.
         Example of call number C10-CJSB-L001

First Group, First letter     C = CLASSICAL
                              E = EASY LISTENING
                              J = JAZZ
                              T = THEATER
                              M = COMPLETE PROGRAMS
           Second letter      I = INSTRUMENTAL
                              V = VOCAL
                              M = MIXED INSTRUMENTALS AND VOCALS
                              B = BALLET OR BIG on big band
                                  recordings
                              O = OPERA

           Third letter       B = BAND
                              D = DUET two instruments or vocal
                                  duet.
                              S = SOLO single instrument or one
                                  voice accompanied by one
                                  instrument
                              N = NARRATED
                              T = TRIO
                              Q = QUARTET OR QUINTET
                              G = SMALL GROUP OR ENSEMBLE
                              O = ORCHESTRA
                              H = HUMOR OR MUSIC FOR SPECIAL
                                  HOLIDAYS
                              E = ELECTRONIC (MOOG)
                              M = COMPLETE OPERA OR OTHER WORK
                                  OR MIXED SIZES OF GROUPS
                              A = A CAPPELLA (choral music)

Second group, First letter    C = COMPOSER
                              K = CONDUCTOR
    indicates what the        P = PERFORMER
    music is filed under      N = NONE OF THE ABOVE

    Second, third and fourth  represent the composer, conductor,
    letters                   performer, or other classification
                              VAR = VARIOUS

Third group, First letter     L = LP RECORD
                              C = COMPACT DISK
                              T = CASSETTE TAPE
                              R = REEL TO REEL TAPE

    Last four are numbers     Example: C10-CJSB-L0001
    which are numerical                C10-CJSB-L0002
    for the particular                 C10-CJSB-L0003
    combination of call                C10-CJSB-L0004
    letters.
MEANING THERE ARE FOUR LP'S OF ORCHESTRA MUSIC OF JOHANN
SEBASTIAN BACH
```

DAILY SCHEDULE

	SUN	MON	TUES	WED	THUR	FRI	SAT		
6:00								6:00	
6:30	CAMBRIDGE FORUM						▶TOTALLY WIRED	6:30	
7:00	FIRST PERSON RADIO						▶CHILDREN'S JOURNAL	7:00	
8:00	MONITORADIO		MORNING EDITION — News & Information from National Public Radio / Local News with Kim Silarski					8:00	
	WEEKEND EDITION with Susan Stamberg						WEEKEND EDITION with Scott Simon		
10:00								10:00	
	THE LISTENING ROOM with Chris Felcyn		DAVE DIXON'S PROGRAM — Free Form Variety					BLUES FROM THE LOWLANDS with Robert Jones	
12:00								12:00	
1:00	THE BEST OF A PRAIRIE HOME COMPANION	Marian McPartland's PIANO JAZZ	PORTRAITS IN BLUE	EVOLUTION OF JAZZ	AFROPOP	CYPRUS AVENUE	FOLKS LIKE US with Matt Watroba	1:00	
2:00								2:00	
3:00	THE THISTLE & SHAMROCK		JUDY ADAMS' MUSIC GALLERY — World Music Variety					3:00	
4:00	▶HARC						THE ARKANSAS TRAVELER with Larry McDaniel	4:00	
4:30	▶ARABESQUE							4:30	
5:00	ALL THINGS CONSIDERED		ALL THINGS CONSIDERED — News & Information from National Public Radio / Local News with Chuck Wilbur					5:00	
6:00	EL GRITO DE MI RAZA with the Latino Radio Collective	CROSSROADS	VISTAS: LATIN WORLD MAG.	HORIZONS	▶SOUNDPRINT	DIALOGUE DETROIT with Chuck Wilbur	CAR TALK	6:00	
6:30								6:30	
7:00								7:00	
7:30								7:30	
8:00	▶DIMENSION with Martin Bandyke		THE ED LOVE PROGRAM — Classic Jazz				NEW RELEASES IN REVIEW with Ann Delisi	JAZZ YESTERDAY with Jim Gallert	8:00
10:00	▶SHOWCASE DETROIT with John Ciaravino					REGGAE VIBRATIONS with Mikie Dread	52nd STREET with Rudy Tucich	10:00	
11:00								11:00	
12:00	▶DESTINATION OUT with W. Kim Heron		THE NKENGE ZOLA PROGRAM — Music, Poetry, Interviews & Event Calendar				RADIOCLASH with Anita Tackett		12:00
1:00	NEW SOUNDS						BLUES AND MUSIC AFTER HOURS with Famous Coachman	1:00	
2:00						FAST FORWARD with Alan Oldham		2:00	
4:00			THE NIGHTSHIFT with John McMullen				OUT OF BOUNDS with Allen Mazurek		4:00
6:00								6:00	

Every Monday: WSU Events Calendar with Caryn Mathes Every Friday: WDET Music Calendar with Ann Delisi ▶Triangles indicate new programs or new time slot.

FIGURE 19.5
Wayne State University WDET's program schedule. (Courtesy WDET and WSU.)

PUBLIC RADIO

Public radio is the second largest category of noncommercial broadcasters. Over three hundred stations receive NPR support. As mentioned, NPR outlets enjoy higher power and larger coverage areas than most other noncoms, and while most areas have at least one Public radio station, nearly fifty percent of the medium and metro markets have two or more.

The programming goal of most Public radio stations is to serve the people who share a strong curiosity about ideas and events and an attraction to classical music or jazz. "It's Public radio's philosophy to respond to the listening needs and desires of the public. It wants the listener to use the station for local, regional, and national items and programs. It does not wish to be a background source," notes Miskimen.

News and information programming constitutes the main drawing card of Public radio stations, followed by classical music and jazz. Among several other popular Public radio offerings are folk music, documentaries, new music, and drama. Most Public radio outlets devote two-fifths of their airtime during a routine week to network and syndicated programming. Says Miskimen: "Public radio offers in-depth news coverage and features. It goes that extra mile to make the listener understand and comprehend what is going on in the world. Two NPR programs reflect this statement. The Peabody Award winning 'All Things Consid-

ered' is a ninety-minute weekday (sixty-minute weekend) look at the day's news in detail. It airs during afternoon drive-time and is tremendously popular. Starting the day is 'Morning Edition,' which airs at 6:00 A.M. This is an excellent two-hour news and features magazine. Both programs take the time to completely tell the story."

Several regional Public radio groups, such as Southern Educational Communications, Eastern Public Radio, Public Radio in Mid-America, West Coast Public Radio, and Rocky Mountain Public Radio provide listeners throughout the country with high-caliber programming, and in many markets they enjoy large and devoted followings.

The diversity of Public radio's audience is revealed in a report funded by CPB and prepared by Linda Liebold, says Jim Miskimen. The report states: "Half of these listeners are between 25 and 44 years old. Over two-thirds have completed college or attended graduate school (71%), half (48%) are employed in professional or technical occupations, and one-third (32%) live in households earning more than $50,000 annually."

COMMUNITY RADIO

More recently, a third category of noncoms has been making an impression on the listening public by offering a schedule of diverse, if not eclectic, features. All told, there are less than one hundred Community radio outlets in the country, but their broadcasts are being tuned by more and more listeners each year.

The National Federation of Community Broadcasters (NFCB) constitutes the largest association of Community radio stations. The following statement aimed at prospective members presents the federation's view on the role of Community radio: "The National Federation of Community Broadcasters exists to serve the needs and interests of radio and television broadcasters—groups operating stations and those seeking to build them—who work to bring a measure of humanity and excitement to the airwaves, who approach their efforts with an experimental and open-minded view to the potential of the spectrum, and who care a great deal about both the aesthetic beauty and social force of the material they bring to their communities."

NFCB participation is open to radio stations that:

"are incorporated as not-for-profit organizations;
are governed by a group broadly representative of the community they serve;
have a stated and demonstrated commitment to the participation of women and Third World people in all aspects of the organization and operations;
have a stated and demonstrated commitment to access by the general public to the airwaves;
provide or seek to provide a service to the general public and not to any single group, organization or institution;
seek to reflect a diverse range of culture and opinion in their communities through the operations."

Most Community radio stations operate at low power, with the exception of a handful that put out formidable signals. Few Community noncoms air a single or primary format. The block programming approach is most common, as WMNF's program director, Randall Wynne, observes: "Our listeners expect diversity. Included in our program schedule are folk, jazz, alternative rock, big band, bluegrass, reggae, and so on. We also program to particular ethnic groups and offer substantial amounts of news and public affairs. Our goal is to be a genuine alternative to the other stations in this area. WMNF listeners expect programming with more integrity and imagination—a less commercial sound and more aesthetic sensitivity when determining program content. I guess the real distinction between us and the commercial sector is our airing of music that is less popular and news that is more in-depth. We're a station with many formats. This is something you won't find in commercial radio." (Wynne's comments originally appeared in the author's book *Radio Programming: Consultancy and Formatics*.)

Funding is always the major challenge facing Community radio stations. The NFCB states that the medium "must rely primarily on . . . communities for support. In addition to public funding sources, other revenues come from listener donations and

local business and foundation underwriting grants."

Many Community radio stations are operated by minority groups, such as Blacks, Hispanics, and Native Americans. In fact, notes the NFCB, "Many Community stations are bilingual, too. Some speak Spanish in Colorado; others, Lakota Sioux in South Dakota; and still others, Eskimo in Alaska. In all, over twenty different languages can be heard on Community radio stations across the country."

NONCOMMERCIAL RADIO PRODUCTION

It can be argued that the most innovative, creative, and elaborate radio production today is found on the noncommercial end of the FM dial. Public radio, in particular, is responsible for some of the most ambitious productions—everything from clever sound bites to episodic series. Whereas commercial radio has all but given up on the production of radio dramas, documentaries, and variety shows, these audio art forms have been almost single-handedly kept from extinction by Public radio.

Whereas few live productions are broadcast by commercial stations, many noncommercial outlets offer listeners a wide-range of live fare, such as concerts, dramas, and variety shows. A single individual will assume overall responsibility for a program's production. Typically, this person is assisted by a staff, which includes technical people who handle mixing and mic setup, script people who research and prepare program text, and talent. Budgetary constraints sometimes require that these areas be handled by one person—the producer.

Public radio programmer Julie Rogier observes: "NPR and Public radio are in the

FIGURE 19.6
NPR brochure.
(Courtesy NPR.)

WHAT'S DIFFERENT ABOUT NATIONAL PUBLIC RADIO?

Our Programs. ALL THINGS CONSIDERED®, MORNING EDITION®, WEEKEND EDITION® — NPR's news programs are a regular, reliable source of national and international news. Millions of NPR listeners tune to these newsmagazines for in-depth coverage, for analysis beyond the headlines, for news they trust as thorough and balanced.

NPR's arts and performance programs celebrate the richness of the arts in America and abroad. Perhaps best known for its classical and jazz music, NPR also presents folk, bluegrass, and new music, in addition to humorous variety programs and radio drama. Conversations with writers, musicians, and other artists provide listeners with varied opinion and reflection on all that is current in the arts world.

Acknowledging the diversity of American society, NPR provides programs which focus on minorities, the elderly, and the disabled. NPR is designed to encourage broad participation. The resulting programs are as original and varied as those who contribute, who in turn are as diverse as the American public.

Our Sound. Always a little ahead of our time, challenging our listeners, challenging ourselves. On location with NPR correspondents, NPR's engineers contribute to the creation of audio portraits, bringing to life the ideas, personalities, tensions, and debates of radio news, demanding and insuring the highest quality sound.

National Public Radio's arts and performance programming takes listeners to the great concert halls of the world, to avant-garde performances off-off Broadway, to crowded jazz clubs tucked away on Bourbon Street. The high-tech special effects which animate Ruby the Intergalactic Gumshoe, the chalky voice of the playwright Sam Shepard, a soaring aria sung by Kiri Te Kanawa, the clarity of Itzhak Perlman's violin — NPR's sound is of the highest calibre.

But it's the absence of some sound that distinguishes our programs from anything on any other radio network. No advertisements. No hard sell — no soft sell. We're not trying to sell our listeners on anything.

Our Partnership. National Public Radio is more than the program-producing center based in Washington, D.C. National Public Radio is also a partnership with more than 350 stations. Highly independent and autonomous, stations respond to the specific needs of their communities and determine how to present NPR's programming.

Stations produce many of the performance programs that are presented nationally by NPR, and stations' news reporters regularly file stories heard on NPR's newsmagazines. And it is through NPR stations that the public directly participates in National Public Radio — as volunteers, contributors, and listeners.

Our Structure. A private, not-for-profit membership organization based in Washington, D.C., National Public Radio was incorporated in 1970 with 90 public radio stations as charter members. Since then, NPR has grown to include 350 stations located in 48 states, Puerto Rico, and the District of Columbia. In addition to programming, NPR provides stations with support services such as marketing assistance; a computerized satellite-delivered communications system; and engineering training and advice. NPR also works with stations to represent their interests before the Federal Communications Commission and other federal agencies.

Our Funding. Funding of public radio is a team effort. NPR stations contribute more than half of NPR's operating budget. National Public Radio makes up the difference with grants and underwriting from national corporations, foundations, associations, and individuals to support both its programming and general operations. NPR stations are supported by their communities: listeners, universities, and state governments. And the Corporation for Public Broadcasting (CPB) makes federal money available to public radio stations in the form of grants.

Our Listeners. The weekly audience for all public radio programming is 10 million people. The weekly audience for all NPR news programming is six million. NPR's programs — both news and performance — attract an audience most notably distinguished by its level of education, professional success, and community involvement.

Our Mission. "Radio is a personal medium of incalculable impact. Realizing that potential is perhaps the most fundamental responsibility National Public Radio can fulfill. As information continues to transform our world at an incredible pace, our responsibilities to one another are more important than ever. The need for a touchstone — for clarity, continuity, a renewed sense of community — is becoming increasingly essential. National Public Radio, at the leading edge of the very technology that has created these new needs, has as its mission to be that touchstone."

— Douglas J. Bennet
President, National Public Radio

NATIONAL PUBLIC RADIO®

forefront of stereo recording techniques, documentary production, and fine arts production. At WGTE, we air live studio recitals of classical performers, such as string quartets, guitarists, vocalists, and pianists. We broadcast the local symphony orchestra from the concert hall once a month via microwave and M-S (two microphones) stereo recording technique. Production values come first, since by virtue of our noncommercial classical format, we have the time and dedication to make our sound superior. Our audience is made up of high-income, educated listeners, who are themselves audiophiles with high expectations concerning sound quality. These are the same people who tune NPR's award winning news show 'All Things Considered.' The lost art of documentary can be heard daily on this program, as well as news stories told using radio art or 'sound paint.' Again, the noncommercial format ensures the time to tell a story completely and creatively. American Public Radio produces exceptional radio. For example, in the 1980s 'Prairie Home Companion' brought back the live radio music/comedy variety show, and 'Good Evening' is now broadcast live every Saturday night."

Maintaining the highest production standards possible is the goal at NPR, says Skip Pizzi: "We try to sound as good as possible given the circumstances of time and economics. For news, intelligibility is the primary criterion, and for music, drama, and other arts-related programs, fidelity is the chief concern. Stereo is encouraged whenever possible in the latter category, but always with a major emphasis on mono compatibility. We eschew multitrack recording for the most part, preferring the speed and cost-effectiveness of recording direct to stereo or mono, and using the multimachine approach to audio postproduction. This, of course, implies a lot of skill, quick reflexes, and a bit of luck, but it sure keeps the work interesting."

On the local Public radio station level, production is both challenging and diverse. One of the primary production tasks facing Public radio producers is the mixing of features, says C. Mathes of Detroit station WDET-FM. "We do a lot of program and feature mixing, and drama is also a part of our work as well."

Flagstaff station KNAU's general manager Russell Hamnett agrees, "Production of features is a primary task here. KNAU produces a half-hour daily news magazine, plus several hours of taped programming with a range of content from opera to vintage radio."

News and interview features constitute a considerable part of the mixdown demands at Public radio stations. "News and interview programs involving a complex array of sound bites are very time-intensive," observes Dave Spizale of Lafayette, Louisiana, station KRYS-FM.

Talk and commentary features keep the production director of Indianapolis' WAJC busy. "Our primary job here is to produce three local half-hour talk shows and five, five-minute commentaries," says Richard Miles, who adds, "Keeping up with this on a daily basis is both stimulating and demanding."

While preparing local news shows and features consumes a large part of the day at many Public radio outlets, the mixdown of promos and other sound bites adds to the work load. "We do a lot of program promos, and they are generally mixed by the hosts themselves," says WQLN's Thomas J. McLaren, who adds that "the choice of bed music and other background is completely dictated by the nature of the on-air sound. Although our promos are designed to gain the listener's attention, they must match flow and not fight it."

This is also true at WFPL. "Getting the promos mixed to complement our overall sound is the objective. Promotional announcements are always waiting to be mixed," notes Joseph Vincenza, who adds, "Another thing that involves my department quite heavily is the production of a number of shows for national distribution."

Producing programming material for nationwide use is a common act at many Public radio outlets, especially for those with larger staffs and funding. This, of course, places additional demands on the production department.

The use of audio processing and digital gear factor into the mixdown of programs at many Public outlets. "To enhance the sound of our product we digitally mix. This is especially important with classical programs," says WAJC's Miles. Public radio has been involved with sophisticated sound enhancement techniques from its inception.

FIGURE 19.7
James Madison University student works and trains in WMRA's engineering department. (Photo by Onnie Bailey.)

College radio stations are very much involved in all types of production, although shorter forms of mixdown (promos, IDs, vignettes) are more prevalent than those of feature length. According to WPKN's general manager Harry Minot: "We mix a lot of sound bites for air use, and in addition we offer ourselves to a variety of university and community groups. We produce narratives for various media and mix the university's radio commercials, as well as strike dubs for all the stations airing the spots. We do this, too, for certain psa's we mix and for community group production. Most of these folks can't afford commercial studio time, and if it weren't for us, their projects would go unrealized. Of course, we generally don't permit commercial use of our studios, but we have bartered them out for equipment we've needed."

At College station WGAO, faculty advisor Vic Michaels reviews the types of production his staff is engaged in: "We mix psa's of a local nature to keep a fresh rotation going on the air. We also concentrate on producing top-flight, professional promos. Recently we've added CD players to our production studio, and we've just purchased a (Network) CD sound effects library. It's quite elaborate. We've also purchased an ART Multiverb effects processor that will give us flanging, delay, reverb, echo, and other opportunities in our mixes."

"Our goal is to sound as sophisticated as the big outlets on the dial," says Michaels. "We focus on top quality mixes from every aspect: copy, delivery, and mixdown. Just because we're a school station doesn't mean we intend to sound sophomoric. You'll find the production standards on the rise throughout the College radio medium, and in particular here. My production director reviews everything before it reaches the air. Quality control starts in the mixing studio."

While many Community radio outlets often suffer from a lack of state-of-the-art facilities and equipment, they are still very much concerned with the quality of their production work. KFLR's manager, Alan Cook, states that the standards are high at his outlet. "We work hard to produce the best product possible. We're engaged in a plethora of mixdown projects on a daily basis. News features and promos keep us busy, but we're active in producing developmental material. Music mixing also is a primary task of the production department."

Noncommercial radio production differs from that of commercial in many ways, but the difference is probably most notable in the area of mixdown length. "In noncommercial production there is much less emphasis on thirty's and sixty's—'spots'—as the commercials call them. What we mix, for the most part, is much lengthier—program-type production, if you will," says WAJC's Miles.

WDET's Mathes makes a similar comparison. "The bulk of commercial production centers around spot mix. Here there is greater emphasis on full program production—one-half-hour to one-hour narratives, interviews, and so on, replete with sound effects and music transitions, etc.—than on spot or short-form production."

WMNU's Stephen Dupras succinctly says it: "Noncoms produce pieces. Coms mix spots."

The more elaborate use of production elements in news programs distinguishes noncoms from commercial stations, contends KNAU's Hamnett. "Our news tends to be a more elaborate undertaking. We mix more sound bites and actualities here. I think most news production is more embellished in Public radio. On the whole, there is just more mixing of discrete programs and program content."

WFPL's Vincenza cites the opportunity for more experimentation as a benefit of noncommercial radio production: "We in Public radio have more freedom in the studio. That is, fewer strictures. We can take more chances; try something different—offer a different perspective on whatever it is we're working on. Maybe I'm saying things are a little less formulaic or routine, and that for me is an important difference."

Another thing that distinguishes the noncommercial production room from the commercial one is the emphasis on community participation, says WPKN's Harry Minot. "Our attitude has been to treat the production area, like the station itself, as a community and learning resource. It happens that we report to the Dean of the Library, and although this philosophy predates that relationship, we do feel a kinship with their approach to community service. Our production studio, though neither chic or spectacularly well equipped, does a powerful lot of good in this town and region. It's part of the reason for our reputation as a full and gracious partner in the life of this area."

INDUSTRY NOTES BY ALAN FRANK

Professor Frank is director of radio at Curry College. Here he gives his perspectives on the role of production in the noncommercial radio medium.

* * * *

"I have been involved with radio broadcasting for over twenty years, and I have witnessed the transformation of public radio into a driving force that provides a true alternative to commercial radio. When people discuss public radio today, they may immediately think of the larger FM facility with NPR affiliation and CPB funding, but there are numerous smaller public stations also providing that true alternative—an alternative not only to the commercial outlets but to the larger noncommercial stations as well. These stations can be found on college and high school campuses throughout the country. Most are dependent upon funding from their institutions (licensees), as well as donations from listeners and underwriting from area businesses. Many of these FM stations are extracurricular, which means they are usually funded directly through student government associations, and do not offer academic credit. *Cocurricular* stations provide an academic experience wherein students can earn credit for learning and working in radio. Typically both types of stations provide the alternative service I mentioned earlier.

"Programming is typically free and developed by students. Therefore the station will have many live music programs, as well as news and sports. Programming can be called diversified, which means there is not one target audience but a number of target audiences throughout the broadcast day. How long should the broadcast day be? Well,

FIGURE 19.8
Jim Miskimen, general manager of WMRA and president of Virginia Public Radio, hosting a classical music program. (Photo by Onnie Bailey.)

FIGURE 19.9 Board operator pointers from KXMS operations manual. (Courtesy KXMS.)

KXMS OPERATIONS MANUAL: page 11

AIR CHECKS:

Each board operator is required to record an air check each week. These air checks should be listened to and personally critiqued. Each operator should try to improve week to week. Once a month an air check should be brought to Dr. Clark, so that the operator and Dr. Clark can listen to the air check together and decide on goals to improve operator performance.

BOARD OPERATOR HINTS

Try to make the time you are on the board go as smoothly as possible. You will find some hints below that will help you perform better and overcome the nervousness of being on the air.

1. When you arrive for the boardshift, check through the records and make sure that all the programmed recordings are present in the control room.

2. Check the equipment, especially the position of switches, and make sure that everything is in the proper order.

3. Prepare for your boardshift. Go over the logs and become familiar with what you will be playing. Find the pronunciation of unfamiliar names and write it down so you will remember it. Make notes for the announcements you will be required to make to introduce music selections.

4. Read through your announcements aloud before delivering them on the air. Try to relax. Plan what you are going to say before you open the microphone. Make notes if necessary. If the transitions are planned, they are more likely to go smoothly.

5. Keep some music cued up on the turntables at all times, and keep a cart cued and ready too. These can be useful in case of emergencies to prevent dead air. Knowing they are there and ready will help you relax.

6. Remember Murphy's Law and be prepared.

7. Remember you must announce the composer, title and performer's of all cuts over 12 minutes in length both before you play them and after.

8. Learn the proper operation of all pieces of equipment. Learn how to program the compact disk player to do what you want it to do. Proper operation of the compact disk player will help the smooth flow from one selection to the next.

9. Watch the levels on the VU meters. The soft passages of music should not be lower than 20%, and the loud passages should be barely going into the red above 100%. When you are talking the meter should be registering between 60% and 80%. Watch the levels.

twenty-four hours would be great, but it is difficult to recruit students to work the graveyard shift, especially those having early morning classes. But, somehow, those dedicated souls can be found, and many smaller public stations do broadcast full-time.

"The key behind any successful college radio station is its facilities. If possible, there should be three studios—on-air, production, and training. In creating a production studio, equipment should be easy to use as well as durable. New students unfamiliar with broadcast equipment tend to be a bit heavy-handed. I want my students to become acquainted with hardware they will find in commercial and noncommercial radio stations; therefore, all equipment should represent the state-of-the-art. WMLN-FM at Curry College has excellent equipment. The on-air studio has most recently been soundproofed with Sonnix modules. The console is a Harris Gold Medalist (twelve channel) slider pot system. There are three playback cart decks, a cassette deck, two reel-to-reels, two speakers, a CD player, two direct-drive turntables, and two microphones for news and sports. There is a rack that holds our reel-to-reels, EBS monitor, and remote transmitter equipment. The studio is well grounded to prevent electrical shock and static interference.

"The primary production studio has an LPB console (ten channel), one playback cart deck, and two record/playback cart decks. There are two direct-drive turntables, two mics, two reel-to-reels, a double cassette deck, CD player, sound processor, compressor/limiter, and digital timer. There are two speakers. This studio has also been soundproofed. The most advanced students use this facility. In addition to all the equipment noted, there are a number of editing blocks (Edit-all), splicing tape, reel tape (1.5 mm thick to prevent breaking or stretching).

"The last studio is more a training area. It has an LPB console, two record/playback cart decks, and one playback-only deck. It also has a cassette deck and CD player. It has been equipped with two reel-to-reel tape recorders and two microphones. There are two direct-drive turntables and two speakers. It, too, has a number of editing tools available.

"In both production studios, students are encouraged to work with the equipment and experiment with sound. This experimentation can be as simple as recording sound from turntable to reel or cart. It can also be as challenging as producing (mixing and editing) a radio drama, with all the accompanying sound ingredients.

"It is most important that studios be maintained regularly—kept clean and operating at peak efficiency. This is a weekly, and in some cases a daily, exercise. Students interested in broadcast engineering work with our consulting engineer in daily maintenance. In some cases, this amounts to a thorough dusting of equipment.

"The studios see many students, with varying levels of expertise—ranging from commercial experience to absolutely no experience. There is a student handbook that explains all facets of the station, from personnel to policy. The latter must be adhered to if students wish to remain a part of the radio station. Smoking is not permitted in any studio, neither is drinking or eating. Proper studio decorum is required. In other words, look and act like a pro! In the years that I have been working with future broadcasters, I have instituted a policy that allows entering students to get involved immediately. No waiting. Find out if you really want to be in this unique and exciting business. In my opinion, the only way to do this is to jump right in and get on the air or produce a program. Hard work and dedication are what make good programmers and producers."

CHAPTER HIGHLIGHTS

1. The Public Broadcasting Act of 1967 established the Corporation for Public Broadcasting (CPB), which in 1970 gave rise to National Public Radio (NPR).

2. The CPB is a private, nonprofit corporation authorized to promote noncommercial telecommunications (radio and TV) for the nation.

3. NPR is a private, noncommercial network that produces and distributes programming, operates the public radio satellite interconnection system, and provides technical services and representation. Of the thirteen hundred noncoms nationwide, three hundred are NPR members.

4. Over eighty-two percent of the nation

is served by Public radio, with over twelve million listeners a week.

5. The Intercollegiate Broadcasting System (IBS) is a nonprofit organization serving as an informational resource center and consulting service for educational stations (over six hundred and fifty members).

6. Many noncoms (Public, College, and Community) offer the most innovative and elaborate radio production, ranging from clever sound bites to radio dramas, from documentaries to variety shows. They use the latest technologies to satisfy a fidelity oriented audience.

7. Mixdowns at noncoms are complex because of the number of news and features programmed, plus the program and station promos. Features run the gamut from drama to interviews, to news magazines, to talk shows. Larger Public radio outlets often produce programming for national distribution. Sophisticated sound enhancement technology is common.

8. The primary difference between commercial and noncom production is length, with noncoms generating mostly program-type productions (thirty to sixty minutes), while commercial outlets focus more on spots (thirty to sixty seconds).

SPOT ASSIGNMENTS

1. Listen to area noncoms—Public, College, and Community—and prepare a brief production profile on each.

2. Assess a College station's short-form (psa's, promos, IDs) mixdown values.

3. Determine what distinguishes the local noncoms from the commercial outlets on the dial in terms of their production approaches.

4. Contact at least two local noncoms and inquire as to their use of audio processing equipment in the production room.

5. Tune NPR's "All Things Considered" and critique its use of production elements.

Glossary

Acoustics The science and study of sound; studio sound qualities.
Actuality On-the-scene recorded report; sound bite.
Adjacencies Commercials strategically placed next to a feature.
Ad lib Improvisation; unrehearsed and spontaneous comments.
Aircheck Tape of live broadcast; to listen to what is being broadcast.
Ambience The natural (atmospheric) sounds in a studio area; background sounds.
Amplitude The intensity or magnitude of a sound wave or electrical current.
Analog recording Replication of a waveform onto magnetic tape.
Announcement Commercial (spot) or public service message (psa) of varying length.
AOR Album Oriented Rock radio format.
Arbitron Audience measurement service.
ASCAP American Society of Composers, Artists, and Producers; music licensing service.
Attenuator Volume control; potentiometer (pot); fader; gain.
Audio Sound, modulation, signal.
Audio processor A piece of equipment used to alter or manipulate time, frequency, and amplitude audio domains; effects box, digital processor.
Audition Channel (output bus) on a board that allows sound to be fed to studio loudspeakers without it going over the air; to critically assess (review) recorded material.
Automation Equipment system designed to play prepackaged programming.
Axis Line bisecting pickup path of microphone.

Back announce Recap of preceding music selections.
Bed Music behind voice in commercial, psa, or promo.
Bidirectional microphone Microphone that picks up sound to its front and back; two directional audio pickup.
Blend Merging of complementary sound elements.
BM Beautiful Music radio format.
BMI Broadcast Music Incorporated; music licensing service.
Board Audio console; mixer.
Boom Projectable arm of microphone stand allowing for the adjustment of the mic's position.
Bridge Sound used between program or production elements.
Bulk eraser Tool used to clean magnetic tape of recorded audio; degausser.
Bus Mixing circuit in the board that carries current from inputs to an output(s).

Cable Wire; line; connector.
Capstan Shaft in recorder that drives tape; transport.
Cans Headphones.
Cardioid Microphone with a unidirectional, heart-shaped pickup pattern.
Cart Plastic container holding a continuous loop of magnetic tape.
Cartridge Component of turntable tone arm that converts vibrations from the stylus to electric energy.
Cassette Reel-to-reel magnetic tape housed in a plastic container.
Channel Path through which an audio signal flows—for example, a program channel or an audition channel.
Chopping block *See* **Splice block.**
Compact disc (CD) Digital recording using a laser beam to optically decode surface (encoded) data.
Compressor A device used to squeeze (narrow) the audio range to give signal greater "kick" or "punch" and to reduce distortion; signal processor.
Condensor A microphone that relies on vibrations of the diaphragm to cause a capacity change in a stored electric charge, thus yielding a signal or current; capacitor.

Console A piece of studio equipment through which all signals are processed (amplified, routed, and mixed); board.
Control room On-air studio; master control.
Copy Advertising message; continuity, commercial script.
CPB Corporation for Public Broadcasting.
Crossfade Fade out of one audio element while simultaneously introducing another.
Cue Signal for the start of action; prepare element for roll into mixdown.
Cue burn Distortion at the beginning of a record cut resulting from heavy cueing.
Cut A track or segment on a recording.

DAB Digital audio broadcasting.
DASH Digital Audio with Stationary Head; a digital recording format.
DAT Digital audio tape.
DAW Digital audio workstation.
Dayparts Periods or segments of the broadcast day: 6:00 to 10:00 A.M., 10:00 A.M. to 3:00 P.M., 3:00 to 7:00 P.M., 7:00 P.M. to 12:00 A.M., 12:00 to 6:00 A.M.
Dead air Silence where sound should be; absence of audio.
Decibel A unit measurement of volume.
Degausser See **Bulk eraser.**
Digital recording Process in which a waveform is quantized; numbers represent sounds.
Dolby Noise reduction process available in certain recorders.
Donut spot A commercial in which copy is inserted between vocal segments of a music bed or jingle.
Drive-time Radio's primetimes: 6:00 to 10:00 A.M. and 3:00 to 7:00 P.M.
Dropout Signal loss on recording tape due to deficiencies in oxide coating.
Drops Audio inserts; sound bites.
Dub Copy of a recording; to duplicate (dupe).
Dynamic microphone See **Moving coil microphone.**

Echo Sound perceived as repeated or delayed.
Edit To alter composition of recorded material; splice.
Edit block See **Splice block.**
Electronic editing Insert, assembly, and digital editing.

Equalization (EQ) Adjustment of the frequency balance of a sound source.
Erase Reconstitute or randomize magnetic field on tape so as to eliminate recorded audio; to wipe clean; degauss, demagnetize.
Expander A device that increases the dynamic range of signals that are below threshold.

Fact sheet List of pertinent information on a sponsor.
Fade To slowly raise or lower volume level; pot up/pot down.
Feedback High-pitched squeal or howl resulting from the reamplification of an audio signal.
Fidelity Trueness of sound dissemination or reproduction.
Filter System designed to eliminate or attenuate selected frequencies.
Fixed position Spot routinely logged at a specified time.
Flanging Special effect created by an audio processor; a varying delay.
Flight Advertising air schedule.
Format Type of programming a station offers; arrangement of programming material; formula.
Frequency Number of times (cycles per second) a sound source vibrates; Hertz (Hz).
Fulltrack Recording using entire width of tape; mono, one-track.

Gain Change in volume; volume control device: pot, fader.
Generation A dub-down; dupe.
Graphic equalizer A type of equalizer with faders arranged adjacent to one another, presenting a visual arrangement of the frequency response curve.
Grease pencil Waxy, nonscratching marker used to inscribe recording tape for mechanical editing purposes; china marker.

Harmonics The multiples of a fundamental frequency.
Harmonizer Special effects device that varies pitch and tempo; audio processor offering delay and doubling effects.

Heads Components of a tape recorder that erase, record, and play back.
Hertz Cycles per second; unit of measurement of frequency.
Hot Overmodulated; above prescribed threshold; excessive volume.
Hot clock Wheel indicating when particular music selections are to be aired.
Hub Central part of reel, around which tape is wound.
Hype Exaggerated presentation; high-intensity, punched delivery.

Impedance Opposition from an electric circuit to the flow of alternating current or frequency; resistance.
Input Point receiving incoming signal.
Intro Introduction element to a mix; opening audio.
IPS Inches per second; tape speed.

Jack Connector plug; patch.
Jingle Musical commercial or promo; signature, logo.
Jock Deejay; announcer.

Leader tape Plastic, metallic, or paper tape used in conjunction with magnetic tape for marking and spacing (cueing) purposes.
Level Amount of volume units; audio measurement, loudness.
Limiter Device used to adjust or correct levels of a signal; compressor.
Liner cards Written on-air promos used to ensure adherence to station image; prepared "ad-libs."
Live copy Material read over air; not prerecorded.
Live tag Postscript to taped message.
Loudspeaker Device that converts electric energy into acoustic energy; studio monitor.

Make-good Replacement spot for one missed.
Master Original recording.
Master pot The potentiometer that controls the total output of the board; master gain.
Microphone A transducing device that converts acoustic energy into electric energy.

MIDI Musical instrument digital interface; control system that allows a keyboard to talk to studio synthesizers.
Mixdown Integration of sound elements to create a desired effect; to produce.
Monitor Studio loudspeaker; to listen, aircheck.
Mono Single or fulltrack sound; monaural.
MOR Middle-of-the-Road radio format.
Morning drive Radio's premium daypart: 6:00 to 10:00 A.M.
Moving coil microphone Microphone possessing a thin diaphragm connected to a coil, which when vibrated by sounds creates an electric signal; dynamic mic.
Multitracking Recording using more than two channels; four to thirty-two channel mixing.
Music bed *See* **Bed.**
Music sweep Several selections played back-to-back without interruption; music segue.
Muting System in the board that silences loudspeakers when microphone is activated.
Mylar Magnetic tape backing; polyester.

NAB National Association of Broadcasters.
News block Extended news broadcast.
Noise Any unwanted sound in a recording or broadcast: hiss, buzz, hum, RF (radio frequency).
Notch Attenuate; decrease.

Off-mic Speech outside the normal pickup pattern or range of microphone; off-axis.
Omnidirectional microphone Microphone capable of picking up sound equally from all directions (360 degrees).
Open reel recorders Machines using tape not permanently encased in a cartridge or cassette; reel-to-reel.
Out-cue Last words in a line of carted copy.
Output Point from which a signal is sent to another device; outgoing signal.
Outro Conclusion of produced material; finale, stinger.

Packaged Canned programming; syndicated, prerecorded, taped.

Pan To move sound from one channel (speaker) to another (often used as a special effect).

Patching To connect one source with another using patch cord and patch panel (patch bay).

PBS Public Broadcasting System.

Phase When sound waves are in unison they are said to be in phase; synchronous cycles.

Pinch roller Rubber wheel that presses recording tape against capstan.

Playback Reproduction of recorded sound for listening purposes.

Playlist Roster of music for airing.

Popping Distortion of audio caused by overly accentuating a plosive (*p*, *t*, or *b*); blasting.

Positioner Brief statement used on-air to define a station's position in a market.

Pot Potentiometer; volume control knob, rheostat, fader, attenuator.

Preamp Auxiliary amplifier used for boosting the strength of a weak signal prior to its reaching the input of a primary amplifier.

Print-through Transfer of recorded audio to tape above or below original recording layer, producing echo effect.

Production director Individual in charge of station production department.

PSA Public service announcement; noncommercial message.

Pumping Effect created by compressor; breathing.

Rack To prepare or set up for play or record: to rack it up; an equipment container.

Recut Retake; rerecord, remix.

R-DAT Rotating-head Digital Audio Tape; digital recording system.

Reel-to-reel Open reel recording machine.

Reverb Redundancy of sound; sound reflection.

Rewind Speeded return of recording tape from take-up reel.

Ribbon microphone Microphone using a thin foil element connected between two poles of a magnet to generate an electric signal.

Ride gain To monitor level; to watch V.U. needle.

RPM Revolutions per minute; turntable speed measurement.

RPU (Remote Pickup) Equipment used at a remote location to exchange signals with a station.

Sampler Digital instrument possessing a micro-floppy disc drive used to record and manipulate sounds for mixdown purposes.

SCMS (Special Copy Management System) Type of chip in digital audio tape recorders that protects copyrights by preventing dubbing.

Segue Uninterrupted flow of recorded material; continuous, consecutive.

Sequencer Used in conjunction with a computer to record and store musical data through MIDI.

SFX Sound effect; ingredient of mixdown.

Sibilance High frequency sounds (noise) resulting from the pronunciation of the letters *s* and *ch*.

Signal-to-noise ratio The ratio between the signal level and the noise produced by a piece of equipment used in a mixdown.

Slip-cue Technique for quick-starting a record which involves restraining disc while turntable moves; slip-start.

Sound Vibrations detected by the human ear, usually in the 15 Hz to 18 kHz frequency range.

Sound bite Produced increment of audio; timed sound insert.

Speaker *See* **Monitor.**

Splice To join ends of magnetic tape with adhesive tape.

Splice block A recessed (tracked) metal block employed for the purpose of cutting and joining magnetic recording tape; edit bar, chopping block.

Sponsor Advertiser; client, account, underwriter.

Spot Commercial; paid announcement.

Spot set Group or cluster of announcements; stop set.

Stereo Dissemination of audio through two channels; two-speaker sound reproduction.

Stinger Music or sound effect finale preceded by last line of copy; button, punctuation.

Stop set *See* **Spot set.**

Stylus Needle that rides in grooves of a record sending vibrations to cartridge for conversion to electric energy.

Sweepers Sound bite used to bridge program elements.

Synthesizer Digital audio device employing a keyboard and frequently a MIDI to create special production effects.

Tag *See* **Live tag.**

Tail out Program recorded so that the end or innermost part of tape is outermost on the reel; not rewound.

Talent Radio performer; announcer, deejay.

Talk Conversation and interview radio format.

Tape Magnetic recording tape consisting of oxide coating and plastic (Mylar/polyester) backing; medium used to store magnetic signals for playback.

Tone arm Component of turntable consisting of cartridge, stylus, and balancing system.

Track Portion of tape on which a signal is recorded; fulltrack, multitrack.

Transducer Device that converts acoustic energy to electric energy and vice versa.

Turntable Piece of equipment used to play back analog disc recordings.

Tweeter Component inside a loudspeaker that reproduces high frequencies; cone.

UC Urban contemporary radio format.

Unidirectional microphone Microphone with single path, heart-shaped pickup pattern used to record sound from one point; cardioid.

Voice-over Talk mixed over sound.

Voice track Recording of announcer message for use in mixdown.

Volume Quantity of sound; audio level.

V.U. meter Gauge measuring volume of signal; level meter.

Windscreen Microphone cover (usually foam rubber) used to eliminate effects of plosives; filter.

Woofer Component inside a loudspeaker that reproduces low frequencies; cone.

Wow Distortion of sound created by inappropriate speed; miscue.

Suggested Further Reading

Alten, Stanley R. *Audio in Media*. 3rd ed. Belmont, Calif.: Wadsworth Publishing, 1990.

Ballou, Glen, ed. *Handbook for Sound Engineers: The New Audio Cyclopedia*. Indianapolis, Ind.: SAMS and Company, 1988.

Bartlett, Bruce. *Introduction to Professional Recording Techniques*. Indianapolis, Ind.: SAMS and Company, 1988.

Bloch, Louis. *The Gaspipe Networks*. Cleveland, Oh.: Bloch and Company, 1980.

Borwick, John, ed. *Loudspeaker and Headphone Handbook*. Stoneham, Mass.: Focal Press, 1988.

Davis, Don and Carolyn. *Sound System Engineering*. 2nd ed. Indianapolis, Ind.: SAMS and Company, 1988.

Fornatale, Peter, and Mills, J.E. *Radio in the Television Age*. New York: Overlook Press, 1980.

Gross, Lynne S., and Reese, David E. *Radio Production Worktext: Studio and Equipment*. Stoneham, Mass.: Focal Press, 1990.

Hagerman, William L. *Broadcast Advertising Copywriting*. Stoneham, Mass.: Focal Press, 1989.

Hilliard, Robert, ed. *Radio Broadcasting: An Introduction to the Sound Medium*. 3rd ed. New York: Longman Publishing, 1985.

Huber, David Miles. *Microphone Manual: Design and Application*. Indianapolis, Ind.: SAMS and Company, 1988.

Keirstead, Phillip O. and Sonia-Kay. *The World of Telecommunication*. Stoneham, Mass.: Focal Press, 1990.

Keith, Michael C. *Broadcast Voice Performance*. Stoneham, Mass.: Focal Press, 1989.

Keith, Michael C. *Production in Format Radio Handbook*. Washington, D.C.: University Press America, 1984.

Keith, Michael C. *Radio Programming: Consultancy and Formatics*. Stoneham, Mass.: Focal Press, 1987.

Keith, Michael C. *Radio Programming: Consultancy and Formatics*. Stoneham, Mass.: Focal Press, 1987.

Matelski, Marilyn J. *Broadcast Programming and Promotions Worktext*. Stoneham, Mass.: Focal Press, 1989.

McLeish, Robert. *The Technique of Radio Production*. 2nd ed. Stoneham, Mass.: Focal Press, 1988.

Mirabito, Michael M., and Morgenstern, Barbara L. *The New Communications Technologies*. Stoneham, Mass.: Focal Press, 1990.

Nisbett, Alec. *The Use of Microphones*. 3rd ed. Stoneham, Mass.: Focal Press, 1989.

O'Donnell, Lewis B., Hauseman, Carl, and Benoit, Philip. *Modern Radio Production*. 2nd ed. Belmont, Calif.: Wadsworth Publishing, 1990.

Oringel, Robert S. *Audio Control Handbook*. 6th ed. Stoneham, Mass.: Focal Press, 1989.

Orlik, Peter B. *Broadcast Copywriting*. 3rd ed. Boston: Allyn and Bacon, 1986.

Pohlman, Ken C. *Principles of Digital Audio*. Indianapolis, Ind.: SAMS and Company, 1988.

Sklar, Rick. *Rocking America: How the All-Hits Radio Stations Took Over*. New York: St. Martin's Press, 1984.

Thom, Randy. *AudioCraft: An Introduction to the Tools and Techniques of Audio Production*. 2nd ed. Washington, D.C.: National Federation of Community Broadcasters, 1989.

Watkinson, John. *The Art of Digital Audio*. Stoneham, Mass.: Focal Press, 1988.

Index

Abraham, George, 230
Accessibility, studio layout design and, 38–39
Acid stations, 168
Acoustics, 37–38, 39
Actualities, 69, 218
Additive EQ, 119
Adult Contemporary radio, 169, 189–93
Adult radio production, 166, 189–201
 Adult Contemporary, 169, 189–93
 Country, 166, 169, 193–98
 Middle-of-the-Road (MOR), 166, 189, 198–201
Advertisers, early top radio, 5
Advertising
 creating the sounds, 7–9
 indirect, 4–5
 introduction of, 3–5
 recording the message, 9
Advertising agencies, 6, 9, 81
Album Oriented Rock (AOR), 168–69, 178–82
Allen, Bruce, 195
Allen, Chris, 44, 108
All-News stations, 207
'All Things Considered' (program), 232–33, 235
Alten, Stanley, 38
Amplitude, 89
AM radio, 166, 167, 170, 199, 210, 227
Analog discs, 84, 85–87
Analog tape, digital audio tape vs., 78–79
Arbitron, 199
Arrangement, indexing bed by, 130
Articulation, 142
Artman, Paul, Jr., 25, 33, 205, 206
Art of production, 32–33
ASCAP, 126
Assemble editing, 159
Associated Press (AP), 138
Audio console, 37, 47–62
 components, 47–55
 designs, 55–57, 58
 labeling, 57–59
 locating voice track on reel-to-reel using, 147
 patching, 59–60
 practical points on use of, 59
 price range for, 57
 remoting, 60
 studio layout and, 39
 technical diagram of twelve-channel, 50
Audio equipment, using, 41–42
Audio in Media (Alten), 38
Audio levels, 52
 controlling, 43–44
Audiophiles, 202
Audio processing, 123
 in Adult Contemporary, 192–93

 in News/Talk mixdown, 217–18
 in Oldies stations, 188
 in Religious spots, 222
Audio processors, 109–12
Audio pulse, 65–66
Audio studio. *See* Studios
Audio switchers, 60
Audition, 37
Aural exciters, 119–20, 178
Aural sensibility, 25
Austin, Jim, 211
Automation system, 167

Bailey, Janet, 199
Ball, David, 41, 110
Barbasol commercials, 7
Barnouw, Erik, 8
Baxter, Robert, 107, 108, 113
Beaty, John, 44, 106, 110
Beautiful Music (BM) format, 166, 167, 170, 189, 202, 213
Bed library companies, 127
Bed music, 125–31
 in Adult Contemporary spots, 192, 193
 in Album Oriented Rock (AOR) spots, 182
 bed time, 125–26
 in Classical spots, 210
 in Contemporary Hit Radio (CHR) spots, 178
 in Country spots, 197
 in Easy Listening (EL) spots, 205–6
 indexing, 129–31
 key factors in, 125
 making, 127–28
 in Middle-of-the-Road (MOR) spots, 200
 in News/Talk spots, 217
 in Nostalgia spots, 211
 preproduction assembly of, 143
 in Religious spots, 222
 sources of, 126–28
 strictures, 128–29
 time consumed by, 140
 for Vintage Rock spots, 187
Bell Laboratory, 163
Benet, Stephen Vincent, 32
Berger, Fran, 230
Berry, Chuck, 164
Bidirectional microphone, 91, 93
Big Chill, The (film), 186
Block, Louis, 230
Block, Martin, 81
Block/variety Middle-of-the-Road (MOR), 198
Blore, Chuck, 185
BMI, 126
Board. *See* Audio console

Booth (voice tracking), 37
Borst, David, 230
Boxes, 109–12
Breathing, voice quality and, 142–43
Brelsford, Steve, 197
Broadcast Voice Performance (Keith), 141
Browning, Paul, 179
Brown University, 230
Bruns, Brian, 199
Bryant, Tom, 45, 109
Bulk erasers, 74, 75
Burping effect on cart, 68

Capacitor, microphone, 91
Cardioid microphone, 91, 93, 94
Cart builder, 68
Cart drawer, 40
Cartridge, turntable, 82–83
Cartridge (cart) machines, 65–69
 components of cartridge, 67
 recording with, 66–69
Cartridge tape, 73
Carts (tape cartridge), 9, 14
 DAT, 78
Cassette machines, 69–70
Cassettes, DAT, 79
Cassette tape, 73
CBS, 5
CDs. *See* Compact discs (CDs)
Censoring of live in-studio phone conversations, 220
Century 21 Programming, 127
Chandler, Melody, 218
Chase and Sanborn, 7
Chicken Rock, 189
Chief (senior) announcer, 11
China marker, 153
Chopping block, 153–54
Christian (Jesus) Rock, 222
Christian stations, 222
Cianci, Buddy, 215
Circuitry, combined, 122
Circumaural headphones, 102
Claims, excessive and false, 138
Clark, Dick, 186
Class Ds, 227. *See also* Noncommercial radio
Classical format, 166, 202, 206–10
Classic Hits programming formula, 186, 187
Classic Rock, 186, 187
Clear, Richard, 25, 30, 216, 217
Cochran, William, 41, 45, 109
Cocurricular college radio, 237
College radio, 227, 228–32, 236, 237–39
Commercials
 first, 3–4
 rock spots, 165–66
 types of catchy, 7
 see also Advertising; Mixdown
Community radio, 233–34, 236
Compact disc library companies, 105
Compact discs (CDs), 79, 84–86, 87, 104–5

Companding, 122
Composure, need for, 28
Compression, 89, 107–8
Compressors, 120, 121
Computers, 115–16, 171
Concerts, airing live, 179
Condenser, microphone, 91
Cones, speaker, 98
Congress, 227
Conrad, Robert, 25, 28, 31, 106, 209–10
Console. *See* Audio console
Contemporary Christian radio, 222
Contemporary Country stations, 194–95
Contemporary Hit Radio (CHR), 170, 174–78
Contests, 179, 202–4, 207
Continuous EQ, 119
Control room, 4, 14
Control vs. fidelity trade-off, 120
Conversational style, 137, 173, 197
Cook, Alan, 236
Cook, Michael, 24, 115, 196, 197
Cooper, Greg, 187
Copy
 Adult Contemporary, 190–92
 Album Oriented Rock (AOR), 180, 181
 bed music and, 125
 Classical, 208, 209
 Contemporary Hit Radio (CHR), 174–77
 Country, 195–97
 delivery preparation, 141–43
 Easy Listening (EL), 204–5
 format, 138–41, 173–74
 Middle-of-the-Road (MOR), 199–200
 News/Talk, 216
 Nostalgia, 211
 Religious, 223
 Urban Contemporary (UC), 184
 Vintage Rock, 186–87
 writing, 137–41
Copywriting responsibilities, 15, 29–30
Copywriting skills, 25–26
Corporation for Public Broadcasting (CPB), 227–28, 229, 233
Cortese, Joe, 85, 146
Counters, digital, 146
Country format, 166, 169, 193–98
Cousin Brucie, 165
Creativity, 27, 182, 190–91, 199
Credibility, News/Talk format and, 216, 217
Cue, 54–55, 56
Cue burn, 148
Cueing on turntable, 83–84
Cue-tone (audio pulse), 65–66
Cumming, Steve, 105, 106, 208, 209, 210
Curry College, 239
Curtis, Fred, 152
Cutting block, 153–54
Cutting-edge music, 178

DAT. *See* Digital audio tape (DAT)
Davis, Don, 180

Davison, Jack, 187
DAW, 115, 116, 117, 159
Dead-rolling, 83
Dedication, need for, 28
DeDominicis, Enzo, 206
Deejays, 164–65, 166, 168, 179, 218
 era of, 81
Degaussers, 75
Delayed sound, types of, 122
Delivery
 Adult Contemporary, 192
 Album Oriented Rock (AOR), 180–81
 Classical, 208–9
 Contemporary Hit Radio (CHR), 177
 Country, 197
 Easy Listening (EL), 205
 Middle-of-the-Road (MOR), 200
 News/Talk, 217
 Nostalgia, 211
 preparation, 141–43
 Religious, 223
 Urban Contemporary (UC), 184
 Vintage Rock, 187
Demagnetizers, 75
Demos, 16
 music, 126
Depression of 1930s, 6–7
Descriptions, writing, 138
Digital audio tape (DAT), 75–79, 105–6
Digital audio workstations (DAW), 115, 116, 117, 159
Digital counters, 146
Digital discs, 84–85
 maintaining, 87
Digitalization, 104–6
Digital samplers, 112
Dillard, Vance, 22, 24, 204
Directional characteristics of microphone, 91, 92, 93, 94
Disc jockey, evolution of term, 81. *See also* Deejays
Disco format, 169, 182
Dixon, Ken, 22, 26, 30, 31, 177
Donahue, Big Daddy, 167–68
Donor pool, 222
Doowop radio, 165
Dorman, Dale, 184
Dorwart, Michael W., 23, 28, 30, 104, 105, 216, 217
Douglas, Dwight, 213
Douglas, Paul, 200
Drake, Bill, 169, 185
Dramatized commercial, 7
Drew, Peter, 24, 28, 41, 42, 43, 110, 115, 192
Drive mechanism, turntable, 82
Dual channel mono board, 55
Dupras, Stephen, 237
Dynamic microphone, 90, 91
Dynamics control devices, 120–22

Ear, developing an, 25
Earphones, 99–102

Easy Listening (EL), 202–6
Echo, 38, 39, 122
Eckerea, Russ, 33, 187
Edit block, 153–54, 155
Editing, 152–60
 defined, 152
 illustrating process of, 154–58
 mastering possibilities of, 44
 purpose of, 152
 razorless, 158–59
 splicing vs., 152
 tools of edit, 153–54
Editing skills, 25
Education, College radio and, 230
Edwards, Mike, 214
Effects processors, 109–12
Eight-track tape machine, 106
Electronic editing, 159
Electronic news gathering (ENG), 119
Electronics basics, knowledge of, 22–23
Ellis, Dick, 199
Energy, need for, 28
Enthusiasm, need for, 28
Enunciation, 142
Equalizers (EQ), 55, 56, 108–9, 118–19
Equipment operating skills, 22–23
Equipment use and maintenance, 41–42
Erase head, 70
Erasers, bulk, 74, 75
Expanders, 121–22
Extracurricular college radio, 237

Faders, 49, 51, 52, 55, 56
Federal Communications Commission (FCC), 6, 120, 163, 166–67, 174, 220, 227
Federal Radio Commission (FRC), 6
Feedback, 54
Fidelity vs. control trade-off, 120
Fidelity vs. loudness trade-off, 120
Five-pot monaural console, 55
Five-pot stereo boards, 55, 57
Flight, 17
FM radio, 166–68, 180, 202, 204, 206, 210
 shift of audience from AM to, 169–70
Follow-up responsibilities, 31
Ford, Ty, 43, 107, 116–20, 127
Format
 choosing bed music and, 125
 copy, 138–41
Format radio
 adult stations, 166
 FM radio and, 166–68
 in 1980s and 1990s, 169–70
 pop chart radio, 164–65
 rock spots, 165–66
 role of production in, 171
 sounds of the 70s, 168–69
 specialization, 163–64, 166
 see also Adult radio production; "Good music" radio production; Nonmusic radio production; Rock radio production

Format Reach Chart, 178
Four-track tape deck, 106
Fox, Carolyn, 179
Frank, Alan, 237–39
Frankel, Harry, 7
Freberg, Stan, 32
Freed, Alan, 164, 165
Frequencies, 89
Frequency domain devices, 119–20
Frequency response
 equalizers and, 118–19
 of microphones, 91–93
Frequency spectrum, learning, 118
Full-Service Adult Contemporary, 189–90, 192
Full-service Middle-of-the-Road, 198
Funding, Community radio and, 233–34

Gain controls, 49, 52, 53, 54
 riding gain, 120
Gaspipe Networks, The (Block), 230
Gates, 121–22
Genre, indexing bed by, 130
Gerson, Lawrence Alan, 44, 106
Gerstein, Eric H., 42, 44, 107
Gillman, Jerome, 198
Glossary, 241–45
'Good Evening' (program), 235
"Good music" radio production, 202–12
 Classical, 166, 202, 206–10
 Easy Listening, 202–6
 Nostalgia, 210–12
Government intervention, 4, 6
Grammar, importance of, 137
Graphic equalizer, 119
Grease pencil, 153, 154

Haley, Bill, 164
Halper, Donna, 170, 195, 199
Ham, Al, 210
Hamnett, Russell, 235, 237
Hand-held microphone, 94
Hand signals, 221
Hanson, Bruce, 206
Hard disc audio storage systems (HDAS), 115
Harnsberger, Bill, 28, 31, 204, 206
Harris, Stan, 94
Headphone jack, 54
Headphones, 99–102
Heads, tape, 69, 70–71
Headset mics, 94
Hemma, Paul, 32, 115, 191, 193
Hertz, 118
Hertz range, 108
High-cut filter, 119
High-end demographics, 206
High-pass filter, 119
Hill, Chuck, 25, 31, 104, 180
Hit Country, 195, 197
Hole punching, 121
Hoover, Herbert, 4
Hot Adult Contemporary, 189, 190, 192

Humility, need for, 29
Humor, use of, 180, 187, 208, 211
Hyperbole, use of, 138

Impedance of microphone, 91
Independent radio producers, 3
Indexing
 of beds, 129–31
 of sound effects, 131–33
Indirect advertising, 4–5
Inflection, 142
Inman, D'anne, 30, 204
Inputs, console, 47–48
Insert editing, 159
Instrumentals, 126
In-studio interviews, 220
Intercollegiate Broadcasting System (IBS), 230
Interpersonal relations, need for good, 27
Interpretation of copy, 141–42
Interviews
 production, 220–22
 on Public radio, 235

Jacoretti, Roland, 106
Jennings, Al, 27, 29, 32, 205
Jingles, 7, 16
Joseph, Mike, 170
Judgment, producer's, 117–18

Kappo, Phil, 113
KDKA (Pittsburgh), 3
Kellerman, Ed, 42, 43, 105, 106, 107, 110
Kent, Lee, 26, 32, 110, 174–76, 177, 178
Keys, console, 48–49, 51
KiloHertz range, 108
King, Larry, 215
Kisseloff, Jeff, 8
Knowledge, need for, 28–29
Krause, Joe, 180

Labeling, console, 57–59
Lambert, Dean, 25, 27, 28, 30, 176, 177, 178
Lamphear, Kenneth, 31–32, 116, 205
Lapel microphone, 94
Lawrence, Joe, 26, 27, 116
Layout design for studio, 38–40
Leader tape, 146, 147
Libraries
 bed, 127
 compact disc library companies, 105
 sound effects, 131–33
Liebold, Linda, 233
Limiters, 120, 121
Lite Adult Contemporary, 189, 190, 192, 204
Lite (or Easy) Country, 194–95, 197
Live-assist, 202
Live spot, 8
Ller, Jeff, 195
Log, master, 130
Long playing 33⅓ rpm albums (LPs), 81, 164
Loudness vs. fidelity trade-off, 120

INDEX

Loudspeakers. *See* Speakers
Low-cut filter, 119
Lowe, Michael, 137
Low-pass filter, 119
LP libraries, 127
LPs, 81, 164
Lucky Strike cigarettes, 7

Mac, Chris, 177
MacGregor, Bruce, 178–79
McKenna, Irv, 188
McLaren, Thomas J., 33, 235
McLendon, Gordon, 213
McPherson, Aimee Semple, 222
Magnetic heads of tape machine. *See* Tape heads
Magnetic recording tape, 9, 72–74
Maintenance
 analog disc, 85–87
 audio console, 59
 compact disc, 87
 headphone, 101
 studio, 42
 tape heads, 70
Major market, 11
Market size, 11
Master gain, 49, 52
Master log, 130
Mathes, C., 235, 236
Medium market, 11, 13
Mellow Rock (MR), 169, 189
Meyers, Mel, 182
Michaels, Conrad, 216
Michaels, Ford, 22, 24, 27, 29, 30, 110, 113, 190, 192
Michaels, Vic, 28, 42, 47, 82, 127, 236
Microphones, 89–97
 carbon, 4
 designs, 89–93
 directional characteristics, 91, 92, 93, 94
 frequency response, 91–93
 pickup of, 93–94
 testing, 94
 types of, 91
 use of, 93–97
Middle-of-the-Road (MOR) format, 166, 189, 198–201
 for Country, 195, 197
 for Religious, 222
MIDI (musical instrument digital interface), 115, 127
Miles, Richard, 235, 236
Minority groups, Community radio funding and, 234
Minot, Harry, 237
Misinterpretation, 141
Miskimen, Jim, 227, 232, 233, 237
Mistakes, avoiding, 123
Mixdown
 Adult Contemporary, 192–93
 Album Oriented Rock (AOR), 181–82
 audio console, checking, 146

Classical, 209–10
College radio, 236
Community radio, 236
Contemporary Hit Radio (CHR), 177–78
Country, 197–98
defined, 17, 65
Easy Listening (EL), 205–6
Middle-of-the-Road (MOR), 200
News/Talk format, 217–18
Nostalgia, 211–12
at playback cart machine, 148
postmixdown, 149
on Public radio, 235
at record cart machine, 149
at reel-to-reel machine, 146–47
Religious, 223
responsibilities for, 30–31
timing elements in, 149–50
at turntable, 147–48
Urban Contemporary (UC), 184–85
Vintage Rock, 187–88
Mixdown ingredients, 125–34
 assembling, 143
 music, 125–31
 sound effects, 131–33
 storage of, 133
Mixing skills, 24–25
Monitors, 97–98
Monster-cans, 100
Mood, indexing bed by, 130
Moog synthesizer, 112
Morris, David, 24, 27, 29, 31, 33, 104, 216, 217
Moss, Gary, 193
Mounted microphone, 94
Movie sound tracks, 126
Moving-coil microphones, 96
Moving coil of microphone, 91
Moving-coil speakers, 98
Multimachine production mode, 42
Multitrack audio mixing console, 56, 57
Multitrack editing, 159
Multitracking, 42, 44, 65
Multitracking equipment, 106
Multitrack reel-to-reel machines, 65, 106
Murray the K, 165
Music. *See* Bed music
Musical instrument digital interface (MIDI), 115, 127
Music and Information format, 216
Muting, 54
Mutual Broadcasting System (MBS), 5

National Federation of Community Broadcasters (NFCB), 233
National Public Radio (NPR), 227–28, 232–33
 production of, 234–35
NBC, 5
Needle, turntable, 82–83
Network radio, advent of, 5–6
Newlon, Gary, 41, 42, 110

News
 on Album Oriented Rock (AOR), 179
 on Classical radio, 207
 on Contemporary Hit Radio (CHR), 174
 on Country radio, 195
 on Easy Listening (EL), 202
 on National Public Radio (NPR), 235
 on Nostalgia stations, 211
 production, 218–19
 on Public radio, 232–33
 on Religious radio, 222–23
 on Talk stations, 215
News format, 213–14
News Plus format, 216
News/Talk format, 215–18
News Variety format, 216
News wire services, 138
Nixon, John F., 22, 27, 28, 30, 192
Noncommercial radio, 227–31
 College radio, 227, 228–32, 236, 237–39
 Community radio, 233–34, 236
 CPB underwriting requirements, 227–28
 production, 234–39
 Public radio, 206, 232–35
Nonmusic radio production, 213–24
 interview production, 220–22
 News, 213–14
 News and Talk hybrid, 215–18
 news production, 218–19
 public affairs production, 219–20
 Religious programming, 222–23
 Talk, 199, 214–15
Nostalgia programming, 210–12
Numbers in radio copy, 138, 173–74
Nutzger, Mike, 192, 193

Oberle, Brian, 42, 106, 113, 115
Oboler, Arch, 7, 8
Oldies stations, 185–88
Omnidirectional microphone, 91, 92
 applicability of, 93–94
On-air studio, 14
Organizational flow charts, 12, 13
Organizational responsibilities, 31
Organizational skills, 26
Orkin, Dick, 32
Out-of-station production, 12
Overmodulation, 52, 53
Overproduction, 178, 193

Pacing ("speed-of-read"), 143
Pad time, 125–26
Parametric equalizer, 119
Patching, 59–60
Patience, need for, 28
Personalities, radio
 on Album Oriented Rock (AOR), 179
 on Full-Service Adult Contemporary, 190
 on Middle-of-the-Road (MOR), 200
 on Nostalgia stations, 210–11
Peterson, Rick, 43, 44, 108, 110

Pezzuolo, Rich, 94, 98, 131
Phasing of carts, 68
Phone interviews, 220
Phoneticization of words in copy, 138, 139
Phonographs, 81
Pickup of microphone, 93–94
"Pinning the needle," 52, 53
Pizzi, Skip, 78, 96, 102, 107, 110, 115, 235
Planning. *See* Preproduction planning
Plate, turntable, 81, 82
Playback cart machine, mixdown and, 148
Playback head, 70
Playlisted music, use of, 128
Plosives, 94
"Pop-Bachs," 207
Pop Chart radio, 164–65, 169
Pop-filters, 95, 97
Postmixdown, 149
Posture, breathing and, 143
Potentiometers (pots), 49, 51, 52, 55, 56
 cue mode or channel, 54–55
Power switch, turntable, 81
"P-popping," 94
'Prairie Home Companion' (program), 235
Preamp (preamplifier), 47
Preproduction planning, 137–45
 assembling mixdown ingredients, 143
 delivery preparation, 141–43
 sequencing and setup, 143–44
 writing copy, 137–41
Presley, Elvis, 164
Preview, 54–55
Princi, Carlo, 208–9
Producer
 judgment of, 117–18
 responsibilities of, 116–17
Production director, 3, 11, 12–21
 art of production and, 32–33
 day in the life of, 13–21
 in organizational flow, 12, 13
 qualities, 27–29
 responsibilities, 29–32
 skills, 22–27
Production in Format Radio Handbook (Keith), 137, 184
Production order form, 16
Production staff, role of, 11–21
 out-of-station production, 12
 production director, 11, 12–21
Program director, 11
Programming, 37
Progressive format, 167–68
Progressive Rock, 167
Promotions, 179, 202–4, 207, 235
Pronunciation, 142
Psychedelic rockers, 168
Public affairs production, 219–20
Public Broadcasting Act (1967), 227
Public radio, 206, 232–35
Pumping, 121
Punctuation, 173

Qualities of production director, 27–29
Quality control, 31–32
Quarter-track stereo recorder, 71
 recording paths, 72

Raab, Gregory, 195
Radio
 launching as mass medium, 3–5
 1926 as year of change for, 5–6
Radio Act of 1927, 6
Radio and Records (magazine), 178, 186, 202
Radio producer, use of term, 3. *See also* Production director
Radio Programming: Consultancy and Formatics (Keith), 197, 233
Rarefaction, 89
Razor for editing, 153, 155
Razorless editing, 158–59
Readability of copy, 141
Reading skills, 24
Rebel Rock sound, 194
Reception of signals, early, 5–6
Record-care accessories, 86
Record cart machine, mixdown and, 149
Recorded message, 9
Record head, 70
 cleaning, 15
Record (LP) libraries, 127
Record/playback tape decks, 66
Reel-to-reel tape machines, 63–65
 locating voice track on, 146–47
 multitrack, 65, 106
 primary components of, 63
 recording on, 63–65
 reel sizes, 73
 speed control button, 72
 tape heads, 69
Reel-to-reel to cassette routing through console, 51
Regulation, 6
Religious programming, 222–23
Remoting, 60
Resources, writing copy and availability of, 141
Responsibilities, 29–32, 116–17
Reverberation (reverb), 38, 39, 122, 165
Reynolds, Gary, 187
Ribbon microphone, 91
Richards, Dave, 84
Riding gain, 120
Riding gain, 120
"Riding in the red," 52
"Rip 'n' read" function, 218
Rizzo, Frank, 215
Rock 'n' roll, 164
Rock radio production, 173–88
 Album Oriented Rock (AOR), 168–69, 178–82
 Contemporary Hit Radio (CHR), 170, 174–78
 copy formatics, 173–74
 Urban Contemporary, 170, 182–85
 Vintage Rock, 185–88, 199
Rock spots, 165–66

Rogier, Julie, 234–35
Rome, Michael, 113
Ross, Davie, 196
Rotary pots, 49, 51
Rotation, 17

St. Joseph's College, 227
Sample, 112
Samplers, 112–15, 127
Sandman, Tom, 25, 29, 104, 110, 115, 180–81, 182
Sarnoff, David, 6
Scott, Dave, 127
Second World War, radio production after, 163–64
Seigel, Matt, 184
Selection, mastering, 44–45
Sequencing, 143–44
Setup, 143–44
SFX. *See* Sound effects (SFX)
Shelving, 119
Shotgun microphone, 94
Signals, hand, 221
Singing commercial, 7
Skills, 22–27
Skinner, Kimberly, 27, 177, 178, 187
Slip-cueing (slip-starting), 83–84, 148
Small market, 11
Smith, Elroy, 185
Sound
 delayed, types of, 122
 perception of, 89, 90
Sound bite, 218
Sound effects (SFX), 20, 131–33
 on copy, 174
 early, 7–9
 for Easy Listening (EL) spots, 205–6
 indexing, 131–33
 for Middle-of-the-Road (MOR) spot, 200–201
 preproduction assembly of, 143
 time consumed by, 140
Sound Pressure Level (SPL) chart, 90
Sound waves, 89, 90
Speakers, 97–98
Special effects, equalizers and, 108
Specialization, 163–64, 166. *See also* Format radio
Spec tape. *See* Demos
Speeds, tape machine, 71–72
Speed selector, turntable, 81–82, 83
Spillman, James, 109
Spizale, Dave, 235
Splice block, 153–54
Splice detector, 15, 74
Splicing, defined, 152
Splicing tape, 153, 155–56, 157
Sponsor, choosing bed music and, 125
Sports
 on Album Oriented Rock (AOR), 179
 on All-News stations, 214
 on Classical radio, 207
 on Easy Listening (EL), 202
 on News/Talk format, 216

254 INDEX

on Talk stations, 215
on Urban Contemporary (UC), 184
Spots, rock, 165–66
Spot set, 167, 222
Staff, role of production, 11–21
Step-switched EQs, 119
Stereo boards, 55, 57
Stereo cassette deck, 68
Stereophonic sound, introduction of, 166, 167
Stewart, Bill, 164
Stinger, 26
Stock Music Sales, 127
Stoecker, Kurt, 41, 44, 113
Stone, Oliver, 214
Storage
 for music and sound effects, 133
 in studio, 40–41
Storz, Todd, 164
Stuart, Fred, 26, 27, 29, 30, 31, 33, 177–78
Studios, 37–41
 acoustics of, 37–38, 39
 layout of, 38–40
 maintenance of, 42
 mastering possibilities of, 43–45
 size, 37
 storage, 40–41
Style, copy, 137, 173
Stylus, turntable, 82–83
Subtractive EQ, 119
Suite, 37
Supraural headphones, 102
Sweep EQ, 119
Switchers, 60
Syntax, 137, 173
Synthesizers, 112–15

Talk format, 199, 214–15. *See also* News/Talk format
Talkmaster, 214
Talk Radio (film), 214
Tandy Corporation, 105
Tape
 digital audio, 75–79, 105–6
 magnetic, 9, 72–74
Tape cartridges (carts), 9, 14
Tape heads, 69, 70–71
 maintaining, 70
 on reel-to-reels, 69
 track configurations, 71
Tape morgue, 133
Tape recorders, 63–80
 bulk erasers, 74, 75
 cartridge machines, 65–69
 cassette machines, 69–70
 digital audio tape (DAT), 75–79, 105–6
 magnetic tape, 9, 72–74
 reel-to-reel, 63–65, 69, 72, 73, 106, 146–47
 tape heads, 69, 70–71
 tape machine speeds, 71–72
Tastyeast Candy Company, 7

Technology, knowledge of cutting-edge, 28–29
Telephone interviews, 220
Telescoping, 182
Television, impact of, 163
Tellis, Jeff, 230
Tessitore, 197
Testimonial commercials, 7
Thompson, Art, 223
Time domain effects, 122–23
Time management, 26
Timing elements in mixdown, 149–50
Timing of copy, 138–41, 173
Timing skills, 26
Todd, Chris, 26, 28, 104, 190, 192, 193
Toggle switches, console, 48–49, 51
Toll-casting, 4
Tolliver, Lynn, 184
Tolstedt, Mark, 230
Tone arm, turntable, 82, 83
Top 40 radio, 164–66, 168, 169, 170, 194. *See also* Contemporary Hit Radio (CHR)
Tower in Babel, A (Barnouw), 8
Traditional Country format, 195, 197
Traffic director, 17
Transistor, 163
Transport system on reel-to-reel, 63
TSLs (time spent listening), 210
Tucker, Dave, 208
Turner, Roger, 98
Turntables, 81–84
 components of, 81–83
 cueing on, 83–84
 mixdown and, 147–48
Tuttle, Chuck, 211
Tweeter, 98
Two-way talk back, 214
Typing/keyboarding skills, 26–27

Underground radio, 168
Unidirectional microphones, 91, 93, 94
United Press International (UPI), 138
Urban Contemporary (UC), 170, 182–85
U-shaped studio, 38–39

V.U. meters, 49–54, 63, 66
Vertical slides, 49
Vincenza, Joseph, 235, 237
Vintage Rock, 185–88, 199
Vinyl discs, 9
Virginia Public Radio, 228
Vocal presentation. *See* Delivery
Voice quality, 142–43. *See also* Delivery
Voice synthesizer, 114
Voice tracking, responsibilities for, 30
Voice tracking room, 37
Voice tracks, 16
 locating on reel-to-reel, 146–47
Voicing skills, 23–24
Volume units, 49
Vonnegut, Kurt, Jr., 45

INDEX

Waveform modification, 123
WEAF (New York), 3–4, 5
Whitaker, Charles, 106
White, Sonny Joe, 184
Williams, Greg, 106
Williams, Jay, 171
Windscreens, microphone, 95, 97
Wisconsin, University of, 227

Wolfman Jack, 186
Woofer, 98
Workstations, 115–16, 117, 159
Writing copy, 137–41
Writing skills, 25
Wynne, Randall, 233

You Must Remember This (Kisseloff), 8